The Sacred Gaze

The publisher gratefully acknowledges the generous contribution to this book provided by the Art Endowment Fund of the University of California Press Associates.

The Sacred Gaze

Religious Visual Culture in Theory
and Practice

David Morgan

UNIVERSITY OF CALIFORNIA PRESS
Berkeley / Los Angeles / London

University of California Press
Berkeley and Los Angeles, California

University of California Press, Ltd.
London, England

Library of Congress Cataloging-in-Publication Data

Morgan, David.
 The sacred gaze : religious visual culture in theory and
practice / David Morgan.
 p. cm.
 Includes bibliographical references and index.
 ISBN 0-520-24287-4 (cloth : alk. paper) — ISBN 0-520-24306-4
(pbk. : alk. paper)
 1. Art and religion. I. Title.
N7790.M667 2005
201'.67—dc22 2004013929

Manufactured in the United States of America

14 13 12 11 10 09 08 07 06 05
10 9 8 7 6 5 4 3 2 1

To my teachers, whose patience matched the stature of their calling.

Contents

Illustrations

Preface

This book is for students and scholars of history, religious studies, anthropology, sociology, cultural studies, and any other discipline who study religion in one way or another and would like to think about the place of visual evidence in their work. These chapters have grown from my own work as a scholar and teacher and offer, I sincerely hope, an accessible account of one way of making images and visual practices part of the scholarly study of religion. The aim is to provide an inter-disciplinary approach to the study of religion that can be applied and adapted to different circumstances by students and scholars whose interest is the study and understanding of religions past and present.

I have dedicated this book to the several long-suffering teachers who have contributed mightily to my life. There have been many of them, but I would like to name the several here who have come repeatedly to mind over the years of my career as a college teacher: John Lee, Don Dynneson, Reinhold Marxhausen, Robert Quinn, and Martin Marty. These teachers expertly modeled the craft of teaching by demonstrating the supreme values of patience and persistent encouragement for engaging students in the serious joy of thought and imagination. In every case, they were able to overlook the limits of their student and nurture his passion to think.

My gratitude only begins with my teachers. I would like also to thank many colleagues and friends who helpfully read and commented on various drafts of the book and its countless proposals and outlines. They suffered through listening to me try to frame and reframe my

intentions: Gauvin Bailey, Nandini Bhattacharya, Gretchen Buggeln, Lynn Schofield Clark, Paul Contino, John Davis, Lisa DeBoer, John Dixon, Erika Doss, Elizabeth Edwards, James Elkins, Yacob Gobedo, Jeanne Kilde, Ken Mills, Brent Plate, Sally Promey, Stephen Prothero, Charles Schaefer, Kristin Schwain, Mark Schwehn, Jill Stevens, and Sue Taylor. I would also like to thank several friends and colleagues for their gracious assistance with images, bibliography, travel, consultation, and conversation: Sandy Brewer, Wai-Tung Cho, Don Cosentino, William Dyrness, Jim Green, Cordula Grewe, Ena Heller, Renu Juneja, Connie King, Brian Larkin, Padmini Makam, Harvey Markowitz, Adán Medrano, Birgit Meyer, Polly Nooter Roberts, Jane Pomeroy, He Qi, Karen Racine, Martha Reinke, Allen Roberts, Siriwan Santisakultarm, Charles Schaefer, Holly Singh, Tom Tweed, Nelly van Dorrn-Harder, and Robin Visser.

My experience with the International Study Commission on Media, Religion, and Culture has broadened my view of religious visual culture and has brought me into the happy fellowship of colleagues from around the world. I owe them a great debt. Their curiosity, open-mindedness, and love of travel have helped me refocus as a scholar.

Funding to support research that shaped this book came from Valparaiso University, the Luther Center, the International Study Commission on Media, Religion, and Culture and its source, Stichting Porticus, the American Philosophical Society, the Library Company of Philadelphia, and the National Endowment for the Humanities. Without the time and travel generously enabled by these organizations, the book would never have been possible. Subvention of the publication was provided by the Ziegler Foundation. I would like to convey special thanks to Phyllis and Richard Duesenberg for the substantial support they have provided to me by the endowment in their name. Their commitment to academic excellence in the study and production of the arts has contributed fundamentally to Valparaiso University. Although I'm not sure why, my wife continues to allow me to travel widely and burrow in archives while she handles children and work back home. No matter how much financial and institutional support I received, without her participation and goodwill, I wouldn't have written a word.

Several of the chapters have benefited enormously from their presentation at conferences and symposia. Comments from colleagues and audience members have illuminated problems and moved my thinking to broader and deeper dimensions. These events took place at several institutions and professional conferences, which I can only quickly list:

Vanderbilt University Divinity School, University of Arizona, University of Colorado, Calvin College, Fowler Museum of Cultural History, University of California at Los Angeles, University of Southern California, Getty Research Institute, Ashmolean Museum, Oxford University, University of Iowa, University of Miami, the Metropolitan Museum of Art, the International Association for the History of Religions, the International Association for Media and Communication Research, the American Academy of Religion, American Historical Association, and the American Society of Church History. I express a blanket "thank you" to the large number of people—some known and many unknown to me—who participated in these events and contributed to my reflection while this project was in preparation.

A few portions of this book appeared in different form in essays that I've previously published. A few passages in chapter 2 were derived from an essay in *Belief in Media,* edited by Peter Horsfield, Mary Hess, and Adán Medrano, published by Ashgate. Chapter 4 draws from an essay that appeared in the journal *Religion.* A much shorter version of chapter 6 was included in *American Visual Cultures,* edited by Dave Holloway and John Beck, published by Continuum. A brief portion of chapter 6 appeared in an essay in an exhibition catalogue, *The House of God: Religious Observation within American Protestant Homes,* edited by Margaret Bendroth and Henry Luttikhuizen, for the occasion of an exhibition at Calvin College. And a few paragraphs in chapter 6 appeared in somewhat different form in an essay published in *Mediating Religion,* edited by Jolyon Mitchell and Sophia Marriage, published by T. & T. Clark.

Finally, I would like to thank Reed Malcolm, Sue Heinemann, and Lynn Meinhardt, at the University of California Press, and the copyeditor Robin Whitaker, for their enthusiastic support for and contributions to this book. It is a pleasure to continue to work with Reed and his colleagues.

Introduction

In a modern guidebook on living and dying, the Tibetan Buddhist master Sogyal Rinpoche identifies three methods of meditation that he has combined into a single practice for bringing body, speech, and mind into alignment in meditation—the use of an object such as an image, reciting a mantra, and concentration on breathing, called "watching the breath." Learning to meditate is essential, "for it is only through meditation that you can undertake the journey to discover your true nature, and so find the stability and confidence you will need to live, and die, well."[1] Each of these methods withdraws the practitioner from attachment to fear, envy, and desire by focusing consciousness on itself, the very act of breathing, speaking, thinking. I am reminded of the instruction pregnant women and their birth partners receive in preparation for delivery: selecting a focal object assists women in the struggle of labor by helping them to maintain regular breathing and to resist panic. Having forgotten her focal object at home, my wife chose to squeeze my hand—with a frenzied grip that I've not forgotten. Whatever works—"skillful means," as Buddhists say.[2] Sogyal Rinpoche also teaches that a shrine with pictures can greatly assist the dying person.[3]

Why is it that the contemplation of images exerts the power to arrest the mind and deliver it from the anxieties that fragment consciousness and bind it to such invented torments as frustration, rage, jealousy, or obsession? Before answering that question, we must note that this benevolent effect is not confined to images. Music does this for many people. As do running, gardening, reading, chanting, chopping wood,

or slow walks in the woods. The things we do with our bodies have direct impact on the state of our consciousness. Body and mind are not separate entities, but enmeshed in one another. Touch one and you touch the other; calm one and you calm the other.

Images do this in a powerful way for many people. They seem to fill up consciousness with the presence of the pictured place or person. Buddhism teaches that the undisciplined mind is a hectic rush of thoughts that mirrors the restless turmoil of events that constitute the body and the world around us. Sogyal Rinpoche puts it this way: "Just look at your mind for a few minutes. You will see that it is like a flea, constantly hopping to and fro. You will see that thoughts arise without any reason, without any connection. Swept along by the chaos of every moment, we are the victims of the fickleness of our mind."[4] It is not necessary to be a Buddhist to see the truth in this observation. If consciousness is a shifting fabric of representations, an image used in meditation may serve to stabilize it at least momentarily—calming the eddies that disturb the surface of the mind, displacing the distractions with a single object of attention. If the mind takes the shape that occupies its elastic space, an image of someone whom we respect or cherish will exert a salutary effect—on the mind and the body. This is the regenerative benefit of relaxation.

Perhaps this helps explain why people cherish photographs of loved ones and friends and devote themselves to amassing and organizing photo albums or domestic displays of their pictures. It may also help us understand the allure of art and history museums and the use of icons and statuary in churches and temples. And it may provide a clue to the comfort of television, that glowing electronic hearth whose sounds and flashing images readily become a soothing presence in the home. In every case, viewers experience an absorption in an image. They cultivate a variety of visual practices that engage them in this absorption. Whether the absorption is contemplative, bringing the mind into a deeper experience of itself, or is a mind-numbing distraction that passes time (which can have its own regenerative effect), seeing is the medium that occupies the viewer in some manner of attention. Even if it's the hypnotic trance of channel surfing, the flea-hopping subsides and a certain form of rest ensues.

The Sacred Gaze

Seeing is helpfully understood as a great variety of *visual practices,* forms of engagement with oneself, with others, with the past, with the

worlds engaging viewers as viewers look at them in one manner or another. My aim in this book is to examine seeing and images in just this way. In recent years scholars of "visual culture" have variously suggested that the study of images should take a broader look at how images are actually part of ways of seeing. Vision happens in and as culture, as the tools, artifacts, assumptions, learned behaviors, and unconscious promptings that are exerted in images. But seeing is about more than its product. The argument of this book is that seeing is an operation that relies on an apparatus of assumptions and inclinations, habits and routines, historical associations and cultural practices. *Sacred gaze* is a term that designates the particular configuration of ideas, attitudes, and customs that informs a religious act of seeing as it occurs within a given cultural and historical setting. A sacred gaze is the manner in which a way of seeing invests an image, a viewer, or an act of viewing with spiritual significance. The study of religious visual culture is therefore the study of images, but also the practices and habits that rely on images as well as the attitudes and preconceptions that inform vision as a cultural act. I use the term *gaze* with a certain caution. Like many scholars of visual culture today, I am drawn to the concept of the gaze because the term signals that the entire visual field that constitutes seeing is the framework of analysis, not just the image itself. Yet with this advantage comes the challenge of a passel of meanings and conceptual entanglements associated with the term. The word has been broadly used in the last three decades and often within a thicket of theoretical interpretations that make one wary of the usefulness of the word.[5] Some of these interpretations reduce the gaze to a narrow meaning. For instance, for many writers the gaze has meant something almost singularly negative—the power of the voyeur, the coercive power of the privileged classes, or the totalitarian authority of surveillance. While these kinds of meaning certainly pertain to the controlling use of visual fields, the idea of the gaze should not limited to these ocular forms of manipulation.

I understand the concept of gaze to mean the visual network that constitutes a social act of looking. A gaze consists of several parts: a viewer, fellow viewers, the subject of their viewing, the context or setting of the subject, and the rules that govern the particular relationship between viewers and subject. These rules, implicit in a given genre of imagery and the occasion on which an image is viewed, stipulate conditions such as the subject's knowledge of being seen, what the viewer can expect from the act of seeing, whether the viewer can be seen

looking at the subject, and whether other viewers can see the subject with themselves. Protocols also urge appropriate demeanor, gesture, and response among viewers. For instance, on certain occasions one should yell or sigh or cry or keep silent. The rules outlining suitable behavior are learned and therefore they change over time along with the style, prestige, appeal, and authority of images.

A gaze is a projection of conventions that enables certain possibilities of meaning, certain forms of experience, and certain relations among participants. Although in standard English the word *gaze* means a particular kind of looking—a steady, intense or absorbed form of vision— the term is used here in a technical sense. Gaze designates the visual field that relates seer, seen, the conventions of seeing, and the physical, ritual, and historical contexts of seeing. The central structure of the gaze as it is most frequently constructed in visual experience is the relation between subject and viewer. These two exist in a rough symmetry: subject and setting correspond to viewer and audience. A gaze can run in either direction, depending on the rules in force. Examination of images demonstrates that they tend to fall into two broad categories. Some images portray a gaze as parallel to the viewer's world; others engage viewers in gazing or being the subject of gazing, that is, in being seen while they see. Consider the intent look of the mother pictured with her child in figure 57 (p. 202). This illustration of a Christian tract that seeks to instruct mothers in the proper spiritual formation of their children presents its gaze as exemplary. The mother's act of looking seeks to will the child's hand toward the Bible in front of them rather than toward the transient, earthly pleasure of flowers. Her gaze is so intense that her face seems to dissolve into the child's head, as if by infusion she would transform the child's being into the steadiness of her gaze upon the sacred book. Another instance of the gaze mapped out within an image occurs in Harry Anderson's painting called *God's Two Books* (fig. 24, p. 91). The gaze of the woman who has been studying the Bible in her backyard is met by the looming gaze of Jesus, who appears in a wall of foliage. The glory of nature that she sees takes the form of the deity who is revealed to her in the Bible and looks back at her as an incarnation in nature. If the image is simply meant to corroborate nature and holy writ, the face seems to mean more, intensifying her act of reading and destabilizing any merely instrumental regard for the physical world.

While these two images show in some way how vision happens, other images absorb viewers in the act of looking. Warner Sallman's

popular image of Jesus (fig. 39, p. 156), for example, invites viewers to behold the subject steadfastly, to enjoy Jesus's passive submission to his father's will. This picture presents Jesus in a way that many viewers have celebrated (or derided) for his feminine gentleness. Admirers of the image praise the accessibility and meek humanity of its Jesus. They refer to him as their "best friend." Their absorption in the image is facilitated by the fact that Jesus does not return their gaze, but looks humbly upward, toward his father. Mel Gibson's widely viewed film *The Passion of the Christ* (2004) uses a rather similar likeness of Jesus but subverts his prettiness with outlandish violence and the graphic portrayal of suffering. The film seems to thrive on displaying the bloody abuse of the attractive Jesus, thereby subordinating devout viewers to a merciless demolition of the gaze they bring to the film. This violation is quite intentional. In an interview Gibson stated that he "didn't want to see Jesus looking really pretty. I wanted to mess up one of his eyes, destroy it."[6] His determination to destroy Jesus's eye seems emblematic, as if he intended to assault the very means of vision. By violating the eye, Gibson eradicates the view of Jesus as pretty and effeminate, as well as the theology, piety, politics, and lifestyle that he may believe correspond to that prettiness and effeminacy. Gibson wants to destroy an entire way of seeing and install in its place a manly Jesus who is his father's son, one who by virtue of extreme iconoclasm has been purged of rival ways of seeing. The film plunges viewers into a protracted agony in order to wrench from them the devotional gaze that is fixed on such imagery as Warner Sallman's portrait of Jesus.[7]

I hope this brief discussion signals why I find the word *gaze* useful: it encompasses the image, the viewer, and the act of viewing, establishing a broader framework for the understanding of how images operate. A gaze is a practice, something that people do, conscious or not, and a way of seeing that viewers share. By *gaze* I mean not just one domain of vision, such as "the male gaze," but rather an entire range of ways of seeing. In order to signal the manifold yet related genres of gaze, one may enumerate several acts of vision such as gape, glimpse, and glance, and even such extended ocular performances as glom and glean. As different species of gaze, each configures a discrete relation among viewer, image, and what the image represents. And even more: each configuration carries particular assumptions about what is visible, the conditions under which the visible is visible, the rules governing visibility and the credibility of images, and what power an image may assert over those who see it. There are many more forms of the gaze to be

defined historically and culturally. This stream of alliterations may help readers bear in mind the range of visual operations designated by this book's use of the term *gaze*.

To understand the structure and operation of vision as a religious act, to *see* seeing, as it were, we must look for its visibility in a number of places. Each of the chapters in this books sets out to discern this visibility: in the use of images as visual evidence in historical interpretation (chapter 1); in what people do with images in their rituals of adoration, destruction, devotion, teaching, or commemoration (chapter 2); in the epistemological covenants that viewers enter into with images and how these shape the experience and meaning of what people see (chapter 3); in how the violent removal from sight shifts vision to other objects and relies on the notion of idolatry to do so (chapter 4); in the way that images mediate the visual encounter of two cultures (chapter 5); in the manner that visualizing gender organizes social life (chapter 6); and in how gazing at the flag has come to imagine national identity as powerfully as it has (chapter 7). In short, showing vision as socially and historically constructed religious practices is the task of this study.

My overarching argument is that the study of religious images is best undertaken as the study of ways of seeing. This means that visual practice is the primary datum alongside images themselves and that the two, together, insofar as religion happens visually, constitute the visual medium of belief. Belief is not a proposition or a claim or an act of will prior to what people see or do as believers. Or, if that is all that belief is, it has little to tell us about visual piety, which is the constructive operation of seeing that looks for, makes room for, the transcendent in daily life.

The Medium of Belief

For any approach to the study of religion that regards it as a set of practices more than a set of teachings, the English word *belief* is problematic. A belief or the act of believing understood as assent to a proposition is unequal to conveying the complexity and lived experience of religion. Belief is also a *Christian* way of thinking about religion. Because of the duty that Christianity has required of it, the word *belief* tends by long history to mean "tenet" (from *tenere*, to hold), that creedal (from the Latin *credo*, "I believe") utterance to which one must *hold* in order to belong to the community of the church. Christianity—

Protestant, Catholic, Orthodox—is deeply structured by the idea of right teaching (orthodoxy). One must affirm certain beliefs and deny others. The history of Christian doctrine is a history of vehement disagreement and struggle to legitimate one belief and deny the legitimacy of another. The anthropologist Malcolm Ruel has prudently argued that one must beware of this semantic legacy of *belief*.[8] But English speakers are limited by the tools the history of their language has bequeathed them. *Faith, conviction, assent, doctrine,* and *dogma* are no better, and generally worse.

And *belief* has the advantage of behaving as an active noun, only a step away from its verb form, *to believe*. Belief is something one does, which suits my focus on practice. Moreover, both noun and verb boast the distinct advantage of doing important duty in religious and nonreligious contexts. "I believe this is the correct address" and "It's our belief that the future of the economy is bright." Both utterances may express acts of entirely nonreligious faith and imagination. In addition to a religious conviction, belief may be an opinion, a fantasy, a groundless delusion, a conjecture, or an inference.[9]

Yet, inasmuch as belief is understood principally in terms of assent to a proposition, opinion, or impression, it is an inadequate representation of what constitutes religion, however much that view of belief may accord with important aspects of Christianity's creedalist definition of belief. As one Christian hymn beseeches: "Make us eternal truths receive/and practice all that we believe."[10] According to this piety, God delivers the truth to a passive humanity, which seeks divine help in putting such truth into practice. Belief is the affirmation of divine truth and therefore precedes action or practice. In fact, this is not what belief actually looks like or how it operates in religious life among most Christians. And it certainly does not represent other religious traditions. Practice is far more constitutive of belief than creedal affirmation is.

Ask most Christians, Jews, Muslims, Hindus, Buddhists, or Sikhs about their religion, and it is quite likely that you will receive a combination of the following in reply: an account of certain essential teachings; particular stories of the believer's life or sacred narratives; or descriptions of what are held to be definitive practices, such as prayer, diet, dress, and worship. Religion, in other words, will probably be defined by an interweaving of creedal statement, personal testament or a narrative of its founder, and particular practices and behavior. Although doctrinaire Protestants will rely heavily on verbal formulations, even they, in the end, will need to avail themselves of the practical

difference it makes to believe what they do. For it is almost certainly true that most people spend far more time each day *being* religious than they do merely *reciting* creedal propositions. Belief happens in what people say, but also in what they do. It is embodied in various practices and actions, in the stories and testaments people tell, in their uses of buildings, pictures, in the taste of food and the smell of fragrances, in the way people treat children, one another, and strangers.[11] Belief, in other words, does not exist in an abstract, discursive space, in an empyrean realm of pure proclamation, "I Believe." Belief happens in and through things and what people do with them. Theistic belief is grounded in the assumption that what one says or does in the manner of prayer, worship, or moral effort penetrates to the heart and mind of the deity. The deity sees what the believer does, gazes into the believer's very heart. While many Christian theologians are predisposed to stress the preeminence of words and concepts in delineating belief, this book argues that one gets much further in understanding religion by examining how people combine what they say with what they do and see.

Another way of putting this is that belief is *mediated,* which brings us to another key term to consider—*medium*. I wish to know how religious belief takes shape in the history of visual media. How is visual piety, visual belief, a function of its mediation? How does belief happen visually? How is belief a visual practice? I do not intend by the mediation of belief simply the expression of an antecedent tenet or teaching, though that is certainly a topic that belongs to the study of religious visual culture. The mediation of belief that I have in mind goes to the heart of belief as a historical phenomenon. The history of religion is not the same as the history of theology, that is, the history of what an intellectual elite has said about sacred matters—however relevant that history may be to the larger history of a religion. The history of religion is much closer to the unity that Sogyal Rinpoche discerned between thinking and doing in the practice of meditation. A medium—whether it is words, food, or looking at pictures—is where belief happens.

Accordingly, the study of belief proceeds here with two presuppositions in place, assumptions that, although they may sound simple, are consequential for the study of religion as lived practice. First, that belief does not happen without a body. Even when it happens in the discursive form of a proposition, it must be uttered by one person to another, by someone in the presence of a company of people, or argued, circulated, collected, studied, and taught in print. The material culture of religion is the physical domain of belief, the lived practices that constitute so

much of the ritual, ceremonial, and daily behavior of belief. Ignoring this wealth of evidence means ignoring most of what people do and how what they do shapes what religion does and means for them.

Second, it follows that, rather than being a private or purely subjective matter, belief happens between and among people. Belief is shared in imagery and visual practice, which commonly act as a fulcrum for such rudimentary forms of association and social organization as family, clan, ethnic and racial affiliations, and the elective associations of religious belief in modern societies. Visual culture can be a powerful part of the shared apparatus of memory, national citizenship, and the socialization of the young and of converts. Religions and their visual cultures configure social relations, over time and space and between one life-world and another.

The media scholar James Carey once suggested that communication consists of two rudimentary aspects that remain in tension with one another: the transmission of information and the ritualistic joining of communion. Both draw, he noted, from religious contexts.[12] Certain versions of Protestant Christianity stress the role of conveying information, construing "belief" as assent to doctrines or official teachings, and therefore lay greater emphasis on creed or content as definitive of belief. By contrast, other religious traditions lean more heavily on rituals of communion as definitive of religious identity and as the authoritative source for teaching, socialization, and moral conduct. Of course, orthodoxy (creedalism) and orthopraxy (ritualism) should not be strictly polarized, because belief always engages both sensibilities, though in different preponderances. Moreover, not only do these categories fail to apply helpfully to many religions, they don't always perform well even among those traditions of belief from which they draw their formulation—Christianity and Judaism. But we may wish to complicate creedalism rather than simply dismiss it. Doing so will allow a recentering of its function and will suggest a deeper purpose among practitioners, one that turns out to have a good deal to do with images and the hostility toward them.

The creedalist notion of belief argues that speaking is more powerful as an expression of faith than seeing. Creedalists of one sort or another insist that speech is the medium of the divine creation of the universe and the revelation of holy writ. Divinity reveals itself in what is *heard* (the spoken word, speech), according to Paul (Romans 10:17). Believers living in modern, literate societies quickly assume that speech also, or even primarily, means what is *written*. I do not propose a stark pitting

of hearing against seeing, word against image. To do so merely plays into the hands of religious apologists for the word. More interesting, it seems to me, is to recognize the slippage from spoken to written word and to scrutinize what it means for the experience of visual as well as print media in religious belief. But it is not so simple as regarding the Protestant Reformation as a decisive turn from orality to print culture. Speech and imagery both persist. Charisma and aura find new ways to infuse themselves into mass-culture artifacts. The iconicity of printed texts is a category of experience that Protestants relish.[13]

Regarded in this manner, Protestants, Jews, and Muslims rely, in my hunch, on a number of devices to experience the iconicity of their holy texts, which they all consider to have been inspired by God as his definitive self-revelation. Sortilege, the practice of randomly selecting a passage from the sacred text (Torah, Qur'an, or Bible) as a special message to the seeker, is one such practice. Creating amulets with scripture inscriptions, such as the *hamsa,* used by both Jews and Muslims (see fig. 15 on p. 66), or similar devices, such as the mezuzah on the doorposts of Jewish homes, is another. English-speaking Protestants are often deeply attached to the King James Version of the Bible and have long displayed their Bibles in ornate bindings, enthroned in parlors.[14] And the use of the red-letter, or rubricated, Christian Bible, which marks the spoken words of Jesus in red type, is a noteworthy instance of the way some modern Protestants experience the iconicity of the biblical text. They read the red portions of the Gospels with a special sense of being close to Jesus, reinfusing the written word with the status of utterance, the phonic presence of the speaker. Signaled visually, the red-letter text urges devout readers to hear the sound of their voice reading Christ's words as the sound of his voice. In this cooperation of several media, the graphic signifier promotes the iconicity of the written word qua spoken word. Rubricated text is text made especially transparent or iconic to the divine reality expressed by the words. The public recitation of scriptures in churches, mosques, and synagogues likewise resonates with the sound of the divine, animating the letter with vocal presence. Sikhs sing their scriptures in worship, Buddhists chant sutras, Hindus chant the Vedas.[15] Sound is a powerful "icon" when it turns into the very thing it represents: the voice of the divine. Whether spoken, sung, heard, or seen, sacred forms of representation are performances that transform sounds and images into the things they signify.

This metamorphosis is why the search for the "true image" prevails in many religious traditions. And it is one reason why debates over the

canon or the "authentic" texts of scripture are so important. The conflict between word and image is waged in many religious histories because the two are seen as mutually exclusive competitors for the status of revelation. When late-seventh-century Armenian icon painters insisted, "Our art is light itself, for young and old each understand it, while only few can read the Holy Scriptures," an ecclesiastical council was convened to reprimand the artists and subordinate them to the representatives of the word: "the scribes, the readers, the exegetes."[16] The Iconoclastic Controversy seethed in Byzantium for over a century as successive emperors opposed and vindicated the place of icons in worship. And the Protestant Reformation and its legacy both castigated and rescripted the role of images in Christian life.

One historically significant aspect of the rise of print culture in the West was the tendency to define belief as assent to theological propositions. Since the early centuries of the church, Christian orthodoxy had defined itself in terms of creeds but had resisted allowing verbal utterance to eliminate visual piety. Images belonged to the profession of faith. Seeing, no less than saying, was a fundamental, even liturgical, aspect of believing. This is evident in Eastern Orthodoxy's victory in the Iconoclastic Controversy. It is evident in popular and monastic practice in the West before the Reformation and in official church ritual after. And, as will be clear in chapter 3, it pervades popular Protestantism from Luther's day to the present in spite of vigorous Protestant polemic. The history of Christian visual piety is a history of varied practices and attitudes regarding the configuration of verbal, print, and visual media. Although priority is often assigned to speech, the claim is never without contradiction or qualification. And the claim is pilloried by Surrealist artist René Magritte, as we shall see in chapter 3.

In what follows, I offer a sketch of the sort of analysis that the history of visual media invites if these media are to become primary evidence in the study of religion. I focus on Christian material, in part because the problem that I have articulated is prompted by the history of Christianity and in part because Christian art is my area of expertise. It is also urgent to realize, however, as Malcolm Ruel has argued of the concept of belief, that Christian dogmatics has driven the discussion of word and image in the history of the study of religion in Europe and America. I hope the following consideration will confirm the relevance of Ruel's caution.

No theologian inveighed against images as adamantly as the Protestant John Calvin, who declared that images can teach nothing about Christian truth, since they are the product of the human imagination

and therefore inherently inaccurate on matters of divinity. The human mind, he claimed, is a factory of idols: it knocks out images or portrayals of the divine that are manufactured for the singular purpose of serving human needs.[17] Calvin was right, inasmuch as images take the place of previous referents. The Armenian and the Byzantine iconophiles proved that, as did the ancient Israelites who filled Moses's absence with the creation and worship of the Golden Calf (Exodus 32). Images engage in rivalry with one another, seeking to supplant or replace their competitors. But if this conflict, or *iconomachy* (struggle of images), happens among images, it also takes place in acts of iconoclasm, as I will explore in chapter 4: the destruction of images by those who regard them as an affront to the logocentric understanding of sacred text is, in fact, another form of iconomachy. Consider Calvin's claim that the biblical word is the only proper image of the Holy Spirit.[18]

Arguing against those who subordinated scripture to the effervescent and antinomian dictates of the Holy Spirit, Calvin insisted on the complete and binding agreement of spirit and scripture. The spirit, he contended, "would have us recognize him in his own image, which he has stamped upon the Scriptures. He is the Author of the Scriptures: he cannot vary and differ from himself."[19] Calvin urged his readers to reject an unfettered pneumatology of revelation, which pits living breath against dead letter. He favored a concept of the sacred text in which spirit and word are bound to one another in a cooperative way. The idea of writing that he endorsed understands the Holy Spirit to have imprinted ("stamped") itself in the words of scripture, committed itself to them in a unique, authoritative, and self-confirming unity. Readers, therefore, are not free to sever the spirit from the biblical text, but can only find the two corroborating one another. This cooperation is revelation for faith. Calvin's hermeneutic conflates the Holy Spirit with the spirit or gist or divine intention of the biblical text. In this shift from speech to writing as the medium of revelation, breath becomes essence or meaning. Charisma is constrained by textuality, and text is animated by deeper meaning as discerned by the eyes of faith.

For by a kind of mutual bond the Lord has joined together the certainty of his Word and of his Spirit so that the perfect religion of the Word may abide in our minds when the Spirit, who causes us to contemplate God's face, shines; and that we recognize him in his own image, namely, in the Word.[20]

Understood in the context of Reformed Protestantism's desire to avoid the excess of ritualism and sacerdotalism, on the one hand, and the

libertine extremes of charisma and spiritual antinomianism, on the other, Calvin's hermeneutic marked a substantive direction for the future. In order to make the move from orality to textuality, Calvin advanced a notion of text that sublimated the performative aspect of spirit-as-breath and rejected image as dissimulation.

His position is, of course, quite tendentious. Is holy writ really free of the cultural interests of its plethora of individual authors and redactors? How can the "spirit of the text" be distinguished from "Spirit stamped in the text" without the use of history and tradition? Calvin's assumption that the biblical text enjoys a direct relation to its divine referent is not only critically dubious but also ideologically charged with an important task. By insisting on the dissimulation of images, he created a media hierarchy in which the falseness of images underscored the truth of words and the iconicity of scripture. Calvin needed to vilify images in order to secure the transparency and autonomy of the biblical text.[21]

Among the advocates of images, *acheiropoesis* is the powerful device for legitimating the authority of images. Images *not made by human hands* are the visual equivalent of texts dictated by angels or otherwise revealed to a mortal amanuensis. The history of Hinduism, Buddhism, Islam, and Christianity, indeed, virtually any religion, includes accounts of images fallen from heaven or miraculously furnished.[22] One Hadith of Muhammad states that the Black Stone set within the stone cube, or Ka'bah, in Mecca came down from heaven and now occupies the central place of prayer, where the Stone had been originally placed by Adam himself and subsequently reestablished by Abraham. Tradition states that the Prophet kissed the Stone. The practice is imitated to this day by Muslim pilgrims, who circle the Ka'bah and kiss the Stone, rub it, or gesture ritually toward it in order to receive its blessing, or *barakah* (fig. 1).[23] Apparently the Black Stone *(al-hajar al-aswad)* was literally not made by human hands, having fallen from the sky as a meteor.[24] Originally white, according to Muhammad, it turned black upon absorbing the sins of Adam's offspring. The drama of seeing the Black Stone and other venerable stones set into the cube is enhanced when the black cloth *(kiswah)* that covers the cube is raised to expose the bottom rows of stone in the midst of the pilgrims. The sacred quality of the Stone extends to the cloth, which includes Qur'anic calligraphy and the name of Allah embroidered in gold. The cloth's black color signifies to some the unrepresentable, absolute nature of the divine. Each year the cloth is replaced with a new one, and the old is cut up and

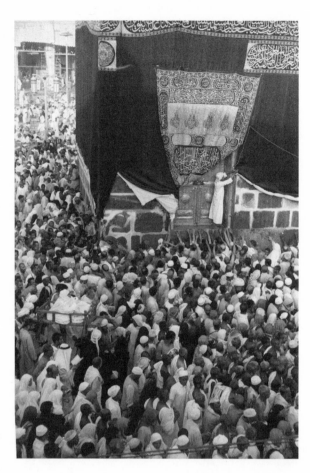

FIGURE 1. Muslim pilgrims encircle the Ka'bah and seek to touch it. Mecca, Saudi Arabia, 1965. Photo: Keystone Features/ Getty Images.

distributed among pilgrims and selected individuals and organizations, disseminating the *barakah* of Islam's holiest site.[25]

A Buddhist narrative describes a dragon that changed itself into the appearance of Buddha in order to reveal the authentic likeness of the Blessed One. After the dragon reverted to its original form, the holy men who had witnessed the apparition described it to artists, who created a wax form that was invested in metal. Several sculptures located in Thailand today are thought by local adherents to be the statue.[26] Other stories tell of images that perform miracles, such as transporting themselves across the sea or appearing in trees, where they are found and then worshipped. In Byzantium and early medieval Rome, icons of Christ and of the Madonna and Child,

believed to have been miraculously wrought or produced by humans with divine help, were displayed on city walls and in processions to protect Constantinople and Rome against invading armies and pestilence.[27] Images that display such origins and power are naturally authorized as special forms of revelation and enjoy unique and enduring claims to credibility.

Seeing Vision

Seeing images like these is the believer's way of learning how to see revelation happen. By carefully scrutinizing such images and the history of their use, scholars of religious visual culture can show how vision takes place; they can study vision as a historical and cultural formation.[28] An example from the history of Christian art will help explain what I mean, especially since it inverts Calvin's hierarchy by making a biblical author also a painter.

Since the seventh and eighth centuries, Orthodox Christians have told the story that St. Luke painted the Madonna and Christ Child as well as wrote the New Testament Gospel that carries his name. The pose of Mother and Child that was thought by early medieval Christians to be the one that Luke portrayed first appears in the seventh century, and images of Luke himself painting Mother and Child appear somewhat later.[29] It has been suggested that the legend of Luke the painter was invented by iconophiles, the defenders of images against those in Eastern Christendom who maintained that icons were nothing more than idols and therefore unsuitable in Christian worship.[30] But if icons shared the historical origin and authorship of the Gospels, who could deny their authority and central place in liturgy and devotion? St. Luke offered the most detailed account of the birth narrative and early childhood of Jesus. If anyone was to know the savior's appearance, it was this ancient authority, whose primary informant had been the apostle Paul. Surviving Byzantine portrayals of St. Luke painting the Virgin and Child often show Luke seated before an easel, painting his subject as a portrait icon—an unmistakable attempt to endorse icons and their veneration. In the later Middle Ages, depictions of St. Luke drawing the portrait appeared in stained glass, manuscript illuminations, and altar paintings with increasing frequency, in step with the rapidly growing cult of the Madonna. Not only seeing Mary herself but also *seeing her seen*, as the subject of a devoted gaze, became important to medieval

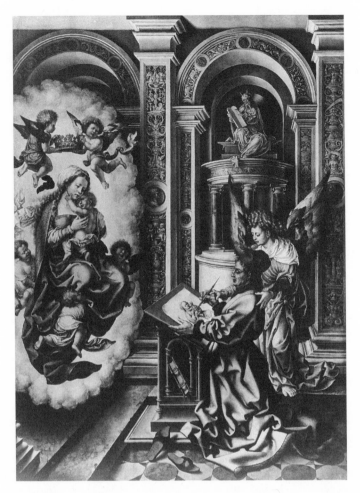

FIGURE 2. Jan Gossaert, *St. Luke Drawing the Virgin,* ca. 1520,
oil on canvas. Kunsthistorisches Museum, Vienna. Photo: Foto
Marburg/Art Resource, New York.

European Christians. And seeing her seen by one of the authors of the
four New Testament narratives of the life of Jesus eventually could be
made to support the ambition of the artist to be more than an artisan.
During the Renaissance, the artist aspired to be more than a copyist or
technician. Those like Leonardo da Vinci or Jan Gossaert worked by
inspiration and genius to offer a moving visual access to the mysteries of
the faith. One senses the stature of the artist rising in Gossaert's image
of inspired seeing, *St. Luke Drawing the Virgin* (fig. 2).

But the issue of what Luke is supposed to have seen is a problem. By his own admission, Luke never laid eyes on Jesus. For that matter, neither had Paul.[31] Luke opens his version of the Gospel with the frank statement to his addressee, one Theophilus (literally: lover of god), that he had culled his narrative from diverse accounts then in circulation:

Inasmuch as many have undertaken to compile a narrative of the things which have been accomplished among us, just as they were delivered to us by those who from the beginning were eyewitnesses and ministers of the word, it seemed good to me also, having followed all things closely for some time past, to write an orderly account for you, most excellent Theophilus, that you may know the truth concerning the things of which you have been informed. (Luke 1:1–4, Revised Standard Version)

Luke based his synthesis on the accounts reported by eyewitnesses and ministers of the word, conceding in effect that he had not seen first-hand what he was able only to report and edit as a single narrative. Text served as a form of reportage, acolyte to the seen, the witnessed events. The result, according to Luke, was the truth understood as a faithful portrayal of what happened. There is no mention of divine "inspiration" of the text, because the text was understood as a record of personal testaments culled and edited by the author, presumed by tradition to be Luke. Luke's writing marks his absence of having seen what happened but seeks to compensate by replacing that absence with the presence of those who did see. Luke's text may even trump his sources by crafting an overview, a synthesis of different views that harmonizes them into a single narrative.

Upon examination it is clear that Gossaert does not claim that Luke saw the Virgin and Child. Instead of gazing upon the vision before him, Luke appears to be looking at his drawing or, at most, caught in the moment of looking from the Virgin to his own image of her, or rather the image that the angel beside him draws by guiding his hand. Luke gestures ambivalently with his left hand: is he responding to the apparition before him or the image taking shape on paper? In either case, the position of the hand says the same: Behold, the Mother of God and her Offspring. That Luke does not gaze at the vision and is assisted by an angel suggests that his gesture replies to the drawing, which, of course, the entire image assures us, is imbued with the glory of its original. In fact, the original was believed to have survived, reported by Eastern sources to exist in Constantinople in the ninth century, and later in

Russia, several in Ethiopia, one in Rome, and one in a church in Regensburg, in Gossaert's day.[32] Including images of Christ, such as the Veil of Veronica, these *acheiropoietai* were painted entirely without the use of human hands or only partially with, having been completed by divine intervention, as in the case of Luke's portrait, according to one twelfth-century treatise on a much older icon of the Virgin and Child located in Santa Maria Maggiore in Rome, which was believed by the Roman church to be the original work of St. Luke.[33] The tradition, however, may tacitly accommodate the impossibility of Luke's having seen the Madonna and Child. In the case of Gossaert's picture, the divine intercession of the angel both compensates for Luke's lack of vision and certifies the authority of the resulting image. It does not matter, the angel's presence assures the viewer, that Luke had not seen his subject. And if that isn't clear enough by the direction of Luke's gaze and the guiding intervention of the angel, one should consider the epiphany of clouds circumscribing the apparition. The clouds suggest perhaps that Mary and Jesus are not really, physically there. They appear as a kind of revelation. But why show them if the angel is there, directing the hand of the artist? The little *putti* do seem to push mightily to keep the Mother of God afloat and to stay the heavy crown of her Celestial Queenship, hovering just above her head. Surely she is real.

Gossaert conveniently scattered clues throughout his picture to prompt the erudite viewer's iconographical sleuthing. It is impossible for the art historian to resist assembling these into a coherent reading. We should not confuse Luke's written Gospel with this act of visual portrayal, for we see what is presumably the clasped volume of his narrative tucked neatly beneath his drawing surface, a sort of classicizing lectern converted into a draftsman's table. What does this mean? That word precedes image? Or that image is not to be reduced to word, but seen as its pictorial equivalent? Or that word and image are inextricably enmeshed in one another? I think the latter. The lectern from which scripture is read in worship services is now the instrument of visual revelation. One is further inclined to interpret the picture as an authorization of image-as-revelation because Luke has removed his shoes and kneels beneath a towering sculptural configuration of Moses. This would make the Virgin and Child a New Testament counterpart to the Burning Bush, an ancient, desert revelation of Yahweh to an errant Moses (Exodus 3). As the bush burned but was not consumed, a similar miracle held with Mary: although the Mother of God, she did not conceive the Son of God in a sexual act. Luke the artist is a new Moses,

one invested with a divine revelation that is conveyed both textually and pictorially, each bearing equal legitimacy.

And what does the sacred artist show the viewer? An illusionism that seeks to accommodate the fact that Luke did not actually see his subject without undermining the authority of what he saw. He was a writer who did not see but whose text envisions what viewers of Gossaert's picture see. Set off from the material space of the church interior, the Madonna and Child appear to the viewer within the visionary space of a cloudy aura, the evocation of an angelic revelation that is transmitted to the obedient artist-evangelist by the heavenly messenger's prompting hands. The viewer of the image sees what takes place on the page before Luke, witnesses the "real thing" or prototype as it is transcribed in its icon, sees the sacred gaze happening. Byzantine icons always showed Luke seated before the Madonna and Child, sharing the same time and space with them, transposing their form. Gossaert infuses the artistic act with a dimension of sacred vision, intermingling two forms of seeing in a way that sacralizes the artist's work and ensures its reliability.

We should not overlook the importance of the subject in Gossaert's day. The *hodegetria*—the Byzantine term for Mary pointing to the Savior-Child as the way of salvation—was the type of image of the Madonna and Child attributed to Luke. This image type was especially powerful in pilgrimage churches and shrines throughout Europe, often serving as the destination of pilgrims seeking indulgence and blessing. A famous picture of the Virgin and Child, a copy of the original image attributed to St. Luke, was displayed in a church in Regensburg in 1519 following a miraculous healing there. Before the end of the year, fifty thousand people came to visit the image and beseech the Madonna for further miracles. In the summer of 1519, Pope Leo X granted indulgences to anyone making proper pilgrimage to the chapel housing the image. A well-known print by Michael Ostendorfer, produced in the same year, depicts the ecstatic devotion of a number of pilgrims fainting beneath a sculpture of the Virgin and Child in the foreground, surrounded by long lines of more orderly visitors who wait their turn to enter the chapel and address their petitions to the copy of St. Luke's painting.[34]

The popular response to a copy of a painting attributed to Luke brings to mind the artifice of Gossaert's and all other portrayals of St. Luke painting his subject: there is no original image of the evangelist-painter seen creating the image. That is entirely the product of artistic

fantasy. Luke did not paint an image of himself painting the Virgin and Child. If Byzantine icon painters portrayed Luke at work in order to bolster the claim for the apostolic authority of icons, Gossaert wished to create a "you-are-there" illusion, an optical record of what actually happened as if it were glimpsed from a few feet away. That meant acknowledging the other than optical source of Luke's image. It also meant finding a way to situate the painter's contemporaries before the event. To this end, the artist juxtaposed the old and the new: the late medieval, characteristically Gothic drapery, delicate gestures, and attenuated fingers are joined by the hyperclassicizing, even fantastical, High Renaissance features of the architecture. It is as if Gossaert intended to place old wine in spanking new skins, to update tradition without sacrificing the familiarity of its contents. While the delicate naturalism of floor tiles and sandals recall the careful observation of Jan van Eyck or Robert Campin, Gossaert's countrymen of exactly a century before (whose work he was commissioned to copy), by comparison the ornate tracery, decorated pilasters, and round inset arches respond to the latest classical fantasies that Gossaert may have encountered in Rome, where he went in 1508 at the behest of his chief patron, Philip of Burgundy, in order to copy works of classical antiquity for Philip's enjoyment.[35]

In what manner does this image show seeing at work? In Gossaert's painting we see seeing happen—we watch Luke witness what we see as fait accompli in images of the Madonna and Child. Paintings of Luke painting the Virgin and Child approximate the historical Luke gathering oral and written accounts of the life of Jesus and assembling them into an overarching narrative. Sacred images, Gossaert's picture suggests, form in the mind but have a way of forming that conceals their origin, such that Luke responds, astonished, at the image that takes shape on the page in front of him. The artist himself is a medium, an intervening agency whose task it is to draw and to be astonished, taken in awe. In the same way, the eyes of faith do not discern the seams and sutures of Luke's Gospel, cobbled together from diverse accounts, but read it as a single, continuous narrative. Seeing, like reading, in other words, is an act of worship, an observation of awe, but also a constructive act that transforms the spiritual into the material. Not only the artist's seeing, but the viewer's as well. Gossaert invites the viewer into a triadic configuration: the celestial, the artistic agent, and the viewer who sees what the artist images. Each is, in one sense, the medium of the others. Any two posit the missing third: the Madonna is absent to Luke but visible to the viewer, who is not present in the image but

implied by the appearance of the Madonna and the perspective of the room. All cohere in a single moment of revelation, of vision-constructing visual piety, an encompassing sacred gaze.

Perhaps this brief discussion of a painting that seeks to challenge the hierarchy of the word's absolute superiority to the image in matters of faith will serve to signal this book's intentions: images and how people look at them are evidence for understanding belief, which should not be reduced to doctrines or creeds of a propositional nature. Belief is an embodied practice no less than a cerebral one. Revelation is a constellation of seeing, speaking, and writing (as well as other media), which are assembled in a particular way in order to bolster one another, as in Gossaert's painting, or to privilege one medium over others, as in Calvin's theology. Of special interest to this study is that images may prompt in their subject, composition, display, and use the very practices of seeing that believers engage in. Such an apparatus of vision, hardly complete in itself, is nevertheless part of the evidence that scholars of religion might seek to excavate by posing socially minded questions of the image. That is, rather than confining one's attention to works of art and the history of style, one might investigate the social function of images, their role in ritual and ceremony, their constellation of viewers with respect to positions of status, gender, or race. And, where possible, one should situate an image within its history of reception, refusing to see it as a fixed, aesthetically permanent entity, but seeing it instead as a social phenomenon defined by an ongoing history of thought and practice. This is the study of visual culture, which has much to offer the study of religion, as the next two chapters seek to demonstrate.

Questions and Definitions

Defining Visual Culture

Whatever else they are good at, academics are inexhaustible generators of nomenclature. Perhaps this is because scholars live in worlds of discourse. They operate within literatures, historiographies, traditions of thought about the subjects they study. And they forge new terms and conceptual schemes to interpret and reinterpret those long, meandering histories of thought about thought. *Visual culture* is yet another, recently devised term. Whether it will enjoy enduring usage remains to be seen. Whether it deserves a try, however, is something worth immediate consideration.

In a characteristically oracular passage that has been quoted so often it has become a sort of truism, Wallace Stevens wrote that humans do not live in a place but in the description of one.[1] Not only scholars—everyone. Perhaps the major claim represented by the term *visual culture* as it is used by many scholars today is that this description is not only linguistic or textual but also visual. Human beings, in other words, create their worlds by visual means, in and by virtue of the pictures they fashion, revere, display, purchase, or exchange.[2] Put succinctly, the study of visual culture consists of asking how images as well as the rituals, epistemologies, tastes, sensibilities, and cognitive frameworks that inform visual experience help construct the worlds people live in and care about.

The Place of Theory

Moving beyond images themselves to examine visual practice and the cognitive and perceptual structures that shape our experience of images

means decentering the traditional approach to studying images. This recalls Stevens's distinction between place and description of place. Theoretical reflection in the humanities has thrived in recent generations of scholarship as a way of problematizing the situated-ness of knowledge-making. Scholars who have "deconstructed" the objects of knowledge have argued that knowledge is discourse, which is an ideological formation that constructs the illusion of truth and reality. Scholars don't simply study the past or the world or literature as if it were a purely objective domain of fact. A significant aspect of any kind of scholarship is scholars studying themselves studying. A necessary feature of critical scholarship is scrutiny of the language, taxonomies, and disciplinary rules that constitute the practice of scholarship. Deconstructive scholarship has foregrounded this aspect and has relied heavily on theoretical discourse to do so. The place of theory is paramount for this approach. Theory, not images or visual practice, often seems to be the real subject of visual studies. The place of thought is not things but the theoretical description of their investigation.

The definition of visual culture I propose refuses to break the tie between image and theory. Theory is interesting and useful as a way of reflecting on the practice of studying religious visual culture. But theory for its own sake is not what motivates my scholarship or the work I find most influential and productive. The place of theory in my approach to visual culture is to keep images within view, to offer fresh ways of thinking about what one sees. Theoretical reflection provides an indispensable service by interposing a critical distance between what scholars see and what they think about what they see. For instance, many scholars ignore images in their research because their notion of evidence does not include pictures. They have determined a priori that certain forms of information, such as textual documents, are primary, and they proceed to interpret these according to certain rules of evidence and analysis. Were they to back up from their preconceptions about evidence and its interpretation, they might find a range of material they were ignoring, material that could enrich their study and help generate new possibilities for understanding their subject matter. This has been argued cogently by several historians in recent years.[3] The term *visual culture* has come to designate work by scholars who wish to broaden and deepen the investigation of images and visual practice—"deepen" because these scholars want to learn new things about images that may have been occluded by conventional forms of study; "broaden" because they want to link their research to the investigations carried out in fields

of study that they find intriguing because of the promise of new ways of thinking about images.

The point of this book is not to formulate the latest critical theory of images or to advance art historical discourse. Instead, I wish to show how visual studies can contribute to the scholarly understanding of religion. The value of theoretical reflection should be measured, finally, by the contribution it makes to illuminating the actual object of study: the visuality of religion. This chapter, therefore, sketches the terrain of current thought in order to clarify what we may meaningfully intend by the new nomenclature.

Visual Culture and Art History

Recent reflections on visual culture have considered whether this rubric should signify a field of study and what relation the study of visual culture bears to other disciplines, most important in North America, to art history.[4] For instance, does visual culture refer collectively to what scholars study—paintings, photographs, posters, film, television—or should it designate a new discipline or subdiscipline, that is, a distinct field of research and teaching with its own methodologies, subject matter, academic departments, and pedagogies, constituting a relatively distinct scholarly discourse?[5] I propose a definition of visual culture that stops short of according it disciplinary status but desires considerably more from the term than a handy reference to a broad range of artifacts. I argue that as a subject matter, visual culture refers to the images and objects that deploy particular ways of seeing and therefore contribute to the social, intellectual, and perceptual construction of reality; as a professional practice of study, visual culture is that form of inquiry undertaken within a number of humanistic and social scientific disciplines whose object is the conceptual frameworks, social practices, and the artifacts of seeing. Rather than a discrete field or discipline, the study of visual culture is the investigation of the constructive operations of visuality in any scholarly study of representation, art historical or otherwise.[6] But since art history is the discipline most consistently engaged in the study of images and visual forms, art history receives the greatest scrutiny here. Not, I hasten to point out, because visual culture is a subfield of art history or because this book is an art historical project. In fact, little if anything I have to say will strike art historians as particularly new. The debate over visual culture among art historians is

largely over. My remarks, it is important to say, are directed not to art historians in the first instance but to scholars and students in other disciplines who may wish to know how the study of images and visual practices can contribute to their particular discipline's investigation of religion.

For generations, art history as a discipline was dominated by the study of iconography and style. In fact, these still serve as fundamental frameworks for the study of art in undergraduate survey textbooks and in the organization and presentation of art exhibitions in many museums. Yet much art historical work today has moved far beyond a focus on style and subject matter. Certainly these considerations remain highly useful as methods of scrutinizing the content and appearance of images. But they do not exhaust the meaning of images. Nor does iconology, that higher tier of signification, according to Erwin Panofsky, who regarded "the work of art as a symptom of something else, which expresses itself in a countless variety of other symptoms."[7] Iconology studies just this content of the work of art, that is, its invocation of a culture's broader "symbolical values." Iconological interpretation seeks to discern in the work of art the subtle signification of this "something else," which is recognizable in the work of art, according to Panofsky, as a visual instance of the same "mental habit" found in adjacent cultural representations such as philosophy, literature, and theology. Art participates in higher cultural thought, the expression of what philosopher (and Panofsky's Hamburg colleague) Ernst Cassirer considered a civilization's "symbolic forms," the conceptual templates that inform any particular cultural representation.

As they were practiced in Europe and the United States through the first half of the twentieth century, iconological interpretation and the analysis of iconography tended to yield a practice of art history that regarded images as the vehicle of ideas. Art history often became a kind of intellectual history, in which the social function of images and the ideology they articulated and visually deployed received little or no attention. This was challenged by the social history of art over a generation ago and by more recent scholarly interests in the ideological interpretation of art.[8] From the 1970s to the end of the century, diverse approaches developed by art historians likewise moved beyond the domain of iconology, iconography, and style (though significant attempts to turn iconology toward the social and ideological analysis of art are noteworthy).[9] Contextualism, critical theory (structuralism, post-structuralism, psychoanalysis), and ideological analysis (Marxism,

feminism, queer theory) all have challenged the traditional object of knowledge and the favored questions that art historians were trained to ask of their objects. Yet a great deal of this work, however sophisticated its theoretical underpinning, is often still quite traditional, inasmuch as it uses critical theory to uncover overlooked iconographies or to engage in a new kind of formal or stylistic analysis or to identify new works or artists to be placed in the canon of fine art or grafted onto the avant-garde. For instance, many art historians using the term *visual culture* to describe their work favor an avant-gardism that limits the meaning of visual culture. Several anthologies and recent works reinscribe avant-gardism and even postmodernism in the study of visual culture. Their analyses stress the disruptive, politically radical, morally transgressive values once hailed as the character and aim of avant-garde art.[10] This conflictual model favored by many critics and visual analysts today can boast the virtue of recognizing the social function of images and the need for their social analysis. Yet this often comes at the price of understanding everyday life and the quotidian visual practices of domestic life, commerce, sport, and religion. The study of visual culture concentrates on the cultural work that images do in constructing and maintaining (as well as challenging, destroying, and replacing) a sense of order in a particular place and time.

One definition of visual culture shared by many writers on the subject is that visual culture is only contemporary. Visuality today, the argument goes, is the result of modern technology and its transformation of the visual field.[11] Others assert that modern social revolutions in the politics of gender and race have overturned the regnant patriarchal epistemology that constructed a visual regime based on the male gaze. Proponents of the latter view tend to use visual culture as a partisan tool to disrupt the invisibility and marginalization of the subaltern by dominant discourses. As one important writer, Irit Rogoff, has put it, "In a critical culture in which we have been trying to wrest representation away from the dominance of patriarchal, Eurocentric and heterosexist normativization, visual culture provides immense opportunities for rewriting culture through our concerns and our journeys." This characterization posits a fundamental ideological conflict and uses the first-person plural to underscore it. To whose concerns and whose journeys does the author refer? To those who reside in "critical culture" and war with white male patriarchy over the trophy of "representation," which is a reified something to be snatched from the grip of one's ideological foes. Rogoff later refers to the *we* of her text as those who

"belong to radically different collectives and cultural mobilizations within the arena of contemporary feminist, multicultural and critically/theoretically informed culture."[12] Her repeated use of *we* and *our* in describing what she considers visual culture as a theoretical intervention into the battleground of society suggests that she is speaking to a relatively discrete audience about interpretations of texts and images that concern like-minded people. In fact, to judge from the intertextuality of the overwhelming majority of studies in visual culture or visual studies or visual culture studies, the field may be accurately described as the project of a few dozen scholars. James Elkins has helpfully enumerated most of them, their canon of founding authors (Benjamin, Barthes, Foucault, and Lacan), and their preferred topics in his own introduction to visual studies.[13] In light of this comparative homogeneity, Rogoff's "we" and "our" are less presumptuous than they might seem, actually reflecting a specific discourse and a defined group of cultural interpreters. For whatever reason, almost none of the scholarship cited by Elkins addresses religious visual culture. Perhaps the avant-gardist disposition among many of these writers inclines them to assume that religion is reactionary and therefore uninteresting. In any event, scholars of religion will find a range of useful ideas in the leading scholarship on visual culture but very little application to religious topics of study.[14]

If the established art historical approach concentrates on determining why images appear as they do, seeking to do so by investigating style, iconography, and patronage, and the newer art history focuses on re-contextualizing images in theoretical discourses, the visual culture approach taken here pursues another tack. It attends to the social functions and effects of the image. The underlying question for scholars of visual culture is: how do images participate in the social construction of reality?[15] Accordingly, scholars of visual culture will be interested in potentially any visual medium as well as a variety of methodologies for interpreting different forms of visual evidence. Moreover, the study of visual culture will regard the image as part of a cultural system of production and reception, in which original intention does not eclipse the use to which images are put by those who are not their makers. Scholars will therefore investigate not only the image itself but also its role in narrative, perception, scientific and intellectual classification, and all manner of ritual practices, such as ceremonies, gift-giving, commerce, memorialization, migration, and display—thereby understanding the image as part of the social construction of reality.[16]

Images are produced by and in turn help construct the social realities that shape the lives of human beings. The study of visual culture scrutinizes not only images but also the practices that put images to use. This means social, cultural, intellectual, and artistic practices, since all of these help make images meaningful. As already indicated, today the study of visual culture is not a discrete or autonomous discipline, but an interaction among several existing disciplines or fields of study. Thus, when scholars study visual culture to explain why some aspect of the past happened the way it did, they operate as historians; when they look at images for the purpose of understanding a cultural practice or social institution, they act as anthropologists or sociologists. They may borrow heavily from one another's disciplines, but their treatment of visual evidence and the ways in which they interpret it and make it contribute to existing bodies of knowledge and social formations, such as professional disciplines, serve to distinguish them from one another. The study of visual culture is not the sole province of a single discipline but happens when either a visual scholar asks socially or culturally minded questions or when a social or cultural analyst investigates visual artifacts or ways of seeing.

But why privilege the *sociocultural* aspect of images and vision in the definition of visual culture?[17] After all, cognitive psychology, epistemology, and taste each contribute to understanding the production and reception of images, since conceptual and affective dispositions shape the ways in which people see. By stressing the role of social and cultural construction in the definition of visual culture, I intend to underscore the importance of shared practices, ideas, institutions, feelings, and values as constitutive of human vision, in particular, of the sacred gaze. I do not wish to exclude or marginalize the personal or individual construction of meaning, such as artistic intentionality, but to place it within its social and cultural context. The accomplishment of a Michelangelo is not undermined by examining the constituents of his acts of seeing—the conceptual schemata he presupposed, those he forged, the reception of his work, and the cultural uses to which it was put, his hopes and intentions notwithstanding. But what is threatened is the traditional emphasis in training students and generating scholarship: the focus on style, connoisseurship, iconography, and the canon of great art by artistic geniuses. It is the traditional discourse of art history that is called into question or at least decentered. And if Michelangelo's mastery is not denied in visual culture studies, neither may it receive the attention it once did. But scholarly fashion is probably no more restless

than the history of taste. There was a time, after all, when artists such as Rembrandt or Grünewald were ignored or even forgotten.

The term *visual culture* marks a fundamental shift in the study of images—from an object- and artist-centered to a practice-centered discourse. A constructivist emphasis does not deny or ignore artistic intention but refuses to stop with its determination as the limit of an artwork's meaning. Many forms of critical theory, the social history of art, the sociology of art, and the study of reception move beyond the object or artist as the primary locus or source of meaning. The object is not eclipsed, is not rendered irrelevant, but neither is it understood as an autonomous expression of genius or artistic intentionality or aesthetic experience. Its production entails an institutional history, a social embeddedness, and its reception endows it with significance that may have nothing to do with its maker's intent. If iconographical and stylistic analysis—whether informed by the latest critical theory or not—concentrates on the object itself, that is, the material artifact of culture, a visual culture approach wishes to scrutinize the social apparatus that creates and deploys the object, the gaze that apprehends the image in the social operation of seeing.

By "social construction of reality" I do not have in mind a dissolution of human agency, human intentionality, the work of art, or artistic skill or accomplishment. People and objects exist as material realities that may not be reduced to social circumstances. But neither does their significance emanate from within them as from an essence. To investigate an image as a social reality means to regard its significance as the result of both its original production and its ongoing history of reception. When does art historical inquiry become the study of visual culture? Whenever the task is no longer one of explaining a work of fine art per se but rather the social and cultural construction of seeing that is embodied in an image of any kind, fine art or not. Yet visual culture, in my view, should operate in a parasitical relationship with visually oriented disciplines such as art history, architectural history and theory, design history, media studies, visual communication, film studies, or visual anthropology. Of these, art history, film studies, and visual communication are perhaps the most frequent and the most established sites on the academic map of American higher education that consistently and self-consciously sponsor the study of images as the aim of historical and critical understanding.[18] These disciplines teach students how to study visual evidence with great care, and they ought to be very interested in what scholars of visual culture have to offer in their research.

Art history, film studies, and visual communication regard images as the visual ordering and articulation of experience. W. J. T. Mitchell has rightly stressed the importance of studying vision and visual experience as a fundamental human activity and not as something reducible to language or texts.[19] This does not entail a purist enterprise of opposing images to language but seeks to give vision its due in the social construction of reality.[20] Seeing is a biological function, just as tasting, touching, hearing, and moving are bodily operations. The study of visual culture, therefore, should be dedicated to studying the image as historical evidence of seeing and to studying seeing as a form of thought and action, an array of social practices that have everything to do with the social construction of reality. In other words, for the student of visual culture, pictures are not merely illustrations of nonvisual events, such as ideas, personalities, or nations, but one powerful way in which ideas, personalities, and nations happen.

Defining Visual Culture and Its Study

The claims advanced here may be condensed into two assertions:

· Visual culture is what images, acts of seeing, and attendant intellectual, emotional, and perceptual sensibilities do to build, maintain, or transform the worlds in which people live.

· The study of visual culture is the analysis and interpretation of images and the ways of seeing (or gazes) that configure the agents, practices, conceptualities, and institutions that put images to work.[21]

Accordingly, the study of visual culture should be characterized by several concerns. First, scholars of visual culture need to examine any and all imagery—high and low, art and nonart.[22] They must not restrict themselves to objects of a particular beauty or aesthetic value. Indeed, any kind of imagery may be found to offer up evidence of the visual construction of reality. At the same time, although not limiting themselves to fine art, neither should these scholars ignore it. It is just that their aim is not to praise, appreciate, or document fine art.

Second, the study of visual culture must scrutinize visual practice as much as images themselves, asking what images do when they are put to use. If scholars engaged in this enterprise inquire what makes an image beautiful or why this image or that constitutes a masterpiece or a

work of genius, they should do so with the purpose of investigating an artist's or a work's contribution to the experience of beauty, taste, value, or genius. No amount of social analysis can account fully for the existence of Michelangelo or Leonardo. They were unique creators of images that changed the way their contemporaries thought and felt and have continued to shape the history of art, artists, museums, feeling, and aesthetic value. But study of the critical, artistic, and popular reception of works by such artists as Michelangelo and Leonardo can shed important light on the meaning of these artists and their works for many different people. And the history of meaning-making has a great deal to do with how scholars as well as lay audiences today understand these artists and their achievements.

Third, scholars studying visual culture might properly focus their interpretative work on lifeworlds by examining images, practices, visual technologies, taste, and artistic style as constitutive of social relations. The task is to understand how artifacts contribute to the construction of a world.[23] Important methodological implications follow: ethnography and reception studies become productive forms of gathering information, since these move beyond the image as a closed and fixed meaning-event.[24]

Fourth, scholars may learn a great deal when they scrutinize the constituents of vision, that is, the structures of perception as a physiological process as well as the epistemological frameworks informing a system of visual representation. Vision is a socially and a biologically constructed operation, depending on the design of the human body and how it engages the interpretive devices developed by a culture in order to see intelligibly.[25] Seeing, as I will explore in chapter 3, operates on the foundation of covenants with images that establish the conditions for meaningful visual experience.

Finally, the scholar of visual culture seeks to regard images as evidence for explanation, not as epiphenomena. Images should therefore be regarded as visual evidence and should be interrogated to determine what they can tell us about acts of seeing as well as the relationship between visual representation and ways of thinking, feeling, acting, and believing, not to mention eating, dressing, fighting, and loving. When visual culture is constitutive of religion in some way, we may speak of the "ocular dimension" of religion as a subject matter in its own right, that is, as a peculiar form of evidence. Understanding how images operate expands the range of evidence and the interpretive tools available to the scholar.

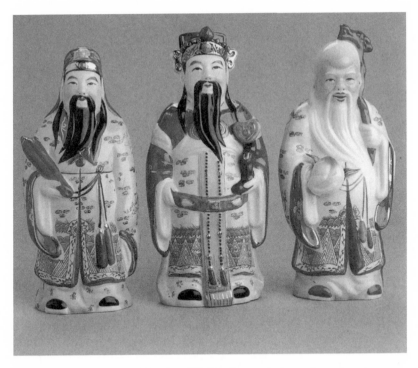

FIGURE 3. *Fu, Lu, Shou* (Blessing, Wealth, Longevity), modern glazed porcelain, each approximately 8¾ inches high. Purchased in Chinatown, Chicago, 1999. Photo: Author.

Images and Argumentation

If we have some idea now about what visual culture is and why scholars study it, we may turn to examine the uses scholars make of images in their arguments. Why, to ask what may seem an obvious question, do scholars reproduce images in their published research or in public presentations, such as the illustrated talk?[26] The most apparent reason is that the image offers evidence for a claim they wish to advance. A set of objects such as those in figure 3, *Fu, Lu, Shou,* may carry within it a corroboration of the scholar's assertion, say, that Chinese folk deities are commonly portrayed in the anachronistic costume of a past aristocracy.[27] To show these figurines is to support the claim with a concrete instance. The image, in other words, provides visual (as opposed to textual, statistical, or some other manner of artifactual) documentation for the claim, not as a purely unique phenomenon, but as the concrete

example of an entire class of phenomena. Were the statuary of Fu, Lu, and Shou the single instance of folk deities dressed as aristocrats, the scholar could not use the image to bolster the general claim. The assertion that folk deities dress as anachronistic aristocrats would then require another kind of evidential support, such as a literary passage containing a description. Images, in this sense, conform to the rules of evidence that govern the use of evidence in argumentation.

Another obvious reason to include an illustration of an image with a scholarly argument is to show an image that is itself the subject of investigation. In the example at hand, one may wish to know who these three figures are and what they mean. Of course, a scholar might wish only to describe the image rather than go to the expense and bother of reproducing it. But that would likely prove unsatisfactory. An image is an object to be interpreted—and every description of one is a form of interpretation. If I were to describe these porcelain pieces as three bearded male figures dressed in elaborate costumes and holding objects, I would focus the reader's imagination on certain features as particularly salient, ignoring all others. That act of narrowing the focus shapes the horizon of interpretation by calling attention to a particular set of features. But if the point of a genuinely scholarly argument is to invite my peers to weigh all available evidence against my interpretation in order to see if they concur with my conclusions, the availability of the image as a preeminent form of evidence seems quite necessary. In the case of figure 3, failing to describe the precise shape of the figures, their manner of coloration and manufacture, their size, and the visual formulas of their decoration, all of which can be made available in a reproduction, would deprive the reader of clues to the nature of these particular objects—how expensive they are, where they can be acquired, who buys them, and how they are used. If they tend to be purchased in variety stores by middle-class consumers as gifts for family members or friends, costing a few dollars because they are small objects made from common ceramic material, that is important for the reader to know. Showing the objects may confirm that aspect of them. Moreover, reproduction of objects in scholarly presentations allows readers to examine the objects for further evidence or counterevidence in the objects themselves or to compare them with other images they have seen.

Generally speaking, *exemplification* and *demonstration* are the dominant reasons that scholars reproduce images in their publications or public presentations. In the first case, visual reproductions exemplify

evidence for an assertion, thereby corroborating a scholar's claim by offering an example of an entire class. In the case of demonstration, or showing the object one intends to interpret, images are reproduced when they are the object of investigation, that is, juridically speaking, when they are to be made to testify on their own behalf, and the scholar-jurist will bring to them the corroborative evidence of exemplification. An art historian, therefore, will reproduce a painting by an artist when the point is to investigate that image. There is a certain object whose singular history and appearance is the object of explanation. The art historian may make use of exemplification by enumerating several instances of a type of image (e.g., images that share the subject matter, technique, patronage, or authorship of the image under question), but if we are to understand why this painting looks the way it does, we must see it. No other form of evidence, such as description or comparison, will substitute fully for the image itself, though reproductions themselves can be ambiguous and limited.

Exemplification is a form of evidence that is of great use to scholars whose interest is not in individual works of art. To return to Fu, Lu, Shou, one might reproduce this set of the three figures if the aim is to study the group of people who characteristically own this particular kind of set (there are many different kinds, ranging from the common, small, and very inexpensive to the large, rare, and quite costly). Or a scholar may wish to understand a low-market circulation of these objects in relation to high-priced versions of the three figures. In either case, what one is explaining is not what anyone did with the *actual* images reproduced but what groups of people do with images *like* them. Even if I were to reproduce an image of a particular informant venerating the images in his home, as a piece of evidence the illustration would remain an *example* of a larger pattern of practice.

Demonstration, or the showing of a discrete artifact, is a primary instance of the evidential status of images when the point is to interpret not a class of artifacts but a single image. Accordingly, art historians tend to make far more use of ostensive evidence than other sorts of scholars investigating visual culture. Since the understanding of the uniqueness of an image is the aim, access to the image is essential. Its appearance is the primary datum to be interpreted. This focus on an object's singularity is certainly one important reason that art history as a discipline has not shown broad interest in mass-produced imagery except where it can be used to shed light on individual works of art. That "fine art" has come to be defined in the last few centuries as any

unique object imbued with its maker's way of seeing and thinking clearly predisposes the art historian to treat ostensive evidence as paramount. Although many art historians have called that definition of fine art into question and proceeded to investigate art for many other reasons, the tendency to explain individual works of art remains the most characteristic feature of the discipline of European and American art history.

A final mode of visual evidence, *comparison*, is commonly used when scholars explain individual images or generalize from particulars. If I wish to know who the three men are in figure 3 and what they mean, I can do one of two things. I might compare them with other images like them and infer from the identity of these others what the objects before me must be; or I may look to other, nonvisual forms of evidence that identify them, such as narratives or ethnographic accounts. The first procedure is a matter of morphology. The analyst places the image at hand within a taxonomy of images much as a botanist or a paleontologist might classify a species of plant or animal life. The argument flows directly from the concrete evidence of the form of the image and is therefore a purely morphological one. The second approach seeks documentation beyond the object itself. An appropriately placed informant is the source of information, such as a poet or scribe who composed a text describing the significance of the three figures at one moment in history or a contemporary of the analyst, such as a Chinese American consumer who bought the three figures and gave them to his grandmother as a gift with hopes for a long, happy, and abundant life. The scholar seeks some kind of insider's report to decode the image's meaning.

When these two forms of comparison are combined, they constitute the method of iconographical analysis. The iconographer identifies an image by locating it within a class of visual motifs or formulas and then links it to a particular time and place by providing (typically) literary evidence that interprets the image's significance in a given moment. Iconographical analysis inserts an image under study within a visual discourse of images. Images are compared with other images, made to talk with one another, as it were, in the language of their visible shape. And then they are compared with the language of written or spoken discourse in order to ascribe a particular meaning to them.

Exemplification, demonstration, and comparison are the forms of evidence that images take in scholarly argument. But they are not the only reasons that images are used in scholarship. In addition to persuading one's audience by evidence and the rules of syllogistic reasoning, scholars make use of images as more subtle, rhetorical means

of persuasion. These means are not to be confused with evidence and logical argument. They are, in fact, tactics of persuasion that rely on the human disposition toward things seen.

I have in mind here the rhetorical "effect" that images can have on human observers. Trial lawyers and prosecutors are very familiar with the impact of images on jurors. People tend to believe what they see, probably because the human neurological system is partial to visual stimuli. As a species, humans rely disproportionately on visual information because their neural network is preponderantly dedicated to processing visual stimuli. Much of the physical world takes the shape of optical data in human beings in the way the world appears as odors to dogs or vibrations to subterranean animals such as moles. Images get our attention and maintain a larger portion of it because our memories and feelings are intermingled with the brain's sensation of sensory stimuli. The defense lawyer and the prosecutor know the power of the minds of jurors to associate their response to an image with a party's guilt or innocence. A defendant shrewdly prepared by counsel will appear in court looking respectable. The prosecutor may display graphic images of violence in court in order to associate the defendant with the violence of the crime and therefore predispose the jury against him or her.

Association and suggestion are uses to which scholars might put images, particularly if they wish to give an upscale appearance to their publications. Illustrations certainly help sell books, as booksellers have long observed. Perhaps that is because images attract attention and are amusing. They invite interpretive responses from even the most casual viewer. By providing unique, exotic, humorous, or enthralling images, a book lures the reader into paying closer attention. Concrete images can be memorable and may make a book stand out in recollection. Although none of this may count as evidence in any hardheaded account of scholarship, images, like poems and other evocative forms of representation, can work very productively by stimulating the imagination and opening the way to new ways of thinking. More than one art historian has discovered a good idea for research by using a spin-off from a colleague's use of an image in his or her work.

Genres of Evidence

With a few definitions in place, a brief case study of visual culture may help clarify the matter of evidence. What kinds of evidence are there for

CENSUS YEAR.	White persons 20 years and over.	White children under 16 years.	Ratio of persons 20 years and over to all children under 16 years.
1790	1,214,388	1,553,260	0.78
1800	1,832,375	2,156,357	0.85
1810	2,485,176	2,933,211	0.85
1820	3,395,467	3,843,680	0.88
1830	4,626,290	4,970,210	0.93
1840	6,440,054	6,510,878	0.99
1850	9,421,637	8,428,458	1.12
1860	13,310,660	11,329,812	1.17
1870	17,070,373	13,719,431	1.24
1880	22,928,219	16,919,639	1.36
1890	30,263,755	20,154,222	1.50
1900	37,748,491	23,846,473	1.58

FIGURE 4. Ratio of White Adults of Self-Supporting Age to White Children: 1790 to 1900. From Department of Commerce and Labor, U.S. Bureau of the Census, *A Century of Population Growth, from the First Census of the United States to the Twelfth, 1790–1900* (Washington, D.C.: U.S. Government Printing Office, 1909), p. 103. Photo: Author.

scholars to use in assembling their arguments? Suppose one wishes to determine why and how images were used in the socialization of youth by American Protestants in the early nineteenth century. The historian proceeds to gather information on demographics, on the initiatives and activities of Protestants during this period, and on the images they produced, circulated, and used. Figures 4, 5, and 6 represent evidence from these three domains of inquiry—statistical, textual, and visual data. Figure 4 is taken from a survey by the U.S. Bureau of the Census of population growth over 110 years. The data are drawn from the first twelve censuses in the United States from 1790 to 1900, showing the number of white citizens in two broad age groups as well as the ratio of white adults of self-supporting age (twenty years and older) to white children (sixteen years and younger). This statistical information offers a form of documentation that is quite useful to a number of different types of social and historical analysis: the relative aging of the population over time as well as twelve snapshots of the configuration of both age groups over a span of 110 years.

The second example of historical evidence is textual: a printed message to parents from the superintendents of the Sunday School New-York Union (fig. 5). The message invited parents to send their chil-

The following is the reverse of the card,—at the foot of this the scholar's name is written.

TO PARENTS.

Ever anxious for the improvement of the dear children you have intrusted to our care, and watchful for their present and eternal welfare ; we have inquired among ourselves, what new thing we could do for their good ; and we now inform you that we have established meetings for moral and religious instruction, on Sabbath and week day evenings, and hope to make them en- gaging and profitable. We invite you to send your children to the meetings when appointed by the Teacher of their class. Peace and the blessing of God be with you.

Your Friends and Servants,

A. B. ⎱
B. A. ⎰ *Superintendents.*

Sunday School New-York Union.

" Wisdom is the principal thing, therefore get *wisdom*, and with all thy getting, get understanding."—*Prov.* iv. 7.

FIGURE 5. Sabbath school meeting card, verso. From "Improvements in Sunday Schools," *American Sunday School Teacher's Magazine* 1, no. 8, July 1824, p. 258. Photo: Author.

dren to "meetings for moral and religious instruction." The text was printed on the back of a card whose front bore the image reproduced as figure 6, a small wood engraving of a boy praying beside his bed. This constitutes the third instance of historical evidence to consider. The two sides of the card—image and the printed message to parents—were reproduced in an 1824 issue of the *American Sunday School Teacher's Magazine* as a device to promote participation in religious classes.

The census information (fig. 4) indicates that in the decade before the appearance of the 1824 advertisement in the *American Sunday School Teacher's Magazine* (figs. 5 and 6), significantly more than half of the white American population was sixteen years old or younger. The percentage of young people significantly declined over the next three-quarters of a century so that by 1900 there were 1.5 times more white American adults than white children. The higher ratio of youth to adults in the early part of the century helps explain why American

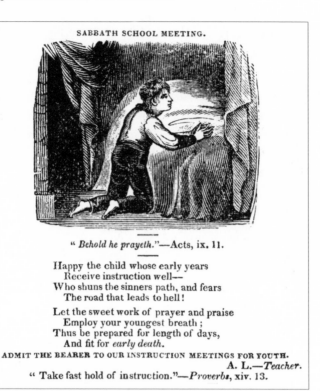

SABBATH SCHOOL MEETING.

" *Behold he prayeth.*"—Acts, ix. 11.

Happy the child whose early years
Receive instruction well—
Who shuns the sinners path, and fears
The road that leads to hell!

Let the sweet work of prayer and praise
Employ your youngest breath ;
Thus be prepared for length of days,
And fit for *early death.*

ADMIT THE BEARER TO OUR INSTRUCTION MEETINGS FOR YOUTH.
A. L.—*Teacher.*
" Take fast hold of instruction."—*Proverbs,* xiv. 13.

FIGURE 6. Sabbath school meeting card, recto. From
"Improvements in Sunday Schools," *American Sunday School
Teacher's Magazine* 1, no. 8, July 1824, p. 257. Photo: Author.

Protestants for the first time produced publications such as the
American Sunday School Teacher's Magazine and developed new
devices for attracting youth and their parents to Sunday school
instruction. We should not be surprised to learn that Protestant ini-
tiatives in religious education only increased as the century passed,
even developing graded curricula. As Americans lived longer and had
fewer children, they invested more resources in the education of chil-
dren and protracted forms of socialization over greater periods of
young people's lives. There were also more adults living longer to
teach fewer young people.

The text of figure 5 indicates that in the early 1820s American Protes-
tants were actively organizing institutions that would inculcate Christ-
ian ideals and that they appealed to parents to send their children to

meetings. The verse printed beneath the illustration in figure 6 intensi-
fied the appeal to parents: religious instruction needs to happen early in
life in order to safeguard the child against moral degeneration and its
eternal consequence. The second stanza echoed the image above it by
lauding the practice of prayer as preparation for a long life as well as—
the parent's greatest fear—an *early death*. The image presents a white
boy who appears well dressed and groomed and who enacts the short
excerpt of biblical text immediately below: "Behold he prayeth." The
seemingly cozy interior of his bedroom envelops the boy in what ante-
bellum Protestants called "the religion of the closet," that is, private,
daily, prayerful devotion. Darkness surrounds him, though his act of
prayer is swathed in a soft illumination that may suggest the spiritual
warmth and intimacy he enjoys in his nightly converse with the Almighty.

The scriptural quotation beneath the image is at first glance a curious
appropriation of a biblical text. Acts 9:10–19 describes a crucial moment
in the life of St. Paul in his conversion from an enemy of Christ into an
apostolic servant. A disciple in Damascus is told by the Lord in a vision
that he will find a man named Saul of Tarsus at a certain house in that
city in the act of prayer (Acts 9:11). The disciple is instructed to bless
Saul, who had recently been knocked from his horse and blinded by a
flash of light. Upon being blessed by the disciple, Saul (or Paul) was
made miraculously to see again and thereafter commenced his Christ-
ian ministry.

The image of the card and the invitation to send children to religious
instruction promoted the message that children were to undergo their
own conversion and discernment of a calling. In an article that accom-
panied the reproduction of the card, religious instruction was praised
for "infus[ing] . . . a devotional sympathy into [children's] minds." The
article quoted a contemporary writer who claimed that "devotional
feelings should be impressed as early as possible on the infant mind,
being fully convinced that they cannot be impressed too soon; and that
a child, to feel the full force of the idea of God, ought *never to remem-
ber a time when he had no such idea*."[28] Parents were encouraged to fos-
ter the conversion and calling of their children by sending them to reli-
gious meetings and to bury the infusion of devotion so deeply in their
formation that it preceded memory. Aligning the fragment of scripture
with the illustration generated a new level of meaning: by blessing their
children with religious instruction, parents would inaugurate the spiri-
tual vocation of their children as well as move decisively toward secur-
ing their children's eternal well-being.

Antebellum American Protestants responded to the large number of children in their society by seeking to socialize them with religious instruction and by regarding their spiritual birth and enlistment as a conversion akin to Paul's transformation from an enemy of the church into one of its greatest servants. The large number of American youth documented by the census information suggests that early-nineteenth-century American parents and Sunday school teachers had their hands full. To this population statistic we might add further demographic information regarding class, gender, ethnicity, or race to generate additional questions to ask when examining the evidence of figures 4, 5, and 6. How did the rise of immigrants contribute to the Protestant initiative to evangelize children? And were attempts to catechize free black children or the children of slaves as systematic as the enterprise to reach white children? If we were to add statistical information about mortality rates for children in the 1820s to the consideration of the visual and textual information provided by the card, the appeal to the spiritual preparation of children in light of "early death" might add yet another layer of meaning to the artifact. And examination of the role of images in public or common school might illuminate the use of images among Protestants.

Was there a reason for portraying a boy rather than a girl in the image? Was his a piety reserved for or pitched especially to boys? Another image from the contemporary evangelical world of New York suggests that this was probably not the case. The same intimacy, grounded in the domestic interior, is visualized for girls by figure 7. Illustrating a British tract reprinted by the American Tract Society (ATS) in 1825, the image—created by the American engraver Alexander Anderson for the ATS—portrays an evangelical paradigm of "early piety," Miss Dinah Doudney, who prays in her bedroom, hands resting on a Bible. As in figure 6, the pious soul is illumined by a light that has no natural source, entering from above rather than through the window before her. In the accompanying story, the young woman is praised for conducting prayer with younger siblings, teaching them the domestic piety and "religion of the closet" considered an essential ingredient in evangelical faith. Comparing the two images is prudent, since both belonged to an iconography of domestic piety among northeastern evangelicals in the mid-1820s. Doing so indicates no gross gender coding regarding domestic private prayer. The closed eyes of the young woman contrast with the open eyes of the boy, but this may not be meaningful, since in other contemporary examples of praying

FIGURE 7. Alexander Anderson (engraver), *Dinah Doudney at prayer*. From Rev. John Griffin, *Early Piety; or The History of Miss Dinah Doudney, Portsea, England* (New York: American Tract Society, 1825). Photo: Author.

youth the opposite is the case (see fig. 18, p. 70). As a form of communication, images tend to operate in a system of signification within a given community of image-users. Although deviation from such a system is always possible and frequently occurs, scholars must look for explicit signaling and justification for the deviation in order to confirm it. Comparing images with one another allows the analyst to establish a sense of visual context that serves as a norm for interpreting imagery.

I have avoided asking an obvious question so far: why did the card include an image? The answer is made clear in the article that accompanied the facsimile of the card in the *American Sunday School Teacher's Magazine:* "The purpose of these cards are *[sic]* to notify the parents of the teacher's appointment, and to obtain the privilege for the child to attend; and as they are passports to the meetings (being given in at the door,) they tend to enhance the importance of the meetings in the minds of the children, and in some measure, tend also to heighten the influence of the instruction given."[29] The picture was a hook to snag the attention of the children to whom the card was given, an inducement and advertisement to attend the meeting. The image was directed to children, and the text on its verso was the message aimed at their parents. But there was something more. Images, the quotation above suggests, possessed a meaning or weight of their own. "In some measure," the writer acknowledged, "[images] tend also to heighten the influence of the instruction." Not only did they magnify the importance of the meeting in the minds of children, images, in their unique power to intensify learning, also brought something to learning that texts did

not. Images possessed a rhetorical power, not so much a content, but an effect greater than mere words, according to Protestant pedagogues.

What does this brief treatment of different forms of evidence tell us about the use of visual culture in historical explanation? In regard to the question that authorized the interrogation of three genres of evidence *(why and how were images used in the socialization of youth by American Protestants in the early nineteenth century?)*, we should consider at least a couple of useful conclusions about the nature and use of visual evidence. The explanatory account developed above paired the image with texts of many kinds—whether poetry, scripture, prose, or the verbal discourse that engaged teachers and students in schools. The task was not to convert the image into a text but to discern how it was interwoven with the intellectual and social practices that composed the world of antebellum American Protestants. As an integral aspect of the education of the young, images were part of domestic and family life as well as the public religious practices of Protestants.

Visual evidence and textual and statistical evidence are interdependent. Forms of evidence, in other words, were made to interrogate one another. The image was not only the object of explanation but also the evidential means of explanation. In the constructivist approach I've taken to define the study of visual culture, the point is not finally to explain a picture but to explain what the picture does, that is, to explain how it operates in visual practice and what is the function of the practice that puts the image to work.

At the same time, there is something peculiar about the image in figure 6, something that resists reduction to textuality. Among those who used it, the card maintained a presence of its own, inasmuch as images were understood to exercise a special attraction to children and were therefore integrated into teaching and other forms of socialization. Among their Protestant viewers, images possessed a power that was intrinsic to them, in this case, their capacity to appeal to children in visual terms, specifically, in terms other than printed or spoken words. Protestant parents and teachers did not believe illustrations were icons or magical talismans of any sort, but they knew that kids liked pictures, and that is why they used them. Moreover, we observed when examining figure 6 that the image conveyed meaning on its own, visual terms. The illumination of the boy's prayerful figure suggested something about his experience of prayer. If this is correct—as comparison with figure 7 indicated it may be—then the visual medium contributed substantively, irreducibly to the meaning of the advertisement, adding

to and interpreting the significance of the textual message. How? By telling us about the feeling or experience of the boy's act of prayer. The result is a configuration of meaning in which text and image shape the viewer-reader's interpretation of each signifier into a single signification.

In the terminology set out above—exemplification, demonstration, and comparison—the image contributed to the inquiry by *exemplifying* an entire class of behaviors and attitudes in antebellum America. The image was an example and therefore visual evidence of the sort of images that were used in the way that the accompanying texts documented. If we were to possess a signed card like the one shown in figures 5 and 6, a card bearing the name of a particular child, we might use it as *demonstrative* evidence in an argument about who used such cards—their ages, gender, ethnicity, and geographical location. Material conditions of the card, such as wear or mode of display (was it framed, hand-colored, carefully preserved or dilapidated from use, collected among dozens of other cards or tucked away in a family Bible?), might also throw light on the use and meaning of the artifact.[30] Finally, by *comparing* figure 6 to figure 7, we learned something about the iconography of light and that private prayer and domestic piety were promoted among both boys and girls. Further such comparisons might multiply insights by revealing visual codes in the iconography of bedroom prayer. By conducting each form of analysis, the scholar of visual culture is able both to treat the relationship of imagery to other forms of evidence and to extract from images and visual practice the evidential import they offer historical explanation.

Visual Practice and the Function of Images

Seeing is a sacred practice in many different religions. More than a merely passive means of receiving sensory impressions of the physical world, seeing is a selective and constructive activity, a way of making order, of remembering, and of engaging people and the material world in relationships. In Hinduism, for example, *darshan* is the ritual act of seeing and being seen by the deity, an encounter that occurs within the gaze of a statue or image in the temple or at a shrine. But Hinduism, like all religions, is complex and varied. In fact, a range of attitudes toward images is discernible in Hindu thought and practice. For many Hindus, the temple image of the deity to whom one is devoted contains the very deity, who is invited there by rituals of consecration conducted by priests. In the case of images of Shiva, whose principal form is the lingam, the devout see only a ritually prepared mask or covering, since the lingam itself is considered by many to be "too strong for mortals and must be shielded."[1] The devout see the deity through its mask. Visibility is often a kind of condescension of the transcendent to the threshold of human experience. The image mediates the viewer and the unseen, both revealing and concealing.

Other Hindus, particularly educated and urban Indians and transnationals, often speak of images as "symbolic" devices that act as instruments to assist contemplation or prayer. Visualization is part of meditation, not an end in itself. Images serve to focus thoughts on the divinity and, through it, the single God of all Hinduism. These Hindus are always careful to stress the monotheism of the tradition and to

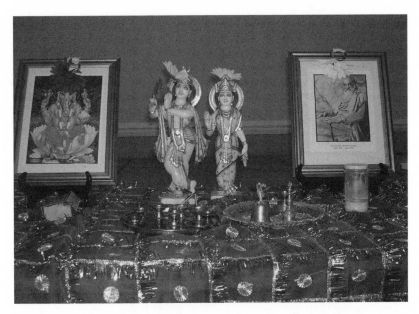

FIGURE 8. Temporary altar table with images of Krishna and his wife, Rada. Indian American Cultural Center, Merrillville, Indiana, 2003. Photo: Author.

regard the pantheon of deities as only aspects of a single God. The importance of imagery such as that shown in figure 8, occupying the central table (a temporary altar) in a northwestern Indiana worship space, is that it orients the devout to the mental and physical space of worship but does so without being anything more than a "symbol," as one member called the images. When I asked her about *darshan* and the sculpted figures, she pointed out that seeing divinity happens anywhere, with anything, with other people, but not with the statuary shown here. The imagery on the table was there to focus thought and to direct prayer.[2] The polychromed marble figures of Krishna and his wife, Rada, preside while incense burns before them, perfuming the room and cleansing it of foul odors. The bells ward off evil when they are sounded to commence worship, and ghee lamps are burned at the close of worship when the faithful approach the imagery for final thoughts and prayers. To the right in figure 8 is a portrait of the teacher who founded the community; on the left is a devotional image of the ubiquitous figure Ganesha, who, in addition to being the remover of obstacles and the deity of auspicious beginnings, is also the Lord of

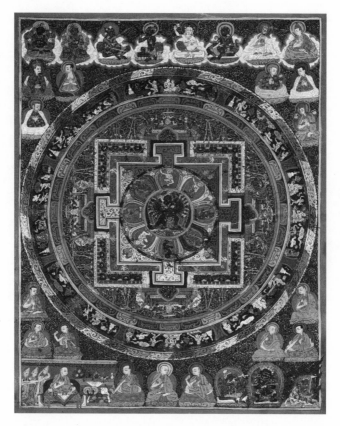

FIGURE 9. Mandala of Hevajra, central Tibet, eighteenth century, ground mineral pigment on cotton. Collection of the Rubin Museum of Art, New York.

Knowledge and is invoked by those who attend services in order to study the Hindu scriptures.

Optical vision can be used to embolden and intensify inner or imaginative vision. Images can serve as a kind of external scaffolding for concentrated interior experience, such as meditation. To this end, esoteric or Tantric forms of Buddhism make important use of mandalas, intricately designed diagrams that model the construction of vast universes of mental vision. These allow the practitioner to "see the Buddha" or tutelary god in a celestial palace where he or she resides. For example, the mandala in figure 9 shows Hevajra, who is one of many meditational deities of importance among Himalayan Buddhists,

serving as a *yidam,* or divine guardian, who may be chosen by a practitioner or selected for one by a lama, or teacher. The practitioner engages in highly detailed visualization of the deity in order to become identified with it. In the mandala Hevajra is embracing his female counterpart, or Shakti, called No Soul. A host of divine figures and lamas are pictured around the outer circle, which contains a pictorial narrative of teachings that circumscribe the central, symmetrical feature of the mandala, inside which are located the deity and his consort. Devotees prepare for mediation by careful study of the image, learning the procedure and meaning of its stages and undergoing an initiation rite to prepare them for union with the god, whose sexual union with emptiness, or no soul, signifies the goal of the meditator. Careful study of the mandala, as one study put it, helps devotees "visualize themselves within the realm of the deity. Once inside the perfected universe of the deity, the practitioner can move a step closer towards spiritual enlightenment."[3] Union with the tutelary deity in Tantric Buddhism means assuming the shape of the Buddha's celestial form. This body corresponds to the written text of his sutras and the corporeal body of his relics enshrined in stupas. Some Japanese Tantric mandalas, or meditation diagrams, even replace the image of the Buddha with text, suggesting an interchangeability of word, image, and wisdom.[4] Seeing the Buddha is a complex act that cuts across the cerebral map of the mandala, the written dharma, and the material traces (hair, tooth, bone) of Siddhartha Gautama's earthly life. In addition to its use of the marvelously dense mandalas, Zen Buddhism locates the practitioner in carefully manicured gardens or before paintings of landscapes or still lifes in order to deepen and guide meditation. In various strands of the Christian tradition, icon veneration, devotional prayer before an image, and the contemplation of imagined scenes of Christ's passion, as in the spiritual exercises created by Ignatius of Loyola, all constitute forms of visual piety.[5] In every case and many more, seeing is a primary medium of belief, a practice that brings viewers into focused consciousness of a reality that underpins their existence.

The acts of looking at images and evoking imagery within the imagination are ritual practices that would not work as they do without imagery. Contemplation and devotion are only two of many different visual practices. Spectacle, display, procession, teaching, and commemoration also serve religious ends.[6] In order to understand the visual nature of religious experience and the cultural work it performs, we must recognize how seeing is intermingled with other forms of activity,

such as reading, meditating, suffering, eating, dreaming, singing, and praying. Images shape religious meaning by working in tandem with other artifacts, documents, and forms of representation, such as texts, buildings, clothing, food, and all manner of ritual. Seeing is not an isolated or "pure" biological or cultural activity. It is part of the entire human sensorium, interwoven with all manner of behaviors and cultural routines. But vision is such a prominent and pervasive human sensation that careful scrutiny of its many forms and effects is well worth the scholar's special attention. The study of visual culture, to repeat the thesis of the previous chapter, is a study not only of images but also of visual practice, imagination, perception, and the cognitive apparatus of any particular epoch or culture that shapes vision.

This approach is well suited to the study of religion because the visual medium of belief is not just images but also everything believers do with them. In order for us to understand what this means, it will be helpful to do two things: first, to put in place a definition of religion, and second, to enumerate and exemplify the particular functions of religious images.

A Working Definition of Religion

Debate over the definition of religion is larger, much older, and far more contentious than debates regarding the definition of visual culture. Although the point of this book is the study of images in religious practice, the underlying definition of religion has portentous implications for how images are to be understood.[7] By religion, I understand configurations of social relatedness and cultural ordering that appeal to powers that assist humans in organizing their collective and individual lives. These "powers" may be supernatural or entirely circumscribed within the domain of natural phenomena. In either case, religion is a way of controlling events or experience for the purpose of living better, longer, more meaningfully, or with less hazard. There are, of course, many ways of organizing social life that need not be religious. Such cultural schemes include nationhood, kingship, marriage, gender roles, and hierarchies of ethnicity, race, and class. Each of these forms of order provides boundaries and enclosures, social structures that bestow shape and character on human communities and individuals. These and other activities become religious under one of two circumstances: either when their ritualistic deployment is regarded as necessary in and of itself in order to ensure order, or when believers appeal to powers

beyond the sphere of human agency and the conventional laws of the material world. Powers in the second circumstance may involve ancestors, sacred tradition, or impersonal forces such as *barakah*, destiny, fate, karma, or progress. The powers may also involve demons, spirits, or deities. Power in the first instance is often expressed as "the way things have always been done" or simply "this is what we do."

In either case, the practice of religion is a way of authorizing order, charging it with a compelling and enduring power. Catherine Albanese has provided a very useful working definition of religion, from which my formulation draws: "a system of symbols (creed, code, cultus) by means of which people (a community) orient themselves in the world with reference to both ordinary and extraordinary powers, meanings, and values."[8] Her distinction of "ordinary" and "extraordinary" is meant to register the difference between living within the everyday world (where "the way things have always been done" is the regnant order) and experience beyond the normal boundaries, encountering powers that surpass the domain of everyday experience (where the superhuman powers of destiny, spirits, or gods prevail and must be successfully engaged if order is to be achieved). Most believers practice both kinds of religion, though they likely spend more of their time in the realm of the ordinary.

Albanese's definition has two strengths that bear special relevance for the study of religious visual culture. First, I prefer the way in which she engages both ordinary and extraordinary in her definition, since defining religion absolutely with or without extraordinary powers is not practical. There are, of course, religions in which the appeal to deities or supernatural powers is quite minimal. One might, for instance, practice yoga or meditation without contact with or regard for any such reality. Buddhism and Confucianism are widely understood to be nontheistic religions. And there is at least one reasoned account of an African religion in which supernatural realities do not appear to play a major role. Yet for every such assertion one can cite exceptions within the same religious tradition. Thus, scholars have pointed out in recent years that popular as well as elite forms of Buddhism have almost always been rife with gods and demons and spirits as well as relics, devotion to imagery, and practices of acquiring merit from Buddha and the bodhisattvas.[9] While Confucianism operates without a god, it does rely on the veneration of ancestors. And although in his study of the Kuria, an East African people, the anthropologist Malcolm Ruel argued that their religion does not depend primarily on supernatural realities, the Kuria do recognize the existence of a solar deity, ancestor spirits, sprites,

and ghosts.[10] Clearly, any robust definition of religion needs to allow for the importance of supernatural realities without requiring them as a necessary condition.

The second virtue of Albanese's approach is her articulation of religion in four parts: creed, code, cultus, and community.[11] She aptly refuses to reduce religion to creedal statements or propositional beliefs, while carefully recognizing that these are important for many religions. Code refers to the prescription of behaviors and conduct so important to the prosaic and official protocols of ordinary religion as well as the often distinctive habits of extraordinary religions. Cultus signifies the rituals and practices that put beliefs to work in an individual's and community's experience. Albanese recognizes in this aspect of religion the preeminence of feelings and the body, of nonrational practices that do so much to make religion a palpable, lived experience. Images and visual practices are a vital part of religion under this aspect. Finally, community refers to the shared and interpersonal as well as the institutional and social character of religion, yet another important site for visual culture. This approach allows for a more inclusive study of religion, one that balances its discursive with its sensory, aesthetic, embodied dimension.

In the typology that follows, seeing is explored as a primary way of addressing boundaries of one sort or another in the formal and informal cultus of lived religion. Boundaries, or the edges of a lifeworld, sacred space, family or clan relationship must be ritually engaged in order to be extended, violated, or reaffirmed. Images often mark such boundaries or are employed to negotiate them. The Christian icon, for example, hovers on the boundary between the present world and the hereafter as a means of invoking a saint. More concretely, however, votive imagery helps sustain the living relationship between the saint and the devotee. The boundaries in question consist of plotting a new narrative in one's life in the case of devotion to St. Jude. In an important study of the meaning of St. Jude for American Catholic women, Robert Orsi examined the way in which touching, gazing at, caring for, and speaking to images of the saint of hopeless causes allowed women to engage him in their causes, to beseech his intervention, and to find comfort in devotion when he did not answer their prayers.[12] "Once the devout began telling their stories within the devotion," Orsi found, "the flow of events was replotted against the unexpectedly glimpsed horizon of hope that opened in the presence of the saint."[13]

Religious Visual Culture: A Typology of Functions

With a working definition in place that underscores the importance of practices and rituals of belief, we may proceed to asking what religious images and visual practices do. Perhaps the best or at least the most practical way to answer this question is to assemble a list of relatively discrete functions. Such a list ought to signal the particular capacities of images and visual practices to structure relations among human beings, the physical world, and superhuman or immaterial worlds. What makes an image "religious" is often not simply its subject matter or the intentions of the person who created it but the *use* of the image as well as the context of its deployment and interpretation. In every instance, the image is better understood as an integral part of *visual practice*, which is, properly speaking, a visual mediation of relations among a particular group of humans and the forces that help to organize their world. The medium of belief—using *belief* in the relational sense of a covenant and not merely assent to a proposition—is not only an image but also everything that a person or community does with and by means of an image.

What do religious images and visual practice do? They accomplish any of the following aims for those who cherish and use them:

- order space and time
- imagine community
- communicate with the divine or transcendent
- embody forms of communion with the divine
- collaborate with other forms of representation
- influence thought and behavior by persuasion or magic
- displace rival images and ideologies[14]

Of course, not only religious images but all manner of images perform many of these functions. Indeed, if one were to replace *divine* in the third and fourth listings with *tradition* or *civilization* or *nation* or *the past*, there would be no difference between the range of functions ascribed to religious images and those ascribed to a great variety of nonreligious images. This accounts for the often striking similarities between religious and secular governments, religious and political icons, religious rites and secular ceremonies, religious and nonreligious memory and narrative; religious bigotry and ethnic strife. In the final chapter I examine the case of civil religion, which maps religion over

national life, often refusing in patriotic and nationalistic moments and symbols to distinguish faith from polis. It is the purpose of such national icons as the flag to undertake just this conflation.

ORDERING SPACE AND TIME

Images and objects can operate very powerfully in religious practice by organizing the spaces of worship and devotion, delineating certain places as sacred, such as pilgrimage sites, temples, domestic spaces, and public religious festivals. The image declares by virtue of its signage or its iconic presence or its incursion into otherwise profane space or its complete isolation from everyday traffic that something significant is happening, or once did, that the devout should pay special heed. Examples abound in every religious tradition—from the temporary placement of statues of Krishna and Rada in a multipurpose room to be used for Hindu worship (see fig. 8) to a hand-painted or lithographic *mizrah,* which hangs on the eastern wall of a Jewish home to indicate the direction for daily prayer.[15] Objects are readily used outdoors in common space—for instance, along roadways in the case of memorial devices such as grave markers or devices that indicate important sites in the landscape. Poignant examples of this are commemorative markers—usually Christian crosses or Jewish stars—that demarcate spots where people were killed in traffic accidents along North American roadways. Such ad hoc monuments recognize a spatial point as well as a time for those who know it, such as family and friends. But for the anonymous thousands who drive by each day, the markers serve to pinpoint a site and, in the words of one man whose wife died in an intersection in Columbia, Missouri, as an urgent alert to motorists: "It's more for other people than something that's really personal. We put that [a white cross] there to warn other people to look out for that crossing."[16]

In formal worship spaces, sacred objects provide an orientation and focus that can be commanding. In the Sikh place of worship, the *gurdwara,* the single pivotal object is the enthroned holy book, known as the Guru Granth Saheb, or "revered book-teacher." When Guru Arjan Dev ji completed the book's compilation of prayers, hymns, and verse in 1604, he encouraged Sikhs to honor it with the status of the Guru. The tenth and final Guru, Gobind Singh, proclaimed, "I have infused my spirit, my heart and soul, into Sri Guru Granth Saheb ji. Let him who desires to see me look into the Guru Granth Saheb. Obey the Guru Granth Saheb, as it is the visible body enshrining the True Guru's

FIGURE 10. Guru
Granth Saheb,
private home,
Valparaiso,
Indiana, 2002.
Photo: Author.

Word."[17] *Guru* is the Punjabi word for teacher but also for God. Thus,
one Sikh told me that the book is the "body of God." The ten histori-
cal gurus were understood to be in union with the divine. The book,
which six of them contributed to, is the written revelation of God. So
the Sikh reverence for the book is also reverence for the historical
gurus, their wisdom and teaching, and for the deity, all of which are
joined in the book. Each day the book is ritually transported from its
private chamber (where it rests on a bed each night) to the gurdwara's
raised platform, where it is installed beneath a canopy and adorned with
veils. Worshippers arrive at services and prostrate themselves before the
enthroned book and take turns attending to the book as if it were a
living guru by passing a fly whisk back and forth over it. Pious Sikhs also
erect throne-beds in their homes for their own copies of the Guru
Granth Saheb (fig. 10). The care and attention that the faithful devote
to the book privately and in the presence of one another during
worship at the gurdwara serves to materialize divine revelation in the
historical gurus (most important, Guru Nanak, the first Guru), who,

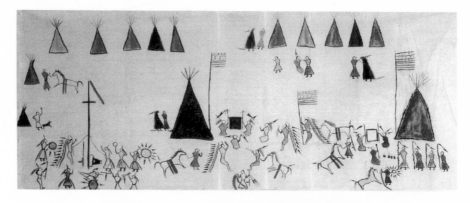

FIGURE 11. Joseph No Heart, pictograph of a Sun Dance, Teton Dakota, Standing Rock Agency, 1900, pigments on muslin, 29 × 69 inches. Collection of the State Historical Society of North Dakota, 10460.

because they were united with God, are alone able to lead the devout to union with God.

Time is also shaped by images into a sacred enclosure when the image, as in the case of an Orthodox icon, is part of the liturgical structuring of temporality in worship. Perhaps the most common shaping of time in religious life occurs in the creation and maintenance of memories as powerful indicators of identity. Sacred marriage certificates or other artifacts received as part of religious rites, such as a bar or bat mitzvah or a Christian confirmation, are frequently displayed in homes in order to remind their owners and families about (and to proclaim to visitors) the heritage and confession of the owner. Other imagery, such as Lakota artist Joseph No Heart's pictograph of a Sun Dance (fig. 11), depicts and remembers a crucial turning point in the lives of a group— in this case, a nation of Native Americans on the western Plains. Created in 1900, the image shows the Lakota after conquest by the American military. Three American flags fly in the right half of the image, in the midst of village life. But on the left side, the outlawed Sun Dance is celebrated. The visual rhythm from right to left of tall and short flags is punctuated by the height of the center pole used in the Sun Dance. The stable uniformity of the line of tipis moving across the top of the image, combined with the ubiquity of the red streamers affixed to the horses of braves and seen atop the Sun Dance pole itself, may suggest an underlying unity in Lakota life. But the stark contrast of the flags and the center pole bespeaks an act of cultural resistance

dedicated to keeping alive the religious rite banned by the occupying military force. Joseph No Heart's image seeks to recall the sacred practice in the traditional vernacular of pictographic symbols for the benefit of those who had been cut off from the ceremony. Though the ceremony was still clandestinely observed, as the image suggests, its primary existence, particularly for the young and the generations to come, was in memory, which images such as figure 11 helped make possible.

IMAGINING COMMUNITY

At the same time as Joseph No Heart's image remembers the ritual of the Sun Dance, it enables Lakota to imagine their communal identity, their being as a people. Communal existence is something both concretely experienced and shared at a distance and over time. Like other forms of imagined community, such as nationhood, members of the community need symbolic forms such as songs, dance, images, and food to allow them to participate in something that is larger both spatially and temporally than their immediate environment. Community must be envisioned in the things believers do (see, for instance, fig. 1) in order for them to realize in a concrete, corporeal way that they belong to this world or clan or tradition and that doing so ensures them of the benefits of membership, such as an enduring identity and sense of purpose. In chapter 7 I examine the role of the American flag as an icon of national identity that demarcates for many new and older Americans what it means to be American, that is, a member of that imagined national community.

COMMUNICATING WITH THE DIVINE OR TRANSCENDENT

Images have long been used by religious peoples around the world to communicate with the unseen, mysterious, and potentially uncontrollable forces that are understood to govern life. Sacrificial offerings before (and often to) images are the material form of an economy of exchange that allows believers to enter into a relationship with deities, which is intended to result in mutual satisfaction. Images make the god or saint or spirit available for petition, praise, offering, and negotiation. Promises are solemnly made during visits or pilgrimages to cult images and recalled by means of images carried about on one's person or installed at home or work. Publicly displayed imagery makes vows more meaningful and the hope for deliverance more promising. While in Thailand, I watched Buddhist pilgrims visiting shrines near the

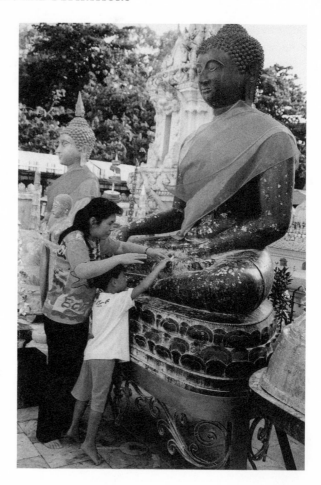

FIGURE 12. Buddhist performing *pid thong* at Wat Prathad-panomvora Mahavi-harn, Northeast Thailand, 2002. Photo: Siriwan Santisakultarm.

Royal Palace at Bangkok. The pilgrims performed *pid thong,* applying layers of gold leaf to statues of Buddha (fig. 12). The Royal Palace includes the famous prototypes of countless copies, such as the Emerald Buddha and many others made of gold, precious stones, and other costly materials. Inexpensive copies are available for those of modest means to decorate with gold leaf in order to pay respect, to improve the outcome of rebirth after they die, or to petition the Buddha's assistance in healing (in which case they apply the gold leaf to that part of the Buddha's body that corresponds to their own ailment or injury). Other people practice *lang phra* (meaning "behind the god") by applying the gold leaf to the backside or less visible portions of the Buddha's figure in order to conceal modestly their offering

of respect and devotion. (The expression *lang phra* is used in Thai society to describe those who do something good without expecting acknowledgment for it.)[18] The image of the Buddha serves as the site at which the exchange of devotion for blessing is negotiated. The act is part of a larger practice of preparing oneself for the journey to the temple, the public act of devotion, and the subsequent waiting for blessing (if it is meant to occur in the present lifetime and not in rebirth). Not only do images of Buddha allow communication with him and the transfer of merit by appeal to his infinite compassion and reservoir of merit, but also making images of Buddha and ritually washing them promise higher rebirth.[19]

Images facilitate communication in another manner that merits our attention. Not only are they the receptacle of human petitions, they also serve as the means by which seekers can learn divine will or find answers about their future or problems they face. This oracular function of imagery is pervasive in African practices of divination.[20] But it is also evident in first-world societies in the pervasive use of tarot cards. Displayed in configurations of images that produce a successive, cumulative reading, tarot cards move from the general to the increasingly specific, triggering associations and interpretations along the way until, in the hands of a skilled reader, the client has assembled a personal narrative. This narrative is tailored to the client's life and addresses anxieties, hopes, frustrations, and possibilities. Oracular forms of communication range from the shape of a saint in a tree or oil stain to the use of sortilege to locate revelatory passages in a scripture. In whatever case, the power of oracularity is the suggestive ambivalence of the signifier that inaugurates and continues to propel a narrative told by an individual or shared by a group. The open-ended symbolism of the tarot card, the splotch of oil, the pattern of soot from incense, or the trail of tears down the surface of an icon beckons the deciphering of a message for oneself or one's community. Someone is speaking in this marvelous incursion into the world, and believers strain to discern the material language of the sacred.

COMMUNING WITH THE DIVINE

Images of many different kinds often yield an experience of divine presence. Icons in the Eastern Orthodox rite serve as a channel of grace that visualizes the holy figure, who directs grace to the believer. In his classic defense of holy images, John of Damascus quoted a passage from

the life of St. John Chrysostom, who was described as reading the epistles of St. Paul while gazing "intently" at an icon of St. Paul, "and would hold it as if it were alive, and bless it, and direct his thoughts to it, as though the apostle himself were present and could speak to him through the image."[21] As in many other religious traditions, images of the Buddha undergo ritual consecration called an eye-opening ceremony. By "dotting" the eyes of the image, devotees are able "to transform an inanimate image into a living deity." Images of Buddha possess powers to ward off evil and are reported to have moved and performed various acts.[22] In northern Thailand monks still practice an ancient Theravada ritual of instilling in new images of the Buddha the power, knowledge, virtue, miracles, and even transcendental states exhibited by the Buddha during his lifetime. The ritual unfolds by retelling the story of the Buddha's enlightenment and calling for all the Buddha's qualities to be invested in the image "for the lifetime of the religion."[23]

Buddha has many bodies, many material manifestations. Bringing them together is the task of the consecration of images of the Buddha. This process invests the visual form with the presence and authority of the historical Buddha *(nirmanakaya)*, his relics (enclosed in stupas), his teachings (dharma), and the ideal form of his glorified body *(sambhagoakaya)*.[24] All merge in the visual practice of venerating the image, which is varied—consecrating an image, bathing it, applying gold leaf to its surface, or contemplating it in meditation. One ancient Chinese writer put the matter regarding Buddha's embodied presence succinctly: "Although the Great Teacher is extinguished, his image is still present. One should venerate it with an elevated mind as if the Buddha were still here. Some may place incense and flowers [before the image] every day, enabling them to produce a pure heart. Others may constantly perform the bathing ritual, completely cleansing their tenebrous karma."[25] Communion and communication of benefits are inseparable in these visual practices, since devotion to a shrine, image, or object produces an absorbing effect on human consciousness that both focuses thought and diminishes awareness of oneself as a distraction. Modern Tibetan Buddhists urge the use of shrines and images for devotion in the face of death for the benefits they render the dying.[26] In this visual piety of devotion the presence and the blessing of the Buddha are indistinguishable.

Other images manifest the supernatural by replacing the identity of the ritual participant with the person of a departed ancestor or spirit. Masks like the one shown in figure 13 have been widely used in West

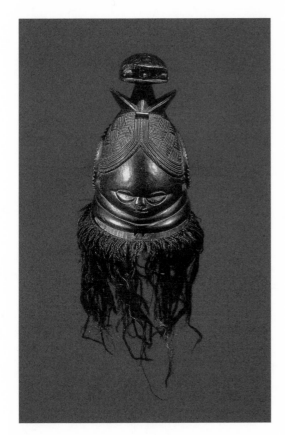

FIGURE 13. Sande mask from Mende people, Sierra Leone, wood and raffia. UCLA Fowler Museum of Cultural History. Photo: Denis J. Nervig.

African cultures in ceremonies to invoke spiritual forces and apply their wisdom, influence, or healing powers to human needs. The Sande society is a secret society among Mende women in Sierra Leone. Members use wooden masks in their secret ceremonies as well as in public events. A woman who wears the mask embodies its spirit, which, among the Sande, is the power of a river-dwelling being. Sande masquerades serve to mediate the two dominant domains of Mende life, the village and the bush, since the spirits come from the bush but the Sande society masks and dances channel the spirits' power into village life.[27] Masks are activated by a ritual of consecration after they are produced for their wearers by craftsmen or "found" in the bush. Offerings of rice and oil are made to spirits in order to urge them to reveal their names, which they do in the dreams of those who own the masks.[28] Once named, the masks may be used in ceremonies. By becoming the spirits who inhabit

the masks, the Mende women in the Sande society serve to transform the powers of the bush so that they may be "directed toward the maintenance of social order and the inculcation and enforcement of rules of social intercourse."[29]

COLLABORATING WITH OTHER FORMS
OF REPRESENTATION

As the ritual use of masks in West Africa suggests, religious images do not stand alone. They are densely interwoven with such media as texts, music, and architecture. This is particularly true of those religious traditions that maintain proscriptions against the use of figural imagery, such as Islam, Judaism, and some forms of Protestant Christianity. But even in the strictest instances, such religious groups do not dispense entirely with visual forms. Indeed, often these religions exhibit the most astounding forms of adornment in architecture and material culture. Although images are not widely a part of Muslim worship of Allah, the interior (as well as the exterior) of many of the oldest and most revered mosques around the world may be decorated with highly crafted, intricate designs and calligraphy, including the black cover of the Ka'bah (see fig. 1). The architecture of the mosque itself (fig. 14) is a medium that works intimately with the spoken word, with sound, serving to amplify as well as materialize it, to give it a place in which to resonate and be experienced within the *ummah*, or community of believers. Moreover, the affirmation of space is fundamental to Muslim worship and devotionalism, since the ornate and often highly elaborate visual decorations that appear in homes and mosques are rooted in architecture. Architectural forms, decorative patterns of mosaic, calligraphic renderings of the Qur'an, and imagery such as depictions of the Ka'bah combine to shape auditory-visual-spatial sensibility as part of a piety that eschews representation grounded in the human figure and the discrete tableau. Interior space is where the community focus of Muslim piety unfolds, principally in the form of prayer and Qur'anic recitation. The exterior form of mosque architecture typically dominates the village or local urban landscape: the prayer tower looms over everything, and the arches, walls, and domes of the mosque proclaim quite unambiguously that faith is the cornerstone of the community.[30]

In light of this configuration of multiple sensations in what is experienced as a single sensation, what might be called a soundspace, it is

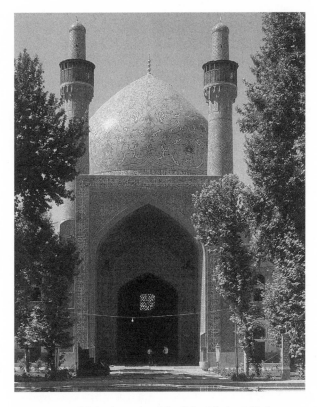

FIGURE 14. Main *iwan* (vault) of the Madar-i Shah
Madrasa, Isfahan, Iran, Safavid dynasty, 1700–1725. Photo:
SEF/Art Resource, New York.

important to recognize that the study of religious material and visual
culture should avoid compressing religious experience into the standard
rubrics of text, image, music, or architecture. The testimony of figure 15,
which shows a display of objects in a midwestern Jewish home, urges
that we approach Jewish artifacts of this sort as "imagetexts," represen-
tations that are neither image nor text alone, but a synthesis that needs
to be classified separately because it is experienced neither as merely text
nor as merely image.[31] These items, forming what their owner called
her "Judaic Wall," intermingle symbol, word, and image to create dis-
crete objects that are more than the sum of their parts. The calligraphy
of Hebrew text is also a highly decorated "image," and the stylized
image of the hand, or *hamsa* ("five" [fingers]), serves as a surface for

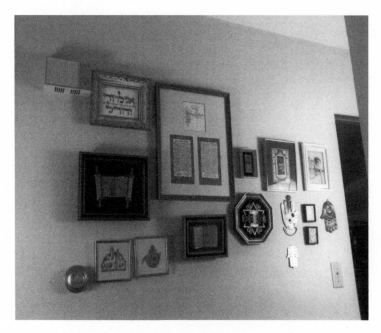

FIGURE 15. Judaic Wall, home of Jane and George Zucker,
Cedar Falls, Iowa, 2002. Photo: Sheri Huber-Otting.

the display of text. Image and text combine in the case of the hamsa in
a very traditional device of popular Jewish culture. The hamsa is an
amulet displayed in the home, on one's person, or in synagogues on
such liturgical objects as lamps to guard against spells and the Evil Eye.
Inscriptions on the metal surface of the hand amulet form consist of the
many names of God and quotations from scripture that are invested
with mystical and symbolic significance.[32] Whether composed entirely
of text or portrayed in highly simplified form, these hybrids of text and
image avoid the injunction against the use of figural images, yet visual-
ize sacred text in a manner that allows its display as an object for the
purpose of aesthetic contemplation as well as veneration. Displayed in
the homes of modern Jews, the objects acquire another layer of mean-
ing as "Judaica," artifacts from the history of the Jewish people that can
be separated from the original magical, mystical, or theological mean-
ings and seen as crafts that affirm the ethnic identity of their owners.
Even in this case, however, the value of the imagetext persists, since
avoidance of highly pictorial imagery remains for many Jews, secular or
pious, a touchstone of Jewish tradition.

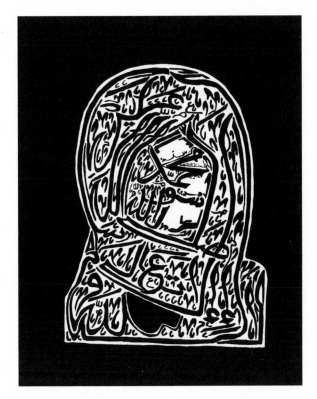

FIGURE 16. Serigne Gueye, son of More Gueye, reverse-glass calligram of Amadou Bamba, glass, pigment, cardboard, and tape, 12⅘ × 9½ inches. UCLA Fowler Museum of Cultural History. Photo: Don Cole.

The imagetext can be found in several religious traditions.[33] A good example occurs among Sufi (Mouride) followers of Sheik Amadou Bamba in Senegal, whose body is transfigured into Arabic script (fig. 16). The text consists of praises to Allah, thus transforming what one sees into a devotional reading, implying, perhaps, that the body of the saint is the Word of God as well as a kind of visual presence, since the devout viewer of the image is also the reader of the text and worshipper of God. The two orders of representation—image and text—are juxtaposed but are also made to metamorphose into one another. Although the devout Mouride cannot see and read simultaneously—since the markings are either word or image, but not both at the same time—it is the proximity of form and content, word and image, Word and body, that the imagetext enables, suggesting inimitably the proximity of the saint and his living praise of Allah. The intermingling of the sheik's form and the Arabic text suggests that his

life and his Mouride followers' veneration of him are conjoint acts of veneration of Allah.[34]

SERVING AS INSTRUMENTS OF INFLUENCE

Like any medium of communication, images can be laden with information, densely encoded with ideas, values, or feelings that certain viewers are able to discern. Images can also be interpreted in ways their makers or original users did not intend, serving to corroborate beliefs or desires important to a viewer or a group of viewers. In either case, an image is a visual medium that can act as an instrument of influence. The influence that images exert may take two different forms. We speak of efficacious influence when describing the power of an image and its ritualistic use to achieve a desired effect. Images appear to act as discrete sources of power that affect events or people as a force or agent of change that requires nothing more to achieve its aim than the originary, authorizing act of its maker and patron. Examples include the use of images to enhance fertility, to attain success in the hunt, to heal wounds or illness caused by a harmful agent such as a spirit or evil spell, to protect someone against a rival, or to harm an enemy. The image does whatever it is charged to do by converting the desire of a petitioner into an agency that does the work. Figure 17 shows an almost unnoticeable instance of this in a storefront window in Chicago's Chinatown. The small round mirror poised between two items for sale serves the store's owner as a talismanic device. Commonly placed above doors or in the windows of Chinese American restaurants and stores, mirrors like this one reflect malignant spirits and harmful forces before they can enter the place of business and hinder commerce. The presence of these protective objects also reassures customers, hence the visible placement near points of entry (which is, of course, in the logic of spiritual matters, where malignance also seeks to gain entrance).

The capacity of images to influence events also very commonly takes the form of action affecting the viewer's perspective. This mode of visual influence treats the image as an encoded message and operates by training the viewer's attention upon an intended content, such as exhorting viewers to display proper conduct, demeanor, or the reverence due respected persons. It is no mistake, for instance, that Buddhism thrived as it spread across Asia by enjoying royal patronage of temples, sculptures, and paintings. Monarch and religious monuments bestowed prestige and status upon one another. Another obvious

FIGURE 17. Apotropaic reflective device, restaurant front window,
Chinatown, Chicago, 2000. Photo: Author.

example of visual influence is the instructional use of illustrations in
religious publications such as Protestant tracts, as in figure 18. Intended
as a piece of advice for Christian parents, this tract and its illustration
detailed the proper domain of influence enjoyed by the parent, espe-
cially the mother. Indeed, the image does not include the father,
because its chief concern was to target mothers and delineate their
influence on children in domestic formation as their preeminent
responsibility. This sort of image is clearly propagandistic, a description
with a very negative connotation, since propaganda operates by subor-
dinating individual liberty to the good of a larger interest. Defined as
"any association, systematic scheme, or concerted movement for the
propagation of a particular doctrine or practice," however, propaganda
is not simply partisan brainwashing.[35] In many cases it may be little
more than that, but every society, and every group in every society,
engages in practices of spreading its claims and the principles upon
which it makes its claims. Even (or especially) in a democracy, a group
using propaganda may consider the menace of group disunity a signifi-
cantly greater danger than individual freedom of conscience—as we
shall see in the final chapter. Such a group may, therefore, prefer
conformity achieved by propagandistic indoctrination to the fractious

FIGURE 18. Artist unknown, mother praying with children. From *The Shepherd and His Flock*, No. 12 (Philadelphia: Baptist General Tract Society, 1824). Courtesy of The Library Company of Philadelphia.

energies of reasoned dissent. As forms of visual information, religious propaganda exhorts certain attitudes and behavior as desirable and vilifies certain groups, individuals, or traits as unacceptable. The message of figure 18, which I discuss in much greater historical detail in chapter 6, is that the family depends fundamentally on the faithful observation of domestic duties by mothers and that fathers are enjoined to support this duty by the salary they earn. Mothers are to be at home, with their children, while fathers are supposed to be earning the daily

bread and enabling the comfortable middle-class existence that allows mothers to preside over the domestic court.

With this in mind, it seems clear that an image such as figure 18 (as well as the Sande mask [fig. 13]) is invested with important aspects of the worldview of those who circulate and value it. This sort of image can be interpreted as a social document that endorses such forms of social structure as gender roles, economic status, racial or ethnic identity, systems of kinship, or social associations. Images that are designed to exert influence as visual forms of persuasion or instruction can be very rich sources of information for the scholar who wishes to understand them as instruments in service to particular interests.

DISPLACING RIVAL IMAGES AND IDEOLOGIES

The final operation of images that I want to outline here consists of the fear or resentment of them in all religions, which often leads to the damage, destruction, or removal of rival images. Iconoclasm, as I explore at much greater length in chapter 4, involves more than mere destruction. Abuse or elimination of images is typically part of a larger task of displacing or discrediting a rival. Images readily become the site of conflicting ideologies or identities. An example from an ethno-graphic project in which I participated makes this clear. When a zealous Protestant evangelist who was trained in Addis Ababa, the capital of Ethiopia, arrived in the provincial western town of Nekemte to begin work at a Lutheran church there, he found a large painting of the crucified Jesus hanging in the main church on the compound of the region's Lutheran headquarters. The evangelist considered the image intrusive and, as he put it, "unnecessary." The evangelist told us: "We do not use such kind of drawings; we don't believe it. This is what the Ethiopian Orthodox Church does."[36] At the evangelist's urging, the image was removed and placed in storage, which is where my col-league and I saw it, resting in a small shed behind the church (fig. 19).

The evangelist contended generally that there was no compelling reason to use images for religious purposes other than for their useful-ness as book illustrations in teaching children. Referring to the painting of the Crucifixion, he asked: "What does it help us? We don't need it. We don't know who Jesus is [from the picture]—we believe in him. We don't know who he is in the picture. In the Roman Catholic Church such pictures exist. Money used for pictures helps us, but not pictures." This seemed a curious claim because, standing in the nave and sanctuary

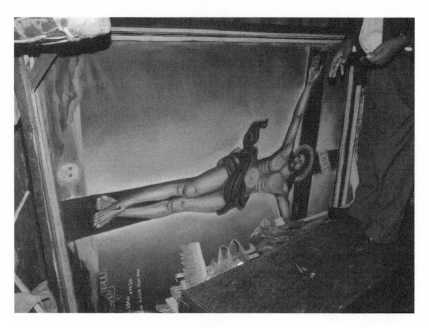

FIGURE 19. Hamsaloo Megistu, *Crucifixion*, 1984, oil on canvas, 6½ × 5 feet, in storage at Lutheran church, Nekemte, Ethiopia, 1999. Photo: Author.

of the church, my colleague and I counted no fewer than nine images on the walls and the altar. Evidently cognitive dissonance is a powerful consequence of iconophobia. One can simply refuse to see certain images. When we asked the evangelist about the abundant presence of images, he paused and then wondered why we were even interested in pictures. Alluding to a small iconic image of Christ on the altar, an image that was an obvious appropriation from the Orthodox tradition (even the biblical text it included, "I am the light of the world," John 8:22, was written in Greek script), the evangelist proclaimed forthrightly: "We don't like anything like this around the altar." He insisted that images were inessential and even harmful, pointing out that Orthodox believers kiss and bow to pictures. "In the future," he announced, "we will try to get the pictures out of here, because they are unnecessary." He consistently expressed the view that knowing the Christ of faith did not depend in any way on pictures. Images were not important for the work of the Gospel. In fact, he contended, images distort the truth and even lie. The evangelist objected to the appearance of Christ in a reproduction of a familiar portrayal of the Crucifixion by

the seventeenth-century Italian artist Guido Reni, which hung in the nave of the church at Nekemte: "But this is not what Jesus looked like. When you compare [it] with the Bible, Isaiah 53:2, he does not have a beautiful face. Jesus looks like he's being satisfied by ice cream and cake. He is drawn as a fat person." He did not offer a counterversion of Christ's appearance. The Christ of faith does not have a *look*. Evangelical faith is faith in what the Bible *says*. For this Ethiopian Protestant, who had been shaped by a polemical inter-Christian rivalry in a nation dominated by Coptic Orthodoxy, which was largely absent in the provinces, images signified the wrong allegiance. Removing or ignoring them was a strategy of purified thinking and ideological opposition.

This list of visual operations begs for articulation and expansion. In fact, each of the chapters that follow will do just that within the context of particular cultures and historical moments. My immediate purpose, however, has been to outline a general range of the various functions of images and visual practices in many different religions. Having done so, I feel it is important to acknowledge, as anyone who has studied the use of images in religious practices will immediately recognize, that none of these functions is entirely discrete. Most images combine two or more purposes. For instance, the image to which someone addresses a petition for deliverance from affliction also delineates a sacred space, and it may influence the petitioner's behavior, offer protection or remedy, enforce gender or class differences, and embody a presence for the sake of divine communion. Images do what their users require of them, which may involve many things at once. The point of the typology I have outlined is, first, to enumerate the different but often interwoven functions of visual practices and, second, to suggest how much the meaning of an image depends on the ritual or practice that employs it in the temple, home, or community. Moreover, the typology is inductive, the result of a historian's study of images, not a philosophical deduction from first principles. It follows, therefore, that the list is incomplete and will need to expand as evidence requires.

A final note. By stressing function, I am aware that my approach to the study of visual culture runs the risk of marginalizing the material characteristics of the image. This is a risk that must be minimized by making a point to attend to the image *qua object,* since it is often the case that the use of the image and the interpretation given it by those who use it are keyed to the image's particular physical features. I want to emphasize, accordingly, that *the study of visual culture should attempt*

to balance reception with production. To this must be added an acknowledgment of the important influence that the physical features and appearance of an image exert on its reception. Yet what believers see is the image as an engaged signifier, not the aesthetic object or curiosity that the connoisseur, art collector, or tourist may see. Vision is a complex assemblage of seeing what is there, seeing by virtue of habit what one expects to see there, seeing what one desires to be there, and seeing what one is told to see there. Parsing these intermingled motives and discerning the cultural work they perform as intermingled is the task of critical scholarship. Understanding how these motives make belief happen in visual media is the subject of the next chapter.

The Covenant with Images

In the art romance *The Marble Faun,* Nathaniel Hawthorne's story of American Protestant art pilgrims in nineteenth-century Rome, the narrator articulates a fundamental principle of art: "A picture, however admirable the painter's art, and wonderful his power, requires of the spectator a surrender of himself, in due proportion with the miracle which has been wrought." Extending the religious metaphor in a novel that explored the rocky transition from traditional piety to the larger Victorian canvas of European culture and the history of art, the narrator continued: "Let the canvas glow as it may, you must look with the eye of faith, or its highest excellence escapes you. There is always the necessity of helping out the painter's art with your own resources of sensibility and imagination."[1] Human vision and the claims viewers make for what they see are invariably presumptuous. One always sees, in one sense or another, with an "eye of faith." The passage from Hawthorne's novel suggests that images work by demanding a prerequisite submission of the viewer, a willful surrendering to belief in the power of the image to work its magic on the viewer. Seeing, Hawthorne's narrator seems to say, is a negotiation of belief with the visual medium in order to empower it to act upon those who stand before it. Viewers enter into a relation with the image in which they are expected to participate imaginatively, contributing what the image itself may not provide but must presuppose if it is to touch the viewer. Hawthorne named this faculty "sympathy" in his novel's spiritual heroine, a rare affinity that allowed her to enter "deeply into a picture."[2]

The viewer, it might be said, must act on faith. Although Hawthorne's female protagonist excels at such faith, the passage quoted above would urge every art lover to cultivate the capacity for sympathy as the proper manner of understanding works of art.

. Hawthorne's neo-romantic cult of Womanhood aside, his moral criticism of art offers an insight into the hermeneutics of viewing images. There is a kind of sympathy at work in the way one sees images. Another, less romantic way of thinking about this relation is to say that viewer and image agree to a particular range of possibilities and codes of interpretation before the viewer is able to see what the image may reveal.[3] To push beyond that limit requires the negotiation of a new contract. There is a tacit agreement, a compact or a covenant, that a viewer observes when viewing an image in order to be engaged by it, in order to believe what the image reveals or says or means or makes one feel—indeed, in order to believe there is something to believe, some legitimate claim to truth to be affirmed. The miracle of seeing what the image envisions does not happen without this covenant. Even as they operate in the practices examined in the last chapter, images enter into this contractual relation with viewers. What is it that images do to make belief or trust or agreement or the visual experience of truth possible? What role do they play in creating the medium that joins viewers with what they see? This chapter argues that while looking at an image, a viewer makes certain tacit assumptions that provide a necessary condition for affirming what the image delivers. In other words, the covenant struck between viewer and image has portentous significance in determining what the image is seen to show. A particular covenant stipulates the terms of the gaze that joins viewer and image in a social relation.

Covenants are necessary whenever people must operate on trust, which holds true in virtually every department of life. Covenants do not pertain only to religious or legal affairs, but even to quotidian aspects of perception and knowledge. Human consciousness may be characterized as a tissue of beliefs, expectations, assumptions, and trusts, a shifting array of covenants drawn up between individuals and the groups to which they belong. Seeing cannot escape the practicality of such covenants, and one enters into them in every moment of life in maintaining the cultural relations in which one exists. These covenants or compacts take several different forms depending on the society and situation in question. But the following list may capture the majority of conditions under which a representation such as an image is regarded as compelling. Cultures may define the nature of the covenant differently—does it render "truth" or

"validity" or "conviction" or "trust"?[4] For purposes of discussion, I use the appropriately ambivalent term *true*, whose meanings range from "credible," "accurate," and "correct" to "faithful" and "loyal." In each case, *true* designates not the image as much as the proactive contribution of the "eye of faith."

1. One may accept an image as true because it bears the will of one's community.

2. One may accept an image as true on the authority of someone who is believed to know.

3. One may accept an image as true because it appears to satisfy certain established criteria such as conformity to previous experience or corroboration by other representations.

4. One may accept an image as true because it represents an ideal or desirable state of affairs.

This list suggests how pervasive and fundamental covenants of representation are in human experience.[5]

The Presumption of Seeing

As innocent as seeing may seem when we think of the world pouring into an eye, vision is far less passive than it appears. One must presume much in order to see something as meaningful. A photograph of the inside of an atom, published in a German newspaper in 2000 with the caption "First Look at the Inside of an Atom," makes starkly visible the sheer presumption of seeing. And a small photolithograph of this newspaper clipping by the German artist Gerhard Richter compounds the sense that visibility is what we commonly demand of the world if it is to be intelligible.[6] The photograph that Richter reproduced purports to show what the interior of an atom looks like, in the same way that a newspaper photograph offers the likeness of the winning goal in a football game or the unhappy expression of a politician at an inopportune moment. Something rare, unexpected, and quite fleeting: a snapshot of a telling instant that one would not ordinarily see. The covenantal agreement one strikes with such images is that seeing something proves its existence. But the photograph that Richter reproduced consists only of a gray, blotchy haze with no discernible forms. One sees literally

nothing. The presumption of the genre of photojournalism clashes with the limits of image-making in this instance. If atoms exist, they must have a look. Seeing is believing, according to common sense as it is defined in Western societies. Indeed, many photographs accorded classic status in the history of photography attempt to capture the otherwise imperceptible moment of an event, serving to expand the threshold of human perception beyond the unaided capacity of the eye. Eadweard Muybridge's shots of galloping horses and Etienne Jules-Marey's vaulting figures, nineteenth-century "spirit photography," x-ray photography, Robert Capa's frozen image of the death of a soldier in the Spanish civil war, Harold Edgerton's stroboscopic photography of drops of fluid, or Nicholas Nixon's annual photographs of the Brown sisters aging from 1975 to the present—all seek to make visible what is invisible to the unaided eye by reducing the distance or size or the speed of a natural phenomenon in order to render it a subject of "normal" human vision.[7]

Seen in this light, Richter's image actually subverts perception by technological assistance, laying bare the conviction that photography captures the elusive reality of things. Reality does not exist as a static essence to be beheld. What shows itself in this "first look" is the fact that there is not exactly anything to see. Nebulous blobs, indefinable shapes that don't look like anything, that aren't even fully there. The atom, one might say, has no likeness. Its very image subverts the covenant of seeing.

And yet the idea that a blurry, indeterminate snapshot captures something as infinitesimally small but absolutely universal is bracing. What if that is what atoms look like? Is this, then, an icon of the foundation of matter as we know it? Does this picture bring viewers to the mysterious threshold of the structure of existence, of the entire cosmos? Some viewers may wonder if there is hovering somewhere within the gray haze the primordial substrate of being. With that query the epistemological covenant begins to merge with a metaphysical covenant: this "first look" or glimpse into a domain of mystery is alluring because it promises an even more encompassing knowledge. At least, this is how some viewers might regard the image—just as some peer into the astronomical depths of outer space in hope of discerning divine fingerprints. The willingness with which such viewers might submit themselves to Richter's image (or some distant nebula) as telling the truth about something far beyond their capacity to see is itself a leap of faith, an act of seeing that is an act of belief.

Whether or not gazing at the picture of an atom's inside is religious,

most viewers are inclined to believe that what they see is what they are told to see by the caption. That is the normal expectation of photojournalism, whose prevailing covenant with the viewer is to issue "strange but true" photographs. There is an operation of assent, not the same as an act of religious faith, but a kind of compact one enters into with the photographer, the institution that sponsored the original photograph (the University of Augsburg), the German newspaper, and whomever one in turn shows the picture to, exclaiming "Look at this!" Viewers believe that the picture corresponds to facts in the manner of a predication, a declaration, or an assertion of fact. The photograph's caption tells us so. A great deal of ordinary visual culture involves linking images and texts as if they were mutually supportive, faithful versions of one another. This is one of the most common and powerful forms of the covenant with images practiced in everyday life.

It may seem odd to say that a picture is actually an assertion, but human vision does not occur without language. Even the infant is engaged in matching the visual stimuli with corresponding sounds uttered by its parents. Seeing and knowing are intertwined in human beings, and knowledge is inseparable from representation. To know something is to be able to represent it. When we see a picture that is indecipherable, we naturally ask, "What is that?" expecting that language can help us recognize what we are missing. We also presume that the image can be inserted into a discourse, a conversation or an interchange structured as a set of terms and ideas. Our confidence, however, is presumptuous, because the image may not be a representation of anything; it may declare nothing.

What happens to representation when the covenant underlying it is called into question? This question is implicit in the reflections above on the photograph of an atom's interior and Richter's photolithograph of the newspaper photo. It is the central question confronting viewers of Gerhard Richter's paintings from the 1960s: black-and-white images of ordinary objects and people that the painter found in a variety of common photographic images. These paintings problematize the covenant with images by blurring their subject matter. The portrait of student nurses created by Richter in 1966, for instance, is based on the photographs of eight individuals published in newspapers internationally after they were murdered that year in Chicago by serial killer Richard Speck (fig. 20).[8] The identical size of Richter's paintings (thirty-six by twenty-seven inches) and their uniform black-and-white tonality and blurred features alert us to the artist's interest in focusing

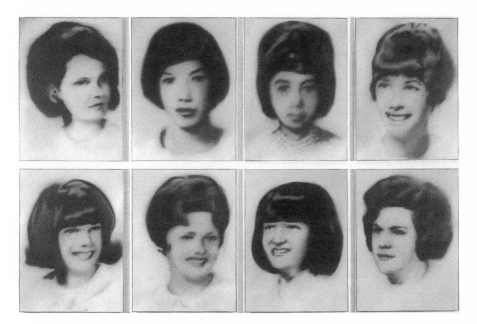

FIGURE 20. Gerhard Richter, *Eight Student Nurses,* 1966, oil on canvas, each
36⅜ × 27⁹⁄₁₆ inches. Used with permission of the artist. Courtesy of Hans and
Brigitte Wyss Collection, Zurich, Switzerland.

on the element of artifice in such prosaic images. The individuals are
anonymous (though their names were listed in newspapers). More-
over, seen in full, the eight images lined up bear clear similarities in
coiffure, format, expression, and presentation of the self as though to
observe a ceremonial occasion such as high school graduation. The
genre diminishes peculiarities, and Richter's manner of execution only
accents that transformation of individuals into types. Yet characteristic
features remain. Each face belongs to a discrete person, and one has no
difficulty imagining that each registers an individual's personality. The
fact that each woman was brutally executed by a maniac heightens the
viewer's horror and desire to see their individual features. Looking at
them, however, we have an inescapable sense of the burden of type, its
preponderance in every case. If these individuals have made choices
about hairstyle and fashion, they have been choices circumscribed by a
narrow range of options shared by a large number of people. The uni-
formity of presentation is clearly echoed in the uniforms they each
wear. In other words, these ritualized documents of identity argue that

identity is hardly limited to idiosyncrasies but largely geared toward locating individuals within encompassing taxonomies of class, time, and place. The prevailing indices of identity are signs of membership in a group. And this membership is signaled and sorted by a visual rhetoric of what is probably the graduation photo, which easily recalls other genres of photographic portraiture, such as the family portrait. One wonders who Speck murdered—individuals lost in the haze of a bland pictorial genre? Yet these dim elegies register the loss of eight innocent people feebly but nevertheless hauntingly. The abrupt juxtaposition of the generic and the terribly unique in this series of paintings makes the viewer unusually aware of the visual apparatus that frames the act of seeing.

The covenant with images takes a particular form within each genre of imagery. The tourist photo, for instance, asks viewers to trust its assertion of having been there, of the authenticity of its claim, "I was here (and you weren't)." The pornographic image says: "I present myself to you, I submit myself for your pleasure, without expectation of anything in return, such as personal engagement or respect." The celebrity photo declares: "Here is the person you want to be" or "Here I am! It's really me—the one you've heard so much about!" The advertising image proclaims: "This is what you need to be happy, to be complete, to be wanted or needed." In each case viewers behold the image, having already accepted as true, as their very compact with it, what it asserts about itself to them. The burden of contradiction rests on the viewer. The covenant frames a way of seeing or a gaze by establishing the epistemological and even moral conditions under which viewers encounter an image. With the compact in place, viewers are prepared to hear the image speak to and act upon them. If for some reason the image fails to live up to the covenant, the viewer reacts by denying its claim to truth and so falls out of trust with the image. This could lead to violence toward the image but most often results in a renegotiation of the contract under which one views it.

Thus the disturbing quality of Richter's painting of student nurses: the looming anonymity of each person is exacerbated by the large and uniform size, the tonal palette, and the blurring of the images—all of which refuse to deliver the concrete persons who lost their lives. The images themselves cannot tell viewers who the people are, and, worst of all, the visual rhetoric of the photographs suggests that their identity is irretrievable. Perhaps this infuses them with an elegiac character, underscoring their loss. Grimly, this may have been on the artist's mind. When asked in an interview in 1966 if working from photographs

conflicted with the need as a portrait painter to know the sitter, Richter replied:

I don't think the painter need either see or know his sitter. A portrait must not express anything of the sitter's "soul," essence or character. Nor must a painter "see" a sitter in any specific, personal way; because a portrait can never come closer to the sitter than when it is a very good likeness. For this reason, among others, it is far better to paint a portrait from a photograph. . . . In a portrait painted by me, the likeness to the model is apparent, unintentional, and also entirely useless.[9]

A portrait by Richter is not a portrait; it presumes to capture nothing on the surface of or within the person whose image appears on the canvas. Using photographs cancels the presence of the sitter and removes from Richter the burden of the covenant of likeness. When asked if he mistrusted reality since he relied so much on photographs, Richter responded: "I don't mistrust reality, of which I know next to nothing. I mistrust the picture of reality conveyed to us by our senses, which is imperfect and circumscribed."[10]

The covenant of images that viewers enjoy is predicated on their desire for something valuable to be mediated in the image. What one wants in the paintings of the photographs of student nurses, for example, are icons of those who were murdered. Viewers covenant with an image because of their interest in what it will deliver or enable them to possess or behold. Images are of special interest in the study of religion for this reason: their promise, or the viewer's expectation, of a conveyance of something that will repay the investment of faith in them. By blurring the mass-produced imagery he painted, Richter alienated the viewer from it, disturbing the normal process of belief, trust, or fidelity that confirms one's relation with the image.

What covenant with the viewer does he put in place of likeness? Richter spoke of his fascination with "the human, temporal, real, logical side of an occurrence, which is simultaneously so unreal, so incomprehensible and so atemporal." He wanted "to represent it in such a way that this contradiction is preserved."[11] This may indicate that the actual subject of his work is not subject matter, such as a person, but the pictorial genres of seeing, the history of visual formulas, the rhetorics of vision, the conventions of picture-making and memory-making linked to images—all of which constitute the visual culture of everyday life, the "belief" that philosopher David Hume long ago defined as the medium of ordinary judgment.[12] If so, Richter would contract with the

viewer to show the very features of showing, to see vision happening. This is a compact that requires the dismantling of such covenants as likeness.

If it is true that viewers enter into a relation of trust with an image, what does this imply about the operation of explicitly religious imagery?

Word and Image and the Compact of Communicability

Published by the American Sunday School Union in 1909, the lesson card shown in figure 21 first strikes the viewer with its unexpected juxtaposition of four apparently unrelated images. What, after reading the caption, could each of these depictions have to do with the "power of the tongue," let alone with one another? My immediate response, steeped in the art historical method of comparing and contrasting images, was to think of René Magritte's penchant for doing the same thing, as in *The Interpretation of Dreams* (1930; fig. 22). It is not an unreasonable comparison, it turns out, since Magritte based his pairing of word and image on the child's primer.[13] Yet Magritte's image, whose title is inspired by the name of Freud's first great tome, departs from—indeed, deliberately undermines—the stable taxonomy of a primer's careful alignment of language and things. Words and images in Magritte's painting share the same graphic field in a grid whose order the viewer recognizes as the very template of reason itself, the lexical structure of the way meaning happens in modern print culture. For nearly three centuries children in North America and Europe, for instance, learned to read by using primers and instructional books that correlated word and image in an endless series of direct visual and alphabetical correspondences (fig. 23). But in Magritte's image the two axes of representation, word and image, depart abruptly from one another, and the viewer is not sure which is right and which is wrong. Are the words misplaced or the images? In a later version of the same subject, Magritte even teased viewers by offering one "correct" alignment in the grid of correspondences, which goads one on to decipher the remaining, errant couplings.[14] Instinctively and persistently, the viewer looks at figure 22 for some reasonable association between visual and textual signs. In the didactic imagery of primers, as in figure 23, writing, speech, and image are presented as corresponding fully to one another, almost as if the

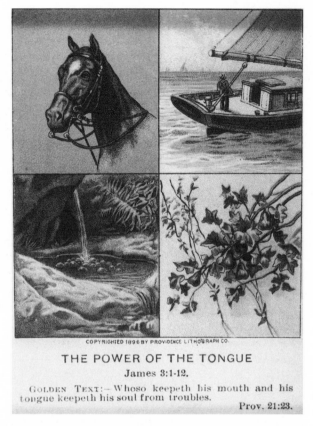

FIGURE 21. "The Power of the Tongue." From Little
People's Lesson Pictures (Philadelphia: American Sunday
School Union, 1909). Courtesy of the Billy Graham
Center Museum, Wheaton, Illinois.

sound of the alphabet and the writing it composes were supposed to
bear an analogous relation to the things it designates, which are medi-
ated by imagery. The idea is that writing, speech, and images are links
in a single semiotic chain that terminates in material reality. Images in
this chain are a kind of half-condensed language, pictographs on the
way to being script.

Magritte's painting challenges the integrity of this chain. The
terms in the painting seem largely to cohere as a set of references to
natural elements—snow (*la neige*), moon (*la lune*), storm (*l'orage*),
desert (*le désert*), and acacia tree (*l'acacia*). And the set of images

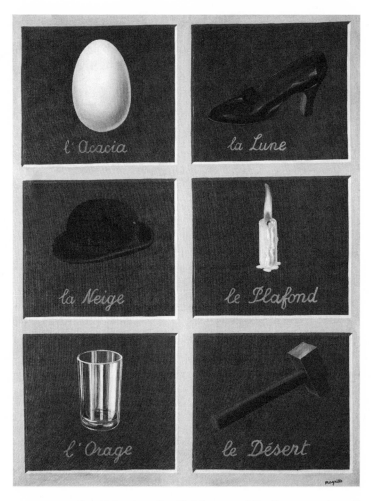

FIGURE 22. René Magritte, *La Clef des songes* (The Interpretation of Dreams), 1930, oil on canvas, 81 × 60 inches. Photo: Erich Lessing/ Art Resource, New York. © 2004 C. Herscovici, Brussels/Artists Rights Society (ARS), New York.

seems more or less to cohere as a class of ordinary household items. They are just the sort of thing one would see in a primer. Looking at the painting, viewers must decide how to proceed by examining the compact with the image they will presume. Will they insist that the image makes sense, which simply eludes them? Or will they conclude that the disjuncture of word and image casts doubt

Nightingales fing
In time of Spring.

Young OBADIAS,
DAVID, JOSIAS,
All were pious.

PETER denies
His LORD & cries.

Queen Efther fues
And faves the Jews

Rachal doth mourn
For her Firft-Born.

SAMUEL anoints
WhomGODappoints

FIGURE 23. Alphabet page, *The New England Primer,*
Exeter, New Hampshire, 1782. Courtesy of the American
Antiquarian Society.

on the reliability of the instrument? If the latter, a natural reaction is
to imagine a mistake in the printing of the image, a faulty registration
that has resulted in a misplacement of word or image. If, however,
viewers hold to the original covenant governing instructional
imagery—the notion of a one-to-one correspondence between word
and image—they will proceed by attempting to discern a level of
meaning that may not be immediately apparent. Accordingly, one
strains to resolve the disjunction of abutted signs, because the rheto-
ric of the grid prompts the viewer, long accustomed to the graphic
logic of order, to believe that there is good reason to expect it.

Indeed, viewers intolerant of the lack or discontinuity of meaning may go to absurd lengths to make sense of Magritte's image. They might strain to discern hermetic associations. The images on the left side of the painting are smooth and round; those on the right, pointed, hot, or heavy, suggesting a violence or capacity for pain. One might seek to realign the terms with the images, making a kind of puzzle out of the grids. Or one might ask if there is a subliminal association between the existing correspondences, such as the femininity of *la lune* and the lady's high-heeled shoe; the organic nature of the egg and the acacia tree; the severity of the desert and the blunt hammer; the protection the hat gives one's head from the snow; and so forth. It is virtually impossible not to manufacture such interpretations if one is to enforce the covenant that expects a systemic, overarching rationale or program of meaning in the image. But then the link of candle and ceiling (*le plafond*) stubbornly resists explanation. Perhaps that single cell is mistaken? Or perhaps "the ceiling" refers to cloud cover, if we strain a bit to link the term to natural phenomena? The impulse to find meaning is driven by the compact one forces on the image or wants to enforce with the image's cooperation. Magritte delighted in complicating this very presumption.

The Sunday school lesson card (fig. 21) verifies and quickly responds to this predisposition for rationality. Consulting James 3:1–12 promptly solves the mystery. But in the meantime, the brightly colored card has caught one's attention, and that was certainly its purpose. The small details juxtaposed to one another form a visual riddle that the caption only deepens. Is there anything tonguelike in a gurgling spring, a sailboat, a passel of vines, and a horse's head? Did Magritte design Sunday school literature before he became a well-known Surrealist painter?

But, as I said, the biblical passage makes everything clear. The preliminary confusion tactically caused by the imagery on the card vanishes when one reads verses 3, 4, 11, and 12, which identify the iconography. The third chapter of the book of James addresses the trouble caused among communities of faith by the offenses of speech. *Tongue*—in Greek *(glossa)* as in Latin *(lingua)*, the word for both language and the physiological organ that helps produce speech—serves in the English of the King James Version (quoted on the verso of the card) as a metonym of the human inclination to evil: "the tongue can no man tame; it is an unruly evil, full of deadly poison" (v. 8). Later the text uses another favorite poetic representation of the human will to

evil: "if ye have bitter envying and strife in your hearts, glory not, and lie not against the truth" (v. 14). The tongue and the heart both ground evil in the body and in the very nature of humankind. James admonishes his readers to practice restraint, to reign in the impulse to speak evil, and to resist glorying in the strife that moves them. Are not horses restrained by bits in the mouths, allowing the rider to "turn about their whole body" (v. 3)? Are not great ships maneuvered by a small helm (v. 4)? The tongue is small but "defileth the whole body" (v. 6). And how is it, the writer asks, that "out of the same mouth proceedeth blessing and cursing" (v. 10)? This contradicts the lesson seen in nature: "Doth a fountain send forth at the same place sweet water and bitter? Can the fig tree, my brethren, bear olive berries? either a vine, figs?" (vv. 11–12).

The visual puzzle of the lesson card invites scrutiny, because placing images together prompts the viewer accustomed to instructional literature to look for a mechanism of reference in which each image designates some idea and for a possibly allegorical configuration of meaning in the relationship of the four images to one another. In either case, it is essentially impossible to look at the card and not attempt to discern a rationale at work in the selection and arrangement of the four images. The difference between Magritte's painting, titled *La Clef des songes* in French, and the card is that no key *(clef)* exists in the first case. There may be a distorting dream logic at work, but there does not appear to be a secret message that, once determined, resolves any tension or contradiction in the configuration of word and image on the painting's surface. In the case of the lesson card, by contrast, no irresolution remains after the Bible is consulted. The images' resistance to meaning is supposed to dissolve once the biblical words are established as the referent of the images. The hierarchy in Protestant pedagogy generally ranks words above images for several reasons, the most important of which is the metaphysical nature of divine revelation in the biblical word. As I suggested in the introduction, Calvin conflated speech and writing in order, like the Sunday school card, to tame the effervescence of the tongue as the register of the Holy Spirit (glossolalia—speaking in tongues—was one unruly manifestation of the Spirit that did not suit the mainstream Protestant framework of dogmatics, confession, and theological disputation).

In addition to endorsing an orthodox Protestant preference for the systematic, intertextual nature of scripture, of theology as the *science* of theo-logos (God-speech), linking words with images offers other advantages. Words interact with images in a way that allows them the

advantage of both appealing to children and delivering highly defined content. For conservative Protestants, belief is often inseparable from its articulation. As pointed out in the introduction, believing is preeminently the practice of proposing what one believes. Children must recite by memory (or read aloud) long, carefully composed creedal statements. Speech in these instances substitutes for text. Conviction and assertion (replacing utterance) are inseparable. Even personal "testimonies" can become rote exercises. Protestantism, evangelical and fundamentalist Protestantism in particular, interprets human experience as a situation, an apprehensible way of being, a definable state or nature to be understood within a worldview that is normatively expressible in a set of propositions. This worldview and its modus operandi in religious life rely deeply on the *textuality* that informs a host of practices—from devotion, teaching, learning, proselytism, worship, and meditation to governance, jurisprudence, and institution-building.

What is textuality? In the modern world, it means practices of reading, writing, and performing texts that are grounded in print. A text is something written, published, stored, read silently or aloud, purchased and shared, traded, displayed. It is cited, edited, rewritten, compared with other texts, and taught. Modern forms of knowledge and institutions associated with teaching, learning, and study are inconceivable without printed texts. Most forms of authority are based on a form of textual expertise. The very concept of "public" relies on textuality as an established, accessible, shared code, such as a constitution.[15] All of these features can be traced more or less to the invention of movable type, which was exploited by the Protestant Reformation's definition of authority as the individual appeal to God's Word. This Word, perhaps more accurately called Script, made available in mass-produced, vernacular publication of the Bible ("the Book"), was believed to assure the liberty of every human being and could not be contravened by any human institution.[16] Textuality is thus important for its construction of modern society and the individual. What it really is at heart, though, is a fundamental conviction about the structure of reality, which consists of a clear constellation of four elements: reader, text, referent, and writer. Textuality is the intelligibility, or legibility, of these four fitting together in a coherent order. Textuality is about message-sending and about the correct decoding of the message. Accuracy, credibility, and authority are among the cultural preoccupations of textuality.

Images fit into this paradigm for many Protestants as forms of text, inasmuch as they point to other things (referents or other texts) and serve to underscore the stability and significance of them. In print culture, images may act like texts or referents, that is, as signifiers of something else or the thing to which a text refers, a referent, or something in itself. Magritte likes to make images do both; indeed, he is enthralled by the ambivalence of images in this regard. He can make words do the same double duty: they signify, but as painted figures they acquire a life and presence of their own on the painting's surface and in its design. Popular Protestant visual culture, however, is often uneasy about images as anything other than forms of text. Even nature itself is a text, a great book declaring God's glory. And God himself is the Word Incarnate. Conservative Protestants understand biblical revelation as a direct configuration of writer/referent, text, and reader. They become especially disturbed when this simplicity is threatened by the complications of textual analysis or historical scrutiny. Images appear most often anchored to texts, which use pictures or diagrams as forms of reference to themselves. A caption frames how one should "read" an image, foreclosing certain possibilities and narrowing interpretation as much as possible.[17] Word and image are placed in tandem, typically with the image subservient to the text as a form of advertisement or illustration, ancillary and unnecessary as far as the text's capacity to bear its essential significance is concerned.

Even when words are literally absent in Protestant imagery, textuality is not. The interdependence of word and image and the importance of this relationship for conservative Christians becomes clear in a painting called *God's Two Books* (1968; fig. 24), by the twentieth-century Protestant illustrator and religious artist Harry Anderson. Congealing within a dense wall of foliage, the head of Jesus hovers as a looming sculptural presence before a seated woman, who rests one hand on an open Bible beside her. The arboreal visage appears more substantial than ephemeral and transforms nature into a clearer sign of divine authorship—indeed, not a sign at all but the personal presence of Christ himself or perhaps his portrait-icon. Scripture and nature appear to mirror one another, each underscoring and bearing witness to the other.

The difference between images by Magritte and Anderson is that the American Protestant painter strictly controls ambivalence in his painting. In Anderson's picture Jesus is meant to be seen as really there, his being exists in minimal ambivalent relation to the foliage. Magritte, in

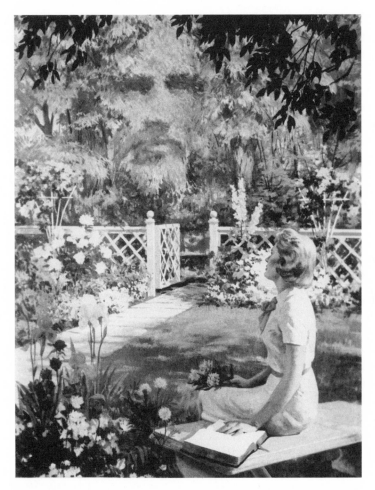

FIGURE 24. Harry Anderson, *God's Two Books*, 1968, oil on canvas.
© Review and Herald Publishing Association. By Artist Harry
Anderson. Used with permission. All rights reserved.

contrast, often makes use of metamorphosis, as in *The Red Model*, a
painting of boots with human toes, in which one cannot be sure
whether the boot is a foot or the foot is a boot.[18] In *God's Two Books*,
Anderson wished to show the perfect coincidence, the seamless join of
sign and referent, literally, of script and savior, word and divinity. God
is here, pressing through nature, imprinting himself upon it in a divine
act of self-expression. Anderson was possessed of a piety shaped by a
Victorian resistance to a universe without God, a universe where

humanity was no longer the measure but only fatefully in possession of "a short and terminable lease of an antiquated tenement."[19] The British Enlightenment produced a Protestant tradition of natural theology that regarded nature as a diverse manifestation of divine design and urged the pious viewer to discern in it a legibility meant to bolster the faith in an age of skepticism and modern biology and geology. The view of nature promulgated by natural theology taught Protestants to regard nature with the same logocentric compact of communicability that shaped their view of images:

This fair earth is recognized to be a mighty parable—a glorious Shechinah. Its manifold forms and hues are the outer folds, the waving skirts and fringes, of that garment of light in which the Invisible has robed His mysterious loveliness. There is not a leaf, nor a flower, nor a dewdrop, but bears His image, and reveals to us far deeper things of God than do final causes or evidences of design. The whole face of nature, to him who can read it aright, is covered with celestial types and hieroglyphics, marked, like the dial-plate of a watch, with significant intimations of the objects and processes of the world unseen. The Bible discloses all this to us.[20]

Nature reflected the Bible's legibility. Nature was both word and image, hieroglyph, a text, and the similitude of the divine. The two semiotic orders were brought together, mapped over one another, and then distinguished. God was seen through, but not as, nature. The textuality or scripturality of nature was premised on the underlying sympathy of the Bible and nature. Nothing written in the Bible could be contradicted by the natural order.

But the "nature" that fit scripture neatly was a cultural production. In order to attain this correspondence of sign and referent, the harmony of scriptural and incarnate word, Anderson had to fabricate "nature." He invented nature in tandem with its other: feminine domesticity, the realm of cultivation, artifice, the arbitrary, the seated woman. Anderson defined a masculine nature in contrast to the ancient discourse of the garden, that Edenic space of serenity, muted and transfigured here into a bourgeois backyard with a manicured lawn and concrete furniture. The fine white lattice of the fence and the delicate trellis separate a colorful foreground from the denser growth and monochrome green of the distance. This distinction, performed by a white horizontal that bisects the picture plane, suggests a passage (signaled by the open gate) from "domestic" to "wild," from "culture" to "nature," "human" to "divine."

What shall we say this picture means? Viewed from the perspective of pious images, it would seem to corroborate nature and scripture as God's two books, the two forms of God's chosen means of self-revelation. If this is so, it may be that the image subordinates nature to scripture as revelation in the positioning of the woman's hand on the Bible as she gazes at the face. Nature, we learn, is an open Bible, but not "the" open Bible. The one is *like* the other, and therefore less than it. We are not encouraged to reverse this: nature is like the Bible, but the Bible is not like nature. After all, nature's laws are being contraverted in order to conform to the textuality of scripture. The woman, in other words, has stirred from an afternoon of meditation to recognize the divine authorship of nature.

But is the image ambivalent? Viewed from the perspective of Magritte's art, one wonders if Christ may be the product of her imaginative projection onto a suggestive configuration of leaves. Although we might not expect it in the work of a devout artist who provided to his art director whatever he was instructed to illustrate,[21] is there here evidence of a vague suspicion that word and image, discourse and world, sign and referent are not hierarchically arranged, not joined by a sacred covenant, the compact of communicability? Is there perhaps an unconscious suggestion that the image can refuse to be dominated by the word, that "nature" can exercise a power that resists domestication by devotional or theological discourse? The looming Jesus pressing through the labile stuff of nature, gigantic and imposing, suggests an unnerving instability to nature and a subversive presence that threatens to overwhelm it. The submission of leaves to the face might suggest that the substance of nature is not real but a mere appearance covering the darker depths of metaphysical reality. *What* has this woman called forth in her afternoon musings? Is the Bible a source of theurgic incantation?

This "reading" would be to treat the relation of book and face as reversible, as uncontrollably ambivalent. But it is difficult to imagine that Anderson intended to call into question the operative relation of sign and referent, because that would undermine the contract that ensures not only communication but Communication as Christianity understands the testament and testimony of nature and the evangel. If the image is to be a medium of communication and visual proclamation of God's revelation in nature as harmonious with his revelation in the Bible, the image can hardly function reliably if it is taken at once to convey contradictory meanings. Anderson conceived of "nature as

undomesticated" in a polarized pairing with its opposite. His picture mediates the opposition. The two terms of the polar scheme are distinguished by the division of the visual field into two zones: the top belonging to Jesus; the bottom to the woman, whose head just touches but does not penetrate into the upper register. It is as if this female Moses drew nigh to the sacred epiphany of the burning bush but stopped short, as piety would demand. Nature and culture construct one another in a tame matching and wedding of word and image, male and female. Although the woman returns the gaze of the monumental Logos, the focus of his gaze is obscured: he appears to take in all time, to oversee the landscape of all creation. The woman sits quite passively in the domestic space of her backyard, a feminine place nestled within the masculine domain of Jesus, the creator-god of all nature. Nature is not a place beyond discourse but the very reflection of it, the masculine counterpart of feminine culture. It is reassurance that the woman draws from her open Bible, reassurance that the wild out-there is but another version of the tame in-here. Nature is simply another kind of open book speaking what this woman, sitting in for all devout Christians, already knows. The image of Christ in nature conforms to the scriptures as well as (it is no surprise) to the ethos of this middle-class, white housewife.

Anderson's intended mediation of opposites into a relation of hierarchical harmony in *God's Two Books* contrasts with the sustained ambivalence intended by Magritte's *Interpretation of Dreams*. This is a telling difference. A similar distinction pertains in a comparison of two other images, a 1995 tract illustration (fig. 25) and the well-known 1953 lithograph called *Relativity* (fig. 26) by M.C. Escher. Clearly the image on the tract, entitled "Where Are You Going?" is a variation of Escher's print. In the tract illustration several figures appear in a gloomy labyrinth of staircases, each of which leads in a different direction. Although at first glance the tract illustration recalls Escher's marvelous design, upon closer examination the two reveal remarkable differences, differences that correspond directly to separate notions of reality, communication, and the task of the image.

Escher masterfully created a paradoxical glimpse into a world of multiple universes that exist on inverted and perpendicular axes to one another. The anonymous figures go about their daily business, obeying the local laws of their universe unaware, or largely unaware, of the proximity of alternate realities. Which is more real? The structure of the image does not allow us to say. But viewing the picture as we do, parallel to our vertical bodies and with the artist's monogram in the upper

FIGURE 25. Tract cover illustration, "Where Are You Going?" ©
1995 American Bible Society, New York. Used with permission.

left, we might wonder whether the faceless fellow in the upper right,
leaning over a banister and peering into the multiplex gallery below,
hasn't got some transcendent sense of the situation. At least, this is the
assumption one wants to make. Stare at the image long enough, and
one can experience a kind of existential claustrophobia. The dronelike
figures march mindlessly to and fro, never arriving and not knowing
whence they've come. They appear blithely unaware of their precarious

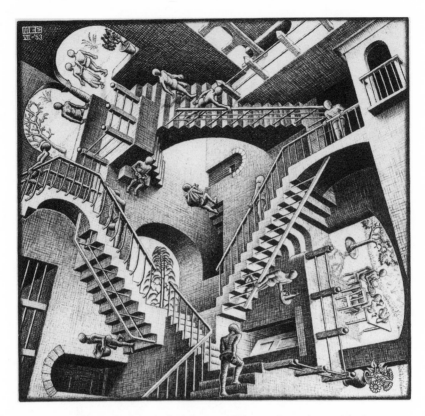

FIGURE 26. M.C. Escher, *Relativity,* 1953, lithograph, 10¾ × 11⅛ inches.
Photo: Art Resource, New York. M.C. Escher's "Relativity" © 2003 Cordon
Art B.V.-Baarn-Holland. All rights reserved.

state. After several minutes of this, one is drawn to interpret the leaning
figure's curiosity as a single transcendent ego. One finds such perches
now and then in daily life, on a park bench, at a baseball stadium, from
the observation deck of a tall building, when the faceless busyness of
our fellow humans resembles the antlike but pointless industry of
Escher's tiny figures. What does it all mean? one asks with a certain
degree of desperation. Escher ventures no answer, content to offer only
a poignant evocation of the experience.

Not so the tract illustration. Driven by the evangelical motive of the
American Bible Society, the tract's producer, the image addresses the
viewer directly—in the manner of religious tracts—with an image that
threatens confusion but provides deliverance. Comparison of the tract
illustration with Escher's print reveals important differences. The tract

image, although it assembles what appears to be a jumble of stairways, in fact creates a singular reality. There is none of Escher's "relativity": all figures walk upright, and the stairs belong to a uniform world of gravity and light. A single light source illumines the shadowy space, coming from the central arch near the top of the image. Although the figures may be coming from different points in the interior, all of them head toward the source of light. The tract asks, "Where are you going?" but it seems clear that everyone is, or at least ought to be, going to one place. The text puts matters plainly: "What is important is the path you take in life. Jesus tells us that there are only two paths to choose from."[22] The tract illustration rejects the possibility of multiple legitimate paths that Escher visualizes among his figures. The tract argues that there are simply two, opposite possibilities: light or dark, up or down, salvation or damnation.[23]

The tract illustration exemplifies the evangelical Christian understanding of communication media as a univocal, unidirectional transmission of information from a sender to a receiver and portrays the Christian life itself as such a communication: one must choose, and the choice is clear and simple, with an unambiguous outcome. The covenant with this image is not the same as the one we draw up with Escher's, which may differ in another manner from the one that would engage us with Magritte's imagery. In the compact governing the conduct of the tract illustration, images must act in subordination to words, which act like simple images: they show the truth.

The Plasticity of Word and Image in Surrealism and Children's Literature

The theological underpinnings of the notion of representation at work in Anderson's picture and the American Bible Society tract illustration—the affirmation of God's self-revelation in Jesus and the theory of the unambiguous sign—clash with the desire for paradoxical reversibility in images by Magritte. His famous paintings, as already seen, treat the relation of sign and referent in the form of a reversible pictorial motif. *The Human Condition* (1933; fig. 27) is a good example of Magritte's fascination with the mythology of the image as coterminous with the reality it represents. Viewers take pictures seriously because they consider these pictures to share some aspect of the reality portrayed. To have this relation called into question, as Magritte's picture

FIGURE 27. René Magritte, *La Condition humaine* (The Human Condition), 1933, oil on canvas, 39⅜ × 31⅞ inches. Gift of the Collectors Committee, Image © 2003 Board of Trustees, National Gallery of Art, Washington. © 2004 C. Herscovici, Brussels/Artists Rights Society (ARS), New York.

does so delightfully, is to be made abruptly aware of the *presumptuousness* of representation and our expectations about its authority. Magritte not only undermines the authority of pictures; he suggests far more radically that our notions of nature and reality itself may be in doubt. Which is more real—the picture or the world that a viewer believes it represents? The seamless relation of sign and referent revealed in *The Human Condition* does not authorize the image so much as raze its foundation, which is "nature" itself. Sign and referent may be of a

FIGURE 28. René Magritte, *L'Espoir rapide* (Swift Hope), 1928, oil on canvas 19½ × 25½ inches. Photo: Bildarchiv Preussischer Kulturbesitz/Art Resource, New York. © 2004 C. Herscovici, Brussels/Artists Rights Society (ARS), New York.

piece, but suddenly that is nothing to be reassured about, for the bottom has fallen out of our presumptuous and complacent confidence in the fidelity of representation.

Magritte did not stop with the artifice of images and nature. He took the even more disturbing measure of implicating the arbitrary relationship of language to both image and nature. *Swift Hope* (1927; fig. 28) assembles the commonplace features of conventional landscape painting but regards them as dark blobs suspended in an indeterminate space, where they are recognized not by shape or feature but by labeling each object in its placement relative to the others. The words designate the objects by referring to the conventions of landscape painting and linear perspective. The relation between words and things is arbitrary. Indeed, the testament of *Swift Hope* seems to be that words reveal nothing about things. The objects beside which they float remain ineffable, completely unresponsive to the semiotic operation of their labels, although the term *chaussée de plomb* pursues the humorous absurdity of

the painting by describing the dark blob as a "road of lead." The object lies diagonally as a road might recede perspectively into a landscape, but Magritte playfully labels the blob itself as a piece of lead called a road. So language is not entirely detached from the things it designates, though one senses the artist's playfulness in this risible concession to realism. Yet portraying a road as a massive piece of lead only underscores the incommensurability of language and things. But the more prominent endorsement is of a drastic nominalism that understands images as convenient tags that refer not to classes of objects so much as to conventions for representing them. In this case, the labels direct the viewer to the conventions of landscape painting. What lie behind signifiers, in other words, are systems of representation that defer to yet other signifiers and systems. One never arrives at a bedrock reality.

Yet Magritte's paintings are more than sketches of conundrums or the provocations of a nihilist. At his best, Magritte produced images that evoke an air of paradox and dreamlike estrangement. Ordinary objects fascinated him, he related in one interview, when they appear to undermine their very familiarity. Indebted to the Symbolist aesthetics of Mallarmé and Rimbaud, Magritte cultivated a form of estrangement of the ordinary in his art that did not nullify representation but aimed at reinfusing human experience with a poetic sense of which modern life deprived it. "We, all of us, are distracted by so many practical things that we miss the mystery. We should stop at times and consider the mystery." This was the purpose of his art—a purpose grounded in a theological sentiment, as he indicated in the same interview: "All we can do is evoke the mystery. We cannot reveal it or define it. That becomes mere joking. Yes, I believe in God, but I don't think anybody can say anything about God. Instead of God, I say mystery."[24]

Comparing Magritte's imagery of windows and landscapes with a chalk talk produced in 1895 for use in Sunday school classrooms in the United States (fig. 29) offers a provocative occasion for exploring how the relationship of word and image serves very different ends among the Surrealist avant-garde and conservative Protestantism. In this illustration of a window looking out over a road leading to the crown of Jesus, we have everything Magritte would deconstruct. The window is meant as a transparent aperture that opens faithfully onto the pathway to Jesus. The road lacks Magritte's ambivalence: language is not a slippery signifier, and the landscape is not a vague and dark place of open-ended mystery or endless indetermination but a limpid road to redemption. But it is not a mere snapshot of a landscape; it is landscape as allegory—a

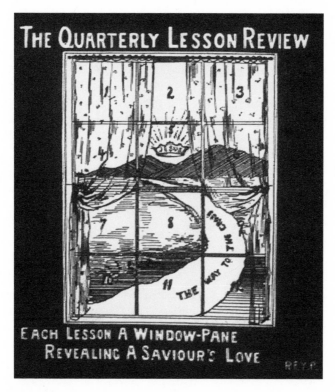

FIGURE 29. Rev. Robert F. Y. Pierce, "The Quarterly Lesson Review," chalkboard drawing. From *Pictured Truth: A Hand-Book of Blackboard and Object Lessons* (New York: Fleming H. Revell Company, 1895). Photo: Author.

symbolic seeding of the world with religious meaning.[25] The image delivers a world of faith. An inscribed passage of words along the winding path affirms a neat fit between language and what it describes. Signifiers and things enjoy a reliable, stable relationship. As a didactic device, the window vouches for transparency and clarity of vision. Its panes demarcate a modular lesson plan that constitutes a whole and organized theological act of seeing that promises spiritual deliverance. The illustration refers to the march of Sunday school lessons over the course of the year toward a comprehensive study of scripture. The parsing of scripture adds up to a complete picture. Seeing is deployed as a reliable metaphor for grasping salvation. To *behold* is to hold firmly in one's hands what the scriptures promise. Seeing and saying are mutually interchangeable, enjoying a correspondence that assures their reliability.

It is just this parity of word and image, signifier and referent, that popular religious culture wishes to affirm. The need for a semantic stability goes to the heart of piety grounded in a common understanding of the Bible as the *literal* revelation of God and to cultures that insist on literacy in order to access the Bible. But it is not just the ability to read God's Word that has motivated Protestants. What they teach their children about the world and human knowledge of it is ultimately no less important than reading the Bible. Indeed, their epistemology must precede their biblical interpretation, because their hermeneutic draws from their prior understanding of the nature of reading and understanding. In other words, teaching children to read has often amounted in significant ways among Protestants to teaching them how both to read the Bible and to see the world as an intelligible and therefore legible text.

An example of this is found in the illustrated pages of *The New England Primer*, first published in 1699 and used throughout the eighteenth century in colonial northeastern America, even enjoying use in classrooms well into the next century. As I have discussed elsewhere, the alphabet page of the primer aligned letter, image, and phrase in order to assist memorization (see fig. 23).[26] But the additional lesson, though tacit, was no less important. Textual, verbal, and visual signifiers were presented as enjoying a natural alliance. The letter helped compose the utterance and sentence, which rhymed and corresponded to the illustrated world of scripture and human experience. This imbrication of word, sound, thought, and image encouraged the idea of an integrated configuration of all aspects of a sign into a reliable representation of a stable world. Such lessons affirmed a close fit between language and experience and stressed the linguistic character of images: they speak, tell, describe, confirm as representations. And they work in tandem with language. Animating each image is a declaration, a predication that can be succinctly expressed in a caption. And the rhyme scheme assisted children in remembering the associations and discerning that English and its proper acquisition consist of a certain music. Part of the truth of representation is its intrinsic coherence—its rhyme and rhythm. Absorbing all of these connections is the overarching lesson of print culture, a lesson about the textuality of images and the senses and the world to which they correspond—a world that is both physical and moral in character. It is a clear articulation of the covenant with images as they are textualized among Protestants as well as many other modern people, religious or not.

One of the important consequences of the acquisition of language and its corresponding form of visual literacy, as *The New England Primer* and countless other instructional texts taught these skills, was the affirmation and articulation of what might be called a culture's "commonsense" notion of reality. This understanding of experience and representation maintains that the world is apprehensible through language: that language is a commonly shared, universal system that mirrors the stability and order of nature. Among believers, language triangulates humanity, divinity, and nature. Embedded in this configuration is the epistemological structure of communication, which forms the foundation or covenant that members of the culture enjoy with communication media such as images.

One of the most effective ways of accepting or coming to believe in the covenant of transparency that informs this commonsense constellation of word and image is, ironically, the distortion of it. Young language users find it most helpful and enjoyable (or helpful because enjoyable) to learn the "normal" operation of language by seeing it stretched or subverted. The flirtation with ambivalence can engage attention and facilitate memory. The enduring appeal of nursery rhymes owes a great deal to the amusing effect of bending language into nonsense through rhyme and a mesmerizing cadence:

Hey diddle diddle!
The cat and the fiddle,
The cow jumped over the moon;
The little dog laughed
To see such sport,
And the dish ran away with the spoon.

Today educators who encourage the use of nursery rhymes in early childhood education (years two through six) cite several advantages in doing so. First, classic nursery rhymes such as "The Cat and the Fiddle" provide children with lasting patterns of narrative: how stories work, how they are constructed. Many educators also stress the significance of nursery rhymes for enriching vocabulary. Hearing this classic rhyme may be the first occasion that a young child encounters the word *fiddle*. One educator noted that a selection of thirty nursery rhymes included as many as one-third of the number of words composing a young child's working vocabulary. Third, nursery rhymes improve language decoding skills and memory and teach children essential features of language, such as alliteration, rhyme, syntax, and grammar. The simple

rhythms and rhyme schemes of nursery rhymes also encourage the generative use of language: children find it quite natural to replicate the rhymes and rhythms in creating rhymes of their own. The music of the language is easily and happily absorbed, which several enthusiasts stressed as one of the most compelling reasons for using nursery rhymes among young children. When learning is fun, children become far more engaged in it, and the acquisition of many different kinds of knowledge and skill is enhanced.[27] And all of these advantages presuppose the performative context in which nursery rhymes are employed: they are recited by those who know them to enrapt audiences who watch as well as listen. The rhyme comes to them as an embodied performance: facial expression, eye contact, gesture, words, images (in the case of an illustrated book), and tonality intermingle to interpret the rhymes. When teachers and parents read the rhymes with an illustrated book in hand, they are typically showing images of the rhymes as they read them. These illustrations underscore and augment the text by means of setting, costume, and characterization of the figures.

Nursery rhymes are able to teach young children language by distorting it, because the distortion underscores the conventions of "proper" usage as controlled, normal, or default. The rule becomes apparent in every playful deviation from it. "The Cat and the Fiddle," for example, opens with the repetition of an unusual word, *diddle,* a verb that means "to waste time" but also "to move quickly back and forth," that is, the motion of playing a fiddle, producing a playful song with no other purpose than the enjoyment of playing it. *Diddle* is not a word children would know or use, nor would many adult speakers of English, for that matter. Its formal role in the rhyme is its metrical scan and its relationship to *fiddle.* As the rhyme unfolds, the sentence structure becomes quite orthodox: subject, verb, and object are entirely straightforward. The content and action described, of course, are anything but "normal." Cows do not jump over the moon, little dogs do not laugh, and dishes do not run away with spoons. But it is the musical expression of nonsense in perfectly sensible grammar that provides the rhyme's delight. One hears the parent or teacher chortling with the young child about the silliness of the scene. It is the very deviation from the everyday character of language as a conveyer of information and description of plain facts that makes the nursery rhyme enjoyable. One might also say that this deviation reinforces the capacity of language to describe and inform, to grasp and construe the ordinary. As long as the language of the nursery rhyme is circumscribed by the protocol of play

or make-believe, it is enjoyed as willful deviation from normal discourse and thereby, ultimately, as its affirmation. A similar operation appears at work in Anderson's painting (see fig. 24): the menace of ambivalence in the emergent face of Christ is checked by the prevailing reference to the Bible beside the woman as well as by the pastoral setting and the bourgeois appearance of the bemused housewife. The marvel of a supernatural epiphany ultimately affirms the authority of the Bible and the social order that clings to it.

The alienation of language or imagery is welcome because it not only confirms the utility of words and pictures in the whimsical overturning of normalcy and convention but also discloses something every child soon grasps through the playful figurations of song and rhyme. The imagination operates by intuiting rules and generating new applications of word and image on the basis of those rules. Children spout new rhymes, create sentences using the words they've learned, replicate the cadences of the nursery rhyme with new contents of their own. This is a highly useful ability and therefore a very important skill to develop among children. Inasmuch as replication bolsters the common utility of language and images as reliable representations of reality, it is also a very conservative cultural force. I say "conservative" because replication confirms and conserves forms of representation as shared and therefore as binding cultural instruments and vessels of conviction. Literacy in the use of forms of representation is considered indispensable among parents, teachers, elders, and authorities of a given culture, because that literacy assures the transmission and veneration of what the culture cherishes—whether that be religious beliefs, moral values, class structure, political liberties, or philosophical wisdom.

Articulating the Covenants

My argument has been that affirming the truth, trust, or reliability of an image depends on the operation of a compact, an agreement that sets out the conditions under which an image may deliver what the viewer expects from or seeks in it. We view images through something like epistemological lenses that determine, at least in part, what we see. Images by Anderson, Richter, Escher, and Magritte reveal alternative and rival theories about the relation of language and imagery. The following list is an inductive assemblage, not a deductive or prescriptive one. The list may be lengthened. But it expands upon the earlier list of

conditions under which viewers take an image to be true. We may now enflesh that list with greater specificity, articulating and adding to it. Two groups of covenants are arranged according to their common features. The first group pertains to criteria entirely external to the image itself; the second group describes the imitative or mimetic nature of representation and those forms of representation that renegotiate it or subvert it altogether.

Group I

1. The *communal* compact assures viewers that what they see is what the group or community holds as true.

2. The *orthodox* covenant assures viewers that what they see will be ideologically correct and suitable for consumption.

3. The *authoritarian* covenant assures viewers that what they see is valid or trustworthy because it bears the approval of an acknowledged authority.

4. The *open* contract assures the viewer that no conditions dictate the viewer's interpretation of the image, but it vouches that a meaningful engagement with the image will be repaid in some manner.

Group II

5. The *mimetic* compact or covenant assures viewers that what they see is a reliable portrayal because it conforms to what they already know something looks like.

6. The *allegorical* covenant assures viewers that what they see is a symbolic representation, not a depiction, but a visual code that must be deciphered.

7. The *exemplary* compact assures viewers that an image presents to them the ideal, typical, or formulaic appearance of a subject.

8. The *expressivist* compact assures viewers that what they see is the essence or spirit of a subject, not its accidental appearances.

9. The *deconstructive* covenant assures viewers that the image they see self-critically questions the motives of vision, the conventions of image-making, and the relationship of images to any other form of representation.

These covenants operate as guarantees (rather like the content rating that films receive in the United States) but also as something like a key or legend on a map: images will generate widely varying interpretations

and responses depending on the contractual conditions under which they are viewed. Invoking a new covenant can quickly and dramatically modify the meanings ascribed to an image. Renegotiating the prevailing covenant can be an activity of creative, critical, and even revolutionary significance in the history of visual production and reception. And any image might combine several covenants in its viewing and visual consumption. Indeed, the more contractual relations in place, the more secure the meaning ascribed to the image and the more confident the gaze that apprehends the image.

Providing visual examples of each covenant may clarify the gnomic definitions above. Regarding the alphabet page from *The New England Primer* (fig. 23) in the way that schoolchildren conventionally did when learning to read is a fine example of the *communal* compact at work: children accepted as authoritative the network of letters, images, and sentences, not simply because the teacher or parent told them to do so (invoking the authoritarian covenant), but because they saw the rules exemplified in the primer's pages at work in the discourse of their homes and churches and in the public world around them. The chalk talk image prescribing the path to salvation (fig. 29) presupposed an *orthodox* compact with viewers. Parents and teachers using it to convey the truths of Protestant Christianity to their wards invited them to expect they would see nothing in the diagram that delivered anything other than dogmatically pure Protestant teachings. As with the previous instance, it is generally the case that the terms of an orthodox contract are combined with an *authoritarian* covenant, since authority, community, and orthodoxy reinforce one another in constructing a bulwark of consensus. A political propaganda poster is an image that relies on a compact of authority: one believes it because the government says so.

The *open* contract is the one that readers of novels form with their authors, viewers of abstract paintings draw up with their makers, or clients of tarot readers agree to in their search for meaning. The open contract invites chance into the construction of meaning and avoids excessive restraints on the open-ended gamble that creative seeing or reading exploits. It is not that all restraint is eliminated; rather, it is developed over the course of rumination. One agrees to arrive at an eventual meaning and even then to allow for a final lack of closure. This relation may enable a viewing of Wassily Kandinsky's painting *Improvisation 30* (1913; fig. 30), which refuses to assign the image an explicit or final meaning.

The *mimetic* compact is one that, at first sight, seems perfectly ordinary: the agreement that guarantees a viewer that an image will yield a

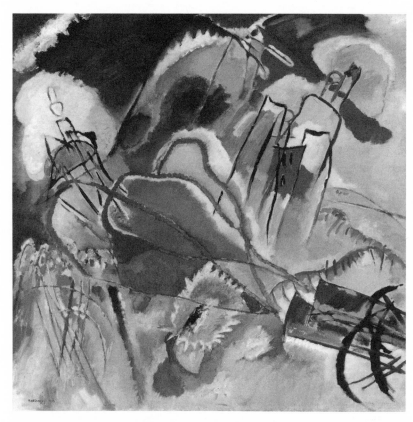

FIGURE 30. Wassily Kandinsky, *Improvisation 30 (Cannons)*, 1913, oil on canvas, 43 × 43¼ inches. Arthur Jerome Eddy Memorial Collection; image © Art Institute of Chicago. © 2004 Artists Rights Society (ARS), New York/ADAGP, Paris.

straightforward representation of something. The viewer will see a landscape or a portrait as an accurate, reliable reflection of the stable physical world that all viewers inhabit. As such, however, the mimetic contract is no less presumptuous than any other, since any representation as well as the world it purports to envision relies on conventions, assumptions, and interventions to make it recognizable. Even a photograph, in one regard undeniably a trace of the very thing it images, is inextricably bound up in the viewer's contributions to its intelligibility. Because it is a frozen instant in the flow of time, John Berger has written, seeing a photograph as meaningful requires placing it within a narrative. "An instant photographed can only acquire meaning insofar as the viewer can read

into it a duration extending beyond itself. When we find a photograph meaningful, we are lending it a past and a future."[28] The beholder's share in visual meaning-making reduces an image's ambiguity.

But images and covenants make different use of ambiguity. Some strictly limit ambiguity; others seek a high level of ambivalence. As the child's use of nursery rhymes endorses the default, or "normal," mode of language, so do certain forms of pictures presuppose a norm from which they deviate in order to achieve an alternative way of seeing. Anderson's *God's Two Books* (fig. 24) may invite the reader to view it in the terms of a covenant that allows for something other than strictly "realism," since gods do not peek through trees in ordinary experience. The unusual appearance is meant to be seen *allegorically*—bearing a meaning other than but expressed in the refiguration of the ordinary. An instance of this is the manner in which the pious viewer was meant to regard figure 21, whose mimetic depictions of objects failed to deliver the Christian meaning until they were seen through the allegorical filter of the biblical text. Or, in a very different instance, one might view Kandinsky's painting (fig. 30) as bearing secret or arcane meanings embedded in his treatment of forms and colors.

The *exemplary* compact holds most commonly in visual advertisements or in fairy tales or soap operas: any formulaic image that portrays an idealized appearance. This genre of compact assures viewers that the deviation from ordinary appearances in the image (the girl next door is a beauty queen, the prince is handsome and without character flaw, the villain is reprehensible and without any redeeming qualities) is a deliberate device designed to entertain or admonish. The viewer can know what to expect in appearance and behavior from the character because he or she will conform to a paradigm.

In yet another instance of deviation from the mimetic, we may return to Kandinsky's painting (fig. 30). If we take the artist at his word, this image was not simply an arbitrary execution of color and form but an image created out of what Kandinsky called "inner necessity." He defined this creative impulse as the force that moved him to create images instead of submitting himself to reproducing an object's physical appearance. Rather than respond to what he might see before him, the artist responds to a feeling, intuition, or sensibility that he has fostered within himself. What he sees before him is then freely, improvisationally transformed in the creative act. Figure 30 still bears the recognizable traces of subject matter—groups of figures, hills and mountains, buildings, and, in the lower right, two

cannons firing into the center of the image. In the year that he painted the image (1913), Kandinsky acknowledged this subject and its temporal relevance: "The presence of the cannons in the picture could probably be explained by the constant talk [of war] that has been going on throughout the year."[29] The expressivist contract assures the viewer that the image is not a faithful reproduction of an object as the visual equivalent of "normal" prose but an interpretation of an object driven by an artist's consideration of its essential or salient features, though perhaps without the brief that an open contract would authorize.

The final covenant is the *deconstructive,* which conditioned my readings of images by Richter and Magritte. To operate as their makers intended them, figures 20, 22, 27, and 28 must be viewed as edgy provocations, as deliberate attempts at dismantling cherished assumptions about the reliability or trustworthiness of images. This subversive or revolutionary purpose aims at destabilizing the mimetic, allegorical, and expressivist paradigms in order to posit a different covenant altogether. Distrusting such relations between viewer and image, many modern artists contend that there is neither objective reality to represent nor creative sympathy to express. Lacking any natural correspondence between image and nature in which to ground the work of art, artists, instead, must stipulate an agreement between image and themselves. The covenant is between the artist and his or her capacity to project or construct a system of signifiers. "There is no spoon," as the young mystic informed Neo in *The Matrix.* There is only the mind bending itself into the shape of a spoon. I borrow the term *stipulation* from the philosopher Nelson Goodman, whose constructivist accounts of representation push far beyond the mimetic and expressivist covenants and accord well with image-making paradigms pursued by modern artists such as Magritte.[30]

Each of these paradigms tends to serve a different epistemology. For example, the mimetic assumes a correspondence theory of truth in which words or pictures conform to the realities they represent. The expressivist compact shifts from a fixed relation of imitation to a form of representation in which the signifier does not seek to describe a static, given reality but puts in its place a metaphor or a performance of visual elements that interprets the subject. The deconstructive covenant doubts or even rejects the possibility of a preexisting, static world to copy or a spiritual essence to intuit and express metaphorically. Regarding such a transcendent reality as God to be beyond knowledge, the

deconstructive trust may proceed in the belief that the divine is a mystery discernible in the subversion of the systems of reference that an image-maker, and by extension a culture, stipulates or constructs. The covenant in each case consists of a compact that the viewer presumes in apprehending and trusting the image.[31]

But as I have said, most images are viewed and used and interpreted with more than one covenant in force. Moreover, each covenant offers important advantages within the life of what we might call a single community of interpretation. Assisted by authoritarian, communal, and orthodox contracts, the mimetic covenant is valuable for the solidarity it provides by rendering a common, objective world. The expressivist invigorates the experience of reality by plunging beneath appearances and extracting a renewed contact with whatever it is that is held to matter there. And the deconstructive compact challenges the presumptions of the former two, calling their regimes of authority and privilege into question in a deconstruction of unexamined assumptions.

None of these seems capable of standing alone. Perhaps they work together in a dialectical manner. Or perhaps they simply conflict with one another without any hope of higher resolution. To some degree, they do work simultaneously. For example, it is not difficult to hear the children reciting *The New England Primer*'s alphabet in a chanted rhythm that mesmerized them and revealed the music of language and the worlds of feeling, experience, and knowledge that the children carried in their bosoms. The rhythm of sounds deepens the human connection to the world by reinforcing the capacity of representation to attach itself to whatever it describes as well as to conjure a web of signifiers that commands its own enchantment and integrity. And inasmuch as children delight in subverting sense and authority with the distortion of language and image, there may be an element of subversion in their play that holds out for even more radical liberties. After all, the Surrealist exercise called exquisite corpse, performed by a group in order to produce images of chance and suggestion that subverted the ideal of a single conscious ego, began as a bourgeois parlor game.[32] And Gerhard Richter, in spite of his deconstruction of such genres of representation as portraiture (fig. 20) and photojournalism, still muses about the power of art to achieve a kind of transcendence. "Art is the pure realization of religious feeling, capacity for faith, longing for God," he wrote in 1988. "Art is human only in the absolute refusal to make a statement. The ability to believe is our outstanding quality, and only art adequately translates it into reality. But when we assuage our need for

faith with an ideology, we court disaster."[33] Richter proposed not a "religion of art" but a view of painting as a uniquely human experience of freedom, a yearning for transcendence. Not art for art's sake, but art as what he once called "moral action," that is, art for the sake of emancipation from an instrumental consciousness that tasks art with the purpose of persuading or convincing or propagandizing. Art that shatters ideology or false consciousness, which humans erect and consider more real than true self-knowledge, is art that can satisfy the longing for God. Such art, Richter said, "would be something like 'faith pure and simple,' which would protect us from flying off after false faiths, religions and ideologies."[34] Magritte, for his part, became mindful of the divine only by estranging the familiar. In either case, there is no true faith without the rigorous interrogation of belief. As Hume once put it, "To be a philosophical sceptic is, in a man of letters, the first and most essential step towards being a sound, believing Christian."[35]

Images and idols, true belief and false, breaking idols and adoring images. These categories rarely appear without one another. Their inextricability is the subject of the next chapter.

Images Between Cultures

CHAPTER 4

The Violence of Seeing

Idolatry and Iconoclasm

When an idol falls, its place does not long remain vacant. A rival is often quickly erected. Or as Stanislaw Lec more poignantly advised aspiring iconoclasts: "When smashing monuments, save the pedestals—they always come in handy."[1] The history of religion is in no small way a history of cultural rivalries. Religious belief has a powerful way of becoming the preeminent banner or symbol in whose name people organize themselves inwardly and understand their relations with other groups outwardly. Religion, in other words, is one means by which a group's "inner" and "outer" are defined and maintained. In the history of Western civilization, this inner and outer have often been configured as attitudes toward images, pivoting on "our" images and "theirs" or our proper avoidance of images and their surfeit of idols. This distinction has often been marked in ritualized acts of violence, generally called iconoclasm, or the destruction of images. Idolatry and iconoclasm have much to do with the understanding of religion as a historical phenomenon, because this ideological pairing has played a major role in the history of cultural conflicts along religious lines. Think only of the familiar manifestations of this pairing: ancient Judaism versus Egyptian and then Canaanite polytheism, Islam versus Arabian polytheism, Judaism versus Christianity, Islam versus Christianity, Christianity versus all forms of polytheism (Greco-Roman, northern European, Asian, Aboriginal), Byzantine Iconoclastic party versus Orthodox iconodules, Protestantism versus Catholicism, and secular Enlightenment versus religious orthodoxy. In every case, one group (often one version of

monotheism) has defined itself in terms of its opposition to a rival's use of religious images, even in the case of the European Enlightenment's cult of reason as the Supreme Being. And in every instance, without exception, a variety of forms of violence have been applied to enforce the distinction, whether that has meant breaking images; destroying temples; proscribing worship; persecuting, imprisoning, exiling, or executing rival groups and individuals; or making outright war. Whether to bolster the sacred gaze or to break it, violence has always been closely associated, symbolically or literally, with seeing (or *not* seeing) religious images.

This chapter seeks to outline a number of important themes regarding the twin concepts of idolatry and iconoclasm. Something of what religious believers see when they look at the world around them, at themselves, and at images is not goodness and light, not heady aesthetic contemplation, but the occasion for violence and scorn. This chapter aims both to discern how idolatry and iconoclasm form two sides of a single coin in the history of religious visual culture and to highlight several promising themes under which scholars and students might proceed to study the violence of seeing.

Work in recent years on the history of iconoclasm has made several important contributions to the understanding of images and the meaning of their destruction or proscription in several world religions. First, scholars have linked iconoclasm to the polemical construction of idolatry and rigorously historicized both concept and practice as polemical formations embedded in social conflict. Second, recent scholarship has integrated the study of the destruction of images into larger, encompassing narratives regarding the social and cultural functions of imagery and its destruction, seeing the image as a locus or crossroads, a site in which long narratives of cultural history take shape. Third, scholars have scrutinized fine art and its history of destruction and veneration since the eighteenth century as both sides of the same coin. These writers have called attention to the modern Western ideology of Enlightenment, which has sought to secularize culture but also to sacralize art and artists and thereby has inevitably authorized certain forms of iconoclasm and image veneration. Finally, important scholarship has identified the magic, allure, and power of images as potent reasons for their very destruction in deeply symbolic acts. This work has situated image veneration and image destruction within interpretive accounts that look far beyond both religious orthodoxy and artistic taste in order to explain a broad range of human responses to images.

Iconoclasm and Its Other

Iconoclasm presupposes idolatry. By definition, iconoclasm cannot be conceived or practiced without the requisite "other" it seeks to rout out of human behavior. But this does not mean that iconoclasts are reacting to anything real. In fact, they often imagine the offense they seek to reprove. They need the other to destroy in order to construct a new tradition in which to exist. And they often proceed by substituting one mode of imagery for another. Iconoclasm, in other words, is not a purging of images *tout à fait* but a strategy of replacement. Yet this fact is easy to overlook, since religious scholarship has widely assumed that entire religions such as Judaism and Islam are aniconic, natively disposed to operate without images and therefore inclined to reject them wherever or whenever they are introduced. In a major study of 1989, art historian David Freedberg called this assumption the "myth of aniconism" and dismissed it as "wholly untenable."[2] In the case of Islam, for example, depending where and at what period one looks, images of various kinds are found in manuscripts, architecture, tapestries, homes, mosques, and personal devotional items. The same holds for Judaism. Those Protestants, Jews, and Muslims, for example, who express disdain for visual imagery in religious practice and seek to proscribe its use as "idolatrous" typically put in its place alternative forms of material culture that provide a different form of iconicity. As observed in the introduction, Protestants cherish their Bibles; some Jews affix parchments of scripture in mezuzahs at their doors; Muslims forbid an item with Qur'anic text written on it to touch the floor. In each case, the text is a material expression of revealed truth that requires reverence as a physical presence of the holy, inasmuch as inappropriate treatment of the text is nothing less than disrespect for its author. This bears at least some similarity to what Byzantine iconodules said of the icon: veneration (or dishonor) of the saint's image passes directly to the prototype.

If scholars should approach with skepticism any culture's claim to do without images, despite whatever its members may say, they must adopt a corresponding sobriety toward the use of iconoclasm's other. *Idol* is not a neutral term but one embedded in the history of Jewish, Christian, and Islamic thought and practice. The definition of "idols," the urgency to destroy them, and the characterization of "idolaters" as fools duped by ignorance or their own vanity form an ancient discourse. Its formation owes much to ancient Israel's experience as a nation

struggling for autonomy in an unstable world dominated by such powers as Egypt, Assyria, Babylon, and Persia. The cult of Yahweh was one among many in the period of political turmoil following the reign of David, particularly in the northern kingdom. During the ninth century a number of prophets in the north, such as Elijah, targeted the cult of Baal, preaching that Yahweh alone is God. The prophets urged Jewish rulers to topple idols and ban their cults. Some of them did. Early in his boyhood reign, Josiah (640–609 BCE) sought to return to the god of David, and therefore

began to purge Judah and Jerusalem of the high places, the Asherim, and the graven and molten images. And they broke down the altars of the Baals in his presence; and he hewed down the incense altars which stood above them; and he broke in pieces the Asherim and the graven and the molten images, and he made dust of them and strewed it over the graves of those who had sacrificed to them. He also burned the bones of the priests on their altars, and purged Judah and Jerusalem. (2 Chronicles 34:3–5)

Longing to reestablish the united kingdom and political strength of David's reign, Josiah looked to the cult of Yahweh rather than the many rival forms of religion active in Judah, the southern kingdom, and in Jerusalem (even practiced in the temple itself) in order to cultivate divine patronage. The violent destruction of sacred sites and pagan cult images (*Asherim* is the plural of the name Asherah, who was the Canaanite mother goddess, regarded by some contemporary Jews as the wife of Yahweh), even the violation of the bodies and graves of those who had worshipped other deities, were among the dramatic means of Josiah's reform. The campaign against Baal had been waged by the prophet Hosea in the eighth century in the northern kingdom of Israel. It was Hosea who characterized Israel as a prostitute who was unfaithful to her husband, Yahweh. Two centuries later, along the shores of Babylon, after the conquest of Judah by the Babylonian army, the prophet Ezekiel raged against a captive Israel for having deserted her husband and Lord like an "adulterous wife" who sought sexual passion for no reason but lust (Ezekiel 16:30–34).[3] From the midst of Babylonian exile, an unknown sixth-century prophet, referred to by scholars as Second Isaiah, insisted categorically for the first time that all other gods were lifeless idols that corresponded to nothing but human delusion (Isaiah 44:20). The god of Israel emerged as the only god ("besides me there is no god," Isaiah 44:6).[4] The discourse of idolatry was formed within this historical period, which saw the formation of

Jewish monotheism as it was set down in prophetic books and extensive redaction of the older books of the Bible. Idolatry as a polemical discourse (laid over and largely concealing the greater portion of actual pagan practice) contributed importantly to the emergence of Jewish identity and to the far-flung legacy of Jewish monotheism.

The proscription of sacred images is also closely identified with Islam. Muslim biographies of Muhammad, accounts of the Prophet's deeds and words (Hadith), and commentary on the Qur'an all include accounts of the destruction of idols. When he took over the city of Mecca in 630 CE, Muhammad is said to have destroyed 360 idols gathered at Islam's holiest site, the Ka'bah (fig. 1). Muhammad allowed only a painting of the Virgin and Child to remain. And the Black Stone. Tradition ascribes to the Stone a venerability that goes back to Muhammad himself, though not without a countervailing tradition of hesitation.[5] Nearly all of the inhabitants of Mecca accepted Islam, thus ending the formative opposition of the Arab tribe of Mecca, the Quraysh, the Prophet's own tribe, who figured as his antagonists in much of the Qur'an. The iconoclastic act of violence proclaimed the return of Arabia to the ancient monotheism of Abraham. According to Muslim tradition, Abraham had introduced Arabs to faith in Allah ("The God") by coming to Mecca to restore the Ka'bah (first built by Adam), in which he was assisted by his son, Ishmael (Qur'an 2:128), who married Arab women and fathered the Quraysh.[6] To this day, the site remains the preeminent destination for Muslim pilgrims and commonly marks the direction of Mecca (*qiblah*) for daily prayers in Muslim homes in the display of its pictorial depiction on tapestries.[7]

Traditional Islamic sources have generally portrayed pre-Islamic Arabs as polytheists and idol worshippers. Yet the Qur'an itself, Gerald R. Hawting argues, does not identify "associators" (the translation of the Arabic term, *mishrikūn*, used in extra-Qur'anic sources to designate those who commit idolatrous practice, called *shirk*, by associating angels or gods with Allah) as polytheists or idol worshippers. Hawting contends that "as a religious system Islam should be understood as the result of an intra-monotheistic polemic, in a process similar to that of the emergence of the other main divisions of monotheism," namely, Judaism and Christianity. Non-Qur'anic traditional Muslim texts "can help us see how early Muslims understood and viewed the past but are not primarily sources of information about that past."[8] Hawting conducts an extensive review of the historiography of the origins of Islamic monotheism in order to demonstrate that there is no compelling proof

that the immediate precursors of Islam consisted of an intermingling of polytheism and monotheism. He seeks to differentiate quite sharply idolatry as an actual polytheistic practice and idolatry as a polemical tactic in monotheistic discourse.

Why should it matter if Islam emerged from disputes among monotheists rather than from a polytheistic background, which came to be called the *jahiliyya,* or age of ignorance of Arab idol worshippers before Muhammad? At the close of his book, Hawting wonders if the emphasis on the polytheistic Arab background has been to underscore the revelatory status of the Qur'an as a divine disclosure to the Prophet. The book came not from Judaism or Christianity but from Allah. It was not a historical evolution from monotheist predecessors but originated in the revelation of divine will to the Prophet, who was called to reestablish the faith of Abraham in Arabia. Muhammad was the final and authoritative prophet in the ancient tradition of monotheism. Moses and Jesus were part of it but not its culmination. The traditional Muslim view sees Muhammad as a kind of Abraham, called from paganism to be the father of monotheism.

This is a powerful claim that longs for consideration of the Qur'an's manifold references to Jewish and Christian texts and faiths. A larger project would pursue this conclusion in light of other monotheisms— biblical as well as Persian and Hellenistic. What was the relationship between Muhammad's movement and local versions of Christianity and Judaism, especially with regard to notions of idolatry and iconoclasm? If pagan Mecca wasn't so pagan, what might have been the Christian and Jewish contributions to the formation of Islam? Is the *jahiliyya* a concealment of sources?

The study of the history of iconoclasm in Christianity has benefited from solid historical investigations of the Byzantine Iconoclastic Controversy (726–787 and 815–843 CE) and the destruction and proscription of church art in Protestant Europe and America during the sixteenth and seventeenth centuries.[9] There is, however, a much more exhaustive history of iconoclasm and iconophobia in Christianity. For example, Spanish religious authorities in midcolonial Andean Peru found it necessary to seek out and destroy the shrines of Andean belief. The official documents generated by Inquisitional investigations of idolatry and magic as practiced by healers and adepts among the Andean people between 1640 and 1750 shed valuable light on popular practices as well as on the personalities, conceptualities, and ambitions of church officials in Lima and the central coastal region of modern

Peru. Historian Kenneth Mills has examined the material culture and practices of Andean religion in order to understand how indigenous religion conflicted with and suffered under Spanish rule and the Inquisition but also survived over time by intermingling with Christian belief and practice.

The story that Mills tells is not one of sheer oppression but explores where the evidence allows an element of Andean resistance, the failure of Christian authorities to eliminate Andean religion, and the development of syncretistic practices. Acknowledging the vigor and systematic character of idolatry inspection in the Archdiocese of Lima, which may have constituted "the most sustained religious persecution of indigenous peoples in the history of colonial Spanish America," Mills nevertheless underscores the tenacity and flexibility of Andean religion in the face of its persecutors.

> Because of its capacity to absorb and make something of new influences, the Andean religious system was emerging [in the seventeenth century] a good deal less impoverished than might have been expected. The transformations of Andean religious ideas and practices, and the indisputable penetrations of Christianity into an evolving Andean religious framework, seem to have owed little to coercive tactics such as those of the Extirpation.[10]

Mills's account carefully portrays religion as a complex set of practices and social relations that includes the experiences of those who seek protection, fecundity, and comfort from their ancient traditions; those who intermingle these traditions with the ways of the new god of the colonizers; those who consciously reject the new in favor of a renewed experience of the old; and those who would convince or compel their colonial charges to abandon the old faith and accept the new. In other words, religion is about assistance, resistance, survival, and domination.

Studies by other scholars of Andean colonialism have also stressed the need to view the colonial subject from multiple perspectives. For instance, Rolena Adorno's work on the Amerindian writer Felipe Guaman Poma de Ayala, who composed a massive and richly illustrated chronicle of the Peruvian peoples for King Philip III of Spain in 1615, stresses the nuance of the author: "[Guaman Poma's] stance was complex but coherent and always unequivocal: in favor of native rule and opposed to colonialism, Guaman Poma was anti-Inca but pro-Andean, anti-clerical but pro-Catholic."[11] Accordingly, the scores of images that Guaman Poma included in his chronicle sustain subtle readings and reveal layered understandings of the cultural encounter of Spaniard and

Andean. In her recent examination of the visual culture of colonial Cuzco's celebration of Corpus Christi, art historian Carolyn Dean constructs a multilayered account of the annual performance, arguing that the same ritual was experienced very differently by Spanish authorities, Inca nobility, and ethnic Andean groups who had been subject to the Incas during preconquest days.[12] Dean's scrutiny of contemporary imagery associated with Corpus Christi complements Mills's investigation of idolatry and iconoclasm, inasmuch as she studies the images that the Spanish authorities sanctioned in place of those they proscribed.

The destruction of images should not be seen in isolation from the imagery that iconoclasm is intended to serve by clearing away its competition. Dean points out that a strategy of substitution was employed by the colonial state: Christianity was mapped out over the indigenous precursor in a pattern that colonial Catholicism often relied on.[13] In the context of the Corpus Christi celebration, the Andean past was appropriated and subordinated in murals and the use of costume that visually performed the triumph of Christianity as the conquest of Andean religion and state. The ritual of Corpus Christi was celebrated to replace the Inca celebration of the solar deity (the Inca's patron deity) at summer solstice. Incan nobility participated in the procession of the new Christian rite wearing traditional costume that included a solar disk, emblem of the Incan sun god but now also the symbol of the Christian deity. Yet in creating this substitution via subordination, the Christian rite of Corpus Christi preserved the pre-Christian meaning. Dean also points out that it allowed the Incan nobility to assert their place in a native hierarchy of colonial subjects.

A central body of evidence for the study of image destruction and the extirpation of idolatry among the Andeans is the record of what and whom the inquisitors examined, what their investigations claimed to find, and how the authorities responded to idolatry and idolaters in the effort to eliminate a tenacious paganism. Mills is very interested in understanding what the examiners, bishops, and archbishops meant by "idolatry." It turns out that it could mean virtually anything that did not fit the inquisitor's notion of Christian orthodoxy—whatever, as Mills puts it, "was deemed to be in error."[14] The campaign to locate idolatrous practices and root them out was motivated by the realization that Christianity was often little more than a veneer on the surface of Andean life and had failed to take deep roots. It also became an opportunity for some churchmen to advance their careers. And the Inquisition worked hand in hand with the colonial interests of Spain, though

church and secular authorities did not always work as allies but sometimes worked as personal rivals. The more it appeared that the church was failing to inculcate its beliefs in a lasting and significant way, the more inclusive the meaning of idolatry became. Accordingly, when conducted in proximity to the *huacas*, or sacred sites of Andean religion, even when explicitly addressed to the Christian deity or Christian saints, prayer and worship threatened syncretism, in which case the Inquisition acted decisively. For this reason, the church undertook widespread and ambitious campaigns of church construction.[15] Building missions and churches was yet another complement to iconoclasm: Christian buildings and monuments were sometimes built on or near Andean holy sites as substitutes for them. The non-Christian sacred site was replaced by a Christian construction. The built environment was part of the new visual and material culture that took the place of the razed precursor.

Mills and even more explicitly Dean stress that this attempt at erasure of the indigenous often failed precisely because it was not an extirpation or deracination but a substitution that preserved the place of the precursor. It was not that Christianity failed to take root but that it was more often grafted onto the still-living plant of indigenous belief. As Mills observes, "Few people faced Christianity with an attitude of either complete acceptance or steadfast opposition." Syncretism, or hybrid beliefs—or, to use Dean's helpful term, *cultural composites*—emerged, complicating the simple polarities of "orthodox and error" and "Christian and heathen," which church authorities preferred in their rhetoric of idolatry and extirpation.[16]

As a focus of monotheistic polemic, idolatry is typically an indictment closely followed by ritual violence or at least by the rhetoric of violence. Encountering claims of idolatry usually means attending acts of violence, whether it is the destruction of images or objects, or the punishment of people, or the proscription of certain behaviors, rites, dress, or food. Colonial Peru was no exception. Why is violence necessary in conducting what might be called the theological routine of idolatry? Why flog the poor peasant who prayed to the huaca to grant him good health or his wife fecundity or his daughter a husband? Humane inquisitors, Mills points out, often dispensed lenient sentences. The more zealous, however, seized on ritual violence in public displays to do more than merely punish individuals. The idea was to mount a spectacle, a theatrical staging of violence that would enact an ideological transfiguration of the past. As a decisive display of power,

public punishment or the forceful upending of a huaca and its removal
or defacement publicly established and enforced the church's authority
and that of the Spanish state that stood beside it. Violence was a the-
atrical performance of change (Mills's term is *theatrical coercion*), a
symbolic act that spilled over into the flesh and bones of the audience
in a visceral way. As a demarcation of the future and the past, violence
marked a sharp turn in the cultural narrative of a people, indeed, even
in the narrative creation of one where no "people" clearly existed
before. It was an effective, memorable, and brutal means of publicly
dethroning one image or symbol and replacing it with another. As such,
violence marked the end or death of one regime and heralded the
triumph of a new order.

The history of colonial violence in the prosecution of idolatry is not
merely the story of the persecution of distant peoples. It is no less the
story of American and European understandings of such peoples as incul-
cated in part in the institutions of religious education and formation.
Religious formation of the young, understood as their individual and col-
lective guidance toward maturity, relied on idolatry as a mark of cultural
benightedness and racial degeneration. An article on idolatry in an 1875
issue of the *American Sunday School Worker*, a Protestant monthly paper
for parents and teachers, asserted that the "history of idol worship is a
history of the moral descent and degradation of the race. . . . Astray from
his God [humankind] seems to gravitate with resistless force downward."
The claim assumes a cultural superiority and historical progression
toward monotheism. Polytheism, the article confidently preached, "is the
religion of the world in its night time." The religion of the Bible, by con-
trast, "is essentially a faith in things unseen, in a God invisible, conquer-
able by no rival." American Protestants of many varieties were convinced
that the fight against idolatry in the global mission field was a sure sign of
the onward march of the religion of the Bible. Consistent with the faith
in spiritual progress of the race under the auspices of Christianity, the
author of the article proudly announced that "today the idols are
falling—Dagon is on his face before the ark of the God of Israel. The
knowledge of the Lord is covering the earth."[17] The ruin of ancient gods
(such as Dagon, a Philistine deity) was an assurance that lingering gods
and their cults would soon pass away before the universal and triumphant
advance of American Protestantism.

The association of idolatry, indigenous peoples, and the formation
of Western Christian children was no mistake. There is a fascinating
parallel between the treatment of children and that of indigenous

peoples: each was considered the analogue of the other. They were both seen as simple, unformed, precivilized creatures in need of the disciplines that religious indoctrination would provide. This analogy accounts for the frequent portrayal of indigenous peoples in nineteenth-century Sunday school literature and children's reading and instructional materials among American Protestants and Catholics.[18] The indigenous were versions of the children who gazed wide-eyed at their visual representations: their degradation was the state that children were being prepared to overcome. Likewise in paternalist colonial policy, the indigenous were seen as mere children—naive, unintelligent, unsophisticated, and requiring intrusive custodial care.

A corresponding parallel between Western children and indigenous peoples appears in the role of violence in the formation of each group. Violence and the evocation of fear figure prominently in religious instructional materials. The idols of the pagan must be smashed in order to demonstrate their inefficacy and emptiness. Accounts in children's literature of the routing of idolatry serve up violent iconoclasm as a signal part of rites of passage that convert the pagan to Christianity and vicariously usher the American child into the disciplines of maturation. Idolatry and iconoclasm go hand in hand in the disciplining of children and indigenous peoples: the conviction of idolatry is driven home by the destruction of the offending gods, whose power restrains the civilization of the subject until it is broken. Idolatry represents the blindness, resistance, and ignorance of the nonbeliever or child. Iconoclasm enacts his or her liberation. This parallel of American child and colonial pagan is apparent in the passage of one bit of material culture from the history of the Inquisition to modern school life. Mills describes the ritual of humiliation and punishment (the notorious auto-da-fé): those convicted of idolatry by the Inquisition were punished by being paraded in public to their flogging. They wore the pointed hat that later became the humiliating sign of the schoolroom misfit who sat in front of class wearing the "dunce's hat."[19]

The Social Life of Images

If the Abrahamic religions have relied on the category of idolatry to fuel their respective missionary outreach and zealous policing of religious purity, the many-layered histories of Hindu images show that idolatry and iconoclasm are strategies of appropriating or denying the

lives of images. In fact, religion scholar Richard Davis argues that violence against images adds new chapters to their long lives. Idolatry is a "category of discourse" that has "been used in a polemical and pejorative manner as a way of classifying and censuring the presumed beliefs and practices of others." Idolatry in Jewish, Muslim, and Christian discourse centers on what Davis calls "a profound denial of livelihood to the images of others. At the same time, it dialectically affirms a community of faith that is distinct from and superior to those it classifies as idolaters."[20] A powerful logic is perhaps at work when Muslims or Christians have destroyed the images of Hindu (or Andean) subalterns: although the victors denounce images as vain, false gods, mere inanimate objects, these images are not dead or empty to those whose gods they embody (nor even to those who destroy the images, as has been argued of Puritan iconoclasts).[21] Iconoclasts attempt a kind of deicide in the service of their conquest. Radical monotheism cannot tolerate other gods because it is premised on the exclusive power and existence of one god. The life of another deity falsifies the monotheistic god, hence Yahweh's and Allah's vigilance in enforcing the first and second commandments in the highly charged destruction of religious images. Idols are an affront to the true deity because they are a denial of its very existence as the only god.

Yet iconoclasm often did not spell the end to a Hindu god's local cult image and the god within but added yet another chapter to its life. Davis contends, and does so with richly detailed and convincing evidence, that the temple imagery of Hinduism possesses a historical life that is much larger than iconoclasm—indeed, of which iconoclasm is but a part. In *Lives of Indian Images* he writes the biographies of many images and the gods they portray, suggesting that the two—image and deity—should not be separated but seen as a single form of life with a history full of meandering turns. Davis regards Indian images "as fundamentally social beings whose identities are not fixed once and for all at the moment of fabrication, but are repeatedly made and remade through interactions with humans."[22] Assuming that the life of an image resides in no single narrative perspective, is controlled by no single storyteller, Davis documents the ongoing biography of an image/god as it moves from one historical or cultural context to another. The local peasant devotee of Vishnu has a claim to the "meaning" of a newly excavated statue that is no less real than the claim of the colonial authority, the local municipality, the museum director, or the art historian. Indisputably some form of life is in the image—is it the life of the

god (and which god—Shiva, Brahma, Vishnu?)? The life of a religious culture? The life of a nation? The life of a conquered, colonized, benighted people? The life of the universal human spirit? The life of artistic genius? The claims are many. Each claimant constructs a particular cultural frame about the image to explain what it means, and each brings it to life within an interpretive community for whose members the image is a material deposit of meaning.

> When art historians, historians of religion, and others of us who concern ourselves with Indian religious objects regard an image . . . , we focus our attention most often on the aesthetic elegance of its form, on the religious meaning of its iconographic composition, or on the social and political context within which it was fabricated. In these matters, we often think, lies the essential significance of the object, as if meaning were fixed once and for all at the moment of creation. But the later lives of Indian religious images and the ways in which these images come to be relocated and revalorized, I argue, also become intrinsic to their significance. Captured by new proprietors and relocated in new surroundings, their identities shifted significantly from what they had been.[23]

Davis offers a thick historical description that involves more than the single, original culture that fashioned the image. Such description includes the worlds of the invader, colonizer, religious and political rivals, the collector, and the scholar. The identity of an image is not fixed but contingent, unstable, and pluralistic.

> The "past" does not exist as such. Rather, it exists only as it is incarnated and reincarnated in memories, texts, objects, and our ongoing collective activity of reconstruction. Nor is the past that is embodied in an object a fixed quality. It comes to be transformed as its audience and the circumstances in which it is encountered are themselves transformed. The historical significance of an object may itself be reconstituted historically.[24]

Yet the image does not dissolve into a postmodern play of power relations. Davis stitches the many historical episodes of reception together into a biography that is endlessly fascinating and deeply mindful of the conflicting claims to cultural property. In this historiography, images may be the only material reality there is. They are the anchor around which human interests swirl, to which people pin their hopes and desires in the mad and whimsical march of the ages, drawing up covenant after covenant with the same image, which outlasts the time-bound compacts of meaning that endure no longer than those who see the image in those particular ways.

By insisting that we speak of the "identity" of an image in a biographical, historical sense, rather than as a fixed, authorized intention bestowed upon an image by its maker and confirmed by the methods of the scholar, Davis wants not only to recover the genuinely historical character of human meaning-making but also to make interpretation responsive to the reality that religious images are larger than any category for naming and valuing them. They surpass any single use to which they might be put, whether by worship, analysis, appreciation, or destruction. This is bold indeed, but it succeeds at making images evidence for cultural interpretation in a broader and more inventive way than they are usually deployed among historians and scholars of religion.[25]

Discoveries in the nineteenth and twentieth centuries by treasure seekers, colonial authorities, and scholars meant new forms of interpretation. Following James Clifford, Davis describes a "taxonomic shift" in the cultural classification of objects from the status of "idols" to "cultural curiosities" to "art." This approach can call on ethnography, historical documentation, missionary accounts, even court records of litigation over the legal status and cultural identity of artifacts. Missionaries, collectors, and early archaeologists helped redefine the lives of Hindu images. In his 1806 study of Hinduism, *A View of the History, Literature, and Mythology of the Hindoos,* Baptist missionary William Ward combined visual documentation of Hindu deities with literary descriptions of rituals, theology, and history to provide readers in England and elsewhere with a detailed introduction to a culture they knew little if anything about.[26] The three chief deities of Hindu belief are presented as idols in figure 31—metal statues that at least dimly echo the Christian trinity in their triadic arrangement. This very association adds yet another layer of meaning to the lives of these images. Yet the degree of detail in the illustrated figures surely registers their ethnological value. There is little distortion or caricature and the suggestion of a straightforward description. The viewer is invited to return the gaze of the three figures and regard them as curious artifacts of another world.

The London Missionary Society collected stone, bronze, and clay deities and sacred objects, which it proudly placed on display in its Missionary Museum in nineteenth-century London as "idols given up by their former worshippers from a full conviction of the folly and sin of idolatry."[27] These objects were presented as a new form of spectacle: not as aesthetic objects for visual delectation, but as trophies of the church triumphant. They were testaments of success and were therefore of greater value intact, undamaged, as indices of evangelical efficacy, than destroyed in the mission field. This amounts to what might be called a

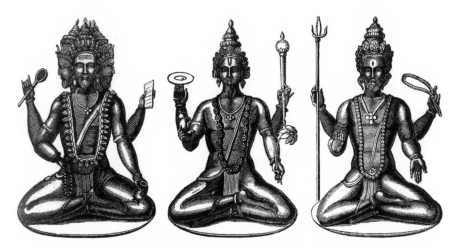

FIGURE 31. "Bramha, Vishnoo, Siva." From Thomas Robbins, ed., *All Religions and Religious Ceremonies: Part I. Christianity, Mahometanism, and Judaism;* [William Ward,] *Part II: A View of the History, Religion, Manners, and Customs of the Hindoos, together with the Religion and Ceremonies of Other Pagan Nations* (Hartford: Oliver D. Cooke & Sons, 1823), facing p. 50. Courtesy of The Library Company of Philadelphia.

soft iconoclasm, in which the image is not physically destroyed but redeployed as an example of a new and decidedly negative taxonomic classification. But as Carolyn Dean noted of the pre-Christian aspects in the rites and images of the Andean Corpus Christi, the objects survived and with them an older life that awaits rediscovery. In the final chapter of his book, Davis provides a splendid story of a medieval bronze figure of Shiva that was sold on the international art market in the 1970s after being exhumed in an abandoned temple by a laborer. The sculpture was acquired by a collector of Asian art in Canada but then confiscated by the British police. Suit was brought by the Indian government for its return as stolen cultural patrimony. By 1991, it was finally returned to the region in which it was discovered, only to be interred in a vault in order to protect "icons" in danger of theft. "After its difficult life," Davis wistfully concludes his book, this image of Shiva "deserves a better retirement."[28]

Art and Enlightenment

Idolatry and its extirpation are rooted in the history of religion, but they extend beyond strictly sectarian experience. In the modern West, often characterized as a secular culture, as the offspring of the

Enlightenment's quest for liberation from oppressive institutions such as the church, idolatry and iconoclasm have nevertheless remained vital categories of cultural criticism. The view installed during the seventeenth and eighteenth centuries has remained in force in scientific, academic, and political discourse: freedom rests in liberation from "superstition" and authority ungoverned by reason. In the lexicon of the Enlightenment, *superstition* is another word for idolatry. Idols or superstitions are the products of ignorance and the tools of oppression. They are errors, the irrational forces of mistaken allegiance. Human beings do best without them, and science and philosophy are the instruments of iconoclastic enlightenment. Reason is the tool that will smash their hold on the human mind. While the Enlightenment may not require the elimination of religion, it certainly seeks to chasten its claims, to limit its power, and to privatize the practice of faith, securing the civil domain for secular governance.[29]

But religion does not go away. Indeed, outside western Europe it has mushroomed during the modern era. In a variety of forms, religion maintains a powerful role in governance, education, public discourse, popular culture, nationalism, and global politics. This provokes the ire of some latter-day descendants of the Enlightenment. Of particular interest to art historian Albert Boime, for example, is the nationalistic idolatry of public monuments in the United States. Whereas Davis and Mills plead for a sympathetic view of the image worshipped in the history of religious belief, Boime urges restraint, or "patriotic iconoclasm," with regard to the nationalist cult of images that has sometimes played a volatile role in American civil religion. Perhaps the most widely recognized are objects in the U.S. cult of nationhood. The national flag, the Statue of Liberty, Mount Rushmore National Memorial, the Marine Corps War Memorial, the Lincoln Memorial, and that fascinating antimonument the Vietnam Veterans Memorial. Boime's book is fueled by the author's concern that art historians undertake the "task of decoding the national icons" in order to free them from the singular claim that conservative nationalist interpretations make on them.[30]

These objects are foremost among the visual vocabulary of symbols used to promote American patriotism and nationalism in a way that infuses them with an *iconic* status—seeing them means encountering their referents in a powerful way. Boime argues that these "national icons share many of the traits of the sacred icon, including consecration in the form of dedicatory ceremonies and their status as pilgrimage

sites." As a scholarly iconoclast, Boime seeks to complicate the direct linkage of each symbol to the intensely felt cult of jingoistic pride that short-circuits historicity and the complexity of signification, that is, the multiplicity of meanings that are often squelched by the cultural politics of representation. He finds in each of these symbols a crossroads of class: "The history of each icon reveals that privileged members of the American hierarchy, bent on maintaining their economic and social class advantages, attempted to appropriate the symbols of America almost from their inception and use them to stimulate an illusion of inclusivity." Once analyzed, he hopes, the sacred objects will appear under a different guise, and viewers will see them without "an attitude of unreflective reverence."[31]

Not that Boime wishes to do away with reverence altogether. To the contrary, he clearly accords those who died in war for American liberty a heroic status and explicitly acknowledges the importance of the national monuments as patriotic symbols. But he uses history in the service of a "patriotic iconoclasm," a breaking of idols, which are only subtly distinguishable from icons for Boime the Marxist art historian. Icons are religious artifacts, and religious faith is a mystifying or veiling of national symbols. The ruling classes exploit the "mesmerizing effect" of the icon for a nationalist cult that installs and maintains their privilege. "The people" lose control over their own symbols and therefore lose control over their interests and their political liberty. Monuments, Boime points out, are access to the past because they are the public means of remembrance, the point at which the past becomes available "for structuring the present." And yet Boime sees "popular memory" as part of the problem, since popular memory is not history in the sense of what critically minded historians write. Apparently the people participate in their own right by obscuring the past. Or perhaps they are duped by the ruling classes to remember the past according to the dominant ideology of their masters. In fact, it is difficult to find an untainted moment in the history of any of the objects that Boime narrates. Class conflict does not begin after a symbol is invented but was there before the forces of history forged a symbol, waiting to devour the loose, inarticulate consciousness of the people as it emerges from its titanic unconsciousness. As he shows in the case of Gutzon Borglum, the creator of Mount Rushmore (fig. 32), the ideology of class dominance was in operation from the beginning with regard to the monument's hymn to Manifest Destiny, which Boime rightly links to Jefferson's territorial plans.[32]

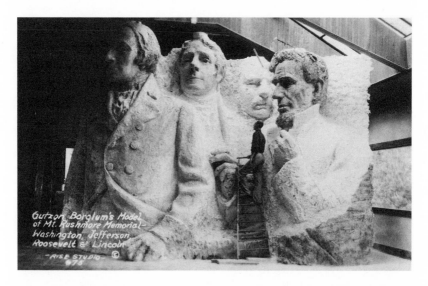

FIGURE 32. Gutzon Borglum's model of the Mount Rushmore National Memorial, 1936, plaster. Courtesy of the Library of Congress, Washington, D.C.

Perhaps the American icon of greatest import is the flag. The story of its sanctification begins most importantly for the modern period during the American Civil War, when the flag became a symbol of the national crisis. Following the war, national unity was proclaimed in the flag that reasserted the sovereign union of the states. Both the flag and the unity it represented, even embodied, were sacralized by the bloody sacrifice of so many killed and wounded by the war. By the end of the century, in the face of new waves of immigrants, numerous hereditary associations such as the Daughters of the American Revolution and veterans' groups such as the Grand Army of the Republic supported legislation to formalize flag protocol, ban desecration, and install in public school rooms across the nation the Pledge of Allegiance (first written in 1892).[33] Litigation continued through the twentieth century as flag ritual became a flash point over First Amendment issues and presidential politics.

Boime devotes considerable space to artistic treatments of the flag in the twentieth century, such as Jasper Johns's well-known paintings of the flag from the 1950s, because he believes that Johns's works "served to neutralize the grand metaphor of Old Glory by holding it up to close scrutiny in the secularized space of Leo Castelli's art gallery."[34]

Boime reasons that this secularization or iconoclastic operation took place because the art gallery was a place in which "no one could experience any sudden patriotic flush or feel inclined to salute." In effect, he states, "the image of the flag was completely divorced from those sites in which the ritual of respect or decorum was normally played out." If he's correct, which he almost certainly is not, the putative iconoclasm was enacted not on the objects themselves but in their location in an art gallery. But even this notion ignores the fact that galleries and museums of modern art have been associated again and again with the sacred spaces of chapels and shrines. Johns's flag paintings weren't carried in parades or patriotic processions, but they were installed in sequestered spaces for the sake of reverent contemplation as sacrosanct objects. It is more accurate in this case to speak of the flag as moving from a culture of American civil religion to American aestheticized religion.

As I will discuss at length in chapter 7, the study of the material culture of American civil religion needs to distinguish patriotism and nationalism, two cultural forces that are not always as carefully differentiated as they should be by many writers. Generally speaking, Boime discerns the importance of patriotism as a shared identity in national life, a common commitment to a national tradition's aims of achieving justice and liberty. He is prudently concerned that patriotism not be collapsed into nationalism, which is an aggressive attitude toward the unparalleled superiority of one's nation and a desire to subordinate the personal liberties of one's fellow citizens and the citizens of other sovereign nations to an agenda of dominance, even outright conquest. The point Boime makes in each instance of the monuments he discusses is that the symbolic discourse of patriotism is readily appropriated and recoded to become the discourse of nationalism. Images and monuments facilitate this process, which Boime instructively scrutinizes in the history of the Marine Corps War Memorial (fig. 33), which went from a photojournalist's documentation of a battle in process to a national icon in the nation's most sacred cemetery. The shift from photograph to monument was accompanied by a succession of covenants: from a mimetic compact (this is what actually happened) to an exemplary covenant (this is the ideal view of what really happened) to communal covenant (this is what Americans believe happened in order to be Americans). Yet the legendary real estate of the national mall provides the place for powerful counter and alternative discourses to find a hearing. Monuments such as the Lincoln Memorial can be appropriated by minority groups who seek access to national symbols in

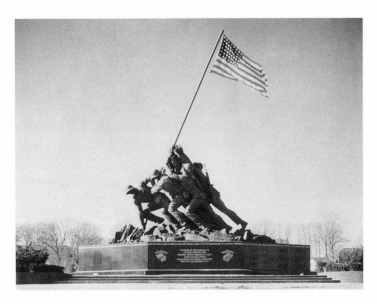

FIGURE 33. Felix de Weldon, Iwo Jima memorial (Marine Corps War Memorial), 1954. Arlington National Cemetery. Photo: Theodor Horydczak. Courtesy of the Library of Congress, Washington, D.C.

order to affix to them their claims for legitimacy and its benefits. The Lincoln Memorial and surrounding space became important for this purpose even before African Americans and nonblack supporters of civil rights rallied there in 1963, when Martin Luther King Jr. delivered one of his most celebrated oratories. On Easter Sunday in 1939, African American singer Marian Anderson held a concert on the steps of the Lincoln Memorial when the Daughters of the American Revolution refused to rent Constitution Hall for the occasion.[35] The Lincoln Memorial is a place to pronounce and consecrate alternative covenants with the nation that challenge the hypocrisy or failure of a regnant order.

But excessively rationalist models of Enlightenment are inclined to overlook or repress the affection and fervor with which patriotic citizens regard their collective symbols. Is it ever possible in the experience of nationhood to transcend religious symbolism in the life of patriotism? As secular as one may wish to be, patriotism is more than a strictly rational dedication to a reasoned, collectively held ideal. The object of patriotic commitment is something to which one relates through

feelings and rituals that encourage a practice of looking that binds one to a nation and its founding principles through the symbol. One may argue about the iconicity of the symbol—its reification or material evocation of the reality to which it refers. But there is almost inevitably something "religious" or at least totemic about the supra-rational operation of patriotic symbols. Yet it should be carefully distinguished from nationalism, which intensifies what might be called the *patriotic gaze* such that the dialectical relation between symbol and reality is collapsed into a kind of identity. The flag, for instance, becomes fetishized: it is the thing one adores, worships, dies for, kills for. Boime does well to deconstruct the symbology of nationalism. That is an idol worthy of iconoclastic toppling. But can one dismantle what might be called the strong totemic operation of patriotism without destroying the symbolic structure of common national life? Are national forms of association able to occur in complete absence of some manner of collective civil religious ties? And if robustly conceived, if civil religion is able to interrogate pride with humility, national triumph with prophetic injunction, might that religion have something constructive to contribute to national life?

Contrary to its easy dismissal as a desperate act of philistinism, iconoclasm is a complex social phenomenon. The history of the destruction of art over the last two centuries is no exception to this generalization. *Iconoclasm* is a term loaded with diverse meanings, reflecting both the judgments of those who abhor the destruction of art and the motives professed by and ascribed to those who have broken, defaced, dismantled, or proscribed objects of art in western Europe since the French Revolution. For some critics, all iconoclasm is vandalism, a willful destruction of cultural property with no other motive than philistinism, ignorance, or violent anarchy. Each of these valuations says much about the social location of those who repudiate the destruction of art in a given instance. The charge of philistinism indicates a judgment of taste with its corresponding distinctions in social class. Ascribing iconoclastic acts to ignorance is often characteristic of those who espouse a program of enlightenment and prefer to explain social pathologies as the acts of the unenlightened, which may mean anything from the uneducated to the bigoted to the unwitting pawns of oppressive ideology. And explaining the destruction of cultural objects as manifestations of anarchy implies an establishment whose interests are threatened by rejection of the regnant political, legal, and economic order.

Compare, for example, the reaction of many U.S. citizens to the events associated with figures 34 and 35. When citizens of Iraq toppled

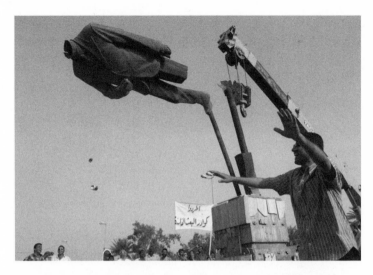

FIGURE 34. Destruction of statue of former Iraqi president and Baath Party leader Ahmed Hasan al-Bakr, by anti–Baath Party protesters in Baghdad, May 18, 2003. Photo: Murad Zezer, AP/Wide World Photos.

a host of bronze statuary depicting Saddam Hussein and members of his party (fig. 34) following the American invasion, many in the United States cheered the events (portrayed repeatedly and triumphally in the media) as emblematic of the removal of a dictatorial regime to make way for a pro-Western, democratic government in the country. But when Americans (and many others) saw the results of the demolition of ancient buddha statues in Afghanistan (fig. 35) by the Taliban, they reacted with outrage. By historical standards as they were construed among Westerners, the ancient stone sculptures were far more valuable than the bronze commemorations of a brutally repressive modern government.

A closer look at the situation in Afghanistan reveals that the destruction of the sculptures was a deliberately calculated political gesture. Speaking on National Public Radio in the spring of 2001, an ambassador of Afghanistan's Taliban regime provided at least two different explanations for the act. He referred to Afghan resentment toward foreigners who, under the auspices of the United Nations, came to Bamiyan to repair the decrepit sculptures. Critics in Afghanistan objected to the expenditure of funds on ancient monuments while Afghan children in the neighborhood were starving. The nation's ruling Council of Scholars, the equivalent of a supreme court, considered

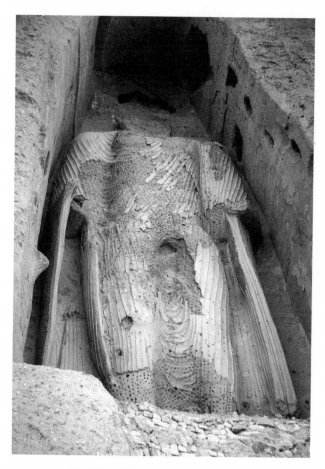

FIGURE 35. Buddha, fifth century, 174 feet tall, eventually destroyed by the Taliban in March 2001, Bamiyan province, Afghanistan. Photo: AP/Wide World Photos.

the matter in light of international sanctions against the country, which they regarded as part of the reason for the children's starvation. The council was baffled, the ambassador reported, by the world apparently caring more about the nation's past than about its present predicament. Significantly, the ambassador did not object to the observation from an American interviewer that the destruction of the buddha figures was "an act of sheer pique . . . to thumb your nose at the world."[36]

The ambassador's acquiescence suggests that the destruction of the sculptures was in fact a very deliberate act of iconoclasm, but not a

religious one (the ambassador cited the council's resolutions not to destroy the sacred images of Afghanistan's Hindu population). Western outrage overlooks the degree to which the West was complicit in contributing to Afghanistan's plight. The U.S. withdrawal from the nation after the USSR ceased supporting a puppet regime there thwarted the opportunity to assist in the creation of a government and social infrastructure that might have restored civil order. The consequence was anarchy and a power vacuum, which was filled by warlords, tribalism, the drug trade, al-Qaeda, and, eventually, the Taliban. The mullahs composing the Council of Scholars reversed their previous judgment not to harm the buddha figures. According to the ambassador, Afghanistan's rulers determined to destroy the figures as a political act that targeted what the regime viewed as an icon of the West's misplaced values and its willful miscomprehension of Afghanistan's desperation. The act was also a violent and defiant reply to mounting American truculence in the search for terrorists, including Osama bin Laden, who had been targeted in 1998 with seventy-five cruise missiles in Afghanistan. The power of images in this instance of iconoclasm consists of the power of the destructive act to offend the West and to strengthen the otherwise largely impotent Taliban. Indeed, according to a French commentator, the mullahs ordered the destruction of the buddhas in order to signal "that all Moslems who had preceded them in Afghanistan, who had respected the statues, were not real Moslems."[37] The Taliban sought to bolster its standing within the nation no less than without by a ritual of image destruction. Although the deed was pitiful, it was not an act of mindless religious fear.

The destruction of art is a political act by virtue of the very terms one applies to interpreting it. In a major study of the modern history of the destruction of art, art historian Dario Gamboni wisely rejects the search for an objective nomenclature, preferring instead to ask under what circumstances an act is labeled vandalism. This allows him to complicate the idea of iconoclasm by exploring the great diversity of ways in which images, objects, and monuments are replaced, relocated, renamed, placed in storage (see, for instance, fig. 19 here), modified, updated, destroyed, defaced, banned, confiscated, stolen—all acts of what might be called, in one way or another, iconoclasm.[38] Challenging visual analysts in the academy and the museum to face up to their insistent failure to take images and the responses they elicit seriously, David Freedberg provided an insightful survey of the history of iconoclasm. Gamboni is able to focus with much greater detail on the last two centuries of

iconoclasm in modern European history. Although Gamboni is not as interested as Freedberg in the psychology of response, he shares Freedberg's (and others') concern to articulate the range of iconoclasms. Thus, although vandalism is the recurrent explanation given to the destruction of works of art by governments, courts, police departments, and such institutions as the church, since each of these strongly prefers civil order to violent acts, Gamboni explores alternative ways of explaining destructive behavior. Vandalism as an explanation does not admit political protest, which complicates matters by introducing a contentious element of legal interpretation and the threat of extending legitimacy to a marginalized and heterogeneous group that may have targeted the very values of the establishment. Yet what is vandalism to one observer who repudiates the desecration of the national flag, for instance, will be potent political protest to the person or group destroying the flag.

Throughout Gamboni's discussion of municipal monuments, one is reminded of the complex and meandering lives of images narrated by Richard Davis. The biographical approach used by Davis to explore the cult object of temple worship lends itself to the study of civil statuary as symbols of the state or the people or socialism or democracy. Yet Gamboni is not engaged in narrating the ongoing life of a particular image, as Davis is. He tends instead to dwell on the political and social narratives in which images are invested. Boime shares this approach. For both Gamboni and Boime, power is not something that inheres in an image and threatens those who see in the image a reality they must destroy, as Freedberg explores in *The Power of Images*.[39] Nor is that power something that can be turned to one's own uses, as Davis finds again and again in the history of Hindu images. The cultural politics of Enlightenment, in which images are propagandistic instruments inscribed in a social discourse of power, has no use for the *metaphysics* of power. The Enlightenment shares the exclusivistic claims of radical monotheism: all other gods are false. The motive for idolatry is simply ignorance.[40]

Gamboni grounds his account of modern artistic iconoclasm in the foundational moment of the French Revolution. This event spelled the end of tyranny and championed the secular, democratic rule of the people. In this new age, art no longer properly served as the propaganda of kings or as the superstitions of the church. Artists claimed a new liberty: they now understood their task to be to direct the critical, prophetic voice of art against abuses of power and regnant conventions. Destroying idols became a favorite activity of the "progressive" or

"avant-garde" artist. Gamboni notes that the definition of *iconoclast* as one who attacks "cherished beliefs or venerated institutions on the ground that they are erroneous or pernicious" arose in the mid-nineteenth century at the same time that the term *avant-garde* was used to describe the progressive aims of artists.[41] Artists such as Courbet, Manet, and the Impressionists in France were regarded by their admirers as attacking staid, bourgeois ideals and overturning them in the interest of new ways of seeing and valuing human experience. By the end of the century, avant-garde artists were being hailed as prophets leading the way to spiritual renewal through the life of the imagination. The early twentieth century witnessed a widespread practice of iconoclasm among modern artists, who came to define their creative practice as necessarily iconoclastic. From Cubism and Futurism to Dada and Surrealism, artists saw the destruction of conventional systems of representation, traditional morality, rationalism, language, or common-sense realism as the focal point of their artistic deconstruction. Marcel Duchamp's "defacing" of a reproduction of Leonardo's *Mona Lisa* is perhaps the most celebrated instance of creative iconoclasm. "Art" itself, as a conceptual idol, became the target. Eventually, by the mid-twentieth century, Conceptual Art did away altogether with art objects.

Originally, *the avant-garde* was a military term that described the "cutting edge" of the light horse cavalry (itself a privileged position accorded to the upper classes or aristocracy), which charged the opposing infantry to break a hole in enemy lines. But by the 1820s the term was used by the Utopian socialist and popularizer of Enlightenment ideals Henri de Saint-Simon (1760–1825) to describe artists, scientists, and intellectuals as a class committed to social improvement.[42] By the mid-nineteenth century the term was being used to signify the advance guard of progressive cultural forces whose target was the establishment, whether church, state, museum, traditional patronage system, art academy, or everyday morality. The artist was one of the enlightened who understood his or her task to be one of smashing the idols of the bourgeoisie. This understanding of the artist prevailed until the mid-twentieth century, when, in the disillusioning days of the 1960s, the avant-garde died a death of institutionalization. Abstract painting was deployed abroad by the United States government to promote Western values of freedom. Critics such as Clement Greenberg, who had identified abstraction with freedom and figuration with the forces of reaction, found their position easily co-opted by Western propagandists. Artists began to celebrate popular culture rather than despise it, premising

their work on commonly circulating forms rather than using concep-
tions such as "kitsch," as Greenberg had, as a foil for defining the
"avant-garde."[43] Shorn of its capacity to destroy its predecessors and
competitors, abstract painting lost its iconoclastic cutting edge. Nowa-
days buses haul schoolchildren to the Museum of Modern Art, where
the crowds of students are taught to pay homage to the reverently
installed idols of Pollock, Rothko, and de Kooning, vaunted icons of
"Culture" and American artistic prominence. This ambiguity of idol
and abstraction is what Bruno Latour has called "iconoclash," the
befuddling sense that the two urges—to love images and to hate
them—are gripped in an opposition that is interminable if left to
itself.[44] The alternative is not a polarity of idol and negation, but a truer
view of what is actually happening in such a contrast: the destruction of
one image in order to replace it with another or with a rival practice of
iconicity such as the sacrality of a text.

Iconoclasm and the Power of Images

"There can be no excuse," Freedberg wrote, "for the historian of visual
cultures to disclaim interest in the acts that destroy what is generally
respected or cherished."[45] Freedberg argued that the motivating force
behind the destructive response to images is typically fear: fear of what
images might do if left to themselves. Often it is fear of what they
represent. Freedberg provided countless instances from the history of
images and visual practices in which signifier and signified collapsed in
fear and devotion. In the economy of religious visual culture, these two
emotions, fear and devotion, are complementary. The anxiety underly-
ing this apposition of opposite feelings may be that fear turns into
devotion if the image/idol is not destroyed. Seen in this way, the image
is a kind of threat that appears to elicit aggressive behavior.

 Golden calves, after all, are more than empty, inanimate images.
Even Aaron thought so. When he was confronted by Moses for the idol
he'd created, Aaron contended that he threw the gold into the fire "and
there came out this calf" (Exodus 32:24). Aaron would have Moses
believe that he did not actually fashion the beast—it sprang forth from
the fire on its own. This may represent the survival of an earlier Hebrew
belief in many gods and the corresponding power of their images, or it
may simply be Aaron's craven attempt to deflect the wrath of Moses
from himself (which seems to have worked). In any case, the danger of

idols for some in the ancient world and in the modern is not that they are vacant signifiers propped up by human vanity but that they possess an autonomy, a life of their own, a power over the human imagination.

The Protestant reformers and iconoclasts of the sixteenth century were of two minds over whether the power of images had its seat in images per se or in the human heart. This can be a subtle, even slippery, distinction, and David Freedberg does well to caution scholars about missing the power of images as a fear of their power to act upon us. John Calvin regarded the root of the problem to be the human mind. In his vehement attack on religious imagery in the *Institutes of the Christian Religion* (1536), Calvin quoted Augustine's warning that the danger of images resided in the power they have to make "infirm minds" believe that the images themselves are animate.[46] Ann Kibbey has argued, however, that Calvin's fear was not only on behalf of weak minds: "Calvin felt threatened by religious statues and paintings exactly because he feared the power of a visual figure to enthrall, contain, or constrain his own concept of the deity." Kibbey reasons that Protestants such as Puritan iconoclasts who shared Calvin's fear "believed it necessary to attack the visual images in church sculpture, glass, and painting not because they disbelieved these images but rather because they believed quite strongly in their power."[47] Yet Calvin's account suggests that it was not images themselves that he feared (he approved of fine art and said nothing to prohibit its enjoyment), but the powerful human inclination to turn such images into idols in the context of religious worship. Calvin believed that the problem resides in human nature, which he called a "perpetual factory of idols."[48] Human nature, he argued, is prone to idolatry in religious matters, to insulting the majesty and the sovereignty of God by creating human likenesses for his incomprehensible divinity. Images of God, Calvin insisted, fail utterly to apprehend and reveal anything about God. The danger of images, therefore, is the ease with which human nature makes them God. Humans possess a strong inclination to fashion images that will do for them what only God properly may do. This is the insult to God's sovereignty that Calvin bemoaned. Calvin implied that this behavior is not only characteristic of "infirm minds." It is part and parcel of human nature as he posited it in order to distinguish it in the sharpest terms from the radical alterity of God.

Other reformers agreed that the human heart is disposed to substitute its desires for God's, which is the root definition of idolatry. But not everyone thought the problem ended there. In an early tract

that promoted the removal of images from churches (1522), Andreas Bodenstein, known as Karlstadt, a teacher at the university in Wittenberg, announced to "all Christians" that they "have idols in their hearts if they reverence images." But Karlstadt went on to confess that he himself suffered from a special, inextricable case of this disposition. Karlstadt described a kind of tenacious stalemate between will and intellect in his psyche. The psychological subtlety of his remarks bears extended quotation.

> With a sigh I must confess my secret thoughts before all the world. I admit that I am faint-hearted. Though I know I ought not fear any image, and I am certain that God demands of his own not to fear idols . . . I also know that God is as small in me as my reverence of idols is great. For God desires to indwell my whole and total heart and cannot in any way tolerate my having an image in my mind's eye. . . . I ought not fear any image just as I ought not honor any. But (heaven help me), my heart has been trained since my youth to give honor and respect to images and such a dreadful fear has been instilled in me of which I would gladly rid myself, but cannot. Thus I am afraid to burn a single idol. . . . Though I have Scripture (on the one hand), and know that images are incapable of anything and that they lack life, blood, or spirit, fear (on the other hand) holds me back and causes me to fear a painted devil, a shadow, and the slightest noise of a rustling leaf, and to flee that which I should seek out bravely.[49]

Karlstadt was attached to sacred images by virtue of a fear instilled and conditioned during his youth. He knew, at least intellectually, that images were "stuffed dummies," as he called them, devoid of life, but he could not bring himself to destroy them. He was afraid of what they might do. Belief and knowledge conflicted to the point that he sought even to expunge images from his "mind's eye."[50]

But how does one do that? Long-suffering prayer and the disciplines of meditation, diligent forms of asceticism, or confessional engagement with a spiritual adviser were the late medieval counterparts to modern psychotherapy. For some of Karlstadt's contemporaries and readers, however, there was another way: violent acts of iconoclasm. For those locked in an otherwise irresolvable conflict of habits of pictorial devotion and a zeal for liberation from them, the removal and destruction of images served to objectify the disposition in the form of the image and to punctuate one's submission to the disposition in a public manner. The public nature of the act bolstered the resolve by one's sharing it with others and publishing testimony. Removing and destroying images symbolized the fear of and desire for them and then ritualistically

overcame that fear and desire. Iconoclastic violence therefore was an objectification, punctuation, and publication of a personal conflict that some found difficult otherwise to resolve. Add to this the fact that for some the imagery symbolized a clerical hierarchy and an economic system of remission of sins that came at the individual's expense, and it becomes even less difficult to imagine why iconoclasm appealed to some such as Karlstadt.[51]

The cultural uses of iconoclasm extended well beyond Protestant zeal during and after the Reformation in Europe and America. Invoking the trope of idolatry in the critique of modern American society draws both from American Puritanism, with its stringent Calvinist suspicion of religious imagery, and from the republican tradition of Enlightenment political thought. In the latter case the operative term is *corruption* rather than *idolatry,* but the two terms mean the same thing: a loss of dedication to the jealous demands of virtue and an unprincipled indulgence of sensuality and infidelity. In the manner of a republican jeremiad, one text stands out in American cultural criticism for its unrelenting attack on the deception and falsehood of images, in large part because it conjoins the Calvinist and the republican critique. Daniel Boorstin even titled his screed against American idolatry accordingly: *Image. A Guide to Pseudo-Events in America* (1961). Boorstin incorporated the discourse of iconoclasm in his denunciation of the idols of American culture, which were unreal, false concoctions meant to deceive both Americans and their allies and enemies. He coined the term *pseudo-event* to describe the use of the "image" to create illusions of reality, lamenting how the allure of cultural representations or "images" had eclipsed reality in modern American life. Boorstin attributed this largely to what he called the "graphic revolution," which consisted of new technological ability arising in the nineteenth century "to make, preserve, transmit, and disseminate precise images." Through the invention of photography, then mass-produced print imagery and film, "vivid image came to overshadow pale reality."[52] Boorstin's lament is perhaps the earliest and most systematic critique of postmodernism on record. The pseudo-event is the "simulacrum" that is more real than the actual reality it claims to represent. Belief in these nonevents or images, what are to his mind nothing more than mirages, amounts to a perversion of American culture that is nothing other than the worship of idols: "We suffer unwittingly from our own idolatry. The more images we present to people, the more irrelevant and perverse and unattractive they find us. . . . The image—limited, concrete, and

oversimplified—inevitably seems narrow and unadaptable. Because it is a projection of ourselves, it declares our conceit."[53]

The ancient discourse against idolatry is resurrected in full. Boorstin claims that idols induce delusion, foster vanity, represent nothing but falsehood, and are worshipped by the duped and ignorant. Moreover, they signal the infidelity of Americans to the covenant that established their national identity and account for the loss of the founding ideals that will be America's only redemption.

The overarching claim in the history of iconoclasm, the assertion made in numerous and diverse historical instances by people of very different religious and philosophical allegiances, is that images fail to tell the truth. This commences paradigmatically for Western intellectual history with Plato's refusal to allow image-makers into the ideal republic and addresses the present day in the work of such writers as Daniel Boorstin and the early work of Susan Sontag in the United States or Jacques Ellul in France.[54] The long history of ideas between Plato and modern critics of visualizing divinity is the subject that Alain Besançon, director of studies at L'École des hautes études en sciences sociales, has undertaken to survey.[55] In fact, his study is more intellectual genealogy than history, a chronicle of major thinkers from ancient Greece to modern Europe who have distrusted the image. This genealogy of the "West" culminates in Western modernity, which Besançon considers to be postreligious and secular.

The book's thesis is that iconoclasm comes in many forms—pagan, Jewish, Christian, Muslim, and secular—but it is always religious in one manner or another. That's because, at base, iconoclasm is a philosophical disposition that maintains the invisibility and metaphysical otherness of what is ultimately real, whether it is Plato's notion of the Good, the Jewish understanding of God, the Platonist-influenced Christian view of God the Father, Kant's philosophy of the thing-in-itself, or Hegel's theory of the postreligious, postartistic evolution of Mind. What is truly real cannot be made visible without forfeiting its claim to ultimacy. When there is an exception to this rule, as in the Christian idea of Incarnation, the result is a history of intense philosophical debate and political contest.

This is a fascinating and insightful thesis, but Besançon's book suffers from its approach to the topic. As he charts the rise of philosophical aniconism from Pascal to Kant to Hegel to abstract painting, Besançon ignores the concomitant rise of Marian apparitions, mass pilgrimages, mass-produced religious imagery, and the explosion of

Protestant visual piety during the last two centuries. This comes in stark contrast to his treatment of the ancient and medieval world, where he rightly discerns the tension and ambivalence of the two sensibilities, iconic and aniconic. Why the difference? Because Besançon the intellectual genealogist regards modernity as secular and modern institutional religion as essentially vestigial. Religious art in the modern period is anachronistic at best and at worst the vain attempt to revive a corpse (as Besançon says of the nineteenth-century German Nazarenes and the British Pre-Raphaelite Brotherhood).[56]

Christianity, Besançon rightly points out, has maintained two minds about images. But by the time his account arrives at the modern era, Besançon has eyes only for Calvin, who reasserts patristic aniconism, and subsequent philosophers from Pascal to Kant and Hegel. The German philosophers regard the image of the divine as defunct and superstitious and foster notions of sublimity that stress the inadequacy of any signifier to an invisible, infinite Other, which is the source of existence (and therefore never to be idolatrously confused with any aspect of the world of existence). Why should this be coded "modern" and regarded the winner and visuality the loser? In the end, Besançon himself is not so sure. He closes his long book by hedging his bet: "Despite what Hegel said on the matter, there is nothing inevitable about the death of the image."[57] This contradicts his application of Hegel's idea about the end of art to nineteenth- and twentieth-century art as a kind of predictive template. Why equivocate about the contemporary art world? Perhaps because the theory of the avant-garde has been undermined by the art market: there is no longer a leading style or artist or group of artists who dominate the cultural marketplace. Instead, the market is diverse, happy to revive any and all schools of art for the sake of entrepreneurship. The transcendence of the figural in the sublime, so beloved of modernists and culminating triumphantly and radically in abstraction, is no longer privileged. Aniconism is just one more trend to be commodified by art galleries and collectors.[58] The sublime is no longer a radical transcendence of culture, a bracing purge of human falsehoods, but one style among many, one idol on the shelf in the grocery store of culture. Perhaps Bruno Latour is right: now is the time to move beyond the culture war of images. The binary opposition of idol and abstraction can be viewed for what it is—not an absolute expression of truth and falsehood, but an ideological construction as enduring as the interest it serves.

The Circulation of Images in Mission History

If religious images help to organize human experience into an ordinary regime of enduring order, they can also operate to subvert the ordinary as peoples encounter one another, their visual covenants clashing as their respective constructions of time, space, and authority lock in ideological conflict. Sometimes the result is quite creative. In any case, new images and covenants are born in this time of crisis when things that seemed certain and secure come to appear less so. Catherine Albanese's notion of "extraordinary religion," discussed in chapter 2, applies very well to the use of images to challenge rival gods as well as to conceive of new forms of community and experience of the divine. This happens nowhere with such consequence for interreligious encounter as in the history of proselytism.

The Traffic of Images

When missionaries land on the shores of a world not their own in order to undertake religious proselytism, a historical process has already begun to unfold. Emissaries from a strange land, newcomers in a society they do not understand or even fully recognize as it operates all about them, missionaries grope along the fault lines separating two worlds. A common strategy is to map the terrain and locate those features on it that will favor the presentation of the missionary message. If the visitors are armed, as was the case of Pizarro in sixteenth-century

Peru, the topography the newcomers seek will be one less given to eye-to-eye encounter than to military domination.[1] But not all missionary encounters are coercive, at least in physical terms. Jesuits in Asia, for instance, far in advance of European imperialism, scouted out natural linkages, formations in the cultural landscapes of two worlds that brought Roman Catholicism close to indigenous custom.[2]

Whatever their efforts, the new language, culture, and history that missionaries encounter form the lens through which their hosts regard them. Subjects of wonder and resentment, they are watched and scorned, feared and laughed at. Two worlds view one another at the naked range of the sound of words, the taste of food, the touch of strange clothing. How can we study images in order to find out what they may tell us about such cultural encounters and the process of religious migration, change, and resistance that follows upon encounter? Some worlds, of course, refuse to be bridged, and sometimes media mediate nothing. Yet there are cultural syntheses and there are indigenized religions that change the original faith and create national futures that shape millions of lives. The task is to determine what religious images do when cultures encounter one another. Scholars have examined the complex of intercultural relations in the history of colonialism and missions.[3] This chapter seeks to provide a brief and accessible introduction to the problem of the role of images in mission history, which can seem intimidating, given the sheer size of the scholarly literature, the diversity of languages involved, the inaccessibility of far-flung archives, and the complexity of multiple national and international histories.

To begin, I propose a typology of ways of seeing that is keyed to a succession of different moments in which images perform relatively discrete functions. First, there are images and attitudes that a culture relies on to prepare for mission work. Then there are the images and attitudes that missionaries take abroad and receive from home to use in the field. Next is the indigenous visual response to mission work: the images that artists create as part of the new faith they have embraced. But there is also the rejection of the new faith that can be conducted visually in counterimages and visual practices. As the mission effort takes shape, new generations of missionaries maintain communications with their supporters back home. They send back imagery from the mission field to encourage continued support, and much of this imagery contributes to the visual lexicon of the faith in the world from which the mission originally set forth. Finally, as the faith finds a footing among a people, its administration is indigenized; its identity is

nationalized; and the mission phase is brought to an end. National and ethnic cultural traditions take shape, and the colonial mentality is decisively rejected. In the modern world, art participates in this process of nationalization by providing a national entity with a visual signature, lending the nation or people a visual sense of itself.

All of these visual aspects (as well as any other cultural artifact, such as literature, clothing, food, music, or architecture) can be studied as media in which people form, transmit, and modify their self-understandings, and in which they encounter other groups and form, transmit, and convey (mis)understandings of them. I propose to demonstrate how this can be conceptualized and studied in religious visual culture. As a prolegomenon to fuller historical accounts, it may be helpful to sketch out a model of the historical analysis of images in mission history, an approach to studying the ways in which images have functioned in several different contexts in nineteenth- and twentieth-century missions in Africa and Asia.

An important proviso: In what follows, I offer a framework for approaching the history of the visual culture of Christian missions and the indigenous response to evangelism. While all of my examples are drawn from the history of Christian missions, I do believe that the interpretive framework should not be limited to Christianity, but could also be usefully applied to the histories of Buddhist, Hindu, and Muslim proselytism.[4] The larger concern is hardly specific to Christianity. The point seems clear in a single example of the similarity of Jesus and Buddha in an instance of Western syncretism. In the 1915 edition of Paul Carus's *Gospel of Buddha,* an attempt to fashion a close parallel between Buddhism and Christianity that would be attractive to Westerners, Carus included illustrations of the Buddha as a Caucasian man, seen in poses and situations remarkably similar to episodes from the life of Jesus. One of these shows the Buddha preaching to his monk-disciples (fig. 36) in a manner that immediately recalls Christ delivering his Sermon on the Mount. Even the text of the Buddha's sermon is structured like the Beatitudes of Matthew or Luke. Carus selected and underscored the affinities in order, as he put it, to "bring out a nobler faith which aspires to be the cosmic religion of universal truth."[5] The images are among early attempts to portray Buddha as a non-Asian person. The book and its visual apparatus are excellent examples of the visual program of syncretism, since they are neither strictly Buddhist nor Christian, but what Carus called the "Religion of Truth." This is a non-Christian instance of how images and visual practices mediate one culture

FIGURE 36. Olga Kopetsky, Buddha preaching to the
five *bhikkhus*. From Paul Carus, *The Gospel of Buddha*
(Chicago: Open Court Publishing Company, 1915).
Courtesy of Open Court Publishing Company.

and another and even create new cultural patterns and practices.
Exploring such visual mediations may allow scholars to study cultural
interaction as a process, as a complex, protracted, multitiered negotiation
that can rely on visuality as a key medium of interaction.

The model I'd like to propose roughly divides the visual culture of
Christian mission history into six interdependent moments. The point
is not to clamp a restrictive template over the messy particularity of
lived religion but to develop a model that will help scholars recognize

and examine a considerable range of visual operations. The model does not describe a determinant process in which every type of image must occur or unfold in some sort of mechanical way. My intention is only to highlight the different moments of cultural encounter in which images may play a relatively distinct role as exercises in seeing, forms of visual thinking, which exemplify a sacred way of seeing or gaze.

The six moments I've identified make up an extended series of cultural interactions. For the sake of clarity, and at the risk of begetting nomenclature, six terms are introduced to designate these aspects.

- *Missive* imagery and practices are those used to mobilize and instruct domestic efforts to undertake missions.

- *Exported* imagery and practices are actually sent abroad and used by missionaries to teach and preach.

- *Appropriated* images and practices encompass the responses of indigenous believers to missionary activity as well as the ways in which imagery and its uses are adapted to local audiences.

- *Expropriated* imagery and practices signify the adaptation of imagery by nonbelievers to counter the purposes of the missionary or the application of images to religious or political ends other than those sought by the missionary.

- *Imported* imagery and practices refer to the outer migration of indigenous images, particularly to the original, missionary culture, where images may be commodified as well as adapted for religious use.

- *Nationalized* imagery consists of those images, styles, objects, and visual rituals that come to stand for the postcolonial religion and its significance for national identity.

Although this deserves far more discussion than I will allow it here, most of these terms are tropes of property and economic exchange. This seems an important reference point since the history of modern Christian missions unfolded within the context of the nation-state's rush for foreign markets and the resulting exchange of cultural properties. And debates between native or aboriginal populations and the nations in which they reside, such as Canada, the United States, and Australia, among others, continue to be waged legally and politically on the issue of control over and rights to cultural property. Nationalism tends to merge culture and landscape, regarding identity in terms of

property and culture as patrimony, the material possessions that transmit and maintain a people's common heritage. Nations are groupings of people that are closely invested in common places, language, assumptions, and artifacts—manifestations of a more or less distinctive way of life, which is as stable as its material and social sources of practice. Losing control over these manifestations means losing one's culture, that is, the matrix of identity. With this in mind, we see the stakes involved in visual transactions between peoples more clearly. As a trope, property has its own limitations. But any metaphor must. I prefer to stress the strengths of the metaphor, which consist of its historical suitability, its friendliness to the description of economic relations and national formations, and its inclination to take seriously material things such as images and other artifacts as material forms of exchange.

But even outside the context of modern Christian mission history, tropes of property and exchange are quite fitting, since religions spread along trade routes. One need only think of Buddhism's eastern migration toward China, along the spice route, linking the subcontinent to eastern Asia. Or Islam's later propagation along the same lines. There are certainly other metaphors one might use. For instance, religious change often accompanies military conquest. But tropes of struggle, submission, and victory are not only grisly and quite biased; they also easily miss the subtleties of negotiation and intermingling that underlie the crude categories of winners and losers.[6] I concede that the model I've developed is geared largely to modern history and its experience of colonialism, international markets, property, nation-states, and nationalism. But, even if my model turns out not to apply to medieval or ancient settings, its value for the modern history of cultural relations remains.

Six Moments in the Migration of Images

MISSIVE IMAGERY AND PRACTICES

The image of an American missionary preaching to a group of the world's inhabitants (fig. 37), displayed on the cover of the *Christian Almanac* for 1836, is a good example of the kind of image and accompanying text that was intended to mobilize domestic production of materials and resources for missionary enterprises. The missive note is clearly sounded in the biblical text that runs along the left edge of the image: "Go ye into all the world, and preach the Gospel to every

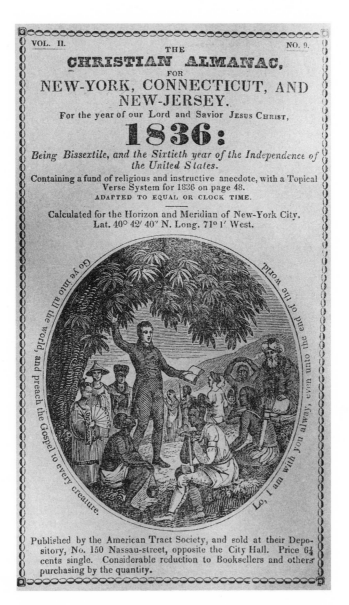

VOL. II.

NO. 9.

THE

CHRISTIAN ALMANAC,

FOR

NEW-YORK, CONNECTICUT, AND NEW-JERSEY.

For the year of our Lord and Savior JESUS CHRIST,

1836:

Being Bissextile, and the Sixtieth year of the Independence of the United States.

Containing a fund of religious and instructive anecdote, with a Topical Verse System for 1836 on page 48.

ADAPTED TO EQUAL OR CLOCK TIME.

Calculated for the Horizon and Meridian of New-York City.
Lat. 40° 42′ 40″ N. Long. 71° 1′ West.

Published by the American Tract Society, and sold at their Depository, No. 150 Nassau-street, opposite the City Hall. Price 6¼ cents single. Considerable reduction to Booksellers and others purchasing by the quantity.

FIGURE 37. Alexander Anderson (engraver), missionary preaching, *Christian Almanac for New-York, Connecticut, and New-Jersey* (New York: American Tract Society, 1836). Courtesy of the American Antiquarian Society.

creature" (Mark 16:15). Published by the American Tract Society, the largest producer and distributor of American tracts in the nineteenth century, the *Almanac* was full of statistics regarding the number of tracts in circulation, the number of people around the world needing evangelism, and the sorts of things readers could do to support the cause. Missive imagery such as a preaching missionary provided a powerful way of shaping the understanding of religious and racial otherness, the international stature of the United States, and the cultural burden of Christianity. Missive images are especially important as domestic representations of foreign cultures. Encoded in them is a worldview and a national mission, a vision that regards national purpose in explicitly religious terms. It is, of course, a thoroughly unilateral disposition, but like all propaganda, what it lacks in alterity and robustness it makes up for in the capacity to mobilize attitudes and resources.[7]

EXPORTED IMAGERY AND PRACTICES

Often didactic, exported imagery and practices are used by missionaries and teachers to instruct people in the new faith, to move them toward conversion, and on many occasions to help install cultural and textual literacy. Accordingly, the images selected typically avoid iconographical or theological intricacies. Simplicity and directness are cited by missionaries as the ideal for such imagery. A European missionary in Ethiopia, for example, told me that the diagrammatic figure reproduced here as figure 38 provided an effective way of teaching new church members about the nature of church membership.[8] The image portrays a robed figure of Jesus, who is the church, which St. Paul defined as the "body of Christ" (1 Corinthians 12:27). Within the contours of Christ's body are smaller groupings of figures that depict the duties and practices of church members. The image offers the missionary and clergy a convenient means of illustrating ecclesiology, the proper relation of the individual member to the collective whole.

Exported imagery may be produced in the country of origin, often without the purpose of mission work in mind. It is used in the field because it is considered helpful in conveying essential ideas about the faith. In a small collection of images published in Switzerland for use among Catholic priests and nuns engaged in African missions, textless color plates portray Western priests, nuns, and saints as well as Christ

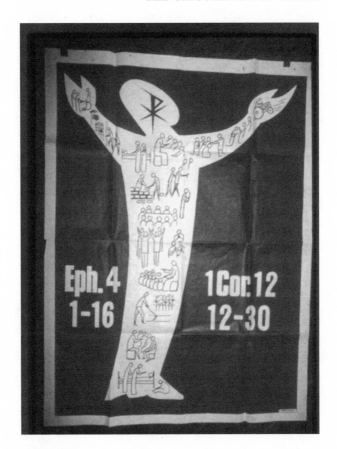

FIGURE 38. Artist unknown, poster illustrating Ephesians 4:1–16 and 1 Corinthians 12:12–30, Aira, Ethiopia, 1999. Photo: Author.

and the Holy Family among African children in tribal dress.[9] The subjects selected for depiction are the Eucharist and last rites, the nativity and Christ blessing the children, St. Francis distributing bread, a priest teaching with a crucifix, and two nuns attending to medical needs of children. Each image is keyed to a fundamental Catholic teaching or a salient moment of inculcating the faith.

Another good example of the sort of image produced at home but deployed in the mission field is Warner Sallman's *Head of Christ* (fig. 39). Taken abroad by Protestant missionaries to Africa, for example, this image of Jesus has been used in teaching in such nations as Ethiopia, Nigeria, and Congo. A Disciples of Christ mission station in Congo

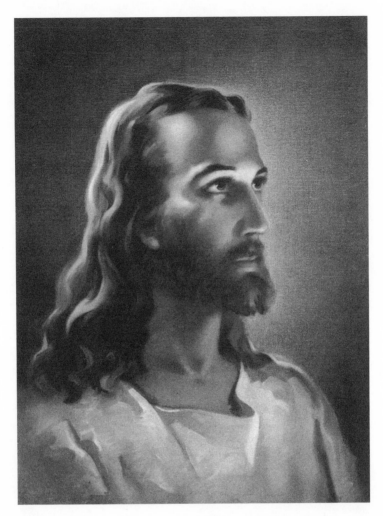

FIGURE 39. Warner Sallman, *Head of Christ,* 1940, oil on canvas,
28¼ × 22⅛ inches. © Warner Press, Inc., Anderson, Indiana. Used
by permission.

found a striking application of the image in 1947. A photograph in a
photo essay in *Life* magazine in that year shows a group of boys at the
mission during Passion week, acting out the Last Supper.[10] Their
celebration takes the form of a tableau vivant based on Leonardo da
Vinci's *Last Supper,* but in the place of Christ in the center appears a
reproduction of Sallman's *Head of Christ.* The missionaries (or the
children themselves) relied in different ways on two ubiquitous pictures

of Christ in order to enact their understanding of his person, life, and religious meaning.

APPROPRIATED IMAGERY AND PRACTICES

When converted indigenous groups adapt nonnative motifs to the visual rhetoric and vocabulary of their own rather than the missionary's culture, one may describe the imagery as appropriated, inculturated, or indigenized.[11] The process can also happen from the other side of the encounter. In what became an often-cited guideline for Catholic evangelism, in the sixth century Gregory the Great advised a missionary to England as follows:

It is not necessary to destroy the pagan temples, but indeed, after having removed the idols, convert them into churches by means of holy water and by depositing relics and erecting altars; because the people will yield more willingly in places that were formerly dear to them, so that [in such places] they may henceforth worship the Lord as soon as they have' recognized him as the true God.[12]

One thinks of the many Catholic churches built on the former sites of indigenous temples, shrines, or sacred spaces in Latin America and elsewhere. This category consists of images and visual practices that modify and adapt either native or nonnative imagery and practice to local circumstances in the interest of rooting the Christian faith in the evangelized culture. An example is the highly stylized figure of Jesus in figure 40, which strongly resembles the image of Krishna, seen here in the conventional portrayal of the Hindu deity in Javanese shadow theater. The Indonesian Christian clergyman who created this drawing of Jesus said that he borrowed the ornate and highly traditional form of stylization in order to avoid attracting the scorn of Muslims in Java. According to the clergyman, the naturalistic depiction of Western Renaissance or Baroque art would have both diminished the stature of Christ in Muslim eyes and possibly provoked an attack on churches from Muslims antagonistic toward the use of images.[13]

It should be clear from this example that appropriated images preserve the Christian identity of the exported source while adapting its form and use to the new, local context of the faith. The indigenous culture makes the Christian symbol its own by transforming its features (often reacting to the cultural biases of the missionizing society) but affirming its Christian identity as universal. In other words, although

FIGURE 40. Artist unknown, Crucifixion, 1995, colored pencil on paper, Jakarta, Indonesia. Courtesy of Nelly van Doorn-Harder.

the artifact exhibits the distinctive features of a particular culture, it also possesses a significant meaning that is shared property among Christians over time and around the world.[14]

There is often a subtle balance to be struck here. Indigenization can be allowed to go only so far before it modifies Christianity into something else. From the perspective of the missionizing culture it is important to subordinate indigenous features to what are considered

FIGURE 41. Yokei Sadakata, *The First Temptation*. Repro-
duced in Daniel Johnson Fleming, *Each with His Own
Brush: Contemporary Christian Art in Asia and Africa*
(New York: Friendship Press, 1938), p. 45.

universally Christian elements. As one American seminary professor put
it in 1938: "Important as it is to express Christianity in Japanese or
Indian modes, the first essential is to know and experience what [Chris-
tianity] is saying to mankind."[15] Therefore, this same writer registered
concern over the excessive "naturalization" of Christianity in the image
The First Temptation (fig. 41), by the Japanese Methodist artist Yokei
Sadakata.[16] It is a portrayal of Christ, but it might also be easily seen as
a depiction of Siddartha Gautama, who also endured a succession of

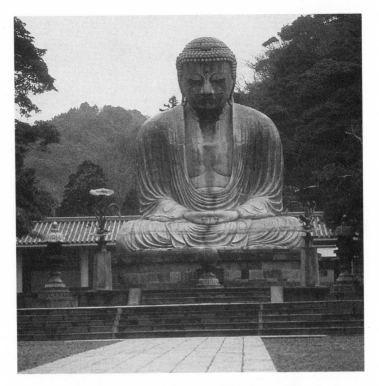

FIGURE 42. Amida Butsa, the Great Buddha, 1252 CE, Kotuku-in Temple, Japan, bronze, 40 feet tall. Photo: Werner Forman/Art Resource, New York.

temptations and assaults from demons led by Mara, the god of illusion, before attaining enlightenment as the Buddha.[17] The likelihood of confusion only seems greater in light of the resemblance of this image to Chinese and Japanese portrayals of the Amitabha or Amida Butsa (fig. 42), who operates in a way not entirely dissimilar to the Christian understanding of grace and salvation. Devotees of Amitabha pray for rebirth to the paradise in which he resides, and he is moved by compassion to grant rebirth to those who call upon his name.

Other Christian artists and missionaries have insisted that indigenous representations are necessary for effective communication of Christianity to take place, even that such images are sure signs that the church is taking root in native cultures. An outspoken Protestant missionary from Great Britain, John Butler, who was one of the most active promoters of indigenous Christian art, stated categorically in 1956 that

"Christianity will never be properly rooted in [non-Western] lands till faith and art are properly integrated in them."[18] But there were limits, even for Butler. When it came to the creative license exercised by one Indian Christian artist, Alfred Thomas, Butler balked. According to Butler, Thomas's art was too deeply shaped by the tradition of portraying the Buddha and "the most sensuous side of popular Hinduism" to be capable of expressing "the creed of Christianity, and especially to depict its central Person."[19] But another authority on Indian Christian art, Richard Taylor, objected, pointing out that Butler failed to realize that "in classical Indian art softness and smoothness are one thing, femaleness another." Taylor claimed that the majority of Thomas's critics "seem to be foreign missionaries—who too frequently have felt called to enforce western orthodoxy on the Indian church."[20] Yet the sensuousness of Thomas's treatment of Christ certainly met with objection from other Christian viewers in India and elsewhere. And when the sensuousness was combined with gestures, deportment, and iconography that recalled portrayals of the Buddha, the imagery encountered even stiffer resistance. A collection of pictures of the life of Christ by Alfred Thomas, published and distributed in 1948 by the Anglican Church's Society for the Propagation of the Gospel, was prefaced with the endorsement of the bishop of Calcutta and a statement: "In this book Christ is represented as a Holy One, an Incarnation whom non-Christians will recognise and Christians adore." The writer assumed an easy accommodation of Christian and non-Christian viewers, though he conceded that Western viewers might find one image by Thomas especially challenging. "For Western eyes the most difficult picture is that of the Transfiguration [fig. 43]. The joy of perfect colouring and design is marred at first sight for us by the blue of Christ's glorified Body. But that which to us is so strange is immediately understandable to Indian eyes. It speaks of the infinity of India's blue skies and proclaims Christ as a Heavenly being."[21] The conviction seems to be that a happy medium was struck by the Indian artist. Yet some critics objected that this meeting of cultures endangered the uniqueness of the Christian Gospel. A contemporary artist from India, S. S. Bundellu, for example, praised Thomas's artistic skill but considered his work "unsuitable for Christian purposes." Thomas, the Christian Bundellu continued, "has not told the true story of Jesus Christ and has not portrayed Him as true God, for his conception of Jesus Christ is that of Buddha. . . . I declare emphatically that I am opposed to the idea of seeing Jesus represented as a Hindu holy man or as a Buddha or as a

FIGURE 43. Alfred Thomas, *The Transfiguration*. From *The Life of Christ: Paintings by Alfred Thomas* (London: Society for the Propagation of the Gospel, 1948), p. 45. Courtesy of The United Society for the Propagation of the Gospel.

Buddhistic monk."[22] An Indian theologian expressed the underlying fear in this criticism of Thomas: cultural intermingling may result in syncretism. One church leader stated a characteristic desire to distinguish religious traditions rather than blur them: "Buddha should always look exactly like Buddha."[23] And, one hardly need add, Jesus should be immediately identifiable as himself alone.

EXPROPRIATED IMAGERY AND PRACTICES

As we have seen, not all local response to missionary efforts elicits the approval of missionaries. An important category of response is non-Christian appropriation of imagery. Expropriated imagery is detached from its Christian context and meaning and redeployed in a non-Christian practice. This may include the destruction of Christian images by those who oppose the faith, or it may involve the ritual abuse of such imagery, as in the case of the *fumi-e,* in which Japanese Christians in the seventeenth and eighteenth centuries were forced to choose between death or the renunciation of their Christian faith by walking on an image of Jesus.[24]

A striking example of intercultural misunderstanding mediated in visual culture is the story of the first Europeans in Cuba. When some natives took Catholic images brought to the island by Columbus's men, buried them in a cultivated field and urinated on them in order to produce a rich harvest, the Spanish responded by burning the offenders to death. As Serge Gruzinski has pointed out in relating the story, the ritual performed by the Cubans bore close resemblance to the way they used their own images. Clearly, they meant no disrespect toward the newcomers. The act was an attempt to insert the new gods into their own visual practice. Engaged in the joint task of colonialization and the defense of their own faith, the Christians interpreted what the Cubans did as an assault by infidels. They responded with brutal violence that enforced colonial rule and protected the uniqueness of their visual culture. If the Cubans saw an analogy between the two visual cultures, the Europeans wished nothing of the kind. Gruzinski commented that the episode "inaugurates the long parade of destructions, appropriations, misappropriations, and misunderstandings weaving through the cultural history of Latin America."[25]

Expropriated imagery is withdrawn from one cultural domain and made the property of another. But the expropriation need not be purely negative or destructive. In both the original setting and the new, each culture may seek points of correspondence or analogies where one culture can be mapped over another. Images provide the way of doing so. This analogizing may be conducted as a means of protest, as a strategy of survival or resistance directed against cultural incursion. It is also useful to bear in mind, however, that in many instances the two territories coexist very happily, so that one culture need not expunge the other. While this is not the case with fundamentalist

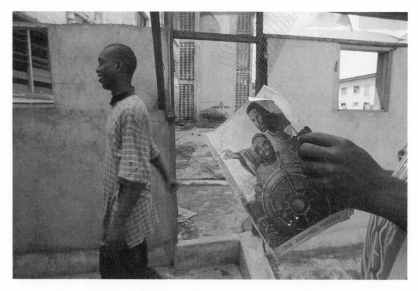

FIGURE 44. Follower of Jesus of Oyingbo with illustrated pamphlet, Lagos, Nigeria, November 1, 1998. Photo: Malcolm Linton/Getty Images.

subcultures in Protestantism and Islam, it is not difficult to think of instances of Sufism, Afro-Caribbean religions such as Vodou, or folk versions of Roman Catholicism where the boundaries between religious cultures are permeable and understood to be quite acceptable as such.[26]

This kind of imagery uses the image as a pivot or metamorphosis, as in the instance of expropriation depicted in figure 44, created by a Nigerian prophet, Jesus of Oyingbo, who preached that he was the Second Coming of Christ. A member of the religious group that gathered around the prophet is shown in figure 44 reading one of his publications, a pamphlet entitled *The Redeemed Paradise*. The cover of the pamphlet is a repainting of a 1950 image by Warner Sallman, called *Christ Our Pilot* (fig. 45). The young helmsman has been reconceived as the Nigerian prophet, wearing ethnic dress, who receives guidance and affirmation from Jesus. The motif of the sailor guided by Jesus has enjoyed far-flung circulation. Sallman himself based his painting on an anonymous U.S. war poster created in 1944 (fig. 46). This migration illustrates both the incessant recycling of imagery and the change of meaning introduced with each avatar.[27] In the World War II poster, Jesus steadies the helm, endorsing the fight of the Allies against

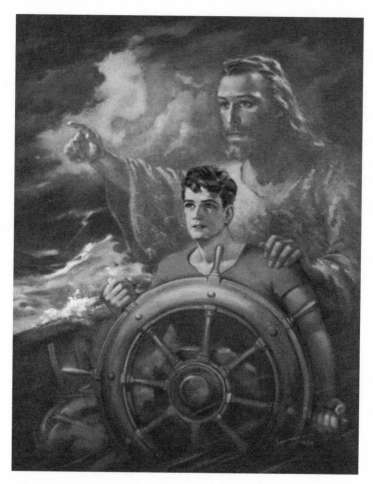

FIGURE 45. Warner Sallman, *Christ Our Pilot,* 1950, oil on canvas,
40 × 30 inches. Courtesy of Warner Press.

totalitarian aggression. In Sallman's image Jesus becomes the friendly,
even brotherly, helper, careful to respect the free will of the young
Christian man by refraining from taking hold of the wheel, as Sallman
himself pointed out. In the Nigerian iteration Jesus authorizes the mis-
sion of his namesake, Jesus of Oyingbo, pictured on the pamphlet's
cover. We witness in the move from one image to the next a shift in the
meaning of the touch: from an act of divine intervention, to a gesture
of benign counsel and care, to one of chiliastic blessing, a laying on of
hands that bestows messianic succession.

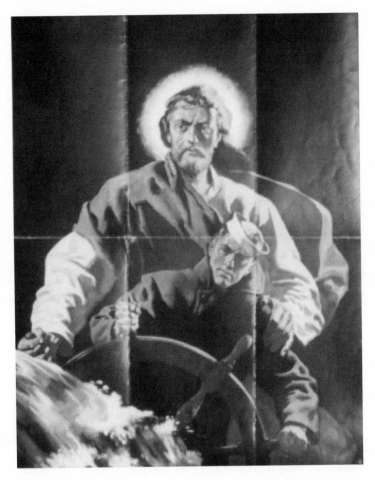

FIGURE 46. Artist unknown, Jesus with sailor (World War II poster). (Chicago: Printed by Extension, 1944.) Courtesy of the Jessie C. Wilson Galleries, Anderson University.

IMPORTED IMAGERY AND PRACTICES

Indigenous productions may introduce new motifs into the global circulation of imagery and visual practice, even returning to the missionizing culture and adding to or modifying it. For example, the painting *Christ before Pilate* (fig. 47), by Chinese Christian artist and seminary professor He Qi, was used on the cover of a church bulletin in a midwestern Episcopalian congregation in November 2000.[28] The original painting represents a Chinese indigenization of a Gospel story.

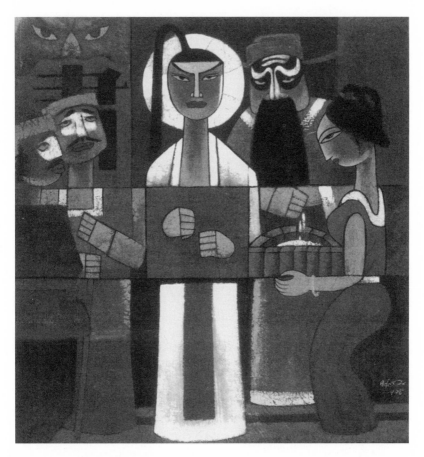

FIGURE 47. He Qi, *Christ before Pilate*, 1998. From a Sunday bulletin cover, 2000. Used with permission of the artist.

The artist has drawn from Chinese literature from the Song dynasty to interpret the biblical story of Christ's examination before the Roman magistrate. The Chinese source is the series of stories about Good Judge Bao, pictured behind Christ in Peking opera costume. In the story at hand, an innocent man is prosecuted and sentenced to death. At the last moment, the wise judge discovers the injustice and saves the man from execution.[29]

Yet the dissemination of the image among American Christians marks another stage of the circulation of imagery in mission history. Mapping the biblical story over the Chinese narrative modifies the former in fascinating ways for an American audience, portraying a

resigned Jesus as a resentful one, who triumphs in the end quite differ-
ently from what's described in the New Testament. With the addition
of the innocent man's lover from the Chinese story, the woman at the
right of Christ may appear to unknowing American Christians as the
Magdalene. Moreover, Good Judge Bao discovers the injustice in
contrast to Pilate, who passively sanctions it in the New Testament
narrative.

Importation also often involves a kind of appropriation whereby
the missive culture puts to work at home imagery that it finds
abroad. By way of bringing things back to nineteenth-century
American evangelicalism, we can consider an illustration from an 1867
issue of the *Child's Paper*, a publication for children produced by the
American Tract Society (fig. 48). A brief article states that this wood
engraving accurately represents an idol excavated in Hawaii, where it
was the victim of an iconoclastic purge conducted by the first wave of
Christian missionaries among the inhabitants of what Westerners
then called the Sandwich Islands. But if the missionaries destroyed
and buried images, the *Child's Paper* exhumed and reinstalled them
as "idols," a cherished Jewish, Muslim, and Christian category of
image that served not only to police the borders of cultures but also
often to justify violent assaults against what this article described as
"debased, ignorant worship."[30] The image as it appeared in this chil-
dren's publication was used by Sunday school teachers, church lead-
ers, and parents to characterize the difference between "heathen"
and "Christian" and to underscore the importance of missionary
outreach. Indeed, the image and article appeared at the time that
Anglo-American Christians were able to claim an unambiguous
triumph in Hawaii. So thoroughly had the population been evangel-
ized that in 1871 the American Board of Commissioners for Foreign
Missions removed the Hawaiian Islands from the list of foreign
missions. In this light, the image of the excavated idol was evidence
of evangelical conquest, but also proof of the need to carry on the
struggle elsewhere in the world, wherever the darkness of idolatry
was to be found. Whether used in the practice of teaching children or
proselytizing native cultures, the image served anew as a missive
device, an orientation toward the world and a conception of the
white American Christian's place and purpose in it. Originating in
Polynesian culture, the image was recoded and redeployed by Chris-
tians in the United States, reinitiating the relentless cycle I have
hastily described.[31]

FIGURE 48. "Idol" from the Sandwich Islands. From *The Child's Paper*, May 1867, p. 20. Courtesy of the Billy Graham Center Museum, Wheaton, Illinois.

NATIONAL IMAGERY

But the cycle is not completed until we consider what happens after the phase of foreign mission work. Indigenization establishes the faith in the new host culture in a generational pattern that makes different uses of the arts. Almost invariably the first generation that responds favorably to mission activity adopts the cultural packaging or media of the missionary's message with enthusiasm. For example, this may include objecting to drums in the liturgy in preference of pianos or organs. In visual matters, the first generation may regard Africanized Christ figures as objectionable, preferring instead the European or American images of Christ. One group of Congolese protested a black Madonna by insisting, "We want the same Madonna as the whites have."[32] Representing biblical figures as Africans has struck some African Christians as a form of Western condescension and others as historically inaccurate.[33] First-generation converts may be strongly motivated to secure difference from their previous religious identities. Often the new faith depends on this difference in order to take hold. Even Western missionaries who are strong advocates of indigenization find it difficult to object to this familiar demand. John Butler, a Protestant missionary and enthusiastic promoter of indigenous Christian art and architecture, summed up this capitulation for his colleagues in an article in the *Congregational Quarterly* in 1956:

When a convert tells us that he wants nothing about his church to remind him of the faith and ways from which he has, as he puts it, escaped, and whose pull back he feels in every aspect of life around him, it is difficult for a missionary, who by his mere good fortune is exempt from such cruel tensions of spirit, to do other than treat these scruples with respect.[34]

Arno Lehmann, a contemporary Lutheran advocate of indigenous Christian art, pointed out that some "members of the so-called Younger Churches . . . especially among the more elderly people . . . would not care about 'indigenization' of the arts, and they would even object to it. They would point to the danger of syncretism likely to creep through the door of art into the church. 'It smells or smacks too much of Buddhism or Hinduism,' they would say."[35]

The following generations of believers, however, may seek to differentiate themselves from the founding cohort by rediscovering aspects of the old culture that had been rejected by their mothers and fathers. Drums, dance, chant, portrayals of black Christs, and songs and liturgies composed in the vernacular serve to fit the faith to the new

generation and turn it away from the preponderance of the foreign missions that appealed to the previous generation.[36] The task now seems to be to *naturalize* the faith, to locate intrinsic correspondences to native rather than alien culture. The recovery of an indigenous ethos takes place in tandem with the emergence of an indigenous leadership, educated in their own national schools and seminaries, and in the context of the twentieth century, in the setting of national liberation from colonial rule and the formation of national identities. The second or third generation of Protestant Christians in many African settings has assumed control of national church bodies, replacing the prominent role of European and American missionaries to undertake the work of building consciously national cultural traditions and institutions. No longer colonial outposts of a foreign nation's religion, these churches regard themselves as national or nationally ethnic expressions of the church universal.

This shift is paradigmatic in significance. It is a creative moment of the rediscovery and invention of a new mythos in which Christianity intermingles with an emergent sense of nationhood. Images and other arts contribute importantly to the creative process by representing the new identity, giving shape to the new national consciousness and providing what may be ethnically diverse, tribally separate, and politically fractious groups with an overarching ethos of unity. Religion can become part of nationalism's "imagined community," as Benedict Anderson aptly named it.[37] Operative metaphors for describing this process are nationalistic and autochthonous. Religious art in this phase is described as "indigenous art that is native and permanently rooted to the soil."[38] Artists return to the pre-Christian styles, subjects, and media of art to mine it for "native" characteristics that will not only clothe Christianity in local garb but evoke a national consciousness, a "birthright" that Christians share as nationals.

Religious Art and Ethnic Identity

The task confronting Christian artists, particularly in nations where they are a tiny minority, is to craft an organic connection between their religious identity and the nation's. One missionary, Richard Taylor in India, noted in 1970 that Christian artists in that country felt themselves "especially under a burden to demonstrate their 'Indianness.'" Generations subsequent to the founding conversions in a national church may

wish, Taylor reasoned, to return to the culture that had been left behind and "reclaim part of their heritage—even, in a sense, to 'baptise' it. This, in my judgment, may be exactly what some of our painters like [Alfred] Thomas and [Frank] Wesley are doing." In his survey of several Indian painters, both Christian and non-Christian, Taylor noted the importance and the difficulty of leaving behind European models. He insisted that "if we take the whole fact of Incarnation seriously then the possibility of portraying Jesus with an Indian body and style cannot by any means be ruled out. On the contrary, maybe in some sense He must become, and be seen to become, an Indian." Taylor therefore expressed alarm at the popularity of Warner Sallman's *Head of Christ* (see fig. 39) in India in the mid-twentieth century, remarking that that image was more frequently garlanded and revered in Indian homes in the same manner as images of Hindu deities, *sadhus*, and ancestors than the Christian imagery by Indian painters.[39]

The aim of indigenizing Christian art in India was, in Taylor's view, well under way, though it was achieved by Christian and non-Christian artists alike. He cited a fascinating visual form that, while not an affirmation of the orthodox Christian understanding of Jesus, was certainly evidence of a native interest in and newly integrative appreciation of Jesus in Indian culture. A large painting in Madras by K. C. S. Paniker, called *Blessed Are the Peacemakers,* portrays the same three figures who appear in popular Indian lithographs in which Jesus, Buddha, and Gandhi are shown side by side as three iconic personalities (fig. 49, by Sitakarna).[40] Not a Christian, Paniker saw Jesus as what Taylor called a "Great Man." Jesus joined Gandhi and the Buddha (who had long since come to be considered an incarnation of Vishnu by Hindus) to promote a moral and social ethic of love.[41]

As John Butler pointed out in his study of Christian art in India, the "plethora of Christian paintings in India is mostly a triumph not of Christ, but of Hinduism, that is, of the 'Higher Hinduism' which holds, roughly, that 'All religions are the same.'"[42] The Higher Hinduism to which he referred had been inaugurated in modern India by a Bengali aristocrat and scholar named Rammohun Roy (1772–1833), who became very interested in Christianity, particularly Unitarian Christianity, in the early nineteenth century. In 1820 Roy published a collection of Christ's sayings and moral teachings, culling them largely from the Sermon on the Mount. According to Roy, Christ's ethic of love offered a vital model for modern Hindus, who needed to rediscover the transcendent monotheism of the ancient Vedic scriptures and

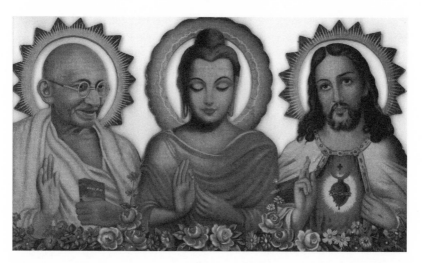

FIGURE 49. Sitakarna, *Gandhi, Buddha, and Christ,* 1961, lithograph on plywood. © S.V. Nantappachettiar and Sons, Salem 1. Gift of Reverend Dr. William and Mrs. Elizabeth Miller Danker. Courtesy of the Brauer Museum of Art, Valparaiso University.

to cast off the corrupt polytheism and its idolatrous practices.[43] Influenced both by Islam and by Unitarian Christianity, Roy went on to found the Brahmo Samaj (Society of the Worshippers of Brahma) in Calcutta, the city that became the center for Hindu reform and national consciousness throughout the nineteenth century. The Bengali renaissance in the twentieth century, centered in Calcutta and Santiniketan and conducted in painting by Abanindranath Tagore, had its source in Roy's efforts and the Brahmo Samaj.[44] From Roy to Paniker and other non-Christian Indians, Jesus represented not the Christian deity but the non-Hindu holy man whose ethic of love confirmed the wisdom of "true" Hinduism.

An emblem of brotherhood, the grouping of Jesus, Buddha, and Gandhi was intended by Paniker and the lithographic versions that followed to encourage the unity of postcolonial India. In 1952 an Indian theologian commented on the importance of Gandhi for Indian culture and the environment in which Christianity existed in the nation in a way that situates figure 49's alignment of Gandhi with Buddha and Jesus:

Gandhi's teachings represent the finest product of Christian influence on non-Christian India. Remaining a Hindu in belief as well as practice, he tried to integrate with the basic teachings of Hinduism the ethical teachings of Christianity, which he learnt primarily from the liberal Christian thinkers like

Ruskin, Tolstoy, Thoreau and others. He did not recognize any fundamental differences between the various religions. All religions stood for truth and love. He interpreted the Indian concept of *ahimsa* [nonviolence], a concept common to Hinduism, Jainism and Buddhism, as essentially the same as love in the Sermon on the Mount. By doing so he gave *ahimsa* a new content. His own example in suffering love showed *ahimsa* as a dynamic principle.[45]

Figure 49 portrays the three figures as revered teachers, each emitting an aura of wisdom and goodness and each presenting his teaching in symbolic devices or hand gestures. Gandhi raises one hand in blessing and holds in the other a copy of the Bhagavad Gita, the popular Hindu devotional text that Gandhi found so important that he translated it into Gujarati. Among his own interpretations of the Gita was the claim that it taught the doctrine of ahimsa.[46] Like Gandhi and Jesus, Buddha is pictured in the act of preaching, his hands shown in the *vitarka*, or explanation mudra, a gesture associated with his discussion of the dharma, or Buddhist law, which includes the admonition not to kill or engage in violence.[47] Jesus displays the Sacred Heart, emblem of his great compassion, and does so in gestures that may suggest an active discourse as in the Sermon on the Mount (among Gandhi's favorite New Testament texts), where he enjoined his listeners to turn the other cheek and to believe that the meek would inherit the earth (Matthew 5). The group argues visually that Gandhi's teaching of nonviolence, which he committed to the cause of a new Hindu national ideal, found all religions sympathetic to the national aim and regarded religious sectarianism as an enemy to peace and national destiny. Figure 49 represents, therefore, an instance of benign *expropriation* of religious iconography. Not intended to critique Christianity (though orthodox Christians might object to the image's reduction of their savior to a *sadhu*, or holy man), the image redeploys Jesus within a new cultural setting that ascribes new meaning to him and gives the visual motif a new currency.

Taylor also praised the work of an Indian Muslim artist, S. Y. Malak. As a Muslim Indian painter of Christian themes, Malak offers another instance of how religious art could be engaged in the cultural politics of identity in postcolonial India. In his watercolor painting entitled *Judas Bargains for Thirty Pieces of Silver* (fig. 50), produced in the 1950s, only a few years after the establishment of Indian national independence, Malak presents a religious subject in the "neo-Bengalese style," an artistic revival undertaken by the Hindu painter Abanindranath Tagore in Bengal. The image depicts Jewish religious leaders who, the Gospels report, paid Judas to betray Jesus. But Malak represents them as three

FIGURE 50. S. Y. Malak, *Judas Bargains for Thirty Pieces of Silver,* ca. 1950s, watercolor. From Arno Lehmann, *Christian Art in Africa and Asia* (Saint Louis: Concordia Publishing House, 1969), Figure 157. Used with permission of Dr. Theo Lehmann.

Brahmanic priests at the temple entrance. He wrote that the priests indicate with their fingers the figure of thirty and that he chose a nocturnal scene to signal the sinister nature of the event. The priests are shown with large stomachs to represent their "greediness and selfishness,"[48] recalling the iconography of northern European religious painting, in which the Jews conducting Christ's examination and persecution bear grotesquely deformed facial features and gestures. Malak put the visual formula to work in his own national context, though to a different end. Judas himself is not one of the Brahmanic Jews but is depicted in sympathetic terms, the victim of Brahmanic treachery. As a Muslim painting a Christian subject, Malak was also able to critique the

Hindu religious orthodoxy through the intermediary form of Christianity, a minority religion far smaller and much less controversial in his day than Islam was. Judas does not appear as a Brahman but gazes helplessly at the viewer and wears a *kurta*, the shirt garment largely associated with North India and the Mogul period, suggesting, therefore, that Judas is Muslim.[49] Wrenching the story from its biblical context and purpose, Malak expropriated a New Testament motif in order to indict what he considered Hindu orthodoxy's narrow religious definition of Indian identity. The contrast between Judas and his Brahmanic masters recalls another painting of a New Testament subject by Malak, *The Good Samaritan,* in which the wounded Jewish person of the biblical story is dressed in a dhoti (the Indian garment favored by Gandhi), and the Samaritan wears the dress of a Muslim.[50] In both cases, Malak appears to have intended his visual maneuver to suggest an underlying harmony between the narrative of Christ's execution and the error and presumption of the religious elite. By portraying both images in the recognized style of a modern revival of Bengali painting, Malak embedded his account in a visual vocabulary that told a Christian story in a way that affirmed a progressive understanding of Indian national culture. India, Malak's paintings seem to say, is more than a priestly and ritualistic conception of Hinduism. It is difficult not to regard the painting as a critique of a narrow-minded Hinduism in the wake of the bloody separation of Pakistan from India only a few years earlier.

Art, Religion, and Nationhood in the Postcolonial Era

The Christian art of national indigenization was vigorously promoted in the second half of the twentieth century by Christian writers, clergy, missionaries, and international church leaders and associations, who promoted a postcolonial flurry of nativizing Christianities in Japan, China, Indonesia, India, Africa, and Latin America. Arno Lehmann, a German theologian who was one of the Western champions of indigenous Christianity and art in the context of national independence in Asia and Africa, argued that indigenous Christian art should play a key role in the postcolonial age.

Since 1945 many nations have struggled for and attained their political independence, and others stand in the process of extricating themselves from old circumstances. With these cataclysmic revolutions, which also stress a decisive turning away from western influence, Christians do not stand neutrally

by. It is well and commends the Church that the new age secures a thoroughly indigenous Christian art and a strong will to do so, its own Christian art, which [regards] everything else as western and which in this time of upheaval and in the future will grow in importance.[51]

Some observers even tied the rise of Christian art in the new, non-Western states to the decline of the West and its art. In an essay of 1958, John Butler argued that the "degeneracy of modern art" was caused by modern Western society's loss of ultimate values, the decay of social solidarity, a lack of robust patronage, and the alienation of artists by stressing the importance of novelty. The religious art of the new, non-Western churches enjoyed a robust affirmation of spiritual values, social integration, support from nascent churches, and a vivacious engagement of artist and community. Butler hoped that the new art "could bring to Western art that new, constructive reinvigoration which it needs for its salvation."[52]

Attitudes toward modern art among Roman Catholic authorities in the twentieth century varied widely. The most important figure in the Catholic Church with respect to mission art was Celso Costantini, who cautioned against the exportation of modern art to the non-Western mission field. For Costantini, apostolic delegate to the Chinese mission in the 1920s, founder of the journal *Arte cristiana,* organizer of the Vatican's epochal exhibition of mission art in 1950, archbishop, secretary of the Sacred Congregation of the Propagation of the Faith, and eventually cardinal, art represented a vital aspect of mission work. Costantini argued for ethnic diversity in art and liturgy while submitting all art everywhere in the church to the unifying power of the Gospel as it was expressed in the Catholic Church and its cult, a view that was eventually endorsed as official policy by the Second Vatican Council in the 1960s.[53] But if he could celebrate the variety of indigenous Christian art for its varied response to the Gospel's inspiration, Costantini dismissed modern art and architecture when it exhibited a spirit that departed from the lesson of the artistic monuments of the past. Thus, "ultra-modern architecture lacks spirituality: there is the basis of the problem; it speaks a language that is barbarous in ecclesiastical settings and to the faithful themselves who frequent the church for gathering and elevating themselves to God." Costantini was even suspicious of the new technical materials used in modern architecture: "Reinforced concrete itself, whose merits and possibilities no one would want to deny, is today in many instances a pretext for useless ostentation and costly eccentricities."[54]

Costantini could even assert that it was advisable to avert one's eyes from the "fatigue" and "depravity" *(dépravation)* of art in the West, preferring instead the "missionary art, even as we turn [our eyes] to the primitifs of the Renaissance." Indigenous artists of the missions, he claimed, "make their art like a prayer, a lifting up, an homage to the deity and the saints. They paint or sculpt with the pure enthusiasm of the neophyte; the works inspired by this spring breeze, by this light of dawn charm and enchant like the works of our primitifs."[55] The works of these new Fra Angelicos promised to revitalize the West.

The Catholic Church, according to Costantini, was guided in its mission work "by a spirit strongly different than the imperialist spirit of colonizing nations." The church had no intention of affirming imperialism's "political-religious domination." If missions had in the past followed the example of colonizers, the pursuit of mission art today was to be undertaken from an advanced level, under the auspices of a scientific missiology and with "more respect to the art and to the culture of different peoples."[56]

Beginning in the 1920s and 1930s, the Catholic Church under the leadership of Pope Pius XI exhibited a concerted effort to revivify world missions. The rise in mission exhibitions during this time and the emergence of mission or missionary art exhibitions from the broader category of historical and ethnological mission exhibition—keenly promoted by Costantini—helped refine the awareness of indigenous art.[57] The point was to promote the indigenization of the faith in the late colonial moment, which would shortly become postcolonial. Costantini's cause was to demonstrate that mission art was a way for the church to show a salutary effect on host cultures. Artistic production, he and many others, both Catholic and Protestant, believed, was a preeminent way to make the faith take root and render organic evidence that the spirit of a people was not colonized but remained true to itself after evangelization, even came into a purer, more spiritual awareness of itself. Costantini summed up this position succinctly in two of the characteristically brief assertions in his widely read book *L'Art chrétien* (Christian Art):

The catholic character of the Holy Church demands that everything in the world that has a certain value, that all lights of beauty and truth, even the most lowly, be incorporated in its language.

 In this intellectual and artistic conquest, the Holy Church does not destroy and does not rank civilizations; with its powerful spirit of unity and universality she [the church] unites them without deforming them.[58]

The archbishop and secretary of the Sacred Congregation of the Propagation of the Faith apparently felt that by stressing the church's catholicity its "conquest" of cultures was not a form of colonialism. Instead, Costantini and Pius XI viewed "catholicity" as an incorporation of the indigenous into a larger spiritual regime. This universal scope, they believed, extended to the culture the right to preserve itself, insofar as aspects of its particular identity did not conflict with Catholic doctrine.

The artistic produce of indigenous cultures was gathered up in new institutions such as the Vatican's Museo missionare-etnologico, which opened on December 21, 1927, the Missionsmuseum in Aachen, opened in April 1933, and a number of others in France, Italy, and Vienna, as well as in dozens of exhibitions of mission art throughout Europe and around the world.[59] Art, Catholic missiologists insisted, was a telling index of indigenization of the faith. As Pius XI put it in an apostolic letter in 1937: "Art, which is one of the highest manifestations of the genius and culture of all peoples, offers to the Holy Church the most dignified and the most beautiful means for celebrating the external cult."[60] In 1935 Cardinal Fumasoni-Biondi, prefect of the Sacred Congregation of the Propagation of the Faith, wrote the American journal *Liturgical Art* the following formulation:

The intention of the Church is evident and simple: to abstain from importing a foreign style of sacred art among the new Christians of a pagan land and to seek to adapt art to the ecclesiastical exigencies existing in each country. This represents an expression of the Church and serves to convince the people whom we wish to convert that the universal *[catholique]* religion *comes from above, not from outside.*[61]

The Catholic doctrine of "adaptation," succinctly stated here, aimed at preserving ethnic or racial identity in the arts and detaching them from political and economic conquest. For Costantini and his colleagues, beauty was both local in its response to the Gospel and universal as a manifestation of divine truth. Indigenous art was the aesthetic strategy of resisting Westernization while assimilating Christianity. As the aesthetic signature of spiritual purity, beauty allowed a clean distinction between politics and faith, forming a unity that avoided the economic interests and exploits of colonialism.

By midcentury, however, the notion that the spread of the Catholic faith could occur without doing violence to native cultures was openly rejected by some, including the French Dominican artist, editor, and arbiter of progressive Catholic taste, M.-A. Couturier. Lamenting the

hapless destruction of the art and culture of "primitive races" by missionaries, Couturier saw the art of Africa as having ended. "The only fecund, vigorous African art at present was born in the slums of large American cities and Southern plantations, with no thought of ancestral Africa."[62] The proclamation of Vatican officials notwithstanding, Couturier blamed the loss of indigenous culture on Western missionaries, who, in matters of art, he claimed, were "no better and no worse than their contemporaries, the military, the colonists, the civil servants of the State." Couturier regretted the importation of Western imagery into the mission field and insisted that "truly living Christian societies will always invent living forms through which to express themselves." Yet he affirmed the redemptive role of the Christian West in spite of its transgressions against colonized peoples: "Contact with Christian realities and Western cultures will spur the invention of new forms corresponding to the genius of each race."[63] Although it is important to remember that Couturier and other Christians applauded the influence of African and Asian art on European artists such as Matisse and Picasso, and therefore they recognized that cultural contact created cross-fertilization; nevertheless, with Christianity as the leaven of the nations, the principle of adaptation remained intact.

The idea of adaptation also appealed to Protestant missionaries and mission art advocates from Europe and the United States, for whom indigenous art was often regarded as a measure of the national autonomy as well as the cultural well-being of an evangelized people. Several Protestant authors published extensively in favor of the indigenous art of Asian and African Christians. Their articles and books celebrated the native art as a sure indicator of the health and rootedness of the emerging native churches. Arno Lehmann asserted that art and the concern for it among the new churches "are important hints of the growth of Christian self-identity and the measure of indigenization, a yardstick for determining how far and deep a church has grown into a people and a culture."[64] Three of the most widely circulating and often-cited books, which contain hundreds of reproductions of art by Christian artists from around the world, hailed the possibilities of indigenous art. Arno Lehmann's *Die Kunst der Jungen Kirchen* (The Art of the New Churches, 1955; 2nd ed., 1957), his *Christian Art in Africa and Asia* (1969), and Masao Takenaka's *Christian Art in Asia* (1975) all advocated a postcolonial recognition of national churches and asserted the central importance of the visual arts in representing a thorough indigenization of Christianity in each nation. Both authors distinguished

between the earlier mission phase of Christianity and the development of national traditions of the faith. The earlier moment had been dominated artistically by the importation of Western imagery, "whole shiploads of European devotional materials," which many observers looked back upon as "inferior representations in poorest taste" that should be blamed for spawning "the low state of our Christian art."[65] It was not until nationals who were trained in art could begin to seek out their own character as artists and Christians within their national tradition that vigorous "styles and idioms" would emerge. According to Masao Takenaka, "one of the most important factors in the cultural renaissance is the rediscovery of self and the releasing of the energy of self-expression." Takenaka understood "the basic concern of nationalism [to be] the selfhood of the people," which he defined as "a community of selves responsibly participating in the course of their own history." He maintained that the human self was part of "the continuous stream of cultural history," not a creation ex nihilo. Postcolonial nationals must struggle to discern this continuity but not by "the nostalgic way of returning to the past." Both Takenaka and Lehmann stressed the significance of the new generation of Christian peoples liberated from colonialism, whom Takenaka described as "people who have regained selfhood."[66] Lehmann expressed himself in the tone of a manifesto:

The Asiatics and Africans, who are right in the midst of today's turmoil, who are imbued with an intense nationalism, and who are opposed to every form of colonialism, though this new form might be only on a spiritual and cultural level, will not even pause to look at Western forms of art, especially if they suspect this art is intended as a vehicle of communication. So art, too, in all its aspects and in the fullest sense, cannot be allowed to continue as the famous and often cited "flower-pot plant" that is imported from the West, whose roots are surrounded by European soil and prevented from making contact with the new soil by the solid surfaces of the flower pot. This kind of art cannot be fostered any longer, not even if one buries the whole works, pot and flower, in the ground, waters and tends it carefully, and it appears as if the flower had taken hold and were growing in the soil of India or Asia.[67]

The political challenge issued by Lehmann is clearly signaled in the original German title of his book, *Afroasiatische christliche Kunst*. Although his translators emended the title when rendering it in English, the term *afro-asiatic* remains in the text to designate a bloc within the international Christian world, its other obviously "Western." In anything other than the cultural politics of Western Christianity, the source

of missions to Asia and Africa, there is no such thing as "afro-asiatic." The very notion undermined the nationalism that Lehmann wished to affirm among his American and European readers. Yet it was no doubt a convenient canopy under which Asian and African ecclesiastics might gather in order to redefine the church and its agenda in the postcolonial era.

"Afro-asiatic art," after all, sounded much grander and more global than "Indonesian art" or "Congolese art" or "Bengali art." Yet it was the energy of nationalist awareness that Lehmann and Takenaka considered the great engine of political economy, and therefore an undeniable condition of religious growth. Indigenization became a primary issue in the post–World War II formation of new nations. Indigenous Christian art was to serve a key purpose. Benedict Anderson has described nationalism as a way of imagining community that differs from the older imagination of religious community. Whereas Christendom, Islam, Confucianism, and Buddhism each understood themselves as cultures measured by a common sacred language (Latin, Arabic, Chinese, Pali) and a geographically expansive history of statehood rather than in terms of nationhood, nationalism consists of imagining community in terms of a circumscribed and enduring geographical unit, a dominant race or ethnicity, and the uniform (if often invented) history of a particular people.[68] This suggests that indigenous Christian art was art that straddled a portentous divide. Advocates of Christian indigenization urged a balance between religious community and national community—the one necessarily international and ancient, the other necessarily national and modern (however ancient its origins might be imagined). Lehmann and Takenaka, probably more than most Catholic missiologists, encouraged the nationalization of Christianity as a way of assuring that it would take root in its host cultures. That process accorded with a Protestant ecclesiastical polity more than with Roman Catholic ecclesiology.[69] The Protestants were also able to bring to national selfhood a concept of individual conscience and vocation that matched modern art and postwar political developments.

The rhetoric of the politics of identity is notorious for the license it takes. For instance, even a glance at the artwork that Lehmann and Takenaka reproduced in their volumes demonstrates that Asian and African artists had spent considerable time looking at European art. Much of the work suggests more than a passing familiarity with twentieth-century painting in France, Germany, Britain, Spain, and the United States. And there is good reason to suspect that modernist

aesthetics and artistic styles undergirded the nationalist imperative in art that Lehmann, Takenaka, and other Christian writers championed. Modernist art had certainly done so in Europe in the case of the truculently chauvinist Italian Futurists, and contemporary American abstract art was being sent abroad as propaganda of the cultural superiority of the West.[70] Not only did late-nineteenth- and twentieth-century avant-garde painting and sculpture in Europe and the United States find the traditional arts of Africa and Asia welcome forms of artistic inspiration, but also, Western artists pursued a self-determination and practice of personal expression that endorsed emancipation from traditional authority and the prescription of taste and beauty. The resulting aesthetic of selfhood clearly appealed to the aesthetics of national indigenization and was explicitly championed by Lehmann and Takenaka as well as many of the artists whose work they praised. Lehmann's faith in the modernist ideal of the avant-garde was sufficiently deep that he even hoped Christian artists might serve prophetically to lead theologians toward indigenization: "Could it not be that in the providence of God the artists could in their way show the way to indigenization even of theology? Artists are said usually to be ahead of others and ahead of the present time!"[71]

In the end, the balance of conservative and progressive forces in the visual culture of national indigenization of Christianity served the task of propagating the Christian Gospel. Lehmann affirmed this in urging Christian artists in Asian and African nations to learn the "native" artistic languages of their respective countries. "Even art," he insisted, "cannot speak a foreign language." But neither is this language spoken merely for its own sake. It exists to communicate a content, and Lehmann stressed the need to submit artistic idioms to the higher task of communicating the Gospel: "Everything that is converted or translated into other kinds of art and expressed in a new language of art must in every case agree with the old and eternal truth of Scripture."[72] Here Lehmann sharply departed from the modernist aesthetics that he found useful only insofar as they stressed the autonomy of the *collective* selfhood of the Christian artist grounded in Asian or African national identities. Such modern artistic sensibilities as those evident in Dada, Surrealism, or the extremely personal self-reflection of artists since the 1960s in Europe and the United States would find the yoke of communication and responsibility to the larger community both onerous and unacceptable. Indeed, they might even insist that such concern makes art into a vehicle for something else, an instrument serving a nonartis-

tic purpose that amounts to an oppressive, even propagandistic limitation of its freedom. The churches in turn might regard such a view as characteristic of Western individualism run amok, resulting in a solipsism and narcissism that find no proper place within Christian ethics.

Any religion will bear a particular relation to media given its understanding of such fundamental coordinates in religious worldviews as revelation, the divine, the material world, and the human body. Christianity's core teaching of the incarnation—the entry of the transcendent into historical and human form in the person of Jesus of Nazareth—has been the touchstone for Protestant and Catholic theologies of mission and communication. Arno Lehmann spoke for many theorists of mission when he claimed that "the ultimate and real reason for the desire for native art and for bringing the Biblical events into the private world of experience and capacity for understanding is based on the incarnation." He proceeded from the idea of the historical and personal particularity of the incarnation to argue that grace—the act of God to redeem humanity—does not erase time and place or cultural specificities, but works through them. "Grace cannot be generalized. There is no such thing as a spiritual-theological Esperanto. Grace does not destroy what we have; it completes nature. Thus art as a language by itself retains its originality. There is no uniform religious brush. The brush will remain Indian, Japanese, African."[73] For Lehmann and other advocates of indigenization, this theological rationale accommodated the formation of the national self in the postcolonial era, which served as the fundamental political unit for Christian churches in the global setting following World War II. It was certainly expressed in the regional associations that emerged to promote the interests of underdeveloped, newly formed national entities in a world dominated by Eastern and Western blocs that were driven by political and economic motives that cared little for local circumstances in light of the high stakes of the Cold War. One such association was the Christian Conference of Asia, which sponsored Takenaka's project to collect and publish Christian art in Asia.

Not everyone shared the optimism found in the projects pursued by Takenaka and Lehmann or their affirmation of modernist art and aesthetics as sympathetic to the indigenous project of non-Western Christian art. In an essay published in 1964, John Butler asserted that the church's long tradition of "adaptation," which he linked to Celso Costantini, had come to an end. Butler was critical of attempts in church architecture and painting that sought to indigenize Christianity,

arguing that these attempts were doctrinally dangerous or simply wrong, and that they led inexorably to an impasse between Westernizing and indigenizing parties.[74] The only way out of this "stalemate" was offered by a new "international style" of reinforced concrete construction (which Costantini had explicitly criticized) and new material such as plastics and industrial metals. These originated in Europe and joined with another European innovation, the liturgical movement, with its emphasis on functional design dedicated to communal worship, to present a significant opportunity of change that was not, according to Butler, regarded as Western by non-Westerners.

Yet Butler's optimism was not to persist over the following decades. In 1973 he published a different assessment. Butler had come to see art and the non-Western church in the light of a new age: the age of the decline of the West and the new nationalism of the non-West. Western society had lost its capacity for critical judgment and settled into a debilitating "relativism," according to Butler, a historicizing of standards that abandoned any claim to "absolute values by which other cultures may be measured and found wanting." Butler welcomed this only inasmuch as it widened appreciation of non-Western cultures, but he considered the "general rejection of absolute standards, and especially its supercilious denial of the insights of the Christian cultural tradition . . . [as] the major tragedy of our times." To this Western failure he added what he called the "paganization of the West," by which he meant the death of God and the minority of Christians in a "militantly pagan milieu."[75] Butler approvingly cited a recent book, *Modern Art and the Death of a Culture*, by a Dutch art historian named H. R. Rookmaaker, an evangelical Reformed Christian for whom modern art portrayed the spiritual devolution of Western culture into something distinctly non-Christian. For Rookmaaker this was a return to the situation of the early Christians in a pagan world.[76]

Butler saw Western culture in a state of confusion. And non-Western art was no longer in the stage of indigenization. The new nationalisms had become antitraditional and dismissive of older forms of culture. "When Cardinal Costantini began his campaign," Butler explained, "a large part of its purpose was to meet the demand that the local traditions be respected and used. But now an incoming religion that seeks to clothe itself in the old local forms is in danger of appearing not in accord with its context, but out of tune with it, not respectful, but merely old-fashioned." Indeed, Butler continued, attempts at indigenization now appeared "anti-national" and were therefore doomed.

"The new nationalisms," he proclaimed, "demand the new forms." This meant that the new states defined modernism essentially in terms of their competition with one another. Whereas the previous generation had sought to balance the adaptation of new ways with the conservation of the old, the present generation believed that "national greatness lies in being ahead of other nations in the power and wealth and techniques and modes of modern life." In art this meant the use of abstraction, which Butler lamented as so much the "product and expression of spiritual decay that it cannot properly be used as the bearer of positive values." Moreover, Butler now regarded indigenous art from a sociological perspective, which "enables us to see that non-Western Christian art is just one special case of the peculiar complexities that occur when diverse cultures meet and stake their claims in the minds and mores of the same people, giving rise to the difficulties and opportunities technically called 'problems of acculturation.'" In light of this new modeling of cultural encounter, the special dispensation of indigenous art and its church seems to have waned in the older Butler's eyes. He urged his readers to consult great moments in the past such as the encounter of Hellenism and Buddhism at Gandhara or Indian and Chinese cultures in Southeast Asia in order to find an answer when asking "whether in any given set of circumstances indigenized Christian art is likely to be a start to a living new art, or instead to peter out in a sterile hybridism." And the answer may not be affirmative. "Art, he glumly concluded, "is in utter confusion. . . . It is all too easy to feel that this is a period in which real Christian art is no longer possible."[77]

This discussion may allow us to draw some preliminary conclusions about the study of images in mission history. The way of approaching the subject outlined here understands images and their uses as the site of cultural engagement between or among groups, as visual means for interpreting and representing one another, and as a medium for a group's self-understanding. The approach finds meaning not fixed in images, but discontinuous, historical, realized in practices, in the circulation of iconography, in the exchange of one covenant for another, and as part of a larger and fluid series of cultural encounters and imaginings that bring vast institutions and global economic forces to the local world evoked by images and what people do with them.

The endless recycling and migration of images may seem a fashionably "postmodern" way of thinking about images, but they are better understood as a historical process that images accommodate. It is not a

deconstruction of images per se that my analysis undertakes, but rather an account of the circulation of meanings and the instability of iconography as images cross the boundaries of one culture and become the property of another, or even as images are used to construct and maintain such boundaries invested in one way of seeing or another. And to the six moments delineated here, we ought by rights to add a seventh. As the work of Richard Davis has suggested,[78] the "lives of images" include their removal from worship settings to museums and, we should not overlook, to scholarly monographs, where yet another deposit of meaning settles over their worn surfaces, allowing new forms of veneration to begin.

PART THREE

The Social Life of Pictures

Engendering Vision

Absent Fathers and Women with Beards

Seeing is not only a biological ability in human beings but also a learned and historically constructed behavior. Cultures equip their members with visual means through which and in which they may see what they take to be real. One of the most important filters through which people see themselves and others is gender, which, like vision, is both biological and cultural. This chapter demonstrates by means of a case study the way in which seeing gender in American visual culture engendered vision.

In chapter 2 religion was defined as a powerful form of boundary-marking and reinforcement. Gender is perhaps one of the most prevalent forms of organizing social life and personal identity. Keying gender roles to religious authority was especially attractive to Protestant moralists, parents, clergy, and educators in the nineteenth-century United States. These representatives of authority and the Protestant status quo faced the menace of deep structural changes in political and economical life, which threatened to transform the ordinary order of domestic affairs and public decorum. If a gaze or way of seeing is a relatively discrete constellation of ideas, feelings, assumptions, and attitudes in certain images and practices of using them, Protestants came to believe that a way of seeing could be instrumentalized, at least in theory, as a way of disseminating particular notions of gender.

Protestant Mothers in the Antebellum American Home

A generation of scholarship on the social history of the white American family has developed a compelling narrative. With the rise of the

industrial revolution in the early republic, the colonial paradigm of the patriarchal family was challenged by a new set of economic circumstances and social arrangements.[1] Production during the colonial period had been centered in the home, with laborers and apprentices living under the same roof as the owner of the mill, farm, or shop, where the master craftsman and father-owner was the principal authority in household and workplace. With the rise of the factory and the expansion of wage-earning urban populations, the owners and managers relocated to quiet side streets and neighborhoods near the business district while the laboring classes congregated in separate neighborhoods. The paterfamilias spent more and more time away from home, working at the office or factory. Responsibility for domestic order, including religious formation, was therefore increasingly invested in the mother during the antebellum period.[2]

This account, however, should neither overlook the many activities of women outside the home nor ignore the evidence of the anxieties of middle-class fathers regarding the lives of their children and the persistent involvement of many fathers in domestic concerns.[3] There was not, in fact, a wholesale exodus of middle-class fathers from the home. And many of the fathers who spent increasing amounts of time away from home suffered guilt and regret for doing so. Yet it remains the case that fathers in the antebellum period left the home for the workplace as American industry and finance expanded and the work force moved from country to town and city. One does well, therefore, to proceed mindful of the complexity of evidence when examining the wealth of visual materials illustrating the publications of antebellum Protestants who were concerned about the state of the American family in the period. The domestic images of mothers with children and paternal absence to be examined here may be better understood as ideological formations than as "snapshots" of family arrangements. The images, in other words, were designed to foster an ideal that responded *both* to the actual circumstances of mothers assuming greater responsibility in home life because of increased paternal absence *and* to the desire of Protestant men and women to resist the movement of women into social roles beyond the home. The new economic forces of factories and the growth of urban centers provided markets for female labor that drew heavily on the (frequently immigrant) lower classes.[4] Middle-class Protestants responded by underscoring class distinctions, clarifying the respective roles for both men and women. The proper sphere for middle-class Protestant women was the home. As Stephen Frank has

pointed out in his fine study of nineteenth-century fatherhood, the working-class practice of sending children into the workplace and valuing them for their economic potential contrasted with the middle-class valuation of children. For fathers who worked increasingly away from home, a new, sentimentalized understanding of children as the organic product of loving mothers at work in the domestic nest of the home contributed to an important social distinction between the classes and helped form middle-class consciousness.[5] Hence the importance of middle-class mothers staying at home and the central role for advice literature to tutor mothers and reinforce this view of maternity.

The image reproduced as figure 51 illustrated a religious weekly of 1857, published in London but distributed in the United States. It shows the bourgeois mother solemnly fulfilling her role in the home while the statuesque patriarchal "head" of the household appears rather like a surly monument to his own absence.[6] The mother teaches her child the Proverbs, indeed, teaches him the importance of teaching him the Proverbs, in particular, Proverb 22:6: "Train up a child in the way he should go." The mother has called her son away from his playthings, which he has obediently left on the floor, in order to be instructed. Above the mother and to the left hangs an elaborately framed painting of an ancient scene, with a mother and grandmother instructing their son/grandson, arguing visually that the modern duty of mother teaching son was in fact an ancient one. It can be determined from another antebellum image that the older woman in the painting is Lois and the younger, Eunice, the grandmother and the mother of Timothy, whom they teach.[7] If the marble bust atop a classically decorated parlor organ or wardrobe represents St. Paul, as the bald head and toga may suggest, the irony is complete, since it was Paul who, in his letter to the Ephesians (6:4), directed fathers, not mothers, to rear their children "in the discipline and instruction of the Lord." Moreover, when Paul remembered Timothy's mother and grandmother in his second letter to Timothy, it was for their faith, not their pedagogical practice (2 Timothy 1:5). Therefore, the image modifies the scriptural record to fit contemporary domestic piety. But even if the bust portrays only a classical figure, it remains the mute effigy of a brooding patriarch who commands only a titular presence in this domestic cult of maternity.[8]

As figure 51 clearly suggests, the audience for admonitions to honor and practice republican motherhood was not working-class women but those of the middle class: that is, not the women who were employed in factories or mills but the wives of factory owners, mill operators,

FIGURE 51. "Train Up a Child in the Way He Should Go." From *The Sunday at Home* 4, no. 185, November 12, 1857. Courtesy of the Billy Graham Center Museum, Wheaton, Illinois.

bankers, merchants, landowners, managers, and entrepreneurs of the middle and upper middle classes. These images and the literature they illustrated helped shape bourgeois self-consciousness and the emergence of a self-identifying middle class. The republican mother, in other words, was a symbol of the middle classes.[9]

In 1820 more than half of the white American population was sixteen years old or younger.[10] Over half of these young people were single and female among urban laboring classes and constituted a

group whom Protestant educators and reformers sought to direct to the safety and propriety of the domestic sphere. Teaching and benevolent work were among the few acceptable public roles for middle-class women in the national campaign to secure the Christian Republic of the United States, as northern Whigs liked to imagine it. Literature produced by the American Tract Society sought to restrict women to the home sphere by reassuring them of its impact on all of society. A tract entitled "Female Influence and Obligations," first circulated in 1836, cautioned women: "It is not your province to fill the chair of state, to plan in the cabinet, or to execute in the field; but there is no department of human life, and no corner of the world, where your influence is not felt."[11] In fact, the tract went on to suggest that if women were to withdraw from such public spaces as the ballroom, the soirée, the theater, and the stage, if women were to denounce duels and drunken men, and if all women would revere the Sabbath by attending church, then nothing less than the millennial and "blessed reign of Christ would be established on earth." But women were not strictly limited to the home, as the image illustrating this tract demonstrates. The tract itself stated that women were better able than men to minister to the children of the poor by gaining access to their homes and bringing them to Sabbath school. The tract urged women to serve as "guardian angels" and "throw [themselves] between these little immortals and destruction!"[12] The woman's redemptive influence was likened to Christ's.

The republican mother was encouraged to influence world affairs from the parlor and the hearth, taking care to shape tomorrow's businessmen and civic leaders within the nurturing dominion of "fireside and the family circle."[13] "While the husband and father is pursuing his business abroad," one tract put it, "the wife and mother is, perhaps, imparting a cast of character to those around her at home, which may extend through many generations."[14] *Home religion* and the *domestic altar* became watchwords in Protestant advice literature. Primers, spellers, and readers were issued by religious and secular publishers alike in order to equip mothers with a pedagogy and curriculum that would instill an evangelical piety stressing duty, benevolence, self-denial, patriotism, and clearly defined gender roles.

The rapid growth of Sunday schools and public schools notwithstanding, depictions of children at home were more common than children in schoolrooms in American Protestant publications before the Civil War. The home remained the archetypal site for shaping the

FIGURE 52. Alexander Anderson (engraver), mother with children. From *Parental Duties,* No. 27 (New York: American Tract Society, 1826). Photo: Author.

character of children, and it was mother who was in charge. Images such as figure 52 appeared on the covers of tracts designed to instruct mothers (and fathers) in the task of instructing their children. Such tracts, books, and articles were more often aimed at mothers than at fathers, since mothers were engaged in childcare from birth. The tract *Parental Duties* (1826) naturalized maternal care of children: "It is indeed a rare thing for a woman to 'forget her suckling child.'" Though the tract addressed itself to "Christian parents," the image on its cover makes clear who was the primary caregiver and for whom the tract was principally intended. If "religion and morals are the glory and strength of a country," as the tract stated, it was mothers, more than fathers, who were understood to bear the lion's share of inculcating religion and morals in the nation's children.[15] The mother in figure 52 is roundly engaged in the task, working with both hands to rock an infant, receive a child's petition, and oversee two other children, one of whom is engaged in a reading lesson. The mother sits enthroned in her domestic court. Father is absent, away at work, at the office or bank. Although she and her children occupy a tastefully appointed interior that opens onto a terrace, the mother does not wallow in luxury. Her thrift and dedication are unmistakable.

FIGURE 53. Family at worship. From Philip Doddridge, *Family Worship,* No. 18 (Boston: Printed by Flagg and Gould for the American Tract Society, 1824). Courtesy of the Billy Graham Center Museum, Wheaton, Illinois.

Other images of domestic piety were also used to illustrate American Tract Society publications. The subject of family worship was treated by two tracts issued in Boston (1824) and in New York (1826).[16] Figures 53 and 54 illustrated tracts taken from the writings of eighteenth-century non-conforming pastor Philip Doddridge. Each portrayed family worship in homely terms. In both images the several members of a single family worship together, gathered within a dark interior, about a hearth. Yet the two images differ from one another and in different ways from their common text. The difference between the two images illustrating the same text registers the ideological shift from the domestic presence of the colonial father to his antebellum absence. The first (fig. 53) is a more faithful illustration of Doddridge's eighteenth-century devotional meditation; the second (fig. 54) represents the domestic practice as it took shape during the early nineteenth century. In figure 53 the individuals are isolated from one another, presumably in order to concentrate in prayer without the distraction of gazing on or even glimpsing one another. Father dominates the scene as the apex of a triangle inscribed across the room, with the hearth as the base. Rank is of great concern, as Doddridge's text signals: the paterfamilias is

FIGURE 54. Alexander Anderson (engraver), family at worship. From Philip Doddridge, *Family Worship*, No. 18 (New York: American Tract Society, 1826). Photo: Author.

located in front of mother (note that the Bible resting on a table faces the father, who was its reader); genders are separated on either side of the room, and what may be a female servant is confined to the back of the room, facing a door. The isolation of each person and the looming, closed doors suggest a tone of solemn privation overseen by paternal authority.

The image reproduced as figure 54 reflects a mitigation of the severity of eighteenth-century patriarchalism. This illustration portrays a cozier domestic interior in which family members recite prayer from a common text (according to Doddridge's text). Their Protestant union is evident by the books they conspicuously hold before them. But there is a curious disjuncture between text and image. Doddridge spoke to the eighteenth-century paterfamilias of Great Britain in the text of the tract, addressing the reader as "Sir," "parent and master," "the father of a family," and the person who was in charge of servants as well as family members. The image, however, does not privilege the older male on the left but centers rather on the hearth, countering pater on the left with mater on the right. There is nothing to indicate that anyone is a servant (the manner of dress and placement in the room signal that rank among the younger is uniform). Mother and father are the bookends to this domestic library of worship. Thus, the American

Tract Society drew on the cultural and theological authority of a well-known preacher and avid supporter of the evangelical revival (from his pulpit in Northampton, England, where he was both an educator and a writer) but visually interpreted his message in a manner that conformed to nineteenth-century notions and practices of family life.

This imagery opens a nostalgically tinted view on the past. If figure 53 is closer to the social structure advocated by Doddridge, the figures are dressed in clothing that was fashionable at the beginning of the nineteenth century as formal attire. By contrast, the elderly male figure in figure 54 is dressed in a clearly anachronistic manner, the better, perhaps, to signify his venerable stature as pater. In somewhat different ways, then, both illustrations urged Americans to practice a Christianity ascribed to their forefathers. If figure 52 more accurately represents the actual social practice of raising Christian children during the early republic, figures 53 and 54 succinctly visualize the ideology of the task. And a lithograph by Nathaniel Currier crystallizes the nostalgic function of domestic visual piety in the antebellum period. The image (fig. 55) conflates a young woman's act of prayer with her pious gaze of vision and memory upon the domestic prayer of mother and father, portrayed in another Currier lithograph on the wall of her parlor. An early example of "product placement," Currier's print envisions the middle-class home as a sacred altar in which commercial, mass-produced imagery facilitates a visual piety of remembering parental practice and securing the "the way to happiness," as the print is titled.[17] But in its own way, figure 55 takes a step closer to the experience of many young women in the middle of the nineteenth century—the single working women and middle-class women who lived alone or at least without a husband.[18] The Bible reader in figure 55 remembers the Bible reader of her youth, her father, whom she now replaces in her solitary search for happiness. In this instance, his absence is visualized as an act of nostalgic memory.

Mother was widely addressed and depicted in antebellum Protestant literature as the child's best friend, teacher, and spiritual counselor—even to the point of eclipsing the paternal presence, as suggested by a tract illustration of about 1830, republished in 1842 (fig. 56), in which the father appears eclipsed or displaced by the regally gesturing mother, a kind of forgotten presence who looks on anonymously over mother's shoulder. As an image illustrating a tract on early religious education, this wood engraving places the emphasis not on the

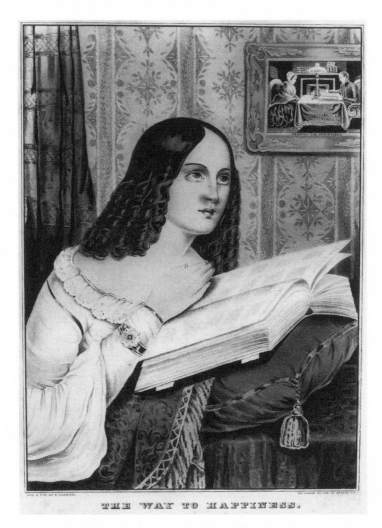

FIGURE 55. Nathaniel Currier, *The Way to Happiness,* ca. 1838–1856, lithography no. 120, 152 Nassau Street, New York. Courtesy of the Billy Graham Center Museum, Wheaton, Illinois.

father's reading of scripture but on the mother's role in directing her children's prayer.[19] As another tract put it, "The wife and mother is a kind of presiding spirit in the sanctuary of domestic life."[20] Religious formation, in other words, was really about what mother instilled in her children, since it was she who occupied the center of their lives and father who was relegated to the boundaries. The emphasis on lived

FIGURE 56. Alexander Anderson (engraver). From "On Early Religious Education," No. 143, in *Publications of the American Tract Society* (New York: American Tract Society, [1842]). Photo: Author.

practice rather than on written word or spoken sermonic discourse also alerts us to the rise of a devotional piety among nineteenth-century American Protestants, who found an increasingly important place for images as suasive moral presences, which were ranked by Horace Bushnell and other advocates of nurture as superior to catechismal indoctrination, inasmuch as they exerted a special power on the unconscious, an unspoken influence on a child's moral development.

Christian advice literature contended that the effect mothers had on infants was unparalleled. Not only did advice authors emphasize the preeminence of the mother in the religious education of her flock at fireside; they also spoke of the mother in the home as officiating in "the sanctuary of religious instruction." It was the mother, not the father, who "must be the earnest and affectionate guide to the Saviour. She must take her little ones by the hand and lead them in the paths of piety."[21] The formation of an infant's identity proceeded from a direct influx of maternal influence. The tract for which figure 57 served as cover illustration stated that "a mother should be what she wishes her children to become" and urged the use of illustrated Bibles and sacred histories as "particularly serviceable in the instruction of the little ones who have not yet learned to read."[22] In the illustration the mother

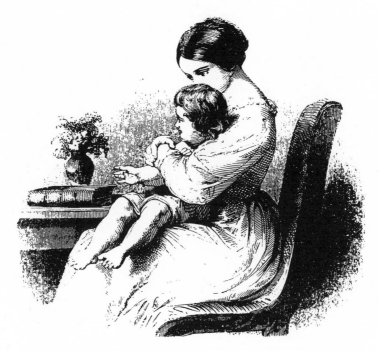

FIGURE 57. Robert Roberts (engraver). From "Letters on Christian Education by a Mother," No. 197, in *Publications of the American Tract Society* (New York: American Tract Society, 1849). Photo: Author.

gazes at a bound volume, no doubt the Bible, while tightly embracing her child. As the child reaches for the vase of flowers, his mother's embrace restrains him, and her gaze redirects his grasp toward the holy scriptures. But there seems to be something more at work here. The instruction practiced by this Protestant Madonna infuses the Protestant discipline of devotional Bible reading with a kind of Christology. One imagines that she gently whispers instruction to her child. If so, mother, not preacher or theologian, converts the written text of scripture *with her gaze* into the spoken word, as moral counsel murmured into the child's ear. As such, she is the mediator of divine and human. The Protestant mother becomes both Mary and Jesus.

Viewing the mother as Christlike was not an isolated practice. Tracts and advice books visualized the parallel of mother and Jesus most frequently by juxtaposing Christ blessing the children with a mother teaching her little ones.[24] In another instance, the American Tract

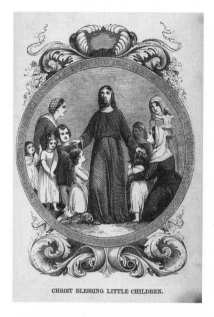

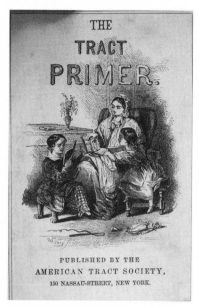

FIGURE 58. Robert Roberts (engraver), *Christ Blessing Little Children*, frontispiece, and Eli Whitney (engraver), mother instructing children, title page. From *The Tract Primer* (New York: American Tract Society, 1856). Courtesy of the Billy Graham Center Museum, Wheaton, Illinois.

Society's *Primer*, first published in 1848, placed a frontispiece of Christ with children next to a title page with a mother using an illustrated primer to teach her children (fig. 58). The two facing pages modeled the modern practice of teaching children on the biblical paradigm of Christ's tenderness toward children. In the terminology presented in chapter 1, the pairing of images exemplifies a broad tendency to maternalize Christ and to regard mothers as Christlike teachers of children. The illustrations further demonstrate how the American Tract Society (but other Protestant associations, too) ennobled modern mothers as the primary source of blessing children with spiritual benevolence and knowledge. The frontispiece image stresses Christ's blessing touch and focuses tenderly on the children—note that the disciples whom he rebukes in the New Testament story are absent, which underscores the female gender of caretakers. Likewise, it is the modern mother's enthroned centrality and her affectionate physical contact with children that the title page image endorses.

The Christology visualized and promulgated by the American Tract Society and other benevolent groups, such as the American Sunday School Union, stressed the accessibility, sympathy, and benevolence of Jesus. The author of "Letters on Christian Education" instructed Christian parents to acquaint their children with Christ's story, the following summary of which paints Jesus in the warm colors of the ideal of mother that enraged later advocates of brawny Christianity in the United States, such as Bruce Barton. Children were to learn about Jesus

from his humble birth, through his life of sorrows, to his crucifixion, resurrection, and ascension into heaven. Tell them of the miracles he wrought, his continual acts of benevolence, his tender sympathy for the afflicted, his condescension to little children, his forbearance toward the wicked, his forgiveness of his enemies, and his meek endurance of suffering in the garden and on the cross. . . . When you observe them tenderly affected by what they have heard from you, pray with them; minutely confessing their faults, and affectionately commending them to the mercy of this kind Saviour.[25]

The visual piety of much nineteenth-century American Protestantism consisted of imaging in children a filial devotion in which self-denial was rewarded by the intimate friendship of a gentle savior who was more like mother than father, whose absence from the iconography of domestic nurture corresponded to his absence from the home. Perhaps the most familiar literary example of domestic matriarchy and the absent father is *Little Women*, published in 1868 by Louisa May Alcott, daughter of Unitarian Bronson Alcott. Separated from their father by the Civil War, the four sisters of the novel gathered one evening about their mother, Marmee, as she read a letter from their distant dad: "They all drew to the fire, mother in the big chair with Beth at her feet, Meg and Amy perched on either arm of the chair, and Jo leaning on the back, where no one would see any sign of emotion if the letter should happen to be touching."[26] Marmee was the center of the cult of the absent father, its priestess and more. She replaced father and mediated between him and the girls. She encouraged the daughters to remain loyal and obedient to their father's will, speaking in his name and acting in his stead. As wise and benevolent teacher and as moral example for the girls, Marmee urged filial piety in the spirit of Jesus, telling the troubled Jo, whose sense of gender seems confused, "to feel the strength and tenderness of your Heavenly Father as you do that of your earthly one." Marmee was everything a Unitarian Christ should be. Alcott's

FIGURE 59. Mother reading to her children. From *Illustrated Family Christian Almanac* (New York: American Tract Society, 1869), p. 41. Photo: Author.

description of the homely scene comports closely with an image of a mother reading to her young adoring children, reproduced in the American Tract Society's *Illustrated Family Christian Almanac* in 1869 (fig. 59). Refashioning the journey of the allegorical Christian in John Bunyan's *The Pilgrim's Progress,* Alcott portrayed the domestic world of the girls as a bourgeois pilgrimage in which selfishness was shed in the interest of the common good of the domestic community. Even though Alcott was Unitarian and her novel transformed the Puritan God of *Pilgrim's Progress* into a benevolent, distant father-figure, the similarity between figure 59 and the scene in *Little Women* demonstrates how broadly the theology of nurture moved across the range of American

Christianity. In the absence of the earthly father, mother became like Christ, and such images as figure 59 served as the domestic equivalent of Christ blessing the children.

Emerging Models of Masculine and Feminine

American Protestants at midcentury were engaged in a broadening of their categories of gender, if not always in a transforming of them. The prominence of mother in popular imagery and literature contrasted, though not necessarily conflicted, with male assessments of youth culture and the perceived needs of boys and young men. Two Unitarian clergymen present the two dominant faces of American masculinity in the antebellum period and make an instructive comparison with the domestic culture of maternal influence. In an 1855 article, "Gymnastics," in the *North American Review,* Unitarian clergyman A. A. Livermore summed up the host of causes widely identified by his contemporaries as threatening modern American well-being:

In the early history of this country, the Olympic games of our people were hunting, woodcraft, and Indian, French, and Revolutionary wars. The wild forests developed the muscles of our fathers, and cottage toil strengthened noble mothers of heroes and patriots. A hardy life in rural pursuits in the open air is still the mighty rampart of our nation against an army of diseases, and the effemination of a whole race of men. But, unfortunately, as our cities grow, as civilization waxes complex and luxurious, and the classes addicted to professional, mercantile, and sedentary life are multiplied, the physical stamina are in danger of succumbing . . .[27]

Livermore discerned a declension of physical activity resulting from the rise of modern American society. Coupled with the growth of cities and the office culture of modern commerce, the expansion and sophistication of civilization, and the decline of warfare, inactivity had sapped Anglo peoples in North America. Livermore characterized this historical process as a national loss of masculinity. Men needed exercise in order to fight the onslaught of "effemination." Livermore strongly urged American educators to use athletics to infuse students—essentially boys and young men—with the vigorous health they lacked. He looked to the history of Western civilization and found in it an abundance of physical culture abandoned by modernity. Exasperated though he was by the "pallid effeminacy" of American youth, Livermore did not despair. Protestant America had something that ancient Greece and

Rome did not: the adornment of "Christian virtues never known to the Porch or the Academy." Physical culture could redeem the bodies of young Americans and therefore place the nation and its religious faith on the throne of Western civilization.[28]

The invigorating effects of sport among American college students, all men of course, amounted to a male counterpart to the female formation in *Little Women*. But another Unitarian clergyman, writing two decades earlier, had been more concerned with the autonomous self. Ralph Waldo Emerson stressed masculinity as the spiritual likeness of human and divine. Emerson's notion of self-culture coded self-indulgence as effeminate and self-denial as masculine. Susan L. Robertson has argued persuasively that character formation for Emerson meant masculinization, a triumph of the ascetic mind over the passionate body. Self-mastery emerged through the suppression of vice, indolence, lust, and appetite.[29] By stressing the power of the individual to fashion and perfect himself, Emerson rejected the Calvinist notion of total depravity. He located the will to self-development within the self and considered it the image of God in human nature. As Robertson has suggested, in order to articulate this organic anthropology in which the self grew from within itself, Emerson relied on a deeply gendered polarity of self and nonself, male and female. Emerson understood his own defection from the Unitarian pulpit as liberation from external constraints and response to the individual call to self-culture.

With this masculine notion of the self in mind, *Little Women* may be read as an implicit critique of Emerson's romantic autonomy and masculine self-formation. In his parting sermon at Boston's Second Church in 1832, Emerson defined his inward relationship to Christianity. He was engaged not by its outer "decent forms and saving ordinances," he claimed, but rather by "its deep interior life, the rest it gives to mind, and the echo it returns to my thoughts."[30] Whereas Emerson's self-culture was rooted in the private domain of the male mind, one version of the legacy of Puritan self-examination, the world of *Little Women*, by contrast, advocated a communitarian vision of the self, in which women were responsible to and for one another in the social nest of the home. Alcott's novel was, in its own way, a recasting of Puritanism, inasmuch as it relocated and recoded the spiritual journey of *Pilgrim's Progress* in the interior of the middle-class home.

But in urging the central character, Jo, to temper her anger, her sister Amy to curb her petulant selfishness, and Meg, the oldest girl, to

relinquish her vanity, Alcott's novel endorsed a conventional under-
standing of character formation and the passions, even if it did so by
making greater room for female agency. And the male ideal it con-
structed was not macho but accommodating and self-effacing. The
absent father in nineteenth-century literature and iconography gener-
ally cultivated a masculinity that stressed manliness rather than
machismo. Unlike the aggressive, often jingoistic masculinity to come
after the war, Christian manliness was less hostile toward women, even
deferential to the preeminence of the female gender, though always in
order to delineate the feminine sphere as properly domestic and non-
public. Manliness was the Christian counterpart to the republican
mother.

The problem of agency of women and their capacity to operate
without husbands occupied moralists and artists alike in midcentury
Victorian culture. Nathaniel Hawthorne ventured to liberate one
woman from the domestic sphere in his art romance, *The Marble Faun*
(1860), whose heroine, Hilda, was an unmarried New England Protes-
tant living in Rome. She resists the courtship of a fellow American
artist, Kenyon, until the novel's end in order to pursue her greater love
for a feminine ideal embodied in devotion to the Virgin. The narrator
pleads her case as well as all women's early on:

This young American girl was an example of the freedom of life which it is pos-
sible for a female artist to enjoy at Rome. She dwelt in her [medieval] tower . . . all
alone, perfectly independent, under her own guardianship, unless watched over
by the Virgin, whose shrine she tended; doing what she liked, without a suspi-
cion or a shadow upon the snowy whiteness of her fame. The customs of artist
life bestow such liberty upon the sex, which is elsewhere restricted within so
much narrower limits; and it is perhaps an indication that, whenever we admit
women to a wider scope of pursuits and professions, we must also remove
the shackles of our present conventional rules, which would then become an
insufferable restraint on either maid or wife.[31]

Hawthorne presents the young artist as consumed by an idealistic love
of art and possessed of the "the warmth and richness of a woman's
sympathy" that propels her into spiritual communion with the masters
whose works she studies in Roman galleries and churches. The
empathic power to enter into the works she admires leads Hilda to set
aside her artistic ambitions. Understanding the works of the great
masters becomes her sole task. "Reverencing these wonderful men so
deeply, she was too loyal, too humble, in their awful presence, to think

of enrolling herself in their society. Beholding the miracles of beauty which they had achieved, the world seemed already rich enough in original designs, and nothing more was so desirable as to diffuse those selfsame beauties more widely among mankind."[32] So Hilda becomes a copyist and thereby no rival to the authority of her male superiors. She submits herself to an artistic piety, attending to the duties of admiration and dissemination, whereby she might educate humankind like a wayward New England schoolteacher or, in the manner of a devotee in the cult of Fra Angelico and Raphael, as a kind of Protestant art nun. Hilda indulges some curiosity in the Roman rite, even entering a confessional in St. Peter's one day to purify her troubled soul and spending several days in a convent, but she never converts, repeatedly calling to mind her "Puritan forefathers," and eventually submits to Kenyon's persistent suit.

In the end, the blameless Protestant lass willingly gives up her freedom in the City of Art for marriage. What she seeks in Rome is an ideal of femininity that she compares to the Virgin but can find only in matrimony. It is not Catholicism she longs for but an ideal of womanhood that seems fostered by it. As she tends the shrine to the Virgin on the wall of the tower in which she lives, the narrator reassures his Protestant readers that the girl's devotion to "divine womanhood" involves no conversion to papacy: "It was not a Catholic kneeling at an idolatrous shrine, but a child lifting its tear-stained face to seek comfort from a mother." Leaving the safety of woman's sphere in New England for the freedom of Rome, Hilda absents herself from her mother, whom she then seeks out in the Madonna. But Hawthorne's American Protestants in the City of the Popes are not transfixed by Catholicism per se; rather, they struggle to find a new set of symbols to respond to their spiritual yearnings. They do not seek conversion to Catholicism so much as escape from the arid and lifeless rigidity that Hawthorne was fond of dubbing "Puritan." His heroine longs for a Protestant ideal of womanhood that she sees one day embodied in a painting of the Virgin on an altar in the Pantheon: "Ah, thought Hilda to herself, why should not there be a woman to listen to the prayers of women? A mother in heaven for all motherless girls like me? In all God's thought and care for us, can He have withheld this boon, which our weakness so much needs?" Absent father and mother, it is mother she seeks out in art and devotion. If Hilda toys with the idea of conversion to modeling herself monastically in devotion to the Virgin, in the end she determines to accept Kenyon's

love and become a Protestant Madonna, to come "down from her old tower, to be herself enshrined and worshipped as a household saint, in the light of her husband's fireside."[33] It is a long detour this Protestant woman makes, fueled by art and romantic adventure, but it concludes its wide course in the familiarity of the home.

If Hawthorne allows his heroine to flirt with the adventure of the nineteenth-century (male) artist-ideal, famously modeled by the German Nazarenes in Rome and the British Pre-Raphaelites, who cultivated a sacred dedication to art, the romance culminates in Hilda's domestic bliss. The message of the novel would seem to be that women could be allowed a Romantic wanderlust, since they would eventually find their way home.

Muscular and Hypermuscular Christianity

The male character Kenyon in Hawthorne's novel is a patient man who worships his Virgin Hilda as a domestic saint of womanhood. Kenyon models a masculinity that subordinates his impatience to Hilda's spiritual quest, resigning himself to the superiority of her feminine sensibility. Protestant moralists and clergy affirmed this repeatedly and considered the principal task of male formation to be character development. In this ideology of manhood, the young male needed to be formed by both mother and father. Yet virtuous as Kenyon may be, his life of the wayward artist was no ideal formation at midcentury. American Protestant advice writers and educators stressed the importance of association with like-minded young men of one's own class. Organized athletics in college or sponsored by the Young Men's Christian Association were believed capable of developing the proper virtues of manliness. The ideal of a "sound mind in a sound body" served as a motto for the YMCA (the first association in the United States was formed Boston in 1851). Here sport stood as a rival to the insidious urban distractions of dancing, gambling, taverns, and circuses—alternative forms of association that not only harmed body and soul but also led to intermingling with lower classes.

The term *muscular Christianity* was used already in the 1860s to signify this notion of masculinity and should not therefore be understood to designate only the machismo that arose in the final decades of the century. Thomas Hughes, British author of the enormously popular novel *Tom Brown's School Days* (1856), spoke for many in the United

States when, in 1861, he defined muscular Christianity as "the old chivalrous and Christian belief" that "a man's body is given him to be trained and brought into subjection and then used for the protection of the weak, the advancement of all righteous causes, and the subduing of the earth which God has given to the children of men."[34] Hughes's distinction of manliness and machismo underscored the virtuous understanding of character.[35] Recalling Emerson's anthropology, the body was a willful force, a base domain of passions that had to be subjected to the controlling power of the mind. The result, achieved through denial and mastery of the bodily urges, was good character. In this masculine regime, the formation of character began with mastering the unruly male body and its passions.

If a maternal Christology seemed to Alcott an appropriate response to the Civil War, for many Americans the war experience helped galvanize gender relations. The effects of the war on conceptions of masculinity hearkened a decades-long shift in the popular understanding of masculinity. During the final decades of the nineteenth century, this change, which was manifold and by no means uniform, was evident in many familiar aspects of American culture that made male segregation and affiliation vital issues in the cultural and social life of the nation. Scholars of American masculinity have rightly pointed to new male roles fostered by Teddy Roosevelt, who once posed for a photographic portrait as a pioneer hunter, dressed in buckskin, evoking folkloric memories of Davy Crockett and Daniel Boone.[36] Another important mythographer in the Gilded Age was the painter and sculptor Frederic Remington, who eulogized the heroics of Indian fighters, cowboys, and soldiers in order to assert the continental aspirations of American civilization in the face of "savage" resistance. Other manifestations of an increasingly self-conscious male culture in the later nineteenth century include the mushrooming of male-only fraternal organizations; the importance of sport among boys and men, including the organization of collegiate and professional sports teams; and a series of revivals dominated by male evangelicals such as Dwight L. Moody, who embraced the ideals of muscular Christianity as taught by the YMCA.[37]

The Civil War helped intensify consciousness about male difference in American society. In the South male honor in the cause of the Confederacy and in the North the integrity of the Union each evoked an appeal to manliness in the face of military aggression.[38] The pivotal shift is evident in a single illustration used by a Sunday school weekly,

FIGURE 60. "What a Change." From *Well-Spring* 18, no. 25, June 21, 1861, p. 95. Courtesy of the Billy Graham Center Museum, Wheaton, Illinois.

the *Well-Spring,* just before the war (fig. 60). The illustration presents a rashly disposed young boy brandishing a sword. The article that the image illustrated asked of young viewers: "Is this the plan for life you would choose?" The emphatic answer in 1860 was no, but when the same children's newspaper reused the identical image a year later, after the Civil War had begun, it inquired: "Who would not now encourage any one in becoming a soldier in his country's cause?"[39] Framed in this manner, the gender differences could not be more starkly drawn in this illustration. What had been the image of a rude young boy before the war was transformed into "the military spirit we are now willing to see in all, even the boys,—a spirit to stand by our country,—to defend our government against every foe." The caption continued, "Even affectionate mothers urge their beloved sons . . . to go forth at their country's call." The image was dramatically recoded to support the Union's campaign against the Confederacy by fostering a new understanding of the relation of sons and mothers. Mother is no longer the teacher, as she had been before the war, but the now passive admirer of her militant son. And the aggressive behavior of

sons is no longer to be subordinated to maternal authority but nurtured as the proper "military spirit."

The rise of the American city, the mobilization of the populace, the campaign for women's suffrage, the arrival of growing numbers of immigrants, and the longing for something to replace the militarism and male association of the Civil War contributed to the emergence of a new kind of masculinity, one that found expression in rhetoric that lamented the softening of the American male and that tended to externalize the threat to self-mastery. The shift became evident in American sport: in 1914, James Naismith, inventor of basketball in 1891, looked back on the development of the sport and regretted the dominant ethos of winning at all costs, which eliminated the older ideal of character formation in boys and young men.[40] Such competition corrupted youth, he felt, because it made cheating desirable in order to ensure winning. Sportsmanship and the honor it endorsed were old-fashioned. Competition ranked personal gain over collective development and regarded the opponent not as a manly fellow citizen but merely as the external hindrance to personal benefit.

For some advocates of male rights and the new masculinity, the quest for masculine characteristics was coupled with a rising anxiety about the status of women. When he directed his attention to refuting women's suffrage in 1869, Horace Bushnell fixed on the physically distinguishing features of masculinity as emblems of men's authority over women. "In physical strength," he wrote, "the man is greatly superior, and the base in his voice and the shag on his face, and the swing and sway of his shoulders, represent a personality in him that has some attribute of thunder. But there is no look of thunder in the woman." Bushnell characterized "Woman" as softness, grace, and beauty and as utterly "unOlympic," while Man's looks spoke "Force, Authority, Decision, Self-asserting Counsel, Victory." If men were warring sons of Zeus, women were normal mortals who belonged at home. Bushnell did not bother to put this with great subtlety: "One is the forward, pioneering mastery, the out-door battleaxe of public war and family providence; the other is the indoor faculty, covert, as the law would say, and complementary, mistress and dispenser of the enjoyabilities." Bushnell objected to women's suffrage as an unwarranted claim to authority, a claim to the right to govern, which was properly reserved for the sex selected by nature for its assertive powers, marked by nature with the beard. For women to seek the right to vote, therefore, was the same as wanting to grow facial hair. "The claim of a beard would not

be a more radical revolt against nature," Bushnell reasoned as he sought to lodge a biological wedge between the genders in order to secure male authority. Absent this difference, Bushnell feared, the ontological status of masculinity would be in doubt. According to him, Man was the law and law was the basis of government. Were the masculine principle of law to fall "into second place or equal place with anything else, it would lose the inherent sovereignty of its nature, when, of course, it would be law no longer." In other words, Man must remain superior to Woman in order to remain Man. Gender identity was premised entirely on sharp and clear difference. As Bushnell reasoned, man and woman are one species, "but if they were two, they would be scarcely more unlike."[41] But Bushnell's urgency to keep the two separate implies that he knew very well such a separation was constructed and enforced, a policed and insecure boundary in the cultural politics of authority.

If the ideology of the republican mother, which was supposed to keep middle-class women at home engaged in childcare, helped feminize American Christianity by likening Jesus to mother, the Civil War militarized and masculinized sons for duty to country, seeing in masculine formation the necessary condition for life outside the home. Additionally, the rise of women's suffrage stiffened resistance among its opponents, who were inclined to deepen gender differences by aggrandizing such biological features as the beard as signifiers of masculinity and its nature-sanctioned rights of preeminence. All of this exerted great influence among those Protestant moralists and intellectuals who envisioned Jesus as the embodiment of the new masculine ideal.

Concern for underscoring the masculinity of Jesus and the significance of the beard fueled critical attacks on traditional portrayals of Jesus around the turn of the twentieth century. In 1903 William Barton decried the absence of virility in historical portrayals of Christ: "It is often a womanly sweetness," Barton complained,

that shows in the face of the Christ of art. "The masculine," so the painters have seemed to say, "is the gross, the sensual, the aggressive, the belligerent. We will make our Christ with a woman's face, and add a beard." Popular thought is in accord with this conception. The newspapers have a standing word of reproach for any form of masculine or aggressive effort professedly Christian, and which they do not like.[42]

Barton's reference to the mass medium of newspapers suggests that the movement of hypermuscular Christianity learned from the feminization

of the church the concept of influence as a device of mass culture. What followed was a truculent call to dominate the cultural means of display, a mobilization of suitably masculine representation as the instrument of influence. Voices promoting virile influence arose and fastened onto mass-produced images as a way of shaping young men's souls. In his 1917 study entitled *Jesus, the Christ, in Light of Psychology*, G. Stanley Hall called on modern artists to overwhelm viewers with portrayals of manly men. "With its skill in depicting women," Hall wrote, modern-day art "should not lose its power to represent virile men. Its virgins should not be superior to its Christs, nor the latter be more effeminate or bisexual in appearance than masculine."[43] Hall observed that modern religion was more affective because less dogmatic, and this threatened a physical and emotional refinement in boys that Hall found unacceptable. But the answer, according to the liberal Hall, was not to enhance the intellectual rigor of the faith, since Hall found the content less than persuasive, but to fix on the appropriately inspirational symbols of belief. Thus, he derided most nineteenth-century depictions of Christ as feminine, as evidenced by "feminine features" and a scant beard that "sometimes almost suggests a bearded lady."[44]

Hypermuscular Christianity appealed to conservative evangelical and to liberal Protestant alike. At the same time that G. Stanley Hall applied his psychology of adolescence to the use of images of Christ in religious formation, the evangelical revivalist Billy Sunday, former professional baseball player, developed a hypermasculine homiletic style. The manly charisma of his jingoistic gestures at the pulpit was captured in postcard photographs that were sold at his tent meetings.[45] In a manner of speaking, therefore, liberal and conservative Protestant men were in agreement on the emasculating influence of women. But was it, as Bruce Barton alleged, a war against fatuous, sentimental Sunday school teachers and the long strings of mother's apron?[46]

Denunciations of images of Christ as a woman with a beard increased in volume following the turn of the century, suggesting that advocates of the new Christian masculinity knew they were fighting a more formidable opponent than mom. In fact, they were waging a losing battle. The last quarter of the nineteenth century witnessed the rise of female activism within American Protestantism. Women's suffrage attracted increasing attention, leading to the ratification of the Nineteenth Amendment to the Constitution in 1920. A prominent activist in this cause, Elizabeth Cady Stanton, identified orthodox Christianity and its Bible as part of the problem, which she attempted

to correct by issuing *The Woman's Bible* in 1895 (volume 1) and 1898 (volume 2). In this controversial publication Stanton challenged Holy Writ and Christian tradition for endorsing the suppression of women, which she considered nothing less than the "slavery of women."[47]

One international evangelical operation, the Salvation Army, even adopted some obvious aspects of the militarism favored by advocates of muscular Christianity. Yet the Salvation Army distinguished itself notably by offering women a fundamental role in its enterprise. In fact, the leadership of the army's American contingent for the first several decades was female, co-led from 1887 to 1896 by Maud and Ballington Booth, then from 1904 to 1934 by the daughter of the couple, Evangeline Booth. Whereas, by tradition, revivals and tent meetings were mostly conducted by men, extending from Charles Grandison Finney to Dwight Moody, J. Wilbur Chapman, and Billy Sunday, the Salvation Army determined that these initiatives were aimed at the middle-class Christian and elected instead to place women on the front lines of evangelical outreach among the urban dispossessed.[48] The American *War Cry* was the principal organ for the army and carried both articles and images that presented the army's conception of the female warrior for Christ.[49]

The perception that women had a much more active and public role to play in the cause of moral reform and redemption is evident in a new wave of images that entered circulation in the 1870s. The aggressive tactics they undertook are the subject of an illustration from T. S. Arthur's *Women to the Rescue,* published in 1874 (fig. 61), to celebrate the founding of the Woman's Christian Temperance Union (WCTU) and promote the new ideal of heroine women engaged directly in the public domain. No longer content to militate at home or at temperance society meetings, zealous women such as those pictured in figure 61 turned from a model of indirect influence (through their husbands) to organized intervention, taking the battle to the enemy's "stronghold," the tavern. A group of women kneel in a public house, before the bar, and conduct vocal prayer, which the barkeepers feel compelled to join, covering their eyes and bowing their heads. The open door indicates that the event was carefully staged for its publicity effect, which the new advocates of temperance became expert at exploiting.

The militant campaign of the new women reformers is dramatically portrayed in another image of the same year, a lithograph entitled *Womans* [sic] *Holy War: Grand Charge on the Enemy's Works* (fig. 62). Issued by Currier & Ives during the founding year of the WCTU, the image

FIGURE 61. "In the Stronghold." From T. S. Arthur, *Woman to the Rescue: A Story of the New Crusade* (Philadelphia: J. M. Stoddart & Co., 1874). Courtesy of The Library Company of Philadelphia.

broadcast the sensation of the new activism (members of the WCTU even wielded axes to smash liquor casks). The WCTU urged women to take a more assertive and open opposition to the abuse of alcohol and even encouraged the political enfranchisement of women by endorsing the national Prohibition Party. As one scholar has argued, the WCTU offered middle-class women instruction in the rhetoric of public campaigning in the form of pamphlets, tracts, organizational literature, national reports, and guidelines on public speaking.[50] Yet as progressive as Frances Willard sought to make the WCTU during her long tenure as president (1879 to 1898), the organization never moved beyond its middle-class Protestant base. This moderate character is registered in the Currier & Ives print. A crusading woman on horseback, swinging a battle-axe and clad in armor and gauntlets, recalls contemporary iconography of Joan of Arc, an enormously popular heroine in nineteenth-century France.[51] Here Joan is Americanized. The image transfigures the romanticized, idealized aesthetic of the pure and uncompromised woman, the Victorian notion of Woman as Redeemer recognizable in Hawthorne's account of the Protestant Madonna and in portrayals of Joan of Arc and Protestant depictions of mother as Christlike (see fig. 58). Now the feminine ideal is emboldened, militarized, activated as a dynamic public presence, a kind of apocalyptic

FIGURE 62. Currier & Ives, *Womans* [sic] *Holy War: Grand Charge on the Enemy's Works,* lithograph, 1874. Courtesy of the Library of Congress, Washington, D.C.

figure who means business. She marks a shift from Woman as pastoral savior to Woman as furious and righteous judge. But she is also a nationalistic figure (bearing a shield with stars and stripes), modeled perhaps on Joan as a symbol of French nationalism and resistance to foreign invaders. As the totem of the WCTU's opposition to alcohol, this American Joan may represent the Protestant establishment's abiding preoccupation with control in the face of an immigrant society, in which the drinkers and the producers of drink were often not

white-bread Protestants but Irish and European newcomers. The Prohibition Party, which the WCTU supported (though a faction split off over this support), sought enforcement of criminal codes against prostitutes, promoted the Comstock law against obscenity in the mails, lobbied for a constitutional amendment to establish Christianity as the national religion, supported enactment of the national observance of the Christian Sabbath, and encouraged the use of the Bible as a textbook in public schools.[52] If women secured a new voice and presence through the efforts of the WCTU, they did so clad in the confining garments of middle-class Protestantism. Under the reassuring banner of moral purity, religious righteousness, and social order, women found their way into the public arena, transforming their image on the way from queen of the home to militant activist on the public battlefield. It was not a perfect revolution, but the measure of liberation it delivered was irreversible, the cant and volume of strident Protestant masculinists notwithstanding.

National Icons

Bibles, Flags, and Jesus in American Civil Religion

Apologists of modern nationhood are often fond of regarding their nations as expressions of divine will, natural law, or the destiny of a particular people. Whatever their origin, nations are a modern form of cultural and political ordering that is widely experienced as bearing some manner of religious significance, often in the form of a civil religion. Aligning state and cult is, in fact, quite ancient. But the polity of the nation (not to be confused with the state) is probably not much older than the seventeenth century. This final chapter examines the national cultus, the religion of a national people and its expression in a set of symbols that are, in the instance of United States history, as contested as they are venerated, even adored.

The bold enterprise of founding a confederation of states governed by the people involved a risk that caused many Americans great worry. Could a constitutional democracy without the hereditary institutions of monarchy or aristocracy prevail against the fractious energies of self-interest? Many wondered if there were sufficient virtue in the body politic and its fledgling institutions to withstand corruption. It was a risk that seemed worthwhile in view of the tyranny that monarchy was believed to entail and the separate set of self-interests that aristocracy ensured. Yet from the foundation of the American republic to the present, the fear that internal and external forces would result in social disintegration and disorder has persisted. The Calvinist anthropology that informed Puritanism and its legacy was stalwartly grounded in the doctrine of Original Sin, which made many American Protestants unable to trust human nature to do the right thing. Formation and

education were necessary interventions for making Christians—and for making *faithful* citizens in the new republic (in the double sense of *faithful*). American civil religion, especially after the Civil War, that great test of "loyalty versus rebellion" in the rhetoric of the winners, stressed the importance of ritualized formation provided by public ceremony, holiday commemoration, and the public schools as the crucial moments for the public making of a loyal citizenry. Anything less than vigilance in this matter neglected virtue and spawned vice, which inevitably produced moral degeneration followed by the decay of institutions and the rise of social disorder. The genealogy of national decline began in the heart of the faithless citizen.

All manner of such rituals, ceremonies, symbols, and the national narratives that install them in the collective memory of American identity are the ways Americans have imagined their nationality. The importance of this active and ongoing practice of imagination for nationhood was the subject of Benedict Anderson's rightfully classic study of nationalism, *Imagined Communities*. Flags, stories, songs, pictures, and monuments can be powerful means of imagining a common identity. Nationalism does not supersede religion, according to Anderson, but develops from it.[1] Civil religion is the cult of the nation (though civil religion might also be other than strictly nationalist). In the American case, moralists, clergy, and politicians who harbored fears of dissolution looked to religion as a countervailing force and such talismans as the Bible, religious imagery, and the national flag as ways of disseminating this binding power among the people.[2]

The American case invites an examination of the use of both religion and its talismanic devices to promote national unity. I am especially interested in the persistent belief that democracy per se will not work and that the American republic requires a religious vigilance on the part of what amounts to a middle-class aristocracy. This middle class forms a dominant culture that has long relied on mass media to conduct a national cult and to disseminate a cultural literacy that assimilates newcomers and reinforces its conception of social order. Americans and their observers abroad have long wondered about the significance of religion in the practice and maintenance of American democracy. It seems clear that the United States has developed a religious practice and set of symbols that have shifted from organized, denominational Protestant Christianity to a civil religion that varies from an inclusive patriotism to a highly exclusive nationalism. This chapter seeks to trace the historical development of the religious visual culture of national

vigilance. Of special interest is the emergence of national icons—Bibles, flags, and pictures of Jesus that were regarded as sacred objects, totems with the power to place viewers in the mystical presence of the republic. I use the term *icon* not in a merely metaphorical sense but to designate the devotional image or object of civil religion. Just as icons among Eastern Orthodox Christians operate as apertures or windows to the sacred, so Bibles and flags in particular have acted as sacred evocations of the divinely ordained republic, the nation that is invested in these symbols to such a degree that the cherishing (or abuse) of them conveys the devotees' veneration of the nation itself.

Protestantism, Print, and National Identity

Protestantism on American soil has generally thrived when it has been fueled by a cause. Many Protestants in the United States found ample cause in the early nineteenth century, following the origin of the nation. Faced with the disestablishment of official or state-sponsored religion, the rise of mass democracy, and the arrival of increasing numbers of non-Protestant immigrants, Protestants in the Northeast during the early decades of the nineteenth century felt menaced. They responded by promoting the spread of literacy through the distribution of religious primers and instructional materials and encouraging the use of the Bible in public school rooms.[3] The strategy was to assimilate newcomers and to socialize children into what most Protestants envisioned as a Protestant nation, the legacy of providence and millennial purpose as it came to be understood during the colonial period.[4] Benjamin Rush, eminent physician, abolitionist, treasurer of the U.S. Mint, signer of the Declaration of Independence, and member of the Constitutional Convention of 1787, spoke for many in 1789 when he proclaimed in an address (issued posthumously as a tract by the American Tract Society in 1830; fig. 63): "We profess to be Republicans, and yet we neglect the only means of establishing and perpetuating our republican forms of government; that is, the universal education of our youth in the principles of Christianity by means of the Bible."[5] For this reason, the Bible belonged in the classroom, a matter, Rush wrote to a clergyman friend, that he considered "of more importance in the world than keeping up a regular gospel ministry."[6] Figure 63 portrays the Bible as a public monument, around which are arrayed the institutions and activities of daily life. The text is open to Isaiah, chapter 60, and

FIGURE 63. Illustration for tract, *A Defence of the Use of the Bible in Schools*, No. 231, by Benjamin Rush (New York: American Tract Society, ca. 1830). Photo: Author.

marked by a slip of paper that reads "Today." Rush's text does not mention Isaiah, so the illustration is the Tract Society's addition to the tract, a visual prompt that serves to connect the scripture of the ancient Jewish prophet with the modern world, as the bookmark literally does by lying against the biblical page and the ground. Isaiah 60 opens with a proclamation that many Americans had long regarded as a call to their nation, the new Israel: "Arise, shine; for your light has come, and the glory of the Lord has risen upon you. . . . the Lord will arise upon you, and his glory will be seen upon you. And nations shall come to your light, and kings to the brightness of your rising" (Isaiah 60:1–3). The chapter ends with a promise that Rush and many others wanted to believe and looked to biblical instruction to secure: "Your people shall all be righteous; they shall possess the land for ever, the shoot of my planting, the work of my hands, that I might be glorified" (60:21). Rush closed his letter with a similarly millennial hope: public education conducted on the study of the Holy Bible would, he believed, "in the

FIGURE 64. "A Choctaw School." From *The Baptist Mission in India* (Worcester: Spooner and Howland, 1840). Courtesy of The Library Company of Philadelphia.

course of two generations eradicate infidelity from among us, and render civil government scarcely necessary in our country."[7]

Many Protestants, including Presbyterians, Congregationalists, Baptists, and Methodists, formed tract and mission societies to publish and distribute printed materials in order to achieve such a millennial goal, even if they found Rush's dream of a country freed of government unlikely. An early mass-produced visual culture contributed importantly to the formation of the ideal of a Christian America. Illustrated tracts, pamphlets, books, and certificates of membership helped attract and instruct children, illiterate adults, Native Americans, former slaves, and immigrants. Tract and Bible societies translated Bibles and instructional materials into various Indian languages for use by Protestant evangelists, who often competed with Catholic priests for the hearts of the Indians. Publishers rushed to issue schoolbooks for use among Indian groups such as the Choctaw, shown here undergoing the orderly rigor of assimilation (fig. 64). The American Tract Society established repositories for its tracts and other publications in cities throughout the Northeast, South, and West before the Civil War and operated regional printing houses in Boston, Philadelphia, Baltimore, Cincinnati, and New Orleans. The items that the ATS produced were placed in cities around the country and handed out by colporteurs, door-to-door

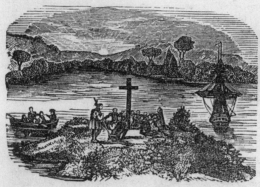

No. 1.

ADDRESS

OF THE

EDITORIAL COMMITTEE

OF THE

CATHOLIC TRACT SOCIETY OF BALTIMORE

TO THE PUBLIC:

TO WHICH IS APPENDED AN EXTRACT FROM THE CONFESSIONS OF ST. AUGUSTIN, TOGETHER WITH THE CONSTITUTION AND BY-LAWS OF THE SOCIETY.

PILGRIMS OF MARYLAND.—*See page 2 of cover.*

"We can do nothing against the truth, but for the truth."—*2 Cor.* xiii.

BALTIMORE:

PUBLISHED BY THE CATHOLIC TRACT SOCIETY:

And to be had at J. Mullan's, Cathedral-yard, at each of the Catholic churches in the city, and from any of the officers of the Society.

FIGURE 65. Landing of Father Andrew White, cover illustration to William George Read, *Oration, Delivered at the First Commemoration of the Landing of the Pilgrims of Maryland* (Baltimore: John Murphy, 1842). Courtesy of The Library Company of Philadelphia.

salesmen. Nearly two dozen different tracts and other texts issued by the ATS argued against Catholicism.[8] Catholics replied with their own tracts, which included images like the one in figure 65, portraying the Catholic pilgrim landing of Father Andrew White in 1634, in what became the colony and later the state of "Mary-land."[9] Catholics and

Protestants squared off with rival discourses about the religious pedigree of the nation. The visual polemics continued, as we shall see, well into the twentieth century.

Many nineteenth-century American Protestants revived a theocratic vision of the New World as God's chosen instrument for the dawn of the millennium. For the American Tract Society (est. 1825) and the American Sunday School Union (ASSU; est. 1824), as well as countless other Protestant organizations such as the American Bible Society (est. 1816), this meant taking a proactive stand on the assimilation of children and the unconverted. Before America could usher in the millennium it had to evangelize its citizens as well as elevate their moral stature. The union of Protestant groups that formed the ATS and ASSU before the Civil War was echoed in the interdenominational identity of the Young Men's Christian Association and the Sunday school movement after the war. Their collaborative efforts were seen as signs of cohesion and hope as the forces of change and disintegration mounted.

Although state legislatures eventually ratified the Bill of Rights, which established what has since been widely interpreted as the strict separation of church and state, many Protestants from the antebellum period to the present have used mass-produced images to compensate for the First Amendment's disestablishment of religion—either by enhancing voluntary campaigns to disseminate Protestant influence, or by appealing to a unifying symbol to gather Christians, or even, in the case of one noteworthy image in the twentieth century (see figs. 39, 71 on p. 250, and 72 on p. 253), by infiltrating public spaces in order to "reclaim" them as evidence of a Christian nation. By *compensating* for disestablishment I mean compensation not for the loss of state monies or a vast membership roll but for the loss of a national mythology, a theocratic vision that placed Protestant Americans at the heart of a cosmic drama. Indeed, in the wake of disestablishment, religious donations and membership ballooned to unprecedented numbers. But the mythology enforced by state sponsorship was replaced by a democratic conception of liberty that, at least in principle, leveled the religious marketplace, requiring new strategies of influence to replace the former powers of coercion. Mass-produced images offered one attractive means of influence.

The task of influencing Americans was premised on regarding them as voluntary consumers of ideas and beliefs. American Protestantism, invoking the example of Martin Luther himself, looked to mass print as an ideal form of mass influence. Protestants aimed at arguing visually as

FIGURE 66. John Sartain, *The Harmony of Christian Love: Representing the Dawn of the Millennium,* engraving, 1849. Courtesy of the American Antiquarian Society.

well as verbally for a fundamental unity of the American nation and Protestant Christianity. Catholics, by contrast, because of their smaller number and embattled presence, focused efforts on ministering to their own and securing their identity as Roman Catholic. Not until the 1830s did vigorous polemicists begin enjoining Protestant critics. A turning point in this regard was the naming of Mary as national patroness of the United States in 1846 by Pius IX, when he ascended to the papacy.[10]

Hitting on the postmillennial notion of "Christian union," Protestants fashioned visual totems for mass distribution. The image in figure 66, engraved by the Philadelphia artist John Sartain in 1849, was distributed by the American Home Missionary Society.[11] The "dawn of the millennium" was portrayed as the harmony and hegemony of American Protestants gathered about the new altar of national purpose. Lutheran, Presbyterian, Congregationalist, Anglican, and Quaker clergy assemble themselves about the millennial altar and are joined by an African slave and an American Indian, who cast off their shackles and implements of warfare, respectively, in recognizing the epiphany of liberation to which the clergymen hearken. Notably absent are a

Catholic priest, a Mormon preacher, and Baptist and Methodist clergy. The "new world order" visualized here is universal in scope only by rendering invisible the truly diverse, hotly contested identity of Christianities and other religions, not to mention ethnicities and genders in the United States.

Protestant propaganda could, of course, be much more explicit and stringent, as in the case of the work of political cartoonist Thomas Nast. German-born Nast immigrated to the United States as a boy. As a young man and ardent Republican, he became an illustrator for *Harper's Weekly Magazine.* In 1870, in the midst of a controversial court case in Cincinnati over the use of the Bible in public schools (and the same year that Pius IX proclaimed the doctrine of papal infallibility), Nast responded with an incendiary cartoon that expressed Protestant fears of Catholic influence in public education (fig. 67), stoking an old phobia of papal conspiracies to topple republican government. In view of the interests of Catholic and Jewish students and in the midst of a nationwide trend of public schools abandoning Bible reading, the Cincinnati Board of Education reversed an existing policy of requiring Bible reading and opening religious exercises each morning in the city's public schools.[12] The board resolved to eliminate any reading of scripture or religious books that promoted religious belief and any opening exercises that constituted worship or religious instruction. The resolution had followed an unsuccessful attempt by the board and the Archdiocese of Cincinnati to bring the city's Catholic schools under the jurisdiction of the public board of education. When Catholics and Protestants objected, the board responded by attempting to remove the offense of Bible reading, hoping to gain Catholic support.[13] It was that resolution of the summer of 1869 that ignited a citywide firestorm. A group of citizens took the board of education to court.

Nast's cartoon was reproduced and circulated in Cincinnati and certainly expressed a popular sentiment, as the litigators themselves were quite aware. In one argument, a lawyer for the board of education, Stanley Matthews, asked the presiding judges to consider the reverse of the situation: what if a Catholic majority were to impose its Roman Catholic pedagogy on a Protestant minority? "Suppose your children were brought to that school and were taught and were made, by a rule of that school, at the name of Christ, to bow the head in adoration, and to cross themselves with the sign of the cross, how would your Honors like it?"[14] The fictional scene described by Matthews was caricatured by Nast's print. The illustration shows a

FIGURE 67. Thomas Nast, "Foreshadowing of Coming Events in Our Public Schools." In *Harper's Weekly Magazine*, April 16, 1870, p. 256. Courtesy of the American Antiquarian Society.

priest sweeping away the Bible and textbooks while a student dips his hand in holy water and two others genuflect at school benches made into prie-dieux. Images of Mary (on the left, with swords plunged into her heart) and the pope have replaced the schoolroom's maps and chalkboard. If Matthews sought to engage the judiciary in a mental experiment designed to demonstrate Protestant majoritarian injustice, one wonders if his rhetorical tactic didn't backfire. The public opinion to which Nast appealed was shared by two of the three judges in the superior court, which decided in favor of the plaintiffs, two to one.

Yet Nast's propaganda failed to keep the uproar in place, partly because the process of appealing the superior court's decision took three years and because board membership changed and principal

figures in the controversy moved on to other matters or left Cincinnati.[15] But it was also the case that ideological lines in the controversy were never so simple as Nast's imagery sought to portray them. One of the most active board members who opposed the resolution to eliminate Bible reading was a liberal Unitarian clergyman. By contrast, Stanley Matthews was an evangelical Calvinist. The only two Jews on the board split votes on the issue. As Robert Michaelson has pointed out, however, the majority of those on the board who voted against the measure were Protestant. The mixture of allegiances mirrored the religious heterodoxy of the city.[16] As is generally the case, the propaganda that Nast circulated misrepresented everything except the groundlessness of Protestant paranoia. When the Ohio Supreme Court reversed the decision in 1873, Cincinnati took the ruling in stride, and the Bible vanished forever from the city's public schools.

From the Bible to the Flag

American political life has been shaped by a history of responding to immigration. Since the Democratic Party, based in the South, relied on immigrant voters to counterbalance the entrepreneurial and industrialist power of the Republicans in the North, the Republican Party often voiced national anxieties about the threat to democracy that newcomers (typically laborers) were believed to pose. If the Protestants' fear of Catholics had lost much of its political currency by the mid-twentieth century, concern about the need for a religiously charged national unity persisted. One way in which Americans have historically sought to counter perceived threats of national degeneration, disruption, or balkanization is by invoking a civil religion of patriotism that often shades into nationalistic sentiments.

From the beginning of the New England colonies, education was an important means of civil and spiritual formation as well as a means of acquiring literacy to enable Bible and devotional reading. If people were by nature sinners, they could be taught to counter the power of sin by reading God's word, and they could become productive members of the spiritual commonweal by schooling. The belief was not lost on later Calvinists and American educators when they faced the challenge of fashioning citizens of the new republic. When growing numbers of non-Anglo and non-Protestant Europeans began to arrive in the 1840s, the national task was only intensified in the minds of Protestants. The

fear was clearly registered in one advocate of Christianity in the American classroom, Frederick Packard, Philadelphia Presbyterian, Whig, and long-time corresponding secretary and editor of publications for the American Sunday School Union. In 1866 Packard anonymously published a study of public schools in four northeastern states. "We cannot avoid the conviction," he concluded in his book, "that under political institutions so free as ours, and with a population so heterogeneous, the exclusion of systematic, judicious, thorough religious instruction from the public schools is a radical, and, we fear, fatal defect."[17] Like many of his fellow religionists in the North, Packard was adamant about the significance of the public school in the spiritual formation of American youth. "No child," he insisted, "should leave a daily public school in our country ignorant of the generally received principles of the Christian faith." Mindful of the legal complications of Catholic resistance to the Protestant (King James) Bible in the schools, which had reached a high pitch in the previous decade, Packard reluctantly acknowledged the power of "the jealousy that so sensitively watches all approach of the ecclesiastical to the civil power."[18] But he agreed with conservative Protestants that a kind of consensus Christianity could be disseminated in the public schools that would not violate the establishment clause in the Bill of Rights (though he did not go so far as to concur with views of Massachusetts Unitarian and educational reformer Horace Mann that this consensus be detached from evangelical Christianity's understanding of scriptural revelation).[19] Moreover, Packard had determined that the deeper problem was not merely reading from the Bible in the public classroom. Matters had become more complex since Benjamin Rush's day. For Packard, the issue centered on hiring teachers who were personally committed to the foundational tenets of Christianity. "No public teacher," he proclaimed, "is fit for his place, in our country, who does not recognize the Supreme Being as the only proper object of religious worship, and Holy Scripture as the revelation of His will." (The latter criterion made all the difference: invoking scripture deftly turned the "Supreme Being" into the God of Israel and Jesus). Accordingly, Packard urged state examiners to make a point of inquiring about teachers' competence "to give proper prominence to the religious element" when they applied for a teaching certificate.[20]

Packard was addressing two fronts in the culture wars of antebellum America. On the one hand, he faced the challenge of liberal Christian educational reformers, such as Horace Mann, whose religion was not sufficiently biblical to satisfy Packard. On the other hand, he responded

to the threat that Catholicism posed. For Packard, matters came down to the authority to be instilled in students as the principal requisite to making good citizens of the republic. He elaborated the implications of authority and firmly charged the public school as the state's instrument for achieving the benefits to be had by inculcating submission to authority. "To this end, " he reasoned, "[students] should assuredly be taught that the supreme authority is in the Creator and Governor of the world, and that earthly potentates are but his vicegerents and subject to his law." Once again, Packard can be heard speaking in two directions. To those such as Horace Mann, who would cede complete control of public schools to the state, Packard preached that the state itself depends on divine authority. To American Catholics, Packard also offered a warning: "Whatever inspires the youthful mind (and especially the American youthful mind) with deference to authority, obedience to conscience and the cultivation of a lofty principle of integrity and social obligation, is a most essential element of our daily public school instruction."[21] The passage is a passel of code words. The "authority" was the republic's God-indebted state, and the "obedience" was to individual conscience, not to the pontiff in Rome. The "integrity" in question was the integration or assimilation of immigrants into the American stock. "Social obligation" to the welfare of the nation could not be subordinated to what anti-Catholic Protestants regarded as the potentially treasonous obedience of Catholic Americans, or at least the obedience of the priesthood and religious orders, to the papacy, which Protestant nativists believed was engaged in an international conspiracy to topple republican governments.[22]

Whether it was the more recognizably Protestant sensibility of Packard or the more liberal religious views of Horace Mann, the generalized Christianity that was advocated by Protestant educational activists in the antebellum United States was a form of civil religion that served as a strategy of assimilating immigrants, the poor, and the working classes. To be a good American, one needed to be a Protestant Christian. The aim was to bind all members of the society to the good of the republic, pitting the cultivation of social virtues against the divisive powers of vice. Packard's book, which appeared the year after the Civil War ended, was intended to seize an initiative for reform in the wake of the greatest threat by far to the nation's unity. In the new context of the costly victory of the North, the national flag acquired a special status, even a presence as the effulgent symbol of national unity. This is quite clear in Henry Ward Beecher's celebrated paean to the flag. In 1861, fol-

lowing the outbreak of the war, Beecher assured a Union audience that the flag "is not a painted rag. It is a whole national history. . . . It is the NATION."[23] In the war's aftermath the memory of rebellion and its defeat combined with the persistence of immigration to occasion a renewed call for the unifying effects of civil religion fostered in the public schools. By the 1880s litigation had turned against reading the Bible in public classrooms, so Protestant advocates of a nationalist civil religion looked for a new means of imposing a civilizing piety on the impressionable minds of the nation's youth to counter the perceived menace of difference and division based on religion and ethnicity. As Civil War veterans in the North aged and began to die, the practice emerged in New York City of veterans presenting their regimental banners and flags to public schools, where children, especially immigrant children, might venerate them.[24] Nationalistic patriotism and the public school intermingled and helped to forge a new variety of American civil religion.[25]

In the spring of 1888, Colonel George T. Balch (1828–1894), West Point graduate, Civil War veteran, and auditor of the New York City Board of Education, visited a large metropolitan public school in the city in order to observe morning exercises. Balch was preparing a history of tenement housing in the city and had become interested in the role of public education in the condition of the urban poor. For fifteen minutes that morning he observed a patriotic ritual in which immigrant school children assembled before the American flag. The event touched him deeply. Balch later wrote that he had never learned so much about patriotism as in those few moments, and he declared that he glimpsed "in them the germ of a patriotic movement, which, in the hands of wise and judicious teachers, could be made to produce results, the far-reaching consequences of which it would be impossible to prognosticate at this time."[26]

Balch went to the school that morning possibly to witness the presentation of a Civil War flag or possibly to observe the patriotic ritual that had come to his attention as a result of recent presentations of Civil War colors to public schools. In any event, his response to the ritual veneration of the flag was informed by his concern for the future of the republic assailed by immigration. In 1890 he published a detailed guidebook for promoting patriotism in the public school. He brought to it an army bureaucrat's eye for procedure and produced a blueprint for the public ritual of a national piety that anticipated the Pledge of Allegiance to the national flag, which would become the central symbol of American nationalism in public schools over the next century. Balch's now largely forgotten book merits close attention, since it prescribes

practices for the public school that stipulate a cultic veneration of the flag and signal its new status as the national icon.

Colonel Balch regarded the American public schools as the government-funded and controlled equivalent of the paternalistic benevolent association, the great Victorian engine of benevolence and social amelioration. It was the public schools that would now engineer mass salvation in American society, redeeming the immigrant hordes and securing the future of the republic. Balch's candor could be startling. He explained that his book's task was

> to show how this human scum, cast on our shores by the tidal wave of a vast immigration, has not been allowed to perish, but as the wards of humanity, under the benign influences of American institutions, and through personal contact with the refined and noble representations of a higher civilization, have been regenerated, and had opened up to them in strange and wide contrast with their hopeless surroundings, all the bright possibilities of an honest and useful life, and of an intelligent and honorable American citizenship.[27]

Balch openly despised sectarian schools, identifying their majority as Roman Catholic and the remainder as Lutheran (German-speaking), Jewish, and "the Episcopal, the Scotch Presbyterian, and the Quaker faiths." The problem with the first three was their resistance to assimilation, which amounted to nothing less than intolerance to Balch. "Many of the [sectarian] schools are made up exclusively of children of the same nationality and faith, in which a foreign language is the language of the school, thus perpetuating not only religious bigotry, but race prejudices as well, than which nothing could be more directly opposed to American ideas and institutions."[28] Immigration and the apostasy of the Confederacy compelled some northern Protestants to view any desire of immigrants to retain the features of their original culture as a threat to American nationhood. In the postwar logic of American nationalism, nationality became the dominant register for identity, subsuming even sectarian religion in an overarching civil religion. Either one was a *faithful* American citizen or one was not.

The nationalist civil religion was a distillation of "the true spirit of Christianity," and Balch took it as axiomatic that "free government" was "but the practical application of Christian charity to the conduct and conservation of social order; and that the best citizens are those most deeply imbued with the spirit and essence of Christianity." But it is striking that his explicit references to Christianity are few. Instead, Balch applied religious language and practice to the cult of nationalist

patriotism as it was to be fostered in the public school. He spoke of the Declaration of Independence as "the catechism of the nation's civil polity" and named as the first means of patriotic education the awakening of the child's "personal relation to this great nation," recalling evangelical Christianity's archprinciple of a personal relationship with Jesus Christ. And if that were not Protestant enough, Balch identified the American flag as "the sole symbol of the greatness of this nation," understanding its exclusively sacred character in terms of a singularity that brings the Reformation doctrine of *sola scriptura* to mind. Such rhetorical appropriations neatly sublimated sectarian Christianity into a civil religion of nationalism. In this light, perhaps the most telling theological transposition occurred in his definition of love of country. "In short, patriotism, to be real and enduring, must be the voluntary offering of a soul filled with the noblest and most generous impulses, and not a half-hearted, reluctant and perfunctory service rendered in obedience to arbitrary law." Patriotism is a complete surrender of the self to the national deity. Balch deftly substituted patriotism, love of country, for charity, the highest Christian ideal of love. In so doing he collapsed patriotism into nationalism. The public schools were to play a key role in this new covenant, because Balch understood them to be "the nursery of the state" and their pupils as "wards of the nation."[29] It is difficult not to think of the republic as conceived by Plato. The national state was the highest good, and the schools existed to instill this sentiment deeply in the souls of the state's wards. If Protestantism reinforced Balch's nationalism, it was also transformed into something else—a nationalist religion with its own code, cultus, creed, and community, to use Catherine Albanese's helpful shorthand for the elements of religion, which amount to the nationalist ethic, ritual, theology, and social identity that Balch endorsed.[30]

Balch organized his treatise around a series of ritualized practices for promoting nationalistic patriotism in the schools. He described in detail the ceremonies, symbols, and utterances that he urged school principals and teachers to enact on a weekly basis in morning exercises that were to follow scripture reading, which persisted in many schools across the nation. Balch stipulated the dimensions and materials for classroom and school building flags, the manner and occasion for their display, the gestures and words to be used in their display and veneration, the organization and conduct of class and school color guards, the way students were to salute the flag, and the military bearing and marching that was to attend the award and veneration of the flag.[31]

FIGURE 68. The Badge of Citizenship for Scholars. From Colonel George T. Balch, *Methods of Teaching Patriotism in the Public Schools* (New York: D. Van Nostrand, 1890), facing p. 16. Photo: Author.

Students competed for the honor of bearing the flag—not academically, which would promote classism, Balch believed, but in the display of public virtues. The strict ritualization of flag display and veneration emulated military protocol. Students who conducted themselves honorably were to be rewarded with the Badge of Citizenship for Scholars (fig. 68). In order to heighten the medal's sacred quality, awardees received it with great ceremony, wore it for one day, and surrendered it (once again, with ceremony) to the teacher. This militarization accompanied the postwar valorization of a more aggressive form of American masculinity, as was discussed in the previous chapter. It also operated for Balch as a public strategy for assimilating the unruly children of an increasingly immigrant society. Students who exhibited the best behavior (modeling punctuality, self-reliance, self-control, self-respect, charity, and generosity) were recognized by the privilege of displaying a flag on their desks. A flag so earned served as "the distinguishing mark for

that day, of the best citizen in the class, instantly recognizable by every visitor." In order to arouse "patriotic enthusiasm" generally, Balch encouraged the ceremonial presentation and display of national flags and portraits of Washington and Lincoln.[32] The sacralization of these icons of the nation was installed in the nursery of the state, whose civil religion promised the blessing of unity and order.[33]

If nineteenth-century protectors of the republic maintained that the Bible was the necessary element in the socialization of citizens young and new and best applied to that end in the public schools, late-nine-teenth- and twentieth-century advocates of homogeneity fixed on the American flag as the preferred talisman for protection against the menace of political and social dissolution and disorder. Indeed, the flag neatly substituted for the Bible, as case law mounted against the use of the Bible in the public school during the late nineteenth century. While Protestants were unable to keep the Bible in the classroom on a perma-nent and national basis, they did succeed at enshrining the flag in legal statutes that mandated its display at public schools. Eventually they were even able to criminalize its abuse as desecration.[34] The efforts to penalize flag desecration cemented the replacement of the Bible by the flag. The conflation of the emblems of American nationhood—Bible and flag—is apparent in the speeches, songs, and patriotic practices of the day.[35] In an address at a banquet of the Sons of the American Rev-olution in 1898, Charles Kingsbury Miller, the outspoken leader and chief orator of the national movement to establish federal statutes against the desecration of the flag, praised the "three sacred jewels" of the United States, "the Bible, the Cross, and the Flag." Miller clearly affixed his call for protection of the sanctity of the flag to fears about American heterogeneity: "In our young republic, devoid of traditions, with a mixed population, augmented by constant arrivals from foreign shores, our government needs a national law to teach these newcomers to this land of liberty, as well as to remind our thoughtless but well-meaning citizens that they must treat with public respect the flag which represents all that makes us noble as a nation." Miller argued that such misuse of the flag as political partisan propaganda, advertisement, street entertainment, prosaic decoration, or as a device to promote labor unions "sets a bad example to the lower classes, who degrade the flag to its nadir." The "emblem of our republic," he claimed, "should be kept as inviolate as was the Holy of Holies in King Solomon's temple."[36] This identification of nation with religious cult was not unusual among proponents of flag protection. In a deliberate invocation of the ancient

practice of identifying the state with a divine patron, an 1895 pamphlet supporting federal legislation against flag desecration proclaimed: "[The flag] is far worthier of self-sacrifice and heroic devotion than any goddess of the olden time."[37] A report to the Daughters of the American Revolution Flag Committee at the 1899 DAR National Convention insisted that the flag be kept as "free and sacred as the cross."[38] Clearly, the flag held specifically Christian significance for vocally patriotic groups whose membership traced a hereditary link to the soldiers whose heroic efforts gave birth to the flag, which "has been baptized in sentiment by the fire and blood and battle," as one member of the DAR testified before a Senate committee in 1908.[39]

The emergence of hereditary organizations in the late nineteenth century answered unmistakably to anxieties about immigration and also to older fears about the mob. It was not just cities filled with unsightly foreign newcomers but also the prospect of mob rule, disorderly electorates voting their own interests, creating their own urban zones of heterodoxic culture, language, and religion. This prospect registered among many Protestants as a threat to the republic, that older ideal that appeared to rely on a middle-class aristocracy. Patriotic organizations formed in order to exclude those who lacked the pedigree of hereditary connections to the heroes and battles that formed the bulging cult of Americanism and to include only those who would unambivalently support lobbying and legislation on behalf of symbols and practices that would enforce the cult.[40]

Yet the movement to make the flag a nationalist icon encountered resistance. The efforts of those who traced a hereditary connection to the historical origins of the nation and its national emblem appeared to some critics as an attempt to bestow upon themselves a privilege that subverted democracy.

There is one form of desecration of our national emblems more serious than those mentioned. That is using them in any way as the distinguishing badge of those self-styled "patriotic" societies which base their membership on their ancestry or which find their chief occupation in opposing the influence of "foreigners." If our flag stands for anything, it stands for opposition to hereditary privilege, the spirit of caste and exclusiveness, and all artificial distinctions and eminences.

The same journal article of 1903 contended that the flag should become "commonplace rather than . . . regarded as in itself sacred."[41] Numerous voices in the academy and newspapers objected in the early years of

the twentieth century to the nationalistic transformation of the flag into an icon, or what E. L. Godkin, editor of *The Nation,* called "idiotic flag-fetishism" and the "new flag-cult" in 1900.[42] A legacy of Balch's enterprise was the spawning of school manuals on patriotism. In the wake of the U.S. annexation of Puerto Rico, Hawaii, Guam, and the Philippines in 1899, at the end of two long decades of economic depression, anxieties about economic instability and immigration were rife. These fears fueled flag mania, which in turn inflated the rhetoric celebrating America's new project of colonialism. Once again, the schools were seen as a primary means of assimilation. Godkin objected to the emphasis placed after the manner of Balch on school rituals to instill patriotism among American children. Imposing such rituals on public school children was comparable, he contended, to "introducing revivalistic appeals at the daily morning prayers." Quoting from one new *Manual of Patriotism,* Godkin singled out religious language toward the flag, concluding that the very "sight of the flag" had become "a signal for emotional hysterics."[43]

In another piece from a few years later, Godkin argued that forcing vows upon children or anyone else was not the way to achieve loyalty from citizens. "The truth is," he claimed, "that love of country, in the high and proper sense, cannot be taught. It is commanded by the country which deserves it. . . . Give men justice, freedom, and equal treatment before the laws, and you do more than all possible schools and schoolmasters to intensify their national love for land and kin."[44] For Godkin and others rule of law, grounded in the Constitution, generated the willing affiliation that would act as social adherence among American citizens and their nation-state by fostering gratitude for securing a just social order. There was nothing mystical about this bond, but something quite rational. The state would merit loyalty on the basis of its service. The flag, it followed, was not a fetish whose adoration was to be coerced and conditioned but a symbol of freely given loyalty. Moving directly against the grain of the American nationalist sentiment of his day and the following century, Godkin insisted that genuine patriotism "transcends the petty bounds of city, State, or country, to embrace mankind. It hates injustice and oppression wherever they exist. It makes cause equally with the tortured negro in the Congo and the massacred Jew in Bialystok." This internationalist or cosmopolitan perspective discerned in what Godkin called "narrow patriotism" a mindset that remains in force a century later. Narrow patriotism "provokes in [the citizen] an exaggerated military enthusiasm

and spirit of belligerency. It opposes international arbitration simply because arbitration requires each nation to refrain from those 'patriotic' hysterics which are dear to many of its rulers and citizens."[45]

Although Godkin's view was not shared by a majority of Americans, legal controversies eventually supported his view of flag veneration as a religious practice. In a decisive Supreme Court case of forty years later, *West Virginia State Board of Education v. Barnette* (1943), the Court recognized that for the majority the flag had come to function as a sacred object, and for this reason it upheld the right of members of the Jehovah's Witnesses to disobey a state law to salute the flag and to recite the Pledge of Allegiance in public schools. According to Jehovah's Witnesses, the decision pointed out, saluting the flag and reciting the pledge violated the second commandment not to make any image or worship it (Exodus 20:4–5). The Court saw enforcement of the state law as a violation of the Bill of Rights. Moreover, it recognized the state law as the attempt "to coerce uniformity of sentiment in support of some end." Appeal to the religious mysteries of the "blood and battle baptism" of the flag fell before the political philosophy of the Bill of Rights, which was premised on the Enlightenment ideal of "government by consent of the governed," a consent that should not be coerced. "There is no mysticism in the American concept of the State or of the nature or origin of its authority," the Court stated. Authority does not descend from divinity or emerge from inherited privilege or arise from religious sentiment or ritual experience. The authority of American government resides in the social contract of the people.[46]

Patriotism and Nationalism

The antimystical view of the flag and any national emblem within American democracy asserts their *symbolic* rather than their *sacramental* character. This is an important distinction in the United States, though it is subtle and repeatedly lost in national life, particularly during moments of crisis. The difference can be described in terms of the distinction of patriotism and nationalism in democracy. It took shape in the second half of the nineteenth century in the United States and is evident in Balch's nationalist redefinition of patriotism, discussed above, in which dedication to the nation was not a legalistic duty but a mystical prompting of each citizen's soul. Adherence to the nation, to a mystical version of Rousseau's "general will," reified as a timeless collective reality, replaced the pre–Civil War patriotism of the revolutionary

generation as well as the hard-won vision of Abraham Lincoln. After the Union victory, the connection of the citizen to the nation tended strongly to subordinate individual rights to the good of the whole. "The older idea of the patriot," one scholar has put it, "as one who defends constitutional rights, reveres liberty, agitates for an end to corruption, and struggles against the outrages of centralized power" was replaced in the second half of the century by a nationalism that exalted national unity as the patriotic ideal.[47] The connection of the citizen to the nation tended strongly to subordinate individual rights to the good of the whole.[48]

Balch's transmogrification of patriotism into nationalism reflects the broad trend of American civil religion during the century that followed the Civil War. What he championed amounted to the nationalism defined by Rousseau in the final, controversial chapter of *The Social Contract* (1762), where the "religion of the citizen" or "civil religion" is contrasted to "the religion of the man," the faith exemplified in Jesus. Civil religion consisted of the "sentiments of sociability" enforced by the state for the good of the state. This faith boasted a minimum of necessary articles—the existence of a powerful, benevolent, all-knowing deity; the life hereafter; the reward of the just and punishment of the unjust; and the "holiness of the laws and the social contract."[49] As a faith controlled by the sovereign for the sake of the commonweal, Rousseau's civil religion recalls the "noble lie" that undergirded Socrates' ideal state.[50] Rousseau conceded that the sovereign "cannot force anyone to believe" the few articles of faith, but "it can banish from the state anyone who does not believe them."[51] And this is precisely what a majority vote in the United States Supreme Court did in a 1931 decision not to extend citizenship to a Canadian theology professor at Yale University, Douglas Clyde Macintosh, who had declared that he would bear arms on behalf of the nation only when his conscience dictated. Macintosh asserted that "he could not put allegiance to the Government of any country before allegiance to the will of God."[52] But the opinion of the Court replied that "he means to make his own interpretation of the will of God the decisive test which shall conclude the government and stay its hand." The opinion continued:

We are a Christian people, but, also, we are a Nation with the duty to survive; a Nation whose Constitution contemplates war as well as peace; whose government must go forward upon the assumption, and can safely proceed upon no other, than [*sic*] unqualified allegiance to the Nation and submission and obedience to the laws of the land, as well those made for war as those made for peace, are not inconsistent with the will of God.[53]

The good of the state depended on absolute submission to its priority over conscience. Individual conscience—"conscientious or religious scruples," as the Court's opinion called it—that abode of personal religion in the tradition of the Protestant Reformation, could not be allowed to trump the authority of the state.[54]

This was a departure from the thought of at least one constitutional framer, James Madison, whose opposition to civil evaluation of religious teachers entailed a clear rejection of what might be called nationalist civil religion. Arguing that "religion be exempt from the authority of the society at large," let alone the legislative body, Madison urged Virginia legislators to recognize that, "in matters of Religion, no man's right is abridged by the institutions of Civil Society and that Religion is wholly exempt from its cognizance."[55] Quoting the Constitution of Virginia, Madison asserted that citizens retained "equal title to the free exercise of Religion according to the dictates of Conscience." The nationalist cult of civil religion militates subtly against the autonomy of conscience. For Madison individual conscience and creator enjoyed a relationship that preceded the bond of the individual to the state. In its imagined community, patriotism of this order directs its allegiance to a nation whose social contract differs from the one described by Rousseau, for whom the "general will" ultimately became sovereign, such that "we as a body receive each other as an indivisible part of the whole." This indivisibility sounds early in Rousseau's treatise as if it will protect the rights of the individual, but what the final chapter on civil religion makes clear is that the state is the end and highest good, outside of which there is no life. To be banished is to be thrown into "the state of nature," where self-preservation is, according to Rousseau, impossible.[56]

Nationalism has a powerful way of erasing or vilifying any other attitude toward the patria. But patriotism is definable as a form of imagined community that is not necessarily nationalistic.[57] Patriotism or love of country will invest in the flag and other objects and places a power to recall and to honor virtues enshrined in the Constitution and in the heroic deeds of those who champion it. The focus of this love is gratitude and esteem for the history of actions and events that secured the social contract that renders the nation a democratic reality. National unity of purpose in a democracy resides not in a particular application of national will but in the collective resolve to maintain the social contract in the face of adversity, injustice, tyranny, or external threat. Since the advantage of democracy is the preservation of liberty, national unity

of purpose may not be served or defined at the expense of dissent. Unity does not mean uniformity; it means common dedication to purpose, which is the preservation of liberty. When the capacity for dissent vanishes, so does democracy. Patriotism, therefore, regards the venerable culture of the nation—everything from flags to monuments to songs to national rituals—as public articulations of a founding contract that includes dissent as a fundamental democratic value.[58] This contract need not be invested solely in a civil religion that sacralizes the state, as Rousseau claimed. Patriotic citizens of a democracy like that of the United States recognize the capacity of cultural forms to function in political discourse as *symbols*, as devices that underscore liberty by maintaining the character of esteemed symbols rather than becoming anything that is sacred in itself. As symbols they will preserve access to public discourse, participation in the public sphere, which can thrive only when dissent and difference are possible. Patriotism is dedication to the principles on which the state is founded and which are exemplified in the individuals, events, and institutions that endorse, conceive, and maintain those principles.

Nationalism, by contrast, installs the flag and other objects and places in a national cult in which reverence of the emblems is understood to secure the nation as an earthly expression of divine will and therefore as a domain that cannot allow dissent. The nation itself is thought to be sacramentally deposited in forms that must be regarded as sacrosanct and holy. Such a view will refuse to distinguish between explicitly religious objects, such as the Bible or the Cross, and the American flag. The flag becomes a national icon, serving like the Bible in the public school as the object of public veneration. Nationalism sacralizes such objects as the flag in order to put them to use in a coercive campaign to eliminate differences that are taken as a menace to uniformity. The only hope for national survival, according to nationalism, consist of interpreting unity as uniformity. Othering is crucial to this enterprise, and the corporate veneration of national icons casts love of nation in religious terms: those who do not worship the national deity are infidels. The "other" of nationalism is the stranger, alien, foreigner, outsider, unassimilated immigrant, savage, or aboriginal. The other of nonchauvinist patriotism is a truculent state as well as one's own failure to realize one's inalienable rights. Such patriotism faces the openness and contingency of the social compact and regards the nation as a willed, historical, mutable construction that requires effort and sacrifice in order to flourish. Nationalism thinks in images of destiny

("manifest destiny"), divine intervention, and the progressive unfolding or self-realization of a national essence or spirit. Nationalism, it seems clear, is a way of imagining a community that is bound by a singular faith, while patriotism may serve as an imagined community driven by common dedication to the justice that founding principles can impart.[59]

This manner of patriotic dedication is a form of belief or assent. It is not surprising, therefore, to find that nonchauvinist patriotism can practice some manner of civil religion. Such practices as mourning war dead lead ineluctably to forms of hero valorization that regard the loss as a sacrifice of sacred character. Yet even revering the dead need not be a rite that slides inevitably into state religion. Patriots may honor the national cultus, such as by visiting the "sacred" spaces of battlegrounds and national memorials; may participate in communal observances of ritual remembrance (Memorial Day, Fourth of July, Veterans Day); may endorse national creeds such as the Pledge of Allegiance; and may uphold the codes prescribed by the state, such as defending the country during war. But these acts do not make them believers in the cult of the nation if the referents of such rites are the principles that are the founding ideals of the nation. The patriotic gaze constructs a relation among citizens, the dead, and founding ideals. In contrast to this, a nationalistic gaze fixes on the god endorsing the state. In either case, however, civil religion is surely at work.

Catholicism and Nationhood

If the American majority was not inclined to distinguish patriotism from nationalism, litigation over the preservation of religious liberty in the first half of the twentieth century helped to do so. One could be a patriotic American without espousing the nationalist view of the (Protestant) majority. Through generations of court cases contesting Protestant hegemony, Catholics and other religious groups challenged the implicit identification of Protestant interests with state and federal government. Catholics themselves engaged in an internal debate over the persistence of individual ethnicities versus adoption of a single, modern, American Catholic identity.[60] Despite the desire of some to cordon off the church from American culture and adopt an antagonistic stance toward national history and engagement with the

society, many Catholic literati searched for a way to make America their own.[61] The 1920s and 1930s proved a pivotal period by witnessing the decline of older styles of mainstream Protestantism and the assimilation of Catholicism into full engagement with American society. Perceived by many Protestants as the national religion in the late nineteenth and early twentieth centuries, Protestantism, not surprisingly, would suffer a loss of prestige when economic and social conditions became especially difficult during the 1930s.[62] Court cases from the mid-1920s through the early 1940s confirmed the loss of Protestantism's privileged status by recognizing the rights of Catholics to operate their own schools (1925) and of Jehovah's Witnesses to refuse to recite the Pledge of Allegiance to the American flag (1943).[63] Intimately identified with American civil religion and the national ethos, Protestantism found its theological and cultural authority suffering the same crisis of faith as the nation.

At the same time, however, many Roman Catholic writers, artists, editors, and educators advanced an optimistic, idealistic vision of America in which they saw a unity of Catholic faith and national identity. Some among the Catholic intelligentsia even claimed to show that American democracy was indebted to Catholic intellectual tradition and that Catholicism was really "the mother of democracy," in the words of one enthusiast.[64] The irony is noteworthy, since this came at the end of a century of Protestant anxieties about the incompatibility of democracy and "popery." But nineteenth-century nativism had declined markedly, the resurgence of such bigotry as the Ku Klux Klan notwithstanding. In the wake of World War I, which had served to insert Roman Catholics into the American fold by virtue of their participation in national defense and the demonstration of their loyalty to the nation, more and more Catholics began to think of themselves as comfortably American and discerned in the American heritage a substantial debt to Catholic thought. Indeed, in the midst of Protestant internal divisions and increasingly conflicted vision in the 1920s and 1930s, many Catholics came to regard themselves, in the words of one Catholic convert, as "the sole heirs by default, to this traditional vision . . . embodied in our Constitution."[65]

In this triumphal vision of their national identity and mission, American Catholics were able to see themselves as quintessentially American. This idea was monumentalized in the National Shrine of the Immaculate Conception, whose construction began in 1920 on the campus of Catholic University of America in Washington, DC. The

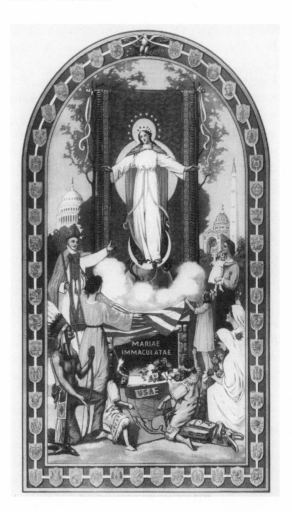

FIGURE 69. Rev. P. Raphael, OSB, *Mary Immaculate, Patroness of the United States*, ca. 1920s. Photograph courtesy of the Archives of the Basilica of the National Shrine of the Immaculate Conception, Washington, D.C. All rights reserved. Used with permission.

grandeur of the shrine championed the Madonna as the national patroness and challenged the ascendancy of a secular, industrial dynamo over the Old World romantic ideal of the Virgin, diagnosed by Henry Adams. In 1922 the editor of *Catholic World* inaugurated that magazine with this observation: "We Catholics are more hopeful for modern civilization than are they who built [it]. . . . We believe that the world has a future. . . . We shall be its saviors."[66] An image appeared in shrine publications in the same year and was reused in order to celebrate and promote the cause of the shrine (fig. 69).[67] Presented in the Baroque rhetoric of a visionary revelation, Mary appears as the Immaculate

Conception, a doctrine formally proclaimed church dogma in 1854 by Pius IX, who stands in full papal regalia beside Mary, presenting her to those gathered before the image. An aged Indian chief bends a respectful knee in acknowledgment of the patroness of the United States, while women and children draw near and tend to the flowers and American flag that accompany the Virgin's apparition. The central motif, borrowed from Venetian paintings of Mary from the sixteenth century, is flanked on one side by the U.S. Capitol building and on the other by the future edifice of the National Shrine itself. The image announces with triumphal and devotional fervor that Mary, totem of Roman Catholicism, has made her way officially to the United States and established her cult in the nation's capital. Once again, as with earlier Protestant visions, state and church intermingle, blurring the constitutional distinction of the two. Moreover, wittingly or not, the Catholic image redeploys the visual rhetoric that had once expressed the optimistic ambitions of nineteenth-century Protestant postmillennialism evident in figure 66. The American Tract Society had produced numerous versions of this sort of image, which valorized the American Protestant missionary preaching to an audience gathered about him or, in figure 66, the national unity and Protestant identity dedicated to a purpose no less glorious than ushering in the final age of humanity. Protestants had imagined a national mission of America as a millennial agent. By the 1920s, Catholic Americans were prepared to assume the cause as part of their national acculturation, which amounted to a partial rescripting of American history, a discernment of the latent influence of Catholic thought in the American past, and an appropriation of erstwhile Protestant enthusiasm. The nation imagined in figure 69 intermingled the old dream of prenational Christendom with the new polity of the American state, providing a bridge to the imagined community of American nationalism for American Catholics. The National Shrine would ground the two forms of imagined community in the same space, leaving to future generations of faithful the task of sorting out the conflicting allegiances that an image such as figure 69 left unarticulated.

The Face of Consensus: Mid-Twentieth Century and the Image of Jesus

Having come to see themselves as good Americans and, no less important, having been accepted as such by non-Catholic Americans, Roman Catholics by midcentury even displayed the same picture of Jesus in their homes as American Protestants did. Indeed, although Protestants

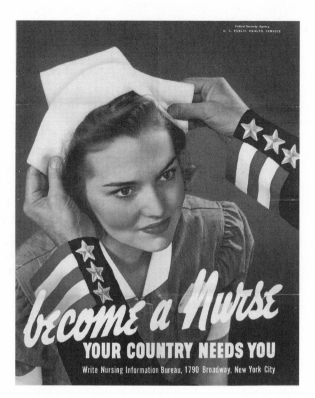

FIGURE 70. "Become a Nurse," poster issued by the United States government, 1942. Courtesy of the Brauer Museum of Art, Valparaiso University.

and Catholics alike assumed that Warner Sallman's *Head of Christ* (see fig. 39) was their own faction's image, more noteworthy was that the image belonged exclusively to no sect. As an image that appealed to both Protestant and Catholic subcultures, this picture of Jesus was used to redirect the nineteenth-century crusade to make the United States a *Protestant* nation toward a twentieth-century campaign to promote the United States as a *Christian* nation. During World War II, Sallman's *Head of Christ* was distributed as a nonsectarian image of Christ among American servicemen in Europe and Asia through the United Services Organization (USO) by the YMCA and the Salvation Army. The filial piety of Jesus, gazing reverently to heaven and bearing an expression of solemn, self-effacing submission to his father's will, also characterized the proper attitude of self-sacrifice encouraged by the government during the war. A poster from 1942 (fig. 70) shows a young woman receiving her commission as a nurse from the descending hands of the national deity, Uncle Sam, whose sleeves carry the national colors.

Bestowing a vocation to serve, these hands enter the visual field in the same manner as the ancient symbol of the biblical deity, the hand of God, occluding his fuller person in conformity to the piety of Jewish and Christian monotheism, but reaching in nevertheless to direct the pious soul to the national task of service. In a striking instance of American civil religion, the poster avoids sectarian iconography without in any way forfeiting the dominant American religious ethos of Christianity and Judaism. While the call to service and self-sacrifice in the face of war is hardly unique to Protestant, Catholic, or Jew, the similarity of the submissive nurse in the poster to Sallman's Jesus and the poster's stark difference from alternative visualizations of wartime women in American popular culture, such as Rosie the Riveter, suggest an alignment with the three major faiths of midcentury United States. Without being one or another of the traditions, the poster can draw from the common features of each and deliver its message as especially compelling: the call to serve the nation comes with a solemnity and authority that is unmistakable. The poster seems to suggest that the call to serve transfigures the individual into a kind of type: the white-clad, finely appointed, and beautifully presented nurse, a gleaming archetype of femininity whose task is to obey male authority and respond to the prompting of the nation-god.

Following the war, Sallman's imagery was put to more aggressively exclusivist use. A Lutheran businessman in Indiana undertook a project called "Christ in Every Purse." His aim was to distribute wallet-sized versions of the *Head of Christ* as widely as possible. The businessman contrasted the need for "card-carrying Christians" to the threat of "card-carrying Communists." His campaign continued through the 1950s and into the 1960s as cold war anticommunism gripped America.[68] A similar, yet historically ironic development took shape in Oklahoma in the late 1940s and 1950s as Ora O'Riley, a Choctaw Indian and Roman Catholic, led a local campaign to make her hometown of Durant, Oklahoma, the only city in the United States to display a picture of Christ in every home and public building. Whereas nineteenth-century evangelical publications often pictured Protestant missionaries at work among Native American communities (see fig. 64), O'Riley returned the favor in the mid-twentieth century as a Roman Catholic and Indian placing Christian images in the public spaces of her town in eastern Oklahoma, where the Choctaw nation had migrated in the late eighteenth century, after a colonial history of alliance with the French and enmity with the British. In 1949 O'Riley persuaded a district judge

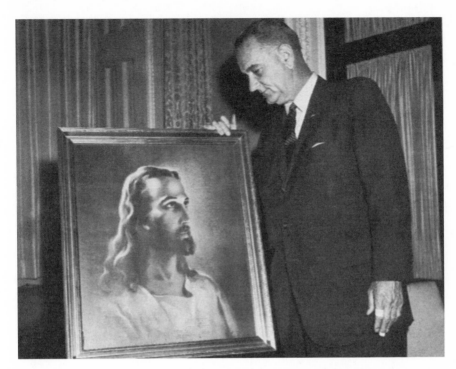

FIGURE 71. Vice President Lyndon B. Johnson with Sallman's *Head of Christ*. In *Durant Daily Democrat*, April 5, 1962, p. 12. Photo: *Covenant Companion*, January 1, 1974. Used with the permission of the *Durant Daily Democrat*.

to hang a copy of Sallman's *Head of Christ* in his courtroom in Durant. Soon the image was proudly placed in the local municipal court, city hall, the fire department, and the chamber of commerce. In 1962 the city of Durant was pleased to have an autographed copy of Sallman's picture accepted by Vice President Lyndon Johnson, who posed in a publicity photo gazing reverentially at the picture of Jesus (fig. 71).[69]

Why was Sallman's image the one to be so widely distributed, avidly received, and ecumenically approved of by diverse Christian groups— from Catholic to Lutheran, Methodist, Baptist, and even Mormon? Surely its nonsectarian portrayal helped. Sallman created an image that avoided the specificity of any denomination and combined with that a direct appeal to the pietistic inwardness that corresponded to a domi- nant strand of popular evangelical Protestant belief. At the same time, the image's soft demeanor registered among Catholics as a devout portrayal of the Savior that comported visually with the mass-produced

images of saints so popular on holy cards before the reforms installed by
the Second Vatican Council (1962–65) consigned them (at least for
many younger Catholics) to an embarrassing and Old World past.
Moreover, in the midst and then the wake of World War II, Americans
experienced what was doubtless the last moment in the twentieth
century when Christianity could represent a broad national consensus.
If the national star of Protestantism had dimmed, the war did much to
stoke the flames of Christian piety and national fervor, and Sallman's
image of Jesus, more than any other, became the emblem of a national
Christianity, a generic religion that served in a period of national crisis
to evoke the pieties of hearth and home and patriotic cultus. The ascen-
dancy of this face of Jesus, which avoids the paraphernalia of divinity
and stresses his human submission of his father's mission, may mark
what sociologist Will Herberg hailed as the tripartite religion of Amer-
ica in mid-twentieth century in his widely noted book, *Protestant-
Catholic-Jew*. Herberg described the social function of religion in
American life: being Protestant, Catholic, or Jewish had become for
Americans the "specific way . . . of being an American and locating one-
self in American society."[70] Protestantism was no longer the sole offi-
cial, national religion of the United States but one of the three official
ways in which Americans understood their national identity as Ameri-
cans. Sallman's picture of Jesus was accepted by many Protestants and
Catholics as the image of their savior and widely recognized by many
Jews, no doubt, as the Christian savior. But the image also served as a
very familiar symbol of American piety. Local chapters of the American
Legion used the image to publicize that organization's "Back to God"
campaign in 1955, which President Eisenhower helped inaugurate with
an address in which he asserted that belief in a supreme being was the
"first, the most basic, expression of Americanism. Without God, there
could be no American form of government, nor an American way of
life."[71] It didn't matter what particular supreme being that might be,
only that one had belief in it. Yet Herberg suggested that Protes-
tantism, Catholicism, and Judaism collectively constituted this "way of
life" for Americans. Although he warned that such culture-religion
lacked the prophetic voice of genuine biblical faith, Herberg insisted
that the "American Way of Life" was a real religious sensibility, what he
called a "civic religion," that bound Americans together into a middle-
class ethos.[72] For many Americans but not all, Sallman's Jesus visually
expressed this ethos and national identity, placing a Christian face on
America. The image was able to signify simultaneously the nonsectarian

consensus of faith at midcentury in the nationalist civil religion *and* the sectarian beliefs of groups as disparate as Baptists, Methodists, Lutherans, and Roman Catholics. The *Head of Christ* silently assured American Christians that the "supreme being" of the national religion was Jesus Christ. Once again, a symbol became an icon and infused patriotism with the religious fervor of nationalism.

The cold war–era campaign to place pictures of Jesus in public buildings marched in step with the infusion of theological language in the Pledge of Allegiance but was perhaps an even more obvious attempt to turn the clock back to the days of the Bible in the classroom. The need for certainty in an atmosphere of panic and fear could express itself in the paranoia of McCarthyism and, less fanatically and more prosaically, in the impulse to secure public spaces and institutions as well as children under the protective presence of the nation's totem. In 1965 a copy of Sallman's familiar picture of Jesus was hung in the hallway of a Michigan public high school to commemorate a beloved secretary. It remained there without comment until 1992, when a student objected to its presence and the American Civil Liberties Union (ACLU) filed suit on the student's behalf in federal court, charging violation of the constitutional separation of church and state, since the local school board supported the superintendent's refusal to remove the picture.[73] After receiving an offer of assistance from evangelist Pat Robertson's 700 Club, the school board agreed to accept legal defense free of charge from the conservative Rutherford Institute of Charlottesville, Virginia, an evangelically sympathetic, private legal foundation committed to promoting freedom of religion. In an attempt to conceal the particularist aspect of the image's meaning for Christians, the school's lawyer argued that the image did not endorse a particular religion but represented Jesus as a historical figure and therefore served a secular purpose rather than a religious one in the public school. Frequent editorials in local newspapers contended that removing the image contradicted the principles enshrined in the Constitution by the founding fathers. "Our country," as one editorialist wrote, "is founded on the principles of God and the morals He teaches through the Bible, his recorded word."[74] The ACLU maintained that the image offended the agnostic student by promoting Christianity.

In a nineteen-page decision, district court judge Benjamin Gibson rejected the school's argument and ruled in favor of the plaintiff, stating that "the true objective [of the image's display] is to promote religion . . . in general and Christianity in particular." Gibson also

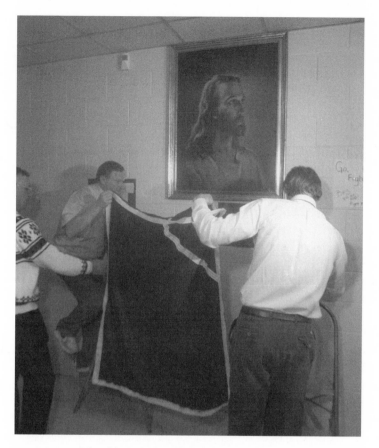

FIGURE 72. School board president places shroud over *Head of Christ*. In *Benton Harbor–Saint Joseph Herald-Palladium*, March 1, 1993. Photo: Jim Merithew. Courtesy of *The Herald-Palladium*.

found that the defendants' "declaration that the picture is displayed as an artistic work or that it is a depiction of a historical figure does not blind this Court to the religious message necessarily conveyed by the portrayal of one who is the object of veneration and worship by the Christian faith."[75]

Supporters of the school board ritualistically cloaked the image (fig. 72) in a red shroud produced by a local women's group and cheered successive attempts at appeal all the way to the United States Supreme Court, which, on May 1, 1995, announced its decision not to hear the case, letting stand the appellate decision to support Gibson's ruling.[76] When the image was finally removed, local clergy led

prayer as supporters wept. School officials left in place of the image the shroud that had covered it. In following days students pinned picture buttons of Jesus to the shroud, but these were removed shortly later after the ACLU threatened to take the school district back to court.[77]

The story sketched in this chapter turns on the recurring recourse some Americans have made to religious visual culture in order to respond to the perceived instability of their democracy. The story moves from the antebellum use of mass-produced images to create a Protestant nation by converting others to the dominant Protestant culture, to the emergence of a national Catholic identity, then to a generic Christian view following World War II (the face of which was Sallman's *Head of Christ*), to the ironic "return of the other" during the cold war period in a crusade conducted by a Native American and Roman Catholic to reclaim the nation for Christianity; it ends in the recent and decisive rejection of the placement of a mass-produced picture of Jesus in a public space, however generic or putatively "historical" that Jesus may be claimed to appear.

In each episode, images—whether pictures of Jesus or ritualized, legally sacralized flags—served as the means for dispersing influence in a nation for which any religious definition of national identity could only be voluntary and not endorsed by the state. In each case the subtle but significant transformation of patriotism into nationalism is evident in the symbols and paraphernalia of an American nationalist cultus. Until the Bloomingdale case, however, no case law stipulated that images of religious figures constitute a coercive or influential effect. What is significant in the Bloomingdale case is that the judicial system affirmed the tendency it had been developing since midcentury: it is no longer inclined to accept the argument of a prevailing religious ethos. In the court's view, images, as elusive as their signification may be, can unambiguously endorse religion when prominently displayed under the auspices of the state. Clearly, this is something that sectors of American Protestantism have believed all along. That the judicial system has caught up with them, however, is no indication that Christians will forsake the currency of images in the quest for an elusive national identity. The recent refusal of a state supreme court chief justice in Alabama to remove a sculpture of the Ten Commandments from a state court house (not unlike a granite version of Benjamin Rush's tract illustration reproduced here as figure 63) is proof that the old argument

is not yet over. In fact, suits in as many as fourteen states were filed in the summer of 2003 concerning the display of the Ten Commandments on public lands or in government buildings.[78] The prevalence of images of sacrifice, self-denial, saintly courage, communal solidarity, and memorial enshrinement suggest that religion and its mass-culture icons remain for Americans one of the most powerful components of their experience of nationhood.

Conclusion

What do scholars stand to gain from the visual study of religion? A tough-minded answer to the question might go like this: Unless scholars are able to show that they learn something more about religion by understanding how it happens visually, the visual culture of religion has little to recommend it as a field or method of study. If that is so, what sort of visual evidence will contribute to the study of religion?

In chapter 6 I argued that the absence of fathers from domestic formation is visually registered in tracts, religious instructional materials, and Christian advice literature. Historians have long noted the idea of absent fathers, but the imagery makes the observation palpable because it connects the absence to an audience of viewers who were invited to think and behave in a way that accommodated the absence. The imagery makes possible the recognition of a visual discourse of the moral formation of children and raises important questions about how images contributed to this history of formation. But one must be careful in weighing the visual evidence. The visual record urges historians to consider the role of images in the circulation of an ideology of gender that may not have been as descriptive of domestic arrangements as it was prescriptive. The images may not reflect the fathers' departure from home for the workplace as much as they assign gender roles to parents: fathers were breadwinners while mothers were directed to devote themselves to the moral formation of their children.

Images were also a register of social change, marking shifts in thought and practice. A telltale trace of change lingers in two uses of

the same illustration one year apart, before and after the beginning of the Civil War (fig. 60). In chapter 5 images were studied as material records of religious conversion, inculturation, and appropriation. Embedded in images are ways of seeing other cultures, the occupying and the occupied, the colonizing and the colonized. If the gaze is a way of seeing, images are the material relays that exercise it. The study of visual culture promises to excavate the visually encoded social arrangements that help empower, disenfranchise, regulate, invent, inspire, and unite people.

But if these instances do not challenge existing narratives so much as focus and accent aspects of them, in chapter 7 the hitherto unnoticed shift from Bibles as national icons to flags, then to an image of Christ, is made clear only by consideration of the visual evidence. Although there is a large secondary literature on the history of American nationalism, knowing that educators at the end of the nineteenth century thought it urgent to instruct American youth in certain national ideals by disciplining their bodies in corporate conduct at public schools is something that scholars of religious visual culture can contribute to the historical understanding of nationalism. Reciting the Pledge of Allegiance in schools, ceremoniously installing and displaying the flag, rewarding student performance with badges, structuring social relations around the protocols of display and observance all contribute to the understanding of what nationalism is, how it is taught and disseminated, and why it persists.

Yet there is another way to regard the contribution of the study of religious visual culture. Enriching scholarship by adding fresh evidence is clearly important, but no less important is what scholars do with the evidence that is already in hand. The history of a field of inquiry is a history of different theories and questions posed of evidence. By defining visual culture as method or approach rather than only as field or subject matter, we are able to focus on interpretation as the measure of value.

Approached in this manner, the study of religious visual culture begins with a question that departs from most art-historical approaches: what do we learn about religion by investigating the *power of images*, that is, their capacity to frighten, seduce, deceive, influence, and inspire? This approach stresses what images do, hence the identification of various functions of imagery in chapter 2. The ways of seeing experienced in religious visual culture are felt more often than they are rationally articulated. As part of the lived experience of belief, they inform the character and everyday life of religion, which Catherine Albanese has helpfully summarized as creed, code, cultus, and community.[1] These

helpful rubrics suggest that a religion is a more or less coherent set of practices regarding what one says, how one behaves, how and what one worships, and how one experiences belief with the group that helps define one's own social identity. The visual culture of religion—that is, the images and visual practices as well as the covenants or assumptions about what one sees and believes one sees—is deeply invested in these coordinates. Each aspect of religion designated by Albanese's terms pertains to a visual aspect. We can speak of the manner in which religion happens visually for a group or individual by examining the peculiar visual forms of creed, code, cultus, and community in a given case.

It is the power of images to charge these coordinates of a religious way of seeing with an enduring authority that lends urgency to the study of religious visual culture. Certainly music and song, verse and scripture, movement and performance, food and dress all do likewise within the practices suited to them. And typically, as I tried to suggest in the introduction, several of these media work together in creating cultures of belief. But in order to study the operation of visual practice with some care, it is necessary to focus on images in their production and reception. Doing so leads to posing questions that take us to the heart of the appeal of images as objects of a gaze that situates viewers toward one another and toward the reality they feel is manifest in the object of their sacred gaze. For example, what did the Taliban imagine they would achieve by demolishing the ancient statues of Buddha (fig. 35)? What do Buddhists in Thailand believe they are doing as they pray before a statue (fig. 12)? Why do those Muslims who disparage sacred imagery circumambulate the Ka'bah and, as its black velvet curtain is ritually raised, gaze raptly on the stones that compose it, in particular, at the Black Stone that the Prophet venerated (fig. 1)? Why do many American tourists experience a flutter and expansiveness when beholding Mount Rushmore (fig. 32) or the Marine Corps War Memorial (fig. 33)? Why do so many Protestants and Catholics see in Warner Sallman's *Head of Christ* the actual likeness of the historical individual and not merely an artist's conception of Jesus (fig. 39)?

In each case, seeing puts believers in the presence of what they wish to see, what they wish to venerate or adore. The sacred gaze allows images to open iconically to the reality they portray or even to morph into the very thing they represent. The latter is perhaps their fondest power for believers. The Taliban saw in the destruction of an "idol," the defeat of the infidel no less than the vindication of God's will, feeling in their iconoclastic victory the flush of discipleship and obedience.

Buddhist devotees honor the dharma and Buddha as one by applying gold leaf to the bronze surface of a sculpture of the meditating Siddhartha Gautama. The very wisdom, power, virtue, and merit of the Buddha reside in the sculpture, placed there in the figure's ritual consecration. Americans gaze upon the totems of nationhood, in some sense the very face of the nation in the case of Mount Rushmore, the embodiment of a transcendent, shared ideal that is the measure of national life. Christians regard the *Head of Christ* as a mass-produced icon, a "true portrait" of the incarnate God.

The concept of the gaze offers to scholars of religion a way of studying the social and cultural embeddedness of seeing. Understanding how sacred images configure vision makes them important evidence for the study of religion, because the projection of rules and the arrangement of viewer and subject that constitute a gaze contribute to the social and historical construction of the sacred. Thus, in its quest for purity, the nationalistic gaze seeks to identify foreigners and then render them invisible by assimilation or deportation. The patriotic gaze seeks to remember war dead by installing them in a cultus of valorization, whereby they come to personify the principles for which their deaths are seen as sacrifices. In each case, a sacred gaze applies itself directly to the task of belief.

Can we understand such practices as devotion, pilgrimage, and prayer without considering the practice of seeing that helps believers perform them? The power of images, which is the power of the sacred gaze, the power of the way believers behold images and are beheld by them and seek to hold others with them, consists of seeing the countenance of the otherwise intangible—whether it is the deity, nation, people, ancestors, destiny, covenant, or duty that guides a community and individual members of it. Inasmuch as visual evocations of the transcendent are part of a religion, the visual culture of belief offers scholars the opportunity to understand the powerful and pervasive ways in which the devout see the world, organize and evaluate it, and infuse into the appearance of things the feelings and ideas that make the world intelligible and familiar to them.

Notes

Introduction

1. Sogyal Rinpoche, *The Tibetan Book of Living and Dying*, ed. Patrick Gaffney and Andrew Harvey, rev. ed. (London: Rider, 2002), 69–71.

2. Joseph Goldstein, *One Dharma: The Emerging Western Buddhism* (New York: HarperSanFrancisco, 2002), 11.

3. Rinpoche, *Tibetan Book of Living and Dying*, 189.

4. Ibid., 17.

5. For a concise discussion of the gaze in the context of Lacanian theory, its primary conceptual orientation, see Nicholas Mirzoeff, ed., *The Visual Culture Reader*, 2nd ed. (London: Routledge, 2002), 593–97. The most helpful introduction to the concept of the gaze for visual analysis is Margaret Olin, "Gaze," in *Critical Terms for Art History*, ed. Robert S. Nelson and Richard Shiff (Chicago: University of Chicago Press, 1996), 208–19.

6. Peter J. Boyer, "The Jesus War: Mel Gibson's Obsession," *New Yorker*, September 15, 2003, 60.

7. I discuss Gibson's film at greater length along these lines in an essay entitled "Manly Pain and Motherly Love: Mel Gibson's Big Picture," in *After The Passion Is Gone*, ed. J. Shawn Landres and Michael Berenbaum (Lanham: AltaMira Press, 2004), 149–57. For further discussion of Sallman's imagery and its reception, see David Morgan, *Visual Piety: A History and Theory of Popular Religious Images* (Berkeley: University of California Press, 1998).

8. For an insightful discussion of the cultural relativity of the idea of "belief" and the importance of recognizing the Christian influence on it in anthropological study, see Malcolm Ruel, "Christians as Believers," *Belief, Ritual and the Securing of Life: Reflexive Essays on a Bantu Religion* (Leiden: E. J. Brill, 1997), 36–59; also excerpted in John Davis, ed., *Religious Organization and Religious Experience* (London: Academic Press, 1982), 9–31; abridged in

Michael Lambek, ed., *A Reader in the Anthropology of Religion* (Oxford: Blackwell, 2002), 99–113.

9. Modern philosophical thought has recognized the importance of non-rational assent in the operation of human understanding. Philosopher David Hume used *belief* to designate the mind's most ordinary operations of thought. Belief, by Hume's account, is none other than the judgment of associating a cause with an effect, experienced as a feeling, a lively, forcible, steady conception that something is in fact the case, such as the continued existence of a body, even if it is not present to the senses, without consulting reason or relying on imagination. See Barry Stroud, *Hume* (London: Routledge and Kegan Paul, 1977), 68–76.

10. "Creator Spirit, by Whose Aid," *Lutheran Worship* (St. Louis: Concordia Publishing House, 1982), 167. Text attributed to Rhabanus Maurus (776–856), trans. John Dryden (1631–1700).

11. See several examples from the history of American Christianity. On food: Daniel Sack, *Whitebread Protestants: Food and Religion in American Culture* (New York: St. Martin's Press, 2000); on dress, Diane Winston, *Red-Hot and Righteous: The Urban Religion of the Salvation Army* (Cambridge, MA: Harvard University Press, 1999); on music and song, Stephen Marini, "Hymnody as History: Early Evangelical Hymns and the Recovery of American Popular Religion," *Church History* 71, no. 2 (June 2002): 273–306.

12. James W. Carey, *Communication as Culture: Essays on Media and Society* (Boston: Unwin Hyman, 1989), 13–36.

13. For an examination of the aura of Protestant tracts, see David Morgan, "Protestant Visual Piety and the Aesthetics of American Mass Culture," in *Mediating Religion: Conversations in Media, Religion, and Culture*, ed. Jolyon Mitchell and Sophia Marriage (London: T. and T. Clark, 2003), 107–20.

14. American Protestant practices of Bible display and veneration are discussed by Colleen McDannell, *Material Christianity: Religion and Popular Culture in America* (New Haven: Yale University Press, 1995), 67–102; and by Paul C. Gutjahr, *An American Bible: A History of the Good Book in the United States, 1777–1880* (Stanford, CA: Stanford University Press, 1999), 39–88. Martin Marty has discussed the iconicity of the Bible in an insightful essay, "America's Iconic Book," in *Humanizing America's Iconic Book: Society of Biblical Literature Centennial Addresses 1980,* ed. Gene M. Tucker and Douglas A. Knight (Chico, CA: Scholars Press, 1982), 1–23.

15. For discussion of the sacred significance of breath in several religious traditions (ancient Greece, Judaism, Christianity, Islam, Hinduism, Taoism, and Buddhism), see Ellison Banks Findly, "Breath and Breathing," *Encyclopedia of Religion,* ed. Mircea Eliade (New York: Macmillan, 1987), vol. 2, 302–8.

16. Quoted in Peter Brown, "Images as a Substitute for Writing," in *East and West: Modes of Communication: Proceedings of the First Plenary Conference at Merida,* ed. Gene M. Tucker and Douglas A. Knight (Leiden: E. J. Brill, 1999), 15.

17. John Calvin, *Institutes of the Christian Religion,* 2 vols., trans. Ford Lewis Battles, ed. John T. McNeill (Philadelphia: Westminster Press, 1960), vol. 1, bk. 1, chap. 11 (pp. 99–120).

18. On this point Calvin recalls Jacques Derrida's signal distinction between speech and writing. In his major, inaugural work, *Of Grammatology* (trans. Gayatri Chakravorty Spivak [Baltimore: Johns Hopkins University Press, 1976], see esp. 6–26), Derrida argues that writing replaces speech when it is understood to capture spoken language, generating meaning when speech is absent, substituting a graphic trace for the presence of the voice as if the two were comparable. As a form of memory, or aid to memory, writing is dead, always a memorial marker of the absence of logos, which is present to speech. Inexorably, however, textuality eclipses phonic performance and establishes itself as the primary bearer of thought or meaning. Modern scientific, theological, and even literary discourses are no longer principally substitutes for vocal performance but operate as autonomous systems of discourse, engrossed in the intricacies of intertextuality—referring not to original speech events but to other texts. Texts do not generate voice but are consumed in silence and in tandem with other texts. One thinks of the literary critic William Hazlitt's remark regarding Shakespeare's work: "We do not like to see our author's plays acted." They are better read, silently, relished in private rumination.

19. Calvin, *Institutes of the Christian Religion,* vol. 1, bk. 1, chap. 9, para. 2, (pp. 94–95).

20. Ibid., bk. 1, chap. 9, para. 3 (p. 95).

21. Lest one object that the opposition of image and word in Calvin is an exclusively Christian or Jewish or even Muslim monotheistic cultural logic, it is helpful to recall that Socrates does something quite similar in *The Republic* when he objects to any stories or images of the gods that depart from the austere rationalism of his theology of what befits deity. Homer, he contends, must be censored if justice is to prevail in the formation of children and the operation of the state.

22. For a discussion of acheiropoetic stones and statuary in ancient Greece and elsewhere, see David Freedberg, *The Power of Images: Studies in the History and Theory of Response* (Chicago: University of Chicago Press, 1989), 66–74.

23. Cyril Glassé, *The New Encyclopedia of Islam* (Walnut Creek, CA: AltaMira Press, 2001), 91.

24. See, for instance, Seyyed Hossein Nasr, *Mecca the Blessed, Medina the Radiant: The Holiest Cities of Islam* (Singapore: Charles E. Tuttle, 1997), 31; and "The Black Stone of Kaaba or Mecca," www.crystalinks.com/blackstone.html.

25. Glassé, *New Encyclopedia of Islam,* 263; Hossein Nasr, *Mecca the Blessed, Medina the Radiant,* 53, 30.

26. As told in Stanley Jeyaraja Tambiah, *The Buddhist Saints of the Forest and the Cult of Amulets: A Study in Charisma, Hagiography, Sectarianism, and Millennial Buddhism* (Cambridge: Cambridge University Press, 1984), 237–38; and Donald K. Swearer, *Becoming the Buddha: The Ritual Image Consecration in Thailand* (Princeton: Princeton University Press, 2004).

27. See a collection of such accounts gathered in Hans Belting, *Likeness and Presence: A History of the Image before the Era of Art,* trans. Edmund Jephcott (Chicago: University of Chicago Press, 1994), 495–99. On the finding and appearance of images in sixteenth-century Spain, see William A. Christian Jr., *Local Religion in Sixteenth-Century Spain* (Princeton: Princeton University Press, 1981), 75–91, and the use of images in cures, 93–105. On apparitions of Christian imagery, see Christian, *Apparitions in Late Medieval and Renaissance Spain* (Princeton: Princeton University Press, 1981).

28. I take the idea of seeing vision from a superb essay by W. J. T. Mitchell, "Showing Seeing: A Critique of Visual Culture," in *The Visual Culture Reader,* ed. Mirzoeff, 86–101.

29. Belting, *Likeness and Presence,* 57–59.

30. Robin Cormack, *Painting the Soul: Icons, Death Masks and Shrouds* (London: Reaktion, 1997), 46–47.

31. Paul had never seen Jesus, at least not in the "optical" sense of the word. Paul suggested in one of his letters that he had once been "caught up into Paradise" in a mystical experience, but he reported only to have "heard things that cannot be told" (2 Corinthians 12:2–4).

32. See Belting, *Likeness and Presence,* 57–58; Cormack, *Painting the Soul,* 45–46; Michael Baxandall, *The Limewood Sculptors of Renaissance Germany* (New Haven: Yale University Press, 1980), 83; and Freedberg, *The Power of Images,* 101.

33. Belting, *Likeness and Presence,* 68, 500.

34. As discussed by and reproduced in Freedberg, *The Power of Images,* 100–103.

35. "Jan Gossart," in *Allegemeines Lexikon der bildenden Künstler,* ed. Ulrich Thieme and Fred. C. Willis (reprint, Leipzig: E. A. Seemann, 1978), vol. 14: 410–13. For a discussion of the identification of Italian models for the painting, see Henri Pauwels et al., *Jean Gossaert dit Mabuse,* exhibition catalogue (Rotterdam: Musée Boymann-van Beuningen, 1965), 108–9.

Chapter 1: Defining Visual Culture

1. "It seems to me to be an interesting idea: that is to say, the idea that we live in the description of a place and not in the place itself, and in every vital sense we do." Letter to Henry Church, April 4, 1945, in *Letters of Wallace Stevens,* ed. Holly Stevens (New York: Alfred A. Knopf, 1972), 494.

2. Not only the images themselves, but the ways of seeing that activate them. Of course, one could say the same of food, dress, architecture, and music as well as the cognitive frameworks that inform eating, dressing, building, feeling, and hearing. In fact, visuality is not a "pure" domain but is intricately interwoven with textuality, aurality, tactility, and so forth. One sees food, clothing, and buildings as well as eats, wears, or inhabits them. And some of the most stimulating work under the uncertain rubric of "visual culture" includes the study of

multiple media. Must every study of visual culture do so? As long as scholars of visual culture bear in mind that they are writing not only for one another but also for students and scholars in other fields far beyond the study of visuality, the focus on images, visual practices, and ways of seeing in "visual culture" seems both practical and prudent.

3. See Peter Burke, *Eyewitnessing: The Uses of Images as Historical Evidence* (Ithaca: Cornell University Press, 2001); Ivan Gaskell, "Visual History," in *New Perspectives on Historical Writing*, ed. Peter Burke (Cambridge: Cambridge University Press, 2000), 187–217; Roy Porter, "Seeing the Past," *Past and Present* 118 (1988): 186–205; and Robert I. Rotberg and Theodore K. Rabb, eds., *Art and History: Images and Their Meaning* (Cambridge: Cambridge University Press, 1988). The idea itself is not new—see E. H. Gombrich, "The Evidence of Images," in *Interpretation: Theory and Practice*, ed. Charles Singleton (Baltimore: Johns Hopkins University Press, 1969), 35–103.

4. See, for instance, "Visual Culture Questionnaire," *October* 77 (Summer 1996): 25–70, for a broad range of responses from scholars of art, literature, and other disciplines on the scope and nature of visual culture as an interdisciplinary study; William Homer Innes, "Visual Culture: A New Paradigm," *American Art* 12, no. 1 (Spring 1998): 6–9; W. J. T. Mitchell, "Interdisciplinarity and Visual Culture," *Art Bulletin* 77, no. 4 (December 1995): 540–44; Mitchell, "What Is Visual Culture?" in *Meaning in the Visual Arts: Views from the Outside: A Centennial Commemoration of Erwin Panofsky (1892–1968)*, ed. Irving Lavin (Princeton: Institute for Advanced Study, 1995), 207–17; Norman Bryson, Michael Ann Holly, and Keith Moxey, eds., *Visual Culture: Images and Interpretation* (Hanover, NH: Wesleyan University Press and University Press of New England, 1994), xv–xxix. Two major collections of essays on visual culture by British authors reflect related concerns. Those writing in *The BLOCK Reader in Visual Culture* (London: Routledge, 1996) seek to move beyond what they call "conventional 'art history'" to a Marxist practice of criticism (3). Chris Jenks, editor of *Visual Culture* (London: Routledge, 1995), is more interested in challenging the positivist methodology of traditional sociology and its art historical equivalent, perceptualism (9–10). John A. Walker and Sarah Chaplin, in *Visual Culture: An Introduction* (Manchester: Manchester University Press, 1997), provide an instructive chapter on the origins of visual culture as a field of study, which outlines its many debts (31–50, see also 3).

5. For use of the term to designate a broader range of images than fine art, see Johanna Drucker, "Who's Afraid of Visual Culture?" *Art Journal* 58, no. 4 (Winter 1999): 37–47; and Innes, "Visual Culture: A New Paradigm."

6. In order to avoid confusion, some writers distinguish "visual culture studies" or "visual studies" as a field from "visual culture" as a subject matter (see Walker and Chaplin, *Visual Culture*, 1; W. J. T. Mitchell, "Showing Seeing: A Critique of Visual Culture," in *The Visual Culture Reader*, ed. Nicholas Mirzoeff, 2nd ed. [London: Routledge, 2002], 87; and "Visual Culture Questionnaire"), while others use the terms interchangeably (Nicholas Mirzoeff, "Introduction," *An Introduction to Visual Culture* [London: Routledge, 1999]).

Visual Studies is a term preferred by some writers, particularly those who are engaged in founding academic departments and programs and providing curricular tools such as introductory texts and anthologies. As a rubric, visual studies is broader than visual culture, which can be both advantageous and troublesome. A thoughtful and prudent introduction to visual studies, and one that is not interested in enforcing a sharp distinction between either nomenclature, is James Elkins, *Visual Studies: A Skeptical Introduction* (New York: Routledge, 2003).

7. Erwin Panofsky, "Iconography and Iconology: An Introduction to the Study of Renaissance Art," *Meaning in the Visual Arts* (Garden City, NY: Doubleday Anchor, 1955), 31. For a brief and accessible discussion of iconography and iconology and their relevance for the historian, see Burke, *Eyewitnessing,* 34–46. For an important study of Panofsky and his significance for the history of art history, see Michael Ann Holly, *Panofsky and the Foundations of Art History* (Ithaca: Cornell University Press, 1984).

8. For discussions of this challenge, see Keith Moxey, "The Politics of Iconology," in *Iconography at the Crossroads,* ed. Brendan Cassidy (Princeton: Index of Christian Art, Department of Art and Archaeology, Princeton University, 1993); and Bryson, Holly, and Moxey, eds., *Visual Culture,* in which several contributors seek to practice a social history of art that sets aside "the traditional concern with the work's aesthetic status in order to show how it plays an active cultural role, one that is just as important to the historical process as any other social agency" (xvii).

9. See, for instance, David C. Miller, ed., *American Iconology: New Approaches to Nineteenth-Century Art and Literature* (New Haven: Yale University Press, 1993).

10. See Bryson, Holly, and Moxey, eds., *Visual Culture; The BLOCK Reader;* Mirzoeff, ed., *The Visual Culture Reader;* Marita Sturken and Lisa Cartwright, *Practices of Looking: An Introduction to Visual Culture* (Oxford: Oxford University Press, 2001); and Jessica Evans and Stuart Hall, eds., *Visual Culture: The Reader* (London: SAGE, 1999). A related approach considers the interpretation of only modern or even postmodern imagery as the purview of visual culture studies. Nicholas Mirzoeff has argued that "visual culture is concerned with visual events in which information, meaning, or pleasure is sought by the consumer in an interface with visual technology" (Mirzoeff, *An Introduction to Visual Culture,* 3). He defines postmodernism as a "visual crisis" in modern culture in which the "visual is contested, debated, and transformed as a constantly challenging place of social interaction and definition in terms of class, gender, sexual and racialized identities" (4). For Mirzoeff, "there is nothing everyday about everyday life any more" (31). By recoding everyday life under the register of conflict, this crisis-oriented approach approximates the avant-gardist interpretation of modernist art. In so doing, it overlooks the fact that visual culture has always been contested, debated, and transformed. And no less important, it ignores the other highly important role of visual culture: its quotidian role in creating and sustaining consensus in order to achieve an

inertial, serviceable, functional, enduring sense of reality. As quickly as visual media change today, they also remain the same, deploying reliable formulas and patterns that resist change and are valued in everyday life precisely for doing so.

11. Mitchell has provided a very shrewd and helpful list of "myths about visual culture," which includes the notion that "we live in a predominantly visual era. Modernity entails a hegemony of vision and visual media" (Mitchell, "Showing Seeing," 90). For a study that asserts what Mitchell cautions against, see Sut Jhally, "Image-Based Culture: Advertising and Popular Culture," in *The Anthropology of Media: A Reader,* ed. Kelly Askew and Richard R. Wilk (Oxford: Blackwell, 2002), 327–36.

12. Irit Rogoff, "Studying Visual Culture," in *The Visual Culture Reader,* ed. Mirzoeff, 26, 33.

13. Elkins, *Visual Studies,* 32–36.

14. Several leading scholars of visual culture have produced very significant studies of religious imagery, some of which are cited by Elkins in *Visual Studies.* The most important work includes Michael Baxandall, *The Limewood Sculptors of Renaissance Germany* (New Haven: Yale University Press, 1980); David Freedberg, *The Power of Images: Studies in the History and Theory of Response* (Chicago: University of Chicago Press, 1989); Keith Moxey, *Peasants, Warriors, and Wives: Popular Imagery in the Reformation* (Chicago: University of Chicago Press, 1989); Hans Belting, *Likeness and Presence: A History of the Image Before the Era of Art,* trans. Edmund Jephcott (Chicago: University of Chicago Press, 1994); Robert S. Nelson, editor, *Visuality before the Renaissance: Seeing as Others Saw* (Cambridge: Cambridge University Press, 2000); and Joseph Leo Koerner, *The Reformation of the Image* (Chicago: University of Chicago Press, 2004). Elkins himself has published a fascinating study, *The Strange Place of Religion in Contemporary Art* (New York: Routledge, 2004). The historiography of the study of art and religion differs in important respects from the history of writing about visual theory. For a sense of the difference, compare the intellectual genealogies sketched by Elkins, *Visual Studies,* chap. 1, and by David Morgan, "Toward a Modern Historiography of Art and Religion," 16–47, in Ena Giurescu Heller, ed., *Reluctant Partners: Art and Religion in Dialogue* (New York: The Gallery at the American Bible Society, 2004).

15. I agree with W. J. T. Mitchell that visual culture is an approach to the study of images that is premised on "the social construction of visual experience." See Mitchell, "Interdisciplinarity and Visual Culture," 540; Mitchell, "What Is Visual Culture?"; and Bryson, Holly, and Moxy, eds., *Visual Culture: Images and Interpretations,* xvii–xxii. See also Walker and Chaplin, *Visual Culture: An Introduction,* esp. 65–110. Authors of the essays reproduced in *The BLOCK Reader in Visual Culture* situate themselves within a Marxist practice of art history, which is by definition deeply concerned with a materialist analysis of art geared toward class formations. Those writing in the collection *Visual Culture,* edited by Jenks, are largely sociologists engaged in describing what Jenks calls a "social theory of visuality" (1). Sally Promey and

I have stressed the social function of images in a recent volume on American religious imagery (see "Introduction," in *The Visual Culture of American Religions,* ed. David Morgan and Sally M. Promey [Berkeley: University of California Press, 2001]).

A number of recent publications on the study of imagery within the social sciences likewise stress "the social rather than the individual construction of meaning" (Marcus Banks, *Visual Methods in Social Research* [London: SAGE, 2001], 11). These include the following studies, which work with or assume theories of social and cultural construction: Elizabeth Edwards, ed., *Anthropology and Photography, 1820–1920* (New Haven: Yale University Press in association with the Royal Anthropological Institute, London, 1992); Michael Emmison and Philip Smith, *Researching the Visual: Images, Objects, Contexts and Interactions in Social Science Inquiry* (London: SAGE, 2000); Theo van Leeuwen and Carey Jewitt, eds., *Handbook of Visual Analysis* (London: SAGE, 2001); Jon Prosser, ed., *Image-based Research: A Sourcebook for Qualitative Researchers* (London: Falmer Press, 1998); Paul Messaris, *Visual "Literacy": Image, Mind, Reality* (Boulder: Westview Press, 1994); Sarah Pink, *Doing Visual Ethnography: Images, Media, and Representation in Research* (London: SAGE, 2001); Marcus Banks and Howard Morphy, eds., *Rethinking Visual Anthropology* (London: Yale University Press, 1997); Gilian Rose, *Visual Methodologies: An Introduction to the Interpretation of Visual Materials* (London: SAGE, 2001); and Jay Ruby, *Picturing Culture: Explorations of Film and Anthropology* (Chicago: University of Chicago Press, 2000).

16. For a related list of normative descriptions of what visual culture consists of as a form of study, see Mitchell, "Interdisciplinarity and Visual Culture," 543–44.

17. A traditional distinction of culture and society states that culture may be defined as the things that people make, such as stories, songs, buildings, and theories, and that society consists of the laws, institutions, and practices that organize the making of those artifacts and their use. It is not always a clear distinction, particularly when it differentiates object and institution too firmly. The two are deeply conjoined in the *practices* of making, commissioning, distributing, displaying, and using artifacts. I understand object and institution to be engaged at the level of practice. My assumption is that images participate in both the social and the cultural construction of reality. The scholar of visual culture, therefore, may stress either one or both, as the subject of study requires.

18. While there are scores of art history and film studies graduate departments and programs in North America, the United Kingdom, Canada, Australia, and New Zealand, a smaller but growing number of programs in visual culture and related fields, such as visual anthropology, are emerging in these countries. Typically, these take the form of forums or "centers" for critical discussion and the promotion of research rather than degree-granting bodies. Very few cater to undergraduates. Perhaps the most developed and ambitious programs in the United States are located at the University of Southern California, at Los Angeles

(visual anthropology), the University of Rochester (visual culture), and the University of Wisconsin, Madison (art history). Graduate and undergraduate programs in visual anthropology, film studies, art history, and visual culture also exist in one form or another at the University of California, Irvine and Riverside; Temple University, Philadelphia; New York University; Bryn Mawr; Sarah Lawrence College; SUNY, Stony Brook; the University of Montreal; the University of Otago, New Zealand; the University of Sussex, UK; and Manchester Metropolitan University, UK. SAGE Publications began publishing the *Journal of Visual Culture* in April 2002 (www.sagepub.com). Other journals, two of them available online, are *Visual Communication,* also published by SAGE, *Iconomania,* published by the University of California, Los Angeles (www.humnet.ucla.edu), and *Invisible Culture: An Electronic Journal for Visual Studies* (www.rochester.edu). For an excellent aid in visual anthropology, see "Web Resources for Visual Anthropology," www.usc.edu/dept/elab/urlist/. A journal, *Visual Anthropology Review,* official publication of the Society for Visual Anthropology, is published at the University of Virginia (etext.lib.virginia.edu). For an even longer list of programs and initiatives from around the world, see Elkins, *Visual Studies,* 9–12.

19. Mitchell, "Interdisciplinarity and Visual Culture" and "What Is Visual Culture?"

20. Mitchell and others have stressed the need to investigate what they call "imagetext" or "iconotext," a visual-textual unit of meaning that cannot be reduced to either pure image or text. See W. J. T. Mitchell, *Picture Theory* (Chicago: University of Chicago Press, 1994), 83–107 et passim; and Peter Wagner, *Reading Iconotexts: From Swift to the French Revolution* (London: Reaktion Books, 1995).

21. Discussions of the cognitive orders or epistemes of images and their historicity are Martin Jay, "Scopic Regimes of Modernity," in *Vision and Visuality,* ed. Hal Foster (Seattle: Bay Press, 1988), 3–27; and, on somewhat different terms, Michael Baxandall, *Painting and Experience in Fifteenth-Century Italy: A Primer in the Social History of Pictorial Style* (Oxford: Oxford University Press, 1972), 29–108.

22. A good case for the exploration of nonart imagery is James Elkins, *The Domain of Images* (Ithaca: Cornell University Press, 1999).

23. A helpful study of visual culture that balances the hermeneutical view of understanding the life-world with the structuralist idea of explanation is Malcolm Barnard, *Approaches to Understanding Visual Culture* (Houndmills, England: Palgrave, 2001). For consideration of this approach in the history of approaches to the study of art and religion, see David Morgan, "Toward a Modern Historiography of Art and Religion," in *Uneasy Partners: Art and Religion in Dialogue,* ed. Ena Heller (New York: Gallery at the American Bible Society, 2004).

24. Instances of the study of the reception of religious imagery or material culture through ethnographic investigation are Thomas A. Tweed, *Our Lady of the Exile: Diasporic Religion at a Cuban Catholic Shrine in Miami* (New York:

Oxford University Press, 1997); Erika Doss, *Elvis Culture: Fans, Faith, and Image* (Lawrence: University Press of Kansas, 1999); and Monique Scheer, "From Majesty to Mystery: Change in the Meanings of Black Madonnas from the Sixteenth to Nineteenth Centuries," *American Historical Review* 107, no. 5 (December 2002): 1412–40.

25. See, for instance, E. H. Gombrich, *The Image and the Eye* (London: Phaidon, 1986); James Elkins, *Visual Studies,* and *The Poetics of Perspective* (Ithaca: Cornell University Press, 1994); Irvin Rock, *Perception* (New York: Scientific American, 1995); Jonathan Crary, *Suspension of Perception: Attention, Spectacle, and Modern Culture* (Cambridge, MA: MIT Press, 1999); Thomas Puttfarken, *The Discovery of Pictorial Composition* (New Haven: Yale University Press, 2000); Christian Kassung and Thomas Macho, "Imaging Processes in Nineteenth-Century Medicine and Science," in *Iconoclash: Beyond the Image Wars in Science, Religion, and Art,* ed. Bruno Latour and Peter Weibel (Karlsruhe and Cambridge, MA: ZKM, Center for Art and Media, and MIT Press, 2002), 336–47; and several excerpted essays in S. Brent Plate, ed., *Religion, Art, and Visual Culture: A Cross-Cultural Reader* (New York: Palgrave, 2002), 19–52. Visionary experience, with its challenge to regnant epistemologies such as naturalism, should also be included in the study of visual culture; see, for instance, William A. Christian Jr., *Moving Crucifixes in Modern Spain* (Princeton: Princeton University Press, 1992).

26. The purpose of the remainder of the chapter is not to provide a study of visual and interpretive theory for its own sake but to offer an introductory consideration of how scholars of visual culture understand evidence and construct their arguments using certain rudimentary conceptual tools. For those who wish to examine the subject of interpretive theory and images much further and as a subject matter in its own right, see the following influential studies: Mitchell, *Picture Theory;* Michael Baxandall, *Patterns of Intention: On the Historical Explanation of Pictures* (New Haven: Yale University Press, 1985); James Elkins, *On Pictures and the Words That Fail Them* (Cambridge: Cambridge University Press, 1998); and David Carrier, *Principles of Art History Writing* (University Park: Pennsylvania State University Press, 1991).

27. For more on these figures, see David Morgan and Sally M. Promey, *Exhibiting the Visual Culture of American Religions,* exhibition catalogue (Valparaiso, IN: Valparaiso University Brauer Museum of Art, 2000), 81.

28. "Improvements in Sunday Schools: Extract from the Report of Sunday School No. 23, New-York Union Society, April 1824," *American Sunday School Teacher's Magazine* 1, no. 8, July 1824, 256.

29. Ibid., 258.

30. An illuminating study of the levels of meaning added to German prints by devout viewers and colorists who hand-tinted them, often transforming Catholic originals into Protestant images of piety, is Susan Dackerman, *Painted Prints: The Revelation of Color in Northern Renaissance and Baroque Engravings, Etchings, and Woodcuts* (Baltimore and University Park: Baltimore Museum of Art and Pennsylvania State University Press, 2002).

Chapter 2: Visual Practice and the Function of Images

1. Stephen P. Huyler, *Meeting God: Elements of Hindu Devotion* (New Haven: Yale University Press, 1999), 137. An excellent discussion of Hindu visual piety is Diana L. Eck, *Darsan: Seeing the Divine Image in India* (Chambersburg, PA: Anima Books, 1981).

2. Conversation with the author, December 7, 2003, Indian American Cultural Center, Merrillville, IN.

3. Meher McArthur, *Reading Buddhist Art: An Illustrated Guide to Buddhist Signs and Symbols* (London: Thames and Hudson, 2002), 175, 73. A very helpful study of the mandala is Denise Patry Leidy and Robert A. F. Thurman, *Mandala: The Architecture of Enlightenment* (New York and Boston: Asia Society Galleries, Tibet House, and Shambhala, 1997). On Tibetan meditation and visualization, see Luis O. Gómez, "Two Tantric Meditations: Visualizing the Deity," in *Buddhism in Practice*, ed. Donald S. Lopez Jr. (Princeton: Princeton University Press, 1995), 318–27; and Jonathan Landaw and Andy Weber, *Images of Enlightenment: Tibetan Art in Practice* (Ithaca, NY: Snow Lion Publications, 1993). For further discussion of the iconography of the Hevajra mandala, see Pratapaditya Pal, *Himalayas: An Aesthetic Adventure*, exhibition catalogue (Chicago: Art Institute of Chicago, 2003), 201.

4. For two examples of these, see T. S. Maxwell, *The Gods of Asia: Image, Text, and Meaning* (Delhi: Oxford University Press, 1998), plates 50 and 51. On the relationship of mandalas and stupas, see Martin Brauen, *The Mandala: Sacred Circle in Tibetan Buddhism*, trans. Martin Wilson (Boston: Shambhala, 1997), 26–29.

5. On Christian practices of visual piety, see David Morgan, *Visual Piety: A History and Theory of Popular Religious Images* (Berkeley: University of California Press, 1998). For selected readings in several religious traditions regarding art and imagery, see S. Brent Plate, ed., *Religion, Art, and Visual Culture: A Cross-Cultural Reader* (New York: Palgrave, 2002). On Ignatius and Jesuit visual piety, see Jeffrey Chipps Smith, *Sensuous Worship: Jesuits and the Art of the Early Catholic Reformation in Germany* (Princeton: Princeton University Press, 2002), 29–55.

6. For a useful collection of essays on various forms of visuality in many different religious traditions, see Plate, ed., *Religion, Art, and Visual Culture*. On visual piety in Christianity, see Morgan, *Visual Piety;* for a study of visual piety in Islam, see Allen F. Roberts and Polly Nooter Roberts, "Displaying Secrets: Visual Piety in Senegal," in *Visuality before and beyond the Renaissance: Seeing as Others Saw*, ed. Robert S. Nelson (Cambridge: Cambridge University Press, 2000), 224–51. For a discussion of the study of religious visual culture in several religious traditions, see David Morgan, "Visual Religion," *Religion* 30 (2000): 41–53.

7. I have found most helpful Catherine L. Albanese's discussion of the definition of religion in her book *America: Religions and Religion*, 3rd ed. (Belmont, CA: Wadsworth Publishing, 1999), 2–11; other studies that may be

usefully consulted on the definition of religion and its ongoing debates are William E. Paden, *Interpreting the Sacred: Ways of Viewing Religion* (Boston: Beacon Press, 1992), and Robert Crawford, *What Is Religion? Introducing the Study of Religion* (New York: Routledge, 2002). A helpful anthology of primary sources on the definition of religion is Walter H. Capps, *Ways of Understanding Religion* (New York: Macmillan, 1972).

8. Albanese, *America: Religions and Religion,* 11.

9. See, for instance, Kevin Trainor, *Relics, Ritual, and Representation in Buddhism: Rematerializing the Sri Lankan Theravāda Tradition* (Cambridge: Cambridge University Press, 1997). This approach was also championed by Donald S. Lopez Jr. in his monumental edited volume *Buddhism in Practice* (see the introduction, 3–36). For a study of the importance of relics and material culture for the practice of Chinese Buddhism, see John Kieschnick, *The Impact of Buddhism on Chinese Material Culture* (Princeton: Princeton University Press, 2003), 5–14, 24–44.

10. Malcolm Ruel, *Belief, Ritual, and the Securing of Life: Reflexive Essays on a Bantu Religion* (Leiden: E. J. Brill, 1997), 18–23.

11. Albanese, *America: Religions and Religion,* 8–10.

12. Robert A. Orsi, *Thank You, St. Jude: Women's Devotion to the Patron Saint of Hopeless Causes* (New Haven: Yale University Press, 1996), 110–14, 207–9, et passim.

13. Ibid., 132.

14. This list derives, in part, from a shorter set of functions described by Sally M. Promey and myself in the introduction of *The Visual Culture of American Religions,* 2–15. Another, shorter but similar, listing of functions of religious images as forms of visual evidence occurs in Burke's *Eyewitnessing,* 46–58.

15. For several examples of the mizrah, see Norman L. Kleeblatt and Gerard C. Wertkin, *The Jewish Heritage of American Folk Art* (New York: Universe Books, 1984); and Geoffrey Wigoder, ed., *Jewish Art and Civilization* (Secaucus, NJ: Chartwell Books, 1972).

16. Quoted in Ted Shaffrey, "Signs of Grief," *Columbia Daily Tribune,* September 8, 2002, 1E. My thanks to Kristin Schwain for sharing this article with me.

17. Quoted in Dr. Santokh Singh, *The Guru's Word and Illustrated Sikh History* (Princeton, Ontario: Spiritual Awakening Studies, 2000), 11.

18. My thanks to Siriwan Santisakultarm, of Bangkok, for her assistance in explaining the practices of *lang phra* and *pid thong* and securing the photograph of figure 12. A fascinating and insightful study on Thai Buddhism, including amulets and images, is Stanley Jeyaraja Tambiah, *The Buddhist Saints of the Forest and the Cult of Amulets: A Study of Charisma, Hagiography, Sectarianism, and Millennial Buddhism* (Cambridge: Cambridge University Press, 1984).

19. See Robert H. Sharf, "The Scripture on the Production of Buddha Images," in *Religions of China in Practice,* ed. Donald S. Lopez Jr. (Princeton: Princeton University Press, 1996), 261–67; and Daniel Boucher, "Sūtra on the Merit of Bathing the Buddha," in Buddhism in Practice, ed. Lopez, 59–68. For

further consideration of Buddhist visual piety, see Heather Stoddard, "The Religion of Golden Idols," in *Iconoclash: Beyond the Image Wars in Science, Religion, and Art*, ed. Bruno Latour and Peter Weibel (Karlsruhe and Cambridge, MA: ZKM, Center for Art and Media, and MIT Press, 2002), 436–55; and Rob Linrothe and Melissa Kerin, "Deconsecration and Discovery: The Art of Karsha's Kadampa Chorten Revealed," *Orientations* 32, no. 10 (December 2001): 52–63.

20. See, for instance, Alisa La Gamma, *Art and Oracle: African Art and Rituals of Divination* (New Haven: Yale University Press, 2000); Mary Nooter Roberts, "Proofs and Promises: Setting Meaning before the Eyes," in *Insight and Artistry in African Divination*, ed. John Pemberton III (Washington, DC: Smithsonian Institution Press, 2000), 63–82; Manuel Jordán, "Art and Divination among Chokwe, Lunda, Luvale, and Other Related Peoples of Northwestern Zambia," in *Insight and Artistry in African Divination*, ed. Pemberton, 134–43; P. M. Peek, *African Divination Systems: Ways of Knowing* (Bloomington: Indiana University Press, 1991).

21. St. John of Damascus, *On the Divine Images*, trans. David Anderson (Crestwood, NY: St. Vladimir's Seminary Press, 1980), 46.

22. Sharf, "The Scripture on the Production of Buddha Images," 261.

23. Donald K. Swearer, "Consecrating the Buddha," in *Buddhism in Practice*, ed. Lopez, 50–58.

24. For a discussion of the three bodies of the Buddha in Mahayana Buddhism, see Boucher, "Sūtra on the Merit of Bathing the Buddha," 60. For a consideration of association of the Lotus Sutra with relics, stupas, and the "eternal body of the Buddha" in Japanese Buddhism, see Willa Jane Tanabe, "Visual Piety and the Lotus Sutra in Japan," in *A Buddhist Kaleidoscope: Essays on the Lotus Sutra*, ed. Gene Reeves (Tokyo: Kosei Publishing, 2002), 81–92; and, by the same author, a very instructive study, *Paintings of the Lotus Sutra* (New York: Weatherhill, 1988), 98–124, which includes illustrations of stupas consisting of Japanese characters from the sutra.

25. Yijing, "Sūtra on the Merit of Bathing the Buddha," quoted in Boucher, "Sūtra on the Merit of Bathing the Buddha," 62.

26. Sogyal Rinpoche, *The Tibetan Book of Living and Dying*, ed. Patrick Gaffney and Andrew Harvey, rev. ed. (London: Rider, 2002), 189.

27. My discussion is based on two major studies: Ruth B. Phillips, *Representing Women: Sande Masquerades of the Mende of Sierra Leone* (Los Angeles: UCLA Fowler Museum of Cultural History, 1995); and Donald Cosentino, *Defiant Maids and Stubborn Farmers: Tradition and Invention in Mende Story Performance* (Cambridge: Cambridge University Press, 1982), esp. 24–29.

28. Phillips, *Representing Women*, 87.

29. Ibid., 53.

30. For a good introduction to Islamic art and architecture, see Robert Irwin, *Islamic Art in Context: Art, Architecture, and the Literary World* (New York: Abrams, 1997). An excellent collection of essays about Muslim uses of space in the Muslim diaspora in the West is Barbara Daly Metcalf, ed., *Making*

Muslim Space in North America and Europe (Berkeley: University of California Press, 1996). On mosques and the meaning of Muslim space in the United States, see Akel Ismail Kahera, *Deconstructing the American Mosque: Space, Gender, and Aesthetics* (Austin: University of Texas Press, 2002).

31. I borrow the term *imagetext* (if not entirely its meaning) from W. J. T. Mitchell, *Picture Theory* (Chicago: University of Chicago Press, 1994), 83. Another version of it, *iconotext,* has been discussed by Peter Wagner, *Reading Iconotexts: From Swift to the French Revolution* (London: Reaktion Books, 1995).

32. On the hamsa and its role as amulet, see Isaiah Shachar, *Jewish Tradition in Art: The Feuchtwanger Collection of Judaica,* trans. R. Grafman (Jerusalem: Israel Museum, 1981), 237–321, esp. 298–305.

33. Hebrew micrography, images composed entirely of Hebrew script, is well known among European and American Jews; see Kleeblatt and Wertkind, *Jewish Heritage in American Folk Art,* 54–55; Leila Avrin, *Micrography as Art* (Paris and Jerusalem: Centre national de la recherche scientifique and Israel Museum, 1981); and Grace Cohen Grossman with Richard Eighme Ahlborn, *Judaica at the Smithsonian: Cultural Politics as Cultural Model* (Washington, DC: Smithsonian Institution Press, 1997), 192–93.

34. For an excellent discussion of this image and the wealth of Mouride visual culture, see Allen F. Roberts and Mary Nooter Roberts, *A Saint in the City: Sufi Arts of Urban Senegal* (Los Angeles: UCLA Fowler Museum of Cultural History, 2003), esp. 55–59.

35. *Oxford English Dictionary* (Oxford: Clarendon Press, 1933), vol. 8, s.v. "Propaganda."

36. Evangelist, Ethiopian Evangelical Church, Mekane Yesus congregation, Nekemte, Ethiopia, interview 19, May 22, 1999, field notes. My colleague, Professor Charles Schaefer, and I interviewed clergy, staff, and laity of the Ethiopian Evangelical Church throughout central Ethiopia concerning the use of images. For further discussion, see David Morgan, "Visual Media and the Case of Ethiopian Protestantism," in *Belief in Media: Media and Christianity in a Cultural Perspective,* ed. Mary Hess, Peter Horsfield, and Adán Medrano (Aldershot, Hampshire, UK: Ashgate Publishing, 2004), 107–20.

Chapter 3: The Covenant with Images

1. Nathaniel Hawthorne, *The Marble Faun, or the Romance of Monte Beni,* vol. 9 of *The Works of Nathaniel Hawthorne* (1860; New York: Caxton Society, 1922), 272. My thanks to William Dyrness for bringing this passage to my attention.

2. Ibid., 276.

3. I am sympathetic to Hans-Georg Gadamer's hermeneutics, though the idea of covenant that I am developing here is not equivalent to Gadamer's idea of the "horizon" of a worldview that is extended or clarified or transformed in interpretation. Gadamer discussed horizon in his major work, *Truth and*

Method (New York: Crossroad, 1985): "Every finite present has its limitations. We define the concept of 'situation' by saying that it represents a standpoint that limits the possibility of vision. Hence an essential part of the concept of situation is 'horizon.' The horizon is the range of vision that includes everything that can be seen from a particular vantage point" (269). In that context, Gadamer was discussing the task of historical interpretation: "The working out of the hermeneutical situation means the achievement of the right horizon of enquiry for the questions evoked by the encounter with tradition." He discussed the hermeneutics of the interpretation of works of art in "Aesthetics and Hermeneutics," in Hans-Georg Gadamer, *Philosophical Hermeneutics,* trans. and ed. David E. Linge (Berkeley: University of California Press, 1976), 95–104. A horizon is changed or transfigured by the encounter with a work of art, which unfolds in negotiation with the hermeneutical preconditions prescribed by the way of seeing, or covenant, that viewers agree to. As we shall see, covenants are often rejected, modified, or replaced in the course of looking and interpreting.

4. For a historically sensitive discussion of the manifold character of belief, see Malcolm Ruel, *Belief, Ritual and the Securing of Life: Reflexive Essays on a Bantu Religion* (Leiden: E. J. Brill, 1997), 36–59.

5. George Steiner wrote eloquently about the rupture of the covenant between word and world in *Real Presences* (Chicago: University of Chicago Press, 1989), see pt. 2, "The Broken Contract." My use of the notion of a compact or covenant with the image explored in this chapter is indebted to Steiner's discussion.

6. Richter's photolithograph is reproduced in Robert Storr, *Gerhard Richter: Forty Years of Painting,* exhibition catalogue (New York: Museum of Modern Art, 2002), 89.

7. For examples of this work and historical discussion of it, see Michel Frizot, "The All-Powerful Eye: The Forms of the Invisible," in *A New History of Photography,* ed. Michel Frizot (Cologne: Könemann, 1998), 273–84; and Marta Braun, "The Expanded Present: Photographing Movement," in *Beauty of Another Order: Photography in Science,* ed. Ann Thomas (New Haven and Ottawa: Yale University Press and National Gallery of Canada, 1997), 150–85.

8. The news clipping is reproduced in Storr, *Gerhard Richter,* 101.

9. "Interview with Dieter Hülsmanns and Fridolin Reske, 1966," in Hans-Ulrich Obrist, ed., *Gerhard Richter: The Daily Practice of Painting, Writings and Interviews 1962–1993,* trans. David Britt (Cambridge, MA, and London: MIT Press and Anthony d'Offay Gallery, 1995), 57.

10. "Interview with Rolf Schön, 1972," in Obrist, ed., *Gerhard Richter,* 73.

11. "Interview with Dieter Hülsmanns and Fridolin Reske, 1966," in Obrist, ed., *Gerhard Richter,* 58.

12. David Hume, *A Treatise of Human Nature,* ed. David Fate Norton and Mary J. Norton (Oxford: Oxford University Press, 2000), 123–44 (bk. I, pt. 4, secs. 1 and 2).

13. Sarah Whitfield, *Magritte,* exhibition catalogue (London: South Bank Centre, 1992), no. 69.

14. See *The Interpretation of Dreams,* 1935, ibid.

15. See Benedict Anderson's influential study *Imagined Communities: Reflections on the Origin and Spread of Nationalism,* 2nd ed. (London: Verso, 1991), 37–46, in which he ascribes a fundamental importance to print-capitalism for the development of nationalism. On the importance of religious publishing for the formation of the public sphere postulated by Jürgen Habermas, see David Zaret, "Religion, Science, and Printing in the Public Spheres in Seventeenth-Century England," in *Habermas and the Public Sphere,* ed. Craig Calhoun (Cambridge, MA: MIT Press, 1992), 212–35.

16. See Elizabeth Eisenstein, *The Printing Press as an Agent of Change: Communications and Cultural Transformations in Early Modern Europe,* 2 vols. (Cambridge: Cambridge University Press, 1979).

17. See Roland Barthes, *The Responsibility of Forms: Critical Essays on Music, Art, and Representation,* trans. Richard Howard (Berkeley: University of California Press, 1991), 27–30.

18. *The Red Model,* 1935, oil on canvas, Musée national d'art moderne, Paris; reproduced in Whitefield, *Magritte,* plate 70.

19. Quoted in Rev. Hugh Macmillan, *Bible Teachings in Nature* (New York: D. Appleton, 1869), 164.

20. Ibid., vi.

21. As noted in Anderson's biography, cowritten by his wife; Raymond H. Woolsey and Ruth Anderson, *Harry Anderson: The Man Behind the Paintings* (Washington, DC: Review and Herald Publishing Association, 1976), 74–75.

22. "Where Are You Going?" (New York: American Bible Society, 1995), 5.

23. It is worth noting that the fantasy film *The Labyrinth* used the Escher motif, but as a test for the heroine, who struggles to find her way through it and defeat evil in the form of the Goblin King, played by David Bowie.

24. "Interview for *Life,*" in René Magritte, *Écrits complets,* ed. André Blavier (Paris: Flammarion, 1979), 610, 611. On another occasion, Magritte acknowledged his fascination with the "void" but explicitly distinguished between "the void" and "mystery": "Le Néant est la suppression d'une chose que le Mystère avait rendue possible. Le Néant est l'absence absolue d'existence. Le Mystère est la nécessité absolue pour que l'existence soit possible" ("La Voix du Mystère," in Magritte, *Écrits complets,* 550).

25. Magritte denigrated symbols in paintings because he felt they substituted meanings for objects themselves. Symbols, he told art critic Suzi Gablik, "are supposed to represent reality, but in truth they don't represent anything. If one looks at a thing with the intention of trying to rediscover what it means, one ends up no longer seeing the thing itself, but thinking of the question that has been raised" ("Interview with Suzi Gablik," in Magritte, *Écrits complets,* 645).

26. David Morgan, "For Christ and the Republic: Protestant Illustration and the History of Literacy in Nineteenth-Century America," in *The Visual Culture of American Religions,* ed. David Morgan and Sally M. Promey (Berkeley: University of California Press, 2001), 49–51.

27. The following web sites offered instructive discussion of the rationale and pedagogical advantages of nursery rhymes: curry.edschool.virginia.edu, home.freeuk.com, www.smarterkids.com, www.speechtx.com.

28. John Berger, "The Ambiguity of the Photograph," in *The Anthropology of Media: A Reader,* ed. Kelly Askew and Richard R. Wilk (Oxford: Blackwell, 2002), 49.

29. Quoted in James N. Wood and Teri J. Edelstein, eds., *The Art Institute of Chicago: The Essential Guide* (Chicago: Art Institute, 1993), 251; on Kandinsky's notion of inner necessity, see Kandinsky's essay, "On the Question of Form," in *Kandinsky: Complete Writings on Art,* ed. Kenneth C. Lindsay and Peter Vergo (New York: Da Capo Press, 1994), 239.

30. Goodman's major work of significance for the study of art is *Languages of Art: An Approach to a Theory of Symbols* (Indianapolis: Hackett Publishing, 1976); Goodman's constructivist approach is discussed for its relevance to developmental theories of cognition in Jerome Bruner, *Actual Minds, Possible Worlds* (Cambridge, MA: Harvard University Press, 1986), 93–105.

31. A major study of deconstruction and art with attention to theological reflection is Mark C. Taylor, *Disfiguring: Art, Architecture, Religion* (Chicago: University of Chicago Press, 1992).

32. Portions of a single figure (or phrase) were created blindly by successively passing a sheet of paper to participants, who drew (or wrote) a portion without seeing its relation to the drawings that preceded theirs; see André Breton, *What Is Surrealism? Selected Writings,* ed. Franklin Rosemont (New York: Pathfinder, 1978), 352, 365.

33. Richter, "Notes, 1988," in Obrist, ed., *Gerhard Richter,* 170.

34. "Interview with Sabine Schütz, 1990," ibid., 212.

35. David Hume, *Dialogues Concerning Natural Religion and the Natural History of Religion,* ed. J. C. A. Gaskin (Oxford: Oxford University Press, 1993), 130.

Chapter 4: The Violence of Seeing

1. Stanislaw Lec, Polish Holocaust survivor and satirist, quoted in David Remnick, "War without End?," *New Yorker,* April 21 and 28, 2003, 62.

2. David Freedberg, *The Power of Images: Studies in the History and Theory of Response* (Chicago: University of Chicago Press, 1989), 54.

3. Moshe Halbertal and Avishai Margalit, *Idolatry,* trans. Naomi Goldblum (Cambridge, MA: Harvard University Press, 1992), 16–17.

4. Mark S. Smith, *The Origins of Biblical Monotheism: Israel's Polytheistic Background and the Ugaritic Texts* (New York: Oxford University Press, 2001), 149–66.

5. The caliph 'Umar commented to the Stone during the ritual circumambulation of the Ka'bah: "I know that you are only a stone which does not have the power to do good or evil. If I had not seen the Prophet kissing you, I would not kiss you" (quoted in Cyril Glassé, *The New Encyclopedia of Islam,* rev. ed.

[Walnut Creek, CA: AltaMira Press, 2001], 91). See also Gerald R. Hawting, *The Idea of Idolatry and the Emergence of Islam: From Polemic to History* (Cambridge: Cambridge University Press, 1999), 85, 106.

6. Glassé, *The New Encyclopedia of Islam*, 22, 221, 245.

7. For an example, see Barbara Daly Metcalf, ed., *Making Muslim Space in North America and Europe* (Berkeley: University of California Press, 1996), 76.

8. Hawting, *The Idea of Idolatry and the Emergence of Islam*, 7, 9.

9. On Eastern Orthodoxy and the iconoclastic controversy, see Charles Barber, *Figure and Likeness: On the Limits of Representation in Byzantine Iconoclasm* (Princeton: Princeton University Press, 2002); Jaroslav Pelikan, *The Spirit of Eastern Christendom (600–1700)*, vol. 2: *The Christian Tradition: A History of the Development of Doctrine* (Chicago: University of Chicago Press, 1974); G. B. Ladner, "The Concept of the Image in Greek Fathers and the Byzantine Iconoclastic Controversy," *Dumbarton Oaks Papers* 7 (1953): 3–33; and Herbert L. Kessler, *Spiritual Seeing: Picturing God's Invisibility in Medieval Art* (Philadelphia: University of Pennsylvania Press, 2000), esp. 29–52 and 64–87. On Protestant iconoclasm during the Reformation, see Eamon Duffy, *The Stripping of the Altars: Traditional Religion in England 1400–1580* (New Haven: Yale University Press, 1992); Sergiusz Michalski, *The Reformation and the Visual Arts: The Protestant Image Question in Western and Eastern Europe* (London: Routledge, 1993); Lee Palmer Wandal, *Voracious Idols and Violent Hands: Iconoclasm in Reformation Zurich, Strasbourg, and Basel* (New York: Cambridge University Press, 1995); Jacqueline Eales, "Iconoclasm, Iconography, and the Altar in the English Civil War," in *The Church and the Arts*, ed. Diana Wood (Oxford: Blackwell, 1992), 313–27; and Carlos M. N. Eire, *War against the Idols: The Reformation of Worship from Erasmus to Calvin* (Cambridge: Cambridge University Press, 1986).

10. Kenneth Mills, *Idolatry and Its Enemies: Colonial Andean Religion and Extirpation, 1640–1750* (Princeton: Princeton University Press, 1997), 170 (on "sustained religious persecution"), 270 (on "capacity to absorb . . .").

11. Rolena Adorno, *Guaman Poma: Writing and Resistance in Colonial Peru* (Austin: University of Texas Press, 1986), 5.

12. Carolyn Dean, *Inka Bodies and the Body of Christ: Corpus Christi in Colonial Cuzco, Peru* (Durham, NC: Duke University Press, 1999), 179–89. See also Adorno, *Guaman Poma*, 13–35. A deft and insightful reading of the role of image worship and destruction in what he calls the "war of images" across the history of Mexico in the sixteenth and seventeenth centuries and beyond is Serge Gruzinski, *Images at War: Mexico from Columbus to Blade Runner (1492–2019)*, trans. Heather MacLean (Durham, NC: Duke University Press, 2001).

13. Dean, *Inka Bodies*, 16–17.

14. Mills, *Idolatry and Its Enemies*, 189.

15. Ibid., 282.

16. Ibid., 281; Dean, *Inka Bodies*, 160.

17. Rev. W. Windsor, "Idolatry," *American Sunday School Worker* 6, no. 7, July 1875, 194–95.

18. See David Morgan, *Protestants and Pictures: Religion, Visual Culture, and the Age of American Mass Production* (New York: Oxford University Press, 1999), chap. 6.

19. Mills, *Idolatry and Its Enemies*, 267.

20. Richard H. Davis, *Lives of Indian Images* (Princeton: Princeton University Press, 1997), 205.

21. Ann Kibbey, *The Interpretation of Material Shapes in Puritanism* (Cambridge: Cambridge University Press, 1986), 42–64; and Sally M. Promey, "Seeing 'in Frame': Early New England Material Practice and Puritan Piety," *Material Religion* 1, no. 1 (March 2005; forthcoming).

22. Davis, *Lives of Indian Images*, 7–8.

23. Ibid., 54–55.

24. Ibid., 85.

25. This is a framework for studying imagery that might be fruitfully applied to other religious settings, such as the Black Stone of the Ka'bah. Along similar lines, I have seen roomfuls of sacred crosses, icons, and sculptural figures discarded and removed from Ukrainian churches by priests and members who wish to cleanse, modernize, or traditionalize decoration and art. The objects were collected by priests and monastics who wish to save the work, restore it, and locate it in an ecclesiastical museum in Lviv. Another process of aestheticization is evident in the transformation of religious objects by the history of their reception as fine art—such as the Elgin Marbles, which is the museum name for the Parthenon deities from the pediment of the fifth-century BCE temple in Athens; or the Hellenistic figure group of Laocoon and his sons, which was spiritualized by Winckelmann and has been variously interpreted by many others. See Richard Brilliant, *My Laocoon: Alternative Claims in the Interpretation of Art Works* (Berkeley: University of California Press, 2000).

26. Ward's book was first published in 1806 under the title *Account of the Writings, Religion, and Manners of the Hindoos*. The title underwent changes in subsequent editions. In 1823 it was published in the United States as the second part of a compilation, Thomas Robbins, ed., *All Religions and Religious Ceremonies: Part I. Christianity, Mahometanism, and Judaism; Part II: A View of the History, Religion, Manners, and Customs of the Hindoos, together with the Religion and Ceremonies of Other Pagan Nations* (Hartford: Oliver D. Cooke and Sons, 1823), where the illustration reproduced here as figure 31 occurs, facing p. 50.

27. Davis, *Lives of Indian Images*, 168.

28. Ibid., 259.

29. For a very helpful discussion of the significance of the secularization thesis for the practice of art history as it relates to the study of religion and art among historians of American art, see Sally M. Promey, "The 'Return' of Religion in the Scholarship of American Art," *Art Bulletin* 85, no. 3 (September 2003): 581–603.

30. Albert Boime, *The Unveiling of the National Icons: A Plea for Patriotic Iconoclasm in a Nationalistic Era* (Cambridge: University of Cambridge Press, 1998), 2.

31. Ibid., 2, 8, 9.

32. Ibid., pp. 10–13, 154.

33. See chapter 7 here for further discussion of the fetishization of the American flag as a national icon.

34. Boime, *Unveiling of the National Icons,* 44, for this and the subsequent quotations.

35. Christopher A. Thomas, *The Lincoln Memorial and American Life* (Princeton: Princeton University Press, 2002), 158–65.

36. "Interview: Roving Ambassador of Afghanistan, Sayed Rahmatullah Hashimi, talks about the hardships in Afghanistan and why the Taliban recently destroyed two ancient buddhas," National Public Radio, March 21, 2001, transcript obtained online at nl.newsbank.com. My thanks to Eric Joll for bringing the interview to my attention.

37. Jean-François Clément, "The Empty Niche of the Bamiyan Buddha," in *Iconoclash: Beyond the Image Wars in Science, Religion, and Art,* ed. Bruno Latour and Peter Weibel (Karlsruhe and Cambridge, MA: ZKM, Center for Art and Media, and MIT Press, 2002), 218.

38. See Dario Gamboni, *The Destruction of Art: Iconoclasm and Vandalism since the French Revolution* (New Haven: Yale University Press, 1997), 20, 32. This broad latitude in defining iconoclasm was first sketched out by Freedberg in his highly suggestive chapter, "Idolatry and Iconoclasm," in *The Power of Images* (378–428), from which Gamboni takes many examples.

39. Freedberg, *Power of Images,* 378–428.

40. It would be rash to conclude that the Enlightenment denigrated images per se. The work of art historian Barbara Maria Stafford stands as a considerable attempt to invoke the Enlightenment's use of visuality as a powerful form of knowledge for our own day. See, for instance, *Artful Science: Enlightenment Entertainment and the Eclipse of Visual Education* (Cambridge, MA: MIT Press, 1994); *Good Looking: Essays on the Virtue of Images* (Cambridge, MA: MIT Press, 1996); and *Visual Analogy: Consciousness as the Art of Connecting* (Cambridge, MA: MIT Press, 1999).

41. Gamboni, *Destruction of Art,* 255.

42. For a good discussion of Saint-Simon and avant-gardism, see Donald D. Egbert, "The Idea of 'Avant-garde' in Art and Politics," *American Historical Review* 73, no. 2 (December 1967): 339–66.

43. For a helpful discussion of Greenberg's ideas in this context, see Hans Belting, "Beyond Iconoclasm: Nam June Paik, the Zen Gaze and the Escape from Representation," in *Iconoclash: Beyond the Image Wars in Science, Religion, and Art,* ed. Bruno Latour and Peter Weibel (Karlsruhe and Cambridge, MA: ZKM, Center for Art and Media, and MIT Press, 2002), 390–91.

44. Bruno Latour, "What Is Iconoclash? Or Is There a World beyond the Image Wars?" in *Iconoclash,* ed. Latour and Weibel, 14–37.

45. Freedberg, *Power of Images,* 421.

46. John Calvin, *Institutes of the Christian Religion,* 2 vols., trans. Ford Lewis Battles, ed. John T. McNeil, vols. 20–21 of Library of Christian Classics (Philadelphia: Westminster Press, 1960), 1: 113.

47. Kibbey, *Interpretation of Material Shapes,* 47.

48. Calvin, *Institutes,* 1: 108.

49. Andreas Bodenstein (Karlstadt) from Karlstadt, *On the Removal of Images and That There Should Be No Beggars among Christians,* 1522, in *The Essential Carlstadt,* trans. and ed. E. J. Furcha (Waterloo, Ontario: Herald Press, 1995), 116–17.

50. Ibid., 103.

51. On the violence associated with Karlstadt's call for the removal of images from Wittenberg churches, see Michalski, *The Reformation and the Visual Arts,* and Carl C. Christensen, *Art and the Reformation in Germany* (Athens, OH: Ohio State University Press, 1979). This is not, of course, the only reason that iconoclastic acts occurred. Kibbey makes the point that Puritan iconoclasts felt compelled to destroy material images and any practice (such as preachers wearing the surplice during worship services) that presumed to make ritual stand in the place of genuine worship (*Interpretation of Material Shapes,* 58–59). By destroying images literally and figuratively, Kibbey claims, Puritans affirmed their "belief in themselves as living icons" (60). Visible sainthood was their aim. This entailed a new semiotic or physiognomy of the sacred. "To make the visible church as much like the invisible," historian Edmund Morgan wrote, "the later Congregationalists argued that the visible church in admitting members should look for signs of saving faith" (Edmund S. Morgan, *Visible Saints: The History of a Puritan Idea* [Ithaca: Cornell University Press, 1963], 34). Iconoclasm served to keep the devout focused on the proper figure or image of faith, the real icon of the divine life: the gathered body of God's elect. An especially perceptive study of Reformation visual piety and iconoclasm is Joseph Leo Koerner, "The Icon as Iconoclash," in *Iconoclash,* ed. Latour and Weibel, 164–213.

52. Daniel J. Boorstin, *The Image: A Guide to Pseudo-Events in America* (1961; New York: Vintage Books, 1992), 13. Daniel Bell accorded the Puritans an important place in the American historical character and lamented the loss of what he called "the Puritan temper" in modern America's degeneration into hedonism and the "idolatry of the self" (*The Cultural Contradictions of Capitalism,* 25th Anniversary Edition [New York: Basic Books, 1996], 15–21).

53. Ibid., 244.

54. In her earlier book *On Photography* (New York: Dell, 1977), Sontag agreed with Socrates about the untrustworthiness of images and their capacity to incite sympathy and move us thereby toward the good (3–24). But in a recent work of great moral scrutiny, *Regarding the Pain of Others* (New York: Farrar, Straus and Giroux, 2003), she has reconsidered (see 105).

55. Alain Besançon, *The Forbidden Image: An Intellectual History of Iconoclasm,* trans. Jane Marie Todd (Chicago: University of Chicago Press, 2000).

56. Ibid., 224.

57. Ibid., 382.

58. The idea of the avant-garde lived on economically in Andy Warhol's transformation of the artist-hero into the artist-celebrity during the 1960s. But as a viable position of critique secure from the commodifying power of the art

market, the avant-garde's existence is dubious at best, though some have looked for a chastened version of it. In a recent book on idolatry, commercialism, and art, Raphael Sassower and Louis Cicotello resist definitions of the avant-garde as complete artistic autonomy in which the artist towers over society by virtue of genius or divine revelation akin to Moses's perch on Sinai (Raphael Sassower and Louis Cicotello, *The Golden Avant-Garde: Idolatry, Commercialism, and Art* [Charlottesville: University Press of Virginia, 2000]). Neither is the artist able to remain detached from commerce. After recalling the story of the golden calf fashioned for the Israelites by their priest Aaron while Moses delayed his return from the stormy summit of Sinai, the authors proclaim: "The culture of idolatry remains intact despite two thousand years of monotheism. That is, desire and aesthetic gratification cannot be overcome by scripture and customs. . . . The precious gold earrings are willingly traded for a sculpture, an idol, a god worth worshipping. And artists are there to accommodate the needs of their patrons, to further the goals of their leaders (in the ancient case, Aaron). Should they refuse the commission? Should they not participate in their culture's upheaval? Can they refrain from taking part in their own culture?" (2).

Artists make idols, the authors believe, when they sell their art, when they turn aside from the sacred and terrible call of the almighty, the genius that must be the sole, exclusive end for art, and surrender to the pleasures of commerce. According to the mythology of the avant-garde, the artist is supposed to be a prophet like Moses, who withdraws from the crowd in pursuit of artistic purity. Aaron is the patron who buys art for aesthetic gratification, which true artists, avant-garde artists, ought to scorn. In fact, Moses returns and berates Aaron, who is not the art-patron but the ersatz-artist, the one who gives the people what they want rather than giving them the sacred endowment of the artist who works beyond the market, submissive only to the dictates of artistic genius. Sassower and Cicotello want to deconstruct the myth of the avant-garde artist. But they also wish to retain the category of idolatry because they believe the artist still capable of some prophetic power. With the sober intention of assessing what art is realistically capable of accomplishing in capitalist, industrial, and "technoscientific" society, Sassower and Cicotello do not believe that art can deliver modern life from the "corruption of capitalism, modern politics, and mass communication" (15). Instead, they argue that art can enact a "critical defiance" in the face of manifold idolatries. And they assert this within the Enlightenment tradition of modern secularity: "If we have lost our trust in religious institutions as a means to a spiritual end, and if we still wish to fulfill some form of spiritual quest, then we desperately need art, among other cultural expressions, as an alternative means through which to reach our spiritual destiny" (13).

Chapter 5: The Circulation of Images in Mission History

1. The literature on religion and contact in Peru is monumental. A good place to start, particularly with respect to indigenous imagery and the representation

of contact, is Rolena Adorno, *Guaman Poma: Writing and Resistance in Colonial Peru* (Austin: University of Texas Press, 1986).

2. The most important study of art and the history of Jesuit missions around the world is Gauvin A. Bailey, *Art on the Jesuit Missions in Asia and Latin America, 1542–1773* (Toronto: University of Toronto Press, 1999). Bailey's book is arguably the best study of the history of mission art. It is grounded in extensive archival research, thoroughly informed by theoretical issues in numerous disciplines, and takes images with the utmost seriousness as primary forms of evidence.

3. See, for instance, Adorno, *Guaman Poma;* Bailey, *Art on the Jesuit Missions;* Serge Gruzinksi, *Images at War: Mexico from Columbus to Blade Runner (1492–2019),* trans. Heather MacLean (Durham, NC: Duke University Press, 2001); Sabine MacCormack, "Art in a Missionary Context: Images from Europe and the Andes in the Church of Andahuaylillas near Cuzco," in *The Word Made Image: Religion, Art, and Architecture in Spain and Spanish America, 1500–1600,* ed. Anne Hawley (Boston: Trustees of the Isabella Stewart Gardner Museum, 1998), 103–26; Tom Cummins and Elizabeth Hill Boone, eds., *Native Traditions in the Postconquest World* (Washington, DC: Dumbarton Oaks, 1998).

4. See, for instance, Charles S. Prebish and Martin Baumann, *Westward Dharma: Buddhism beyond Asia* (Berkeley: University of California Press, 2002), for important studies of the diffusion of Buddhism in the West and its diverse accommodations to non-Asian cultures, especially the essay by Ian Harris, "A 'Commodus Vicus of Recirculation': Buddhism, Art, and Modernity," 365–82, for discussion of Buddhism's influence on modern Western painters. For a theological study of Christian and Buddhist missiologies, see Michael A. Fuss, "*Upāya* and *Missio Dei:* Toward a Common Missiology," in *A Buddhist Kaleidoscope: Essays on the Lotus Sutra,* ed. Gene Reeves (Tokyo: Kosei Publishing, 2002), 115–25. The history of the transformation of the iconography of a bodhisattva from Indian to Chinese and Japanese Buddhism and to a Christian motif provides a case study of cultural and intercultural comparison; see Chün-fang Yü, "Guanyin: The Chinese Transformation of Avalokiteshvara," in *Latter Days of the Law: Images of Chinese Buddhism 850–1850,* ed. Marsha Weidner (Lawrence, KS: Spencer Museum of Art; Honolulu: University of Hawaii Press, 1994), 151–81; Maria Reis Habito, "The Bodhisattva Guanyin and the Virgin Mary," *Buddhist-Christian Studies* 13 (1993): 61–9; Michael A. Fuss, "Buddha und Maria: Dynamische Leere als Ikone des Dialogs," *Studia Missionalia* 43 (1994): 211–44; and Bailey, *Art on the Jesuit Missions,* 89, 97–98. For examinations of Islam in Western diasporic locations, see Barbara Daly Metcalf, ed., *Making Muslim Space in North America and Europe* (Berkeley: University of California Press, 1996).

5. Paul Carus, *The Gospel of Buddha* (Chicago: Open Court Publishing Company, 1915), xv. The artist for the book, Olga Kopetzky, provided a similar statement on her illustrations (307–11). For an examination of Hindu appropriations of Jesus and his iconography, see Stephen Prathero, *American Jesus: How the*

Son of God Became a National Icon (New York: Farrar, Straus and Giroux, 2003), 267–85.

6. Bailey (*Art on the Jesuits Missions,* 22) has also discouraged reliance on the notion of dominance in the study of missions.

7. There are, however, instances of images whose makers seek to convey both the common humanity and the distinctive otherness of their subjects. Kathryn T. Long has considered the important contributions that documentary photographers have made to the portrayal of missionary efforts back home among evangelicals as well as a broader American public, but Long also demonstrates the capacity of missionaries to respond open-mindedly to indigenous peoples: " 'Cameras Never Lie': The Role of Photography in Telling the Story of American Evangelical Missions," *Church History* 72, no. 4 (December 2003): 820–51.

8. Rev. Hermann Domianus, Aira, Ethiopia, May 23, 1999, conversation with the author.

9. *Watòto: Ein Missionsbilderbuch für Kinder,* images by Melchoir Annen, introduction by P. Veit Gadient (Schlieren-Zürich: Neue Brücke, 1933). My thanks to Professor Sandy Brewer for bringing this publication to my attention.

10. Donald Burke, "Congo Mission: Modern Missionaries Combine Faith with Medicine and Education," *Life,* June 2, 1947, 108; photograph by N. R. Farbman.

11. The older anthropological term of choice was *acculturation.* More recent thought prefers *transculturation.* The term used by Christian theologians has been *inculturation.* On the terminology in general, see Bailey, *Art on the Jesuit Missions,* 22–31; for several studies related to the visuality of transculturation see Nicholas Mirzoeff, *The Visual Culture Reader,* 2nd ed. (London: Routledge, 2002), 477–80, 533–90; for discussions of inculturation, see Vincenzo Poggi, S.J., and Patrick J. Ryan, S.J., *Islam and Culture* (Rome: Centre "Cultures and Religions"–Pontifical Gregorian University, 1984); and Lamin O. Sanneh, *Encountering the West: Christianity and the Global Cultural Process: The African Dimension* (Maryknoll, NY: Orbis Books, 1993).

12. Quoted in Celso Costantini, *L'Art chrétien dans les missions: Manuel d'art pour les missionaires,* trans. Edmond Leclef (Paris: Desclée de Brouwer, 1949), 40. All translations into English are my own.

13. As reported to the author by Professor Nelly van Dorrn-Harder.

14. For collections and considerations of appropriated or indigenous imagery, see Sepp Schüller, "Christliche Eingeborenenkunst in Nichtchristlichen Ländern," *Christliche Kunst* 32, no. 7 (April 1936): 198–215; Sepp Schüller, "Einheimische Kunst im Dienste des Religionsunterrichtes in den Missionsländern," *Katholisches Jahrbuch der Schweiz* 5 (1938): 71–81; Costantini, *L'Art chrétien;* Arno Lehmann, *Die Kunst der Jungen Kirchen* (Berlin: Evangelische Verlagsanstalt, 1955; 2nd ed., 1957) (all further citations are to the second edition); Arno Lehmann, *Christian Art in Africa and Asia,* trans. Erich Hopka, Jalo E. Nopola, and Otto E. Sohn (St. Louis: Concordia Publishing House, 1969); Richard W. Taylor, *Jesus in Indian Painting* (Madras, India:

Christian Literature Society, 1975); W. A. Dyrness, *Christian Art in Asia* (Amsterdam: Rodopi, 1979); John F. Butler, *Christianity in Asia and Africa after 1500 AD* (Leiden: E. J. Brill, 1979), and *Christian Art in India* (Madras, India: Christian Literature Society, 1986); Masao Takenaka, *Christian Art in Asia* (Kyoto: Kyo Bun Kwan with Christian Conference of Asia, 1975); Matthew Lederle, S.J., *Christian Painting in India through the Centuries* (Bombay: Heras Institute of Indian History and Culture; Anand, Gujarat: Gujarat Sahitya Prakash, 1987); Masao Takenaka and Ron O'Grady, *The Bible through Asian Eyes* (Auckland, New Zealand: Pace Publishing; Kyoto, Japan; in association with the Asian Christian Art Association, 1991); Anton Wessels, *Images of Jesus: How Jesus Is Perceived and Portrayed in Non-European Cultures* (Grand Rapids, MI: Eerdmans, 1990); Andrew F. Walls, "The Western Discovery of Non-Western Christian Art," in Walls, *The Missionary Movement in Christian History: Studies in the Transmission of Faith* (Maryknoll, NY, and Edinburgh: Orbis Books and T. and T. Clark, 1996), 173–86; and Bailey, *Art on the Jesuit Missions.*

15. Daniel Johnson Fleming, *Each with His Own Brush: Contemporary Christian Art in Asia and Africa* (New York: Friendship Press, 1938), 3.

16. Ibid., 45. For fascinating observations on the intercultural interpretation of African carving inspired by Christian concepts, see Julius E. Lips, *The Savage Hits Back* (New Haven: Yale University Press, 1937), 167–68.

17. Walter Henry Nelson, *Buddha: His Life and Teaching* (New York: Jeremy P. Tarcher/Putnam, 1996), 77–79.

18. John F. Butler, "Christian Art Overseas," *Congregational Quarterly* 34, no. 2 (April 1956): 160.

19. Ibid., 157. Butler was more explicit in a later essay, where he stated that "we used to chide A. D. Thomas because he, in trying to show Christ as an Indian, made Him pseudo-Buddhist, with more hints of effeminacy and (odd though the combination may sound) of both sensuality and other-worldliness" (John F. Butler, "New Factors in Christian Art outside the West: Developments since 1950," *Journal of Ecumenical Studies* 10, no. 1 [Winter 1973]: 116).

20. Taylor, *Jesus in Indian Paintings,* 121. A British missionary in India, Taylor defended the style of Thomas's paintings of Christ, though long after the controversial period in the late 1940s and 1950s (see Taylor, "Some Interpretations of Jesus in Indian Painting," *Religion and Society* 17, no. 3 [1970]: 82). Speaking of the erotic female nude in Thomas's *Temptation of Christ,* Taylor argued that there was sound theological basis for the sensuous nature of the artist's paintings: "I think that it is terribly important to point out that Thomas here assumes what many in the Western Christian tradition have not dared to face, that Jesus's full manhood must include, in some sense, his authentic maleness" (83).

21. *The Life of Christ: Paintings by Alfred Thomas* (London: Society for the Propagation of the Gospel, 1948; reprint, 1961), 4. Thanks to Professor Sandy Brewer for the gift of this book.

22. Quoted in Lehmann, *Christian Art in Africa and Asia,* 38–39. For further discussion of the reception of Thomas's work, see Lehmann, *Die Kunst der Jungen Kirchen,* 36–39.

23. Cited and quoted in Lehmann, *Christian Art in Africa and Asia*, 38. For the definition of syncretism ("Syncretism signifies accommodation of content and eventuates in a synthesis of the contents of faith"), see Lehmann, ibid., 50. William Dyrness (*Christian Art in Asia*, 19–23) has discussed the debate over Thomas's work.

24. Bailey, *Art on the Jesuit Missions*, 81.

25. Serge Gruzinski, *Images at War: Mexico from Columbus to Blade Runner (1492–2019)*, trans. Heather MacLean (Durham, NC: Duke University Press, 2001), 12. For accounts of cultural encounters and the overmapping of religious practices and material culture between French Jesuits and Native Americans in the seventeenth century, see Richard Wrightman Fox, *Jesus in America: Personal Savior, Cultural Hero, National Obsession* (New York: HarperSanFrancisco, 2004), 52–67.

26. For abundant examples of Vodou expropriation of Christian imagery, see Donald J. Cosentino, ed., *Sacred Arts of Haitian Vodou* (Los Angeles: UCLA Fowler Museum of Cultural History, 1995). An example from Africa is Bwiti, a synthesis of Fang and Christian culture in Gabon that has produced an identifiable iconography in carved objects; see Rosalind I. J. Hackett, *Art and Religion in Africa* (London: Cassell, 1996), 161–65.

27. For considerations of syncretism, cultural encounters, and the history of Christian missions, see Th. Sumartana, *Mission at the Crossroads: Indigenous Churches, European Missionaries, Islamic Association, and Socio-religious Change in Java 1812–1936* (Jakarta, Java: PT BPK Gunung Mulia, 1993), 309–52; Daniel H. Bays, ed., *Christianity in China: From the Eighteenth Century to the Present* (Stanford: Stanford University Press, 1996); Kevin Caroll, *Yoruba Religious Carving: Pagan and Christian Sculpture in Nigeria and Dahomey* (New York: Praeger, 1967); J. D. Y. Peel, *Religious Encounter and the Making of the Yoruba* (Bloomington: Indiana University Press, 2001); on syncretism, Sidney M. Greenfield and André Droogers, eds., *Reinventing Religions: Syncretism and Transformation in Africa and the Americas* (Lanham, MD: Rowman and Littlefield, 2001); on Haitian vodou, see Cosentino, ed., *Sacred Arts of Haitian Vodou;* and Leslie G. Desmangles, *The Faces of the Gods: Vodou and Roman Catholicism in Haiti* (Chapel Hill: University of North Carolina Press, 1992); on Jesus of Oyingbo, see Norimitsu Onishi, "After Carnival of 'Second Coming,' an Apocalypse," *New York Times International,* December 8, 1998, A4; and on Sallman, see David Morgan, *Visual Piety: A History and Theory of Popular Religious Images* (Berkeley: University of California Press, 1998).

28. For a brief article on He Qi, see Janice Wickeri, "A Vision of Chinese Christian Faith: The Art and Life of He Qi," *Presbyterian Outlook* 181, no. 34 (October 18, 1999): 6–7.

29. My thanks to Professor Robin Visser for this example and assistance with its literary meaning. For a discussion of the legend of Good Judge Bao and three examples of courtroom dramas, see George Hayden, *Crime and Punishment in Medieval Chinese Drama: Three Judge Bao Plays,* Harvard East Asian

Monographs, no. 82 (Cambridge, MA: Council on East Asian Studies, Harvard University, 1978). My thanks to He Qi, the artist, whom I was able to contact for confirmation of the subject matter. He Qi indicated in personal correspondence that Jews had lived in Kaifeng, where Judge Bao lived during the Song dynasty, and that he believes the Chinese there were influenced by stories from the Hebrew Bible, such as the Judgment of Solomon. If so, this suggests yet another layer of meaning and religious intermingling to discern in the picture.

30. The short article carefully points to the features of the face it considers most ferocious and "horrid," assuring the reader of the image's realistic portrayal of the original: "The nose, eyes, and ears are very accurately presented in the picture"; "Idol," *Child's Paper* (May 1867): 20. In fact, the article is correct. Comparison of this illustration with surviving statuary demonstrates the accuracy of the illustration. See reproductions of Hawaiian sculpture in J. Halley Cox with William H. Davenport, *Hawaiian Sculpture,* rev. ed. (Honolulu: University of Hawaii Press, 1988), 128, 136, and 196. For further discussion of the role of fear and images among American Protestants, see Morgan, *Protestants and Pictures,* 217–23.

31. In the twentieth century many Christian organizations and publishers issued collections of hymns, liturgies, and worship settings, drawing from mission fields and church traditions around the world. The publications disseminate these forms internationally, cycling indigenous worship styles back to Western churches to serve as resources for worship renewal. An example is H. B. Thompson, ed., *Worship in Other Lands: A Study of Racial Characteristics in Worship* (London: SPG, 1933), which was based on examples from missionaries in the Church of England's Society for the Propagation of the Gospel. See also Mabel Shaw, *God's Candlelights* (London: London Missionary Society, 1932).

32. Quoted in Lehmann, *Christian Art in Asia and Africa,* 45.

33. On putative condescension, see ibid., 36; on inaccuracy, see chapter 7 here.

34. Butler, "Christian Art Overseas," 157. See also Butler, *Christian Art in India,* 123.

35. Arno Lehmann, "Indigenous Art and Bible-Illustration," *Occasional Bulletin from the Missionary Research Library* 12, no. 2 (February 15, 1961): 4.

36. On dance and music, see Lehmann, *Christian Art in Africa and Asia,* 57–63.

37. Benedict Anderson, *Imagined Communities: Reflections on the Origin and Spread of Nationalism,* 2nd ed. (London: Verso, 1991).

38. Ibid., 22.

39. Taylor, "Some Interpretations," 79, 96–97.

40. On Paniker, see M. Anantanarayanan, *Paniker* (New Delhi, India: Lalit Kala Akademi, 1961).

41. Taylor, "Some Interpretations," 81, 106. Later he mentioned the same motif, with the Sacred Heart, in what may be one of the earliest appreciative discussions of Indian bazaar and calendar art. Figure 49 reproduced here is likely what he was describing. Taylor noted that this kind of image has been

sold to many non-Christians, who place them in their homes (105–6). For yet another mass-produced version of the triadic motif, also produced in Madras, see S. Brent Plate, ed., *Religion, Art, and Visual Culture: A Cross-Cultural Reader* (New York: Palgrave, 2002), fig. 5.1, p. 164, *Message of Love*, which uses Sallman's *Head of Christ* instead of the Sacred Heart.

42. Butler, *Christian Art in India*, 129.

43. Rammohun Roy, *The Precepts of Jesus, the Guide to Peace and Happiness* (New York: B. Bates, 1825), singled out Christ's belief in one God and his merciful disposition and affirmation of love as the central concern of human relations to be "more likely to produce the desirable effect of improving the hearts and minds of men of different persuasions and degrees of understanding," quoted in Stephen Hay, ed. and rev., *Sources of Indian Tradition*, 2 vols., 2nd ed. (New York: Columbia University Press, 1988), 2: 25. For further discussion of Roy and his published works aimed at Hindu reform, as well as excerpts of his writings, see William Bysshe Stein, *Two Brahman Sources of Emerson and Thoreau* (Gainesville, FL: Scholars' Facsimiles and Reprints, 1967), v-xv.

44. See Lederle, *Christian Painting in India*, 60–63, for a brief discussion.

45. J. Russell Chandran, "The Church in and against its Cultural Environment," *International Review of Missions* 41 (1952): 261. For further consideration of Gandhi's relation to Christianity by a Christian missionary in India who knew Gandhi, see E. Stanley Jones, *Mahatma Gandhi: An Interpretation* (New York: Abingdon-Cokesbury Press, 1948), esp. 51–77; and by the same author, *The Christ of the Indian Road* (New York: Abingdon Press, 1925), 73–86. For a scholarly treatment, see Margaret Chatterjee, *Gandhi's Religious Thought* (Notre Dame, IN: University of Notre Dame Press, 1983), 41–57.

46. Chatterjee, *Gandhi's Religious Thought*, 34–35.

47. For the discussion of Buddhist hand gestures, see Meher McArthur, *Reading Buddhist Art: An Illustrated Guide to Buddhist Signs and Symbols* (London: Thames and Hudson, 2002), 112–13.

48. Malak quoted in Lehmann, *Christian Art in Africa and Asia*, 269.

49. My thanks to colleague Renu Juneja for the identification of the shirt and discussion of its associations.

50. As discussed in Lederle, *Christian Painting in India*, 64–65.

51. Lehmann, *Die Kunst der Jungen Kirche*, 11.

52. John F. Butler, "Can Missions Rescue Modern Art?," *Hibbert Journal* 56 (1958): 387.

53. Costantini, *L'Art chrétien*, 32. For the judgment rendered by the Second Vatican Council, see *Vatican Council II: The Conciliar and Post Conciliar Documents,* ed. Austin Flannery, D.P. (Wilmington, DE: Scholarly Resources, 1975), 13–14.

54. Ibid., 117, 116.

55. Cardinal Celso Costantini, *Réforme des missions au XXe siècle,* trans. Jean Bruls (Tournai, Belgium: Casterman, 1960), 242.

56. Costantini, *L'Art chrétien*, 51, 52.

57. For a discussion of this transition by another advocate of Catholic mission art, see Sepp Schüller, "Von der Missionsaustellung zur Missionskunstaustellung," *Priester und Mission* 22 (1938): 38–49.

58. Costantini, *L'Art chrétien*, 34.

59. For discussion of many of these new museums and exhibitions, see Schüller, "Von der Missionsaustellung zur Missionskunstaustellung"; and, by the same author, "Der Priester als Anreger und Schöpfer einheimisch-christlicher Kunst in den Missionsländern," *Priester und Mission* 20 (1936): 83–111.

60. "Die Austellung für einheimische christliche Kunst . . . , Apostolischer Brief des Papstes an Kardinal Fumasoni-Biondi," reprinted in *Priester und Mission* 21 (1937): 132; also in Costantini, *L'Art chrétien*, 22.

61. Quoted in Costantini, *L'Art chrétien*, 148; italics in original.

62. M.-A. Couturier, "A Universal Humanism," *Sacred Art*, ed. Dominique de Menil and Pie Duployé, trans. Granger Ryan (orig. pubn. in *L'Art sacré*, 1951; Austin: University of Texas Press and Menil Foundation, 1983), 83.

63. M.-A. Couturier, "Too Late," *Sacred Art*, 70, 72, 83.

64. Lehmann, *Die Kunst der Jungen Kirche*, 12: "Im Raume der Jungen Kirchen sind sie [die Kunst und ihre Pflege] wichtige Hinweise auf das Wachstum des christlichen Eigenlebens und das Maß der Einwirzelung, ein Gradmesser dafür, wie weit und wie tief eine Kirche in ein Volk und in das Volkstum hineingewachsen ist."

65. Several writers are quoted in Lehmann, *Christian Art in Africa and Asia*, 20.

66. Takenaka, *Christian Art in Asia*, 18, 19.

67. Lehmann, *Christian Art in Africa and Asia*, 30. The flower pot to which Lehmann refers had been articulated by himself in his earlier book, *Die Kunst der Jungen Kirche:* "Die Christen sagen uns, der Christenglaube dürfe nicht einem Blumentopf gleichen, der von außen in einen neuen Raum hineingetragen wird und der seine Blume auch im neuen Raume aus der mitgebrachten, also importierten Erde speist, die vor Vermischung nach außen durch die harten Blumentopfwände abgeschlossen ist. Vielmehr müsse der harte Blumentopf zerschlagen und die schöne Blume müsse in den neuen Boden eingepflanzt und also gleichsam naturalisiert werden. Das Fremde müsse weg, das Eigene müsse in den Ausdrucksformen des christliche Lebens bestimmend und erkennbar werden; anstelle des Westlichen müsse das Bodenständige und Eigengeprägte treten" (21).

68. Anderson, *Imagined Communities*, 12–19.

69. During midcentury and after, the Vatican identified the spread of communism as the prevailing rival of Roman Catholicism's international scope.

70. Serge Guilbaut, *How New York Stole the Idea of Modern Art: Abstract Expressionism, Freedom, and the Cold War*, trans. Arthur Goldhammer (Chicago: University of Chicago Press, 1983).

71. Lehmann, "Indigenous Art and Bible-Illustration," 8.

72. Lehmann, *Christian Art in Africa and Asia*, 31, 42.

73. Ibid., 49.

74. John F. Butler, "Non-European Christian Art and Architecture," in *Christianity and the Visual Arts,* ed. Gilbert Cope (London: Faith Press, 1964), 94, 97.

75. Butler, "New Factors in Christian Art," 97, 98, 115.

76. Although he took exception to Rookmaaker's anti-Catholicism, Butler endorsed the book as "brilliant." The following passage at the end of the book recalls Butler's arguments in many respects: "The world has changed in the last decades. We have seen the crumbling of a culture. Increasingly we see ourselves living in a world that is post-Christian and even post-humanist, a neo-pagan world, one which is nihilist, or anarchist, or mystic. Whatever the signature of the day, however, it must be clear that every day we come nearer to the situation of the early Christians" (H. R. Rookmaaker, *Modern Art and the Death of a Culture* [London: Inter-Varsity Press, 1970], 246).

77. Butler, "New Factors in Christian Art," 106, 108, 116, 117.

78. See chapter 4 here for a discussion of Richard Davis's book *Lives of Indian Images.*

Chapter 6: Engendering Vision

1. See Mary P. Ryan, *Womanhood in America: From Colonial Times to the Present* (New York: New Viewpoints, 1975), 19–191; Nancy F. Cott, *The Bonds of Womanhood: "Women's Sphere" in New England, 1780–1835* (New Haven: Yale University Press, 1977), 1–99; Paul E. Johnson, *A Shopkeeper's Millennium: Society and Revivals in Rochester, New York, 1815–1837* (New York: Hill and Wang, 1978), 37–55; and Carl N. Degler, *At Odds: Women and the Family in America from the Revolution to the Present* (New York: Oxford University Press, 1980), 27–85.

2. Barbara Welter, "The Cult of True Womanhood: 1820–1860," *American Quarterly* 18, no. 2, pt. 1 (Summer 1966): 151–74; Ruth H. Bloch, "American Feminine Ideals in Transition: The Rise of the Moral Mother, 1785–1815," *Feminist Studies* 4 (1978): 101–26; Mary P. Ryan, *The Empire of the Mother: American Writing about Domesticity, 1830–1860* (New York: Institute for Research in History and the Haworth Press, 1982).

3. On women's activism and engagement in various activities that blur the sharp bounds of a "sphere," see Anne M. Boylan, *The Origins of Women's Activism: New York and Boston, 1797–1840* (Chapel Hill: University of North Carolina Press, 2002); Amy Kaplan, *The Anarchy of Empire in the Making of U.S. Culture* (Cambridge, MA: Harvard University Press, 2002), 23–50; and Cathy N. Davidson and Jessamyn Hatcher, eds., *No More Separate Spheres!* (Durham, NC: Duke University Press, 2002). On antebellum fathers, see Shawn Johansen, *Family Men: Middle-Class Fatherhood in Early Industrializing America* (New York: Routledge, 2001), 17–44; and Stephen M. Frank, *Life with Father: Parenthood and Masculinity in the Nineteenth-Century American North* (Baltimore: Johns Hopkins University Press, 1998).

4. See Walter Licht, *Industrializing America: The Nineteenth Century* (Baltimore: Johns Hopkins University Press, 1995), 27.

5. Frank, *Life with Father,* 5.

6. The *Sunday at Home* was published by the Religious Tract Society, London, from 1854 to 1894 as a weekly magazine for family reading on the Sabbath. Publications by the Religious Tract Society were widely used by such American antebellum organizations as the American Tract Society and the American Sunday School Union.

7. See the illustration and caption in "Timothy Instructed in the Scriptures by Grandmother Lois and Mother Eunice," *American Tract Magazine,* March 1830, 1.

8. If the gender politics of the British image were too ironic for some American Protestants, this would perhaps explain why the image of Eunice and Lois was eliminated in a reproduction of the image on the cover of the Congregationalist Massachusetts Sabbath School newspaper, *Well-Spring* 18, June 7, 1861.

9. On class formation among middle-class women active in benevolent work, see Lori D. Ginzberg, *Women and the Work of Benevolence: Morality, Politics, and Class in the Nineteenth-Century United States* (New Haven: Yale University Press, 1990); and David Morgan, *Protestants and Pictures: Religion, Visual Culture, and the Age of American Mass Production* (New York: Oxford University Press, 1999), chap. 3.

10. United States Bureau of the Census, *A Century of Population Growth from the First Census of the United States to the Twelfth 1790–1900* (Washington, DC: U.S. Government Printing Office, 1909), 103.

11. "Female Influence and Obligations," No. 226, in *The Publications of the American Tract Society,* 12 vols. (New York: American Tract Society, n.d. [1842]), 7: 392. This tract first appeared as a separate publication by the American Tract Society in 1829. For a study of the separate spheres among Victorian women in the United States, see Linda K. Kerber, "Separate Spheres, Female Worlds, Women's Place: The Rhetoric of Women's History," *Journal of American History* 75 (June 1988): 9–39.

12. "Female Influence and Obligations," 392, 393.

13. Ibid., 391.

14. Ibid.

15. *Parental Duties,* No. 27 (New York: American Tract Society, 1826), 1, 10.

16. The American Tract Society in Boston, formerly the New England Tract Society, had published tracts since 1814. After changing its name, it reissued the entirety of its tracts in seven volumes in 1824. The American Tract Society in New York was organized in 1825 from the New York Religious Tract Society and the Boston ATS and began issuing tracts in 1825, most of which were the same as those published in Boston.

17. Nathaniel Currier produced *Reading the Scriptures* (the title is visible in the framed print on the wall in *The Way to Happiness*) during the same period in which he issued *The Way to Happiness.* The Gale number for *Reading the Scriptures* is 5505, in *Currier & Ives: A Catalog Raisonné,* 2 vols. (Detroit: Gale

Research Company, 1984). Because Currier's name appears alone on the print, we know the image was produced sometime between 1835 and 1856. In 1857 the signature becomes "Currier & Ives," including the name of Currier's new partner, his brother-in-law James Merritt Ives, who had joined him in 1852. It is likely that Currier produced the image in 1856, because its source appears to have been another image of the same title, *Reading the Scriptures.* The image available to Currier was an engraving of the subject that appeared in a British evangelical newspaper, *Sunday at Home* (3, no. 92, January 31, 1856, 72), where it was ascribed to the British painter Benjamin Robert Haydon (1786–1846).

18. Anne Boylan, *Origins of Women's Activism,* provides statistical evidence to show that the number of single female officers in a large number of New York benevolent organizations in the first four decades of the nineteenth century was as high as 25 percent (table A.5, p. 241).

19. The engraving was copied in part from a painting that was later used as the frontispiece in Timothy Shay Arthur's *The Home Mission.* The 1853 reprint of this image is reproduced and briefly discussed by Colleen McDannell, *The Christian Home in Victorian America, 1840–1900* (Bloomington: Indiana University Press, 1986), 114–15.

20. "Female Influence and Obligations," 391.

21. Rev. John S. C. Abbott, *The Mother at Home; or The Principles of Maternal Duty* (New York: American Tract Society, 1833), 107–8.

22. "Letters on Christian Education by a Mother," No. 197, in *Tracts of the American Tract Society* (New York: American Tract Society, n.d. [1849]), 3: 11, 18.

23. On the redemptive and saintly aspect of women in antebellum views of wife and mother, see Welter, "The Cult of True Womanhood"; Welter, "The Feminization of American Religion, 1800–1860," in *Clio's Consciousness,* ed. Mary S. Hartman and Lois Banner (New York: Harper & Row, 1974), 137–57; and Ann Douglas, *The Feminization of American Christianity* (New York: Knopf, 1977), 60.

24. See, for example, a version of "Letters on Christian Education" earlier than the one reproduced here. The earlier version, illustrated by Alexander Anderson, included a cover showing a mother tending her four children (fig. 52 here) and a tailpiece of Christ with four children: "Letters on Christian Education," No. 197, in *Publications of the American Tract Society* (New York: American Tract Society, [1842]), vol. 7.

25. "Letters on Christian Education," No. 197, in *Tracts of the American Tract Society,* 6:32.

26. Louisa May Alcott, *Little Women* (New York: Penguin, 1989), 8; subsequent quotation from *Little Women* from p. 81.

27. [A. A. Livermore], "Gymnastics," *North American Review,* 81, no. 168 (July 1855): 66–67.

28. [Livermore], "Gymnastics," 69. For further discussion of Livermore and the importance of the gym in nineteenth-century conceptions of American masculinity, see Roberta J. Park, "Biological Thought, Athletics and the

Formation of a 'Man of Character,'" in *Manliness and Morality: Middle-Class Masculinity in Britain and America 1800–1940,* ed. J. A. Mangan and James Walvin (New York: St. Martin's Press, 1987), 18–19.

29. Susan L. Robertson, "'Degenerate Effeminacy' and the Making of a Masculine Spirituality in the Sermons of Ralph Waldo Emerson," in *Muscular Christianity: Embodying the Victorian Age,* ed. Donald E. Hall (Cambridge: Cambridge University Press, 1994), 150–72.

30. *The Works of Ralph Waldo Emerson: Miscellanies,* ed. J. E. Cabot (Boston: Fireside Edition, 1878–1906), 25–26; Robertson, "'Degenerate Effeminacy,'" 165.

31. Nathaniel Hawthorne, *The Marble Faun; Or The Romance of Monte Beni,* vol. 9 of *The Works of Nathaniel Hawthorne* (New York: Caxton Society, 1922), 44.

32. Ibid., 46–47.

33. Ibid., 270, 282, 347.

34. Quoted in David Rosen, "The Volcano and the Cathedral: Muscular Christianity and the Origins of Primal Manliness," in *Muscular Christianity,* ed. Hall, 36.

35. Yet a third distinction is *manhood.* This term was used by African American Christians in the nineteenth century to signify the realization of full humanity as well as their vigorous application to the construction of an independent church in the United States and to an ambitious missionary outreach in Haiti and Africa. See William H. Becher, "The Black Church: Manhood and Mission," *Journal of the American Academy of Religion* 40, no. 3 (1972): 316–33, reprinted in Darlene Clark Hine and Earnestine Jenkins, eds., *A Question of Manhood: A Reader in the U.S. Black Men's History and Masculinity,* vol. 1 (Bloomington: Indiana University Press, 1999), 322–39. A very fine study of the popular iconography of male friendship and the great latitude of meanings that informed it is John Ibson, *Picturing Men: A Century of Male Relationships in Everyday American Photography* (Washington, DC: Smithsonian Institution Press, 2002).

36. The image is reproduced in Michael Kimmel, *Manhood in America: A Cultural History* (New York: Free Press, 1996).

37. For excellent discussions of the masculinization of American culture in the nineteenth and early twentieth centuries, see Gail Bederman, *Manliness and Civilization: A Cultural History of Gender and Race in the United States, 1880–1917* (Chicago: University of Chicago Press, 1995); Margaret Lamberts Bendroth, *Fundamentalism and Gender, 1875 to the Present* (New Haven: Yale University Press, 1993); Kimmel, *Manhood in America,* 72–78; Mark C. Carnes and Clyde Griffen, eds., *Meanings for Manhood: Constructions of Masculinity in Victorian America* (Chicago: University of Chicago Press, 1990); and Kim Townsend, *Manhood at Harvard: William James and Others* (Cambridge, MA: Harvard University Press, 1998). On American Christianity and sport, see Tony Ladd and James A. Mathisen, *Muscular Christianity: Evangelical Protestants and the Development of American Sport* (Grand Rapids: Baker Book House, 1999); and Clifford Putney, *Muscular Christianity: Manhood and Sports in*

Protestant America, 1880–1920 (Cambridge, MA: Harvard University Press, 2001). On muscular Christianity, see Donald E. Hall, *Muscular Christianity: Embodying the Victorian Age,* Cambridge Studies in Nineteenth-Century Literature and Culture, vol. 2 (Cambridge: Cambridge University Press, 1994); and Putney, *Muscular Christianity.* Putney questions the degree to which Moody can be considered a supporter of muscular Christianity, since he valued the place of women in evangelical ministry (2–3). Putney rightly notes that the stridency of later proponents of muscular Christianity far exceeded Moody's. Yet Moody's enthusiastic support of the YMCA and his appeal to a broad audience of American boys and men (as well as women) by virtue of his bushy-faced directness and simplicity of speech represent an early version of a masculinized practice of popular evangelicalism.

38. On the southern conception of honor, see Bertram Wyatt-Brown, *The Shaping of Southern Culture: Honor, Grace, and War, 1760s–1880s* (Chapel Hill: University of North Carolina Press, 2001), 31–55.

39. "What a Change," *Well-Spring* 18, no. 25, June 21, 1861, 95. In a brief paragraph Clifford Putney asserts that the Civil War "actually undermined muscular Christianity in America by certifying the manliness of innumerable men," since those who fought in battle were not compelled to feel the need to exhibit their physical prowess on the sports field; Putney, *Muscular Christianity,* 23. He does not, however, cite any evidence in support of this vast claim, which suggests that it is motivated by a general definition of muscular Christianity rather than particular historical evidence. Elsewhere in his study, Putney regards the Civil War as the demarcation of a major shift in Protestant notions of masculinity (see p. 75). In fact, as he himself points out, the Civil War established the heroic masculinity of an entire generation of American men so thoroughly that the next generation looked to other wars and a militarized ideal of the strenuous life in order to compare with the generation of their fathers.

40. Ladd and Mathisen, *Muscular Christianity,* 70.

41. Horace Bushnell, *Women's Suffrage; the Reform against Nature* (New York: Scribner's, 1869; reprint, Washington, DC: Zenger, 1978), 50 (on physically distinguishing features), 51 (on "forward, pioneering mastery'), 56 (on "the claim of a beard"), 61 (on "the inherent sovereignty" of the masculine principle), 51 (on "if they were two" species).

42. William E. Barton, *Jesus of Nazareth* (Boston: Pilgrim Press, 1903), 504.

43. G. Stanley Hall, *Jesus, the Christ, in the Light of Psychology,* 2 vols. (Garden City: Doubleday, Page & Co., 1917), 1: 27. For further discussion of Hall and religious images, see Morgan, *Protestants and Pictures,* 327–30; and Morgan, "Protestant Visual Culture and the Challenges of Urban America during the Progressive Era," in *Faith in the Market: Religion and the Rise of Urban Commercial Culture,* ed. John M. Giggie and Diane Winston (New Brunswick: Rutgers University Press, 2002), 37–56.

44. Hall, *Jesus, the Christ, in the Light of Psychology,* 1: 23.

45. For further discussion of these images, see Morgan, "Protestant Visual Culture and the Challenges of Urban America during the Progressive Era."

46. See the opening pages of Bruce Barton, *The Man Nobody Knows: A Discovery of the Real Jesus* (Indianapolis: Bobbs-Merrill Company, 1925).

47. See Stanton's letter to Susan B. Anthony, January 10, 1880: "I accept no authority of either bibles or constitutions which tolerate the slavery of women"; *Elizabeth Cady Stanton, as Revealed in her Letters, Diary, and Reminiscences,* ed. Theodore Stanton and Harriet Stanton Blatch, 2 vols. (New York: Harper and Brothers, 1922), 1: 163–64. See also Elizabeth Cady Stanton, *The Original Feminist Attack on the Bible (The Woman's Bible)* (reprint, New York: Arno Press, 1974).

48. Edwin Scott Gaustad, *A Religious History of America,* new rev. ed. (New York: HarperSanFrancisco, 1990), 209.

49. On the Salvation Army's understanding of women, see Diane Winston, *Red-Hot and Righteous: The Urban Religion of the Salvation Army* (Cambridge MA: Harvard University Press, 1999), 44–84.

50. Carol Mattingly, *Well-Tempered Women: Nineteenth-Century Temperance Rhetoric* (Carbondale: Southern Illinois University Press, 1998), 58–72.

51. On the modern history of the Maid of Orleans, see Marina Warner, *Joan of Arc: The Image of Female Heroism* (Berkeley: University of California Press, 2000), 237–75.

52. Ginzberg, *Women and the Work of Benevolence,* 206.

Chapter 7: National Icons

1. Benedict Anderson, *Imagined Communities: Reflections on the Origin and Spread of Nationalism,* 2nd ed. (London: Verso, 1991), 12.

2. For a good overview of the history of American civil religion from the Puritans to the twentieth century, see Catherine L. Albanese, *America: Religions and Religion,* 3rd ed. (Belmont, CA: Wadsworth Publishing, 1999), 432–62.

3. For discussion of the visual culture of religious education in nineteenth-century United States, see David Morgan, *Protestants and Pictures: Religion, Visual Culture, and the Age of American Mass Production* (New York: Oxford University Press, 1999), chap. 6; and David Morgan, "For Christ and the Republic: Protestant Illustration and the History of Literacy in Nineteenth-Century America," in *The Visual Culture of American Religions,* ed. David Morgan and Sally M. Promey (Berkeley: University of California Press, 2001), 49–67.

4. On the Protestant crusade for a Christian America, see two classic texts, Robert T. Handy, *A Christian America: Protestant Hopes and Historical Realities,* 2nd ed. (New York: Oxford University Press, 1984); and Ray Allen Billington, *The Protestant Crusade 1800–1860: A Study of the Origins of American Nativism* (New York: Rinehart, 1938); on the Bible in the school room, see R. Laurence Moore, "Bible Reading and Nonsectarian Schooling: The Failure of Religious Instruction in Nineteenth-Century Public Education," *Journal of American History* 86, no. 4 (March 2000): 1581–99; on the imagery used to

illustrate instructional materials and tracts, see Morgan, "For Christ and the Republic," in *The Visual Culture of American Religions,* ed. Morgan and Promey, 49–67.

5. Benjamin Rush, *A Defence of the Use of the Bible in Schools,* Tract No. 231 (New York: American Tract Society, [1830]), 11. The original publication, "A Defence of the Use of the Bible as a School Book in a Letter to the Rev. Jeremy Belknap of Boston," appeared in *American Museum* 7 (March 1791): 129–36. On the role of education in the promotion of national character in the early national and antebellum periods, see David Tyack, "Forming the National Character: Paradox in the Educational Thought of the Revolutionary Generation," *Harvard Educational Review* 36, no. 1 (1966): 29–41; Timothy L. Smith, "Protestant Schooling and American Nationality, 1800–1850," *Journal of American History* 53, no. 4 (March 1967): 679–95; and Carl F. Kaestle, *Pillars of the Republic: Common Schools and American Society, 1780–1860* (New York: Hill and Wang, 1983).

6. Letter to Jeremy Belknap, July 13, 1789, in *Letters of Benjamin Rush,* ed. L. H. Butterfield, 2 vols. (Princeton: Princeton University Press, 1951), 1: 521.

7. Rush, *Defence,* 11.

8. But when it came to the issue of slavery, the ATS remained silent out of fear of losing its southern membership. Not until the Civil War was nearly over did the Tract Society produce primers and other materials expressly for African Americans. This long reticence led the abolitionist Boston branch to break with the New York–led national organization in 1858. See Morgan, *Protestants and Pictures,* 79–86, regarding the ATS and slavery, and 93–107, on the ATS and Catholicism.

9. See William George Read, *Oration, Delivered at the First Commemoration of the Landing of the Pilgrims of Maryland, Celebrated May 10, 1842, under the Auspices of the Philodemic Society of Georgetown College* (Baltimore: John Murphy, 1842). The illustration appears on the cover of the oration.

10. An early and highly learned polemical organ was the *Religious Cabinet,* begun in 1842, published in Baltimore with the archbishop's approbation, and retitled the *United States Catholic Magazine and Monthly Review* in the following year. The Catholic Tract Society of Baltimore, founded in 1839, produced tracts designed to bolster the faith of laity against Protestant attacks and evangelism. But in the early national period, the tendency among American Catholics, promoted and then led by Archbishop John Carroll, the first Catholic bishop in the United States, was to establish an independent national church, led by an American rather than a foreign appointment from the Vatican. Relations among Catholics and Protestants were much happier in this period than the 1820s and after, when Protestant nativism and its xenophobic zeal targeted Catholicism. For a good discussion of this period, see Jay P. Dolan, *The American Catholic Experience: A History from Colonial Times to the Present* (Garden City, NY: Doubleday, 1985), 101–24.

11. For further discussion of this image, see Morgan, *Protestants and Pictures,* 31–33.

12. Only three years before the Cincinnati conflict erupted, Frederick Packard, determined advocate for religious instruction in the public school, reported with alarm a dramatic decline in the reading of scripture. In 1862 in Pennsylvania, for instance, county returns indicated that scripture reading had been discontinued in 1,377 schools. [Frederick Packard], *The Daily Public School in the United States* (Philadelphia: J. B. Lippincott, 1866), 96.

13. A helpful analysis of the entire process is Robert Michaelson, "Common School, Common Religion? A Case Study in Church-State Relations, Cincinnati, 1869–1870," *Church History* 38, no. 2 (June 1969): 201–17.

14. *The Bible in the Public Schools* (Cincinnati, OH: Robert Clarke, 1870; reprint, New York: Da Capo Press, 1967), 234. On the history of such litigation, see Moore, "Bible Reading and Nonsectarian Schooling." For an overview of Catholic involvement in school controversies, see Dolan, *The American Catholic Experience,* 262–93; and John McGreevy, *Catholicism and American Freedom: A History* (New York: W. W. Norton, 2003), 7–42, before the Civil War, and 91–126, after, including discussion of Nast as well as the Cincinnati court case.

15. Michaelson, "Common School, Common Religion?," 211–12.

16. Ibid., 202–3.

17. [Packard], *The Daily Public School,* 148.

18. Ibid., 18, 91. For a discussion of legal controversies involving Catholics and the public schools in the 1850s, see McGreevy, *Catholicism and American Freedom.* Compare Packard's language about "jealousy" to James Madison's 1785 remonstrance against a bill before the Virginia General Assembly that would have enforced the examination of teachers of religion: "We hold this prudent jealousy to be the first duty of Citizens, and one of the noblest characteristics of the late Revolution" (James Madison, "A Memorial and Remonstrance against Religious Assessments," in *Toward Benevolent Neutrality: Church, State, and the Supreme Court,* ed. Robert T. Miller and Ronald B. Flowers, 3rd ed. [Waco: Markham Press Fund, 1987], 586).

19. On Mann and Packard, see Raymond Culver, *Horace Mann and Religion in Massachusetts Public Schools* (New Haven: Yale University Press, 1927), 56, 79–80, and 270; and Kaestle, *Pillars of the Republic,* 158.

20. [Packard], *The Daily Public School,* 96, 97. The view about a teacher's fitness was one that Packard had long held. In a letter to the governor of Pennsylvania, published as a pamphlet in 1841, Packard reported his observations of British schools, noting that a candidate for public teacher in London "must sustain a decidedly religious character" (*Letter from Frederick A. Packard to the Governor of Pennsylvania, in Relation to Public Schools in England* [Harrisburg: Elliott and McCurdy, 1841], 5). Such a view ran headlong into the position taken by Madison, as noted above (in n. 18), whose remonstrance had helped to defeat a bill to establish civil standards for teaching religion.

21. [Packard], *The Daily Public School,* 98. On Mann and Protestant educational reform, see Kaestle, *Pillars of the Republic,* 97–103.

22. Packard made his view of Catholicism quite clear. Early in his book he stated that "no single change in the habits of a community would so soon and

so disastrously affect its intellectual, not less than its moral and spiritual welfare, as the general abandonment of public worship. And is it not worthy of consideration, whether, among the causes which prevent so large a portion of the community from ever showing themselves in such places (except where the ritual or form of worship appeals merely to the senses), the want of sufficient education to enable them to understand or be profited by the service, is either the last or least?" ([Packard], *The Daily Public School,* 20). Packard needed to account for the larger numbers of Catholics who attended public worship than Protestants and did so by means of a Protestant commonplace, by dismissing the Mass as merely sensuous.

23. Quoted in Colonel Geo[rge] T. Balch, *Methods of Teaching Patriotism in the Public Schools* (New York: D. Van Nostrand, 1890), 1.

24. Ibid., 43–44.

25. A recently published and very instructive study of the history of patriotism in the United States, which I discovered just before this study went to press, is Cecilia Elizabeth O'Leary, *To Die For: The Paradox of American Patriotism* (Princeton: Princeton University Press, 1999). O'Leary's book is a well-researched study of the development of American patriotism and the symbolic function of the flag from the Civil War to World War I.

26. Balch, *Methods of Teaching Patriotism,* xii. For further discussion of Balch's ideas and project, see O'Leary, *To Die For,* 151–55.

27. Balch, *Methods of Teaching Patriotism,* xxxvi–xxvii.

28. Ibid., xviii.

29. Ibid., xvi (on nationalist civil religion), 76–77 (on "free government"), 4 (on Declaration of Independence and child's "personal relation"), 3 (on flag as "sole symbol"), 64 (on definition of patriotism), 13 (on public schools' role).

30. Albanese, *America: Religions and Religion,* 8–10; see chapter 2 here for discussion of these terms and their application to the visual culture of religion. For a full-blown, unrestrained religion of American nationalism, which explicitly subordinated all religious creeds to the cult of the nation, see William Norman Guthrie, *The Religion of Old Glory* (New York: George H. Doran, 1918). At the height of World War I, Guthrie advocated a national faith that regarded all citizens as subject to "the good of the social GOD of the Nation," for which Guthrie demanded "a Rite, a Ritual, a Sacrament, a Ceremony" whose principal object was none other than the American flag (399).

31. Two years before Francis Bellamy wrote the Pledge of Allegiance and President Benjamin Harrison inaugurated Columbus Day as a national holiday, to be observed in public schools, Balch offered his protocol for saluting the flag. At the principal's command, the assembled company of students was to raise "the extended right hand to the forehead (palm down), in unison with a like movement" and salute "the flag in military fashion" (Balch, *Methods of Teaching Patriotism,* 34). On the pledge and Columbus Day, see Donald E. Boles, *The Two Swords: Commentaries and Cases in Religion and Education* (Ames: Iowa State University Press, 1967), 139; and David R. Manwaring,

Render unto Caesar: The Flag-Salute Controversy (Chicago: University of Chicago Press, 1962), 2.

32. Balch, *Methods of Teaching Patriotism*, 25, 77.

33. Balch mentioned in his book that his plan had been tried in two schools of the Children's Aid Society in New York City (ibid., 26). The year after he died his *Patriotic Primer for the Little Citizen* (Indianapolis: Wallace Foster, 1895) appeared. The *Primer* was coauthored with Wallace Foster, who published it, and had gone through several printings by 1909.

34. Balch lamented that it required the formality of law in several states in 1889 and 1890 either to authorize or to require flying flags outside school buildings. He considered his own program of ritualized veneration a more "democratic method of instilling patriotism" (*Methods of Teaching Patriotism*, 65–67).

35. See the convenient collection of narratives, songs, poems, prints, and speeches gathered in Wayne Whipple, *The Story of the American Flag* (Philadelphia: Henry Altemus Company, 1910), 84–159. Most read with the same fervent piety, didacticism, and moral stentorian tone of evangelical tracts. The nationalist penchant for the superlative resounds in the claim that the American flag is "without a rival." The same exclamation states that the flag "has been the pledge of freedom, justice, order, civilization, and of Christianity" (91).

36. Charles Kingsbury Miller, *Desecration of the American Flag and Prohibition Legislation*, pamphlet containing Miller's address; reprinted in Robert Justin Goldstein, ed., *Desecrating the American Flag: Key Documents of the Controversy from the Civil War to 1995* (Syracuse, NY: Syracuse University Press, 1996), 18. Goldstein's collection of texts is an indispensable work of scholarship.

37. *The Misuse of the National Flag: An Appeal to the Fifty-fourth Congress of the United States* (Chicago: National Flag Committee of the Society of Colonial Wars in the State of Illinois, 1895); reprinted in Goldstein, ed., *Desecrating the American Flag*, 12.

38. Report of the Daughters of the American Revolution Flag Committee, in *American Monthly Magazine*, April 1899, 903; reprinted in Goldstein, ed., *Desecrating the American Flag*, 21.

39. *American Flag: Hearings before the Committee on Military Affairs*, 60th Congress, 1st session, April 1908; reprinted in Goldstein, ed., *Desecrating the American Flag*, 33.

40. See Wallace Evans Davies, *Patriotism on Parade: The Story of Veterans' and Hereditary Organizations in America 1783–1900* (Cambridge, MA: Harvard University Press, 1955).

41. "The Flag as Fetish," *Independent*, January 15, 1903, 182–83; reprinted in Goldstein, ed., *Desecrating the American Flag*, 66–67.

42. E. L. Godkin, "Patriotism by Manual," *Nation* 71, no. 1849 (December 6, 1900): 440. For a very informative historical analysis of alternative notions of patriotism developed by major American thinkers during the early twentieth century, see Jonathan M. Hansen, *The Lost Promise of Patriotism: Debating American Identity, 1890–1920* (Chicago: University of Chicago Press, 2003).

43. Godkin, "Patriotism by Manual," 439, 440.

44. E. L. Godkin, "Training in Patriotism," *Nation* 83, no. 2144 (August 2, 1906): 92.

45. Godkin, "Training in Patriotism," 92. Hansen, *The Lost Promise of Patriotism*, xiv, has used the term *cosmopolitan patriotism* to describe a liberal model of citizenship that emerged in the early twentieth century as an alternative to the prevailing nationalist conception of the American citizen.

46. *West Virginia State Board of Education v. Barnette*, 1943; reprinted in Goldstein, ed., *Desecrating the American Flag*, 74–75. For a helpful discussion of this case in the context of the Court's members and American religious history at midcentury, see Martin E. Marty, *Modern American Religion*, vol. 3: *Under God, Indivisible, 1941–1960* (Chicago: University of Chicago Press, 1996), 212–19.

47. Mary G. Dietz, "Patriotism: A Brief History of the Term," in *Patriotism*, ed. Igor Primoratz (Amherst, NY: Humanity Books, 2002), 210.

48. Balch's view was less than libertarian: "One of the fundamental principles on which civil society is based, [is that] the interests of a single individual must ever be subordinate to the general interest of the great body of individuals" (Balch, *Methods of Teaching Patriotism*, 46).

49. Jean-Jacques Rousseau, *The Social Contract*, trans. Christopher Betts (Oxford: Oxford University Press, 1994), 166–67.

50. Plato, *The Republic*, rev. ed., trans. Desmond Lee (London: Penguin, 1987), 122. In commentary on this key term, Lee prefers "magnificent myth" to "noble lie" as his translation of Plato's Greek (118). That translation, however, smoothes over the serious element of propaganda and deliberate brainwashing that Socrates intended for the well-being of his ideal polis.

51. Rousseau, *The Social Contract*, 166. A helpful study of Madison's treatment of the social compact is Gary Rosen, *American Compact: James Madison and the Problem of Founding* (Lawrence, KS: University Press of Kansas, 1999), 10–38.

52. "*United States v. Macintosh*," *United States Reports*, vol. 283 (Washington, DC: U.S. Government Printing Office, 1931), 629.

53. Ibid., 625.

54. The dissenting opinion, written by Chief Justice Charles Evans Hughes, who was joined by three other justices, argued that the "essence of religion is belief in a relation to God involving duties superior to those arising from any human relation" (ibid., 633–34). For a contextualization of the Macintosh case in the history of its day, see Marty, *Under God, Indivisible, 1941–1960*, 140–41.

55. Madison, "A Memorial and Remonstrance," 586.

56. Rousseau, *The Social Contract*, 55, 54.

57. For a very instructive set of essays that debate the definition and value of patriotism from a variety of perspectives, see Primoratz, ed., *Patriotism*. See in particular two essays there that carefully distinguish between nationalism and patriotism: Dietz, "Patriotism: A Brief History of the Term"; and John H. Schaar, "The Case for Covenanted Patriotism," 233–57.

58. Liah Greenfield has argued in her major study of nationalism that the drive to American independence in the late eighteenth century was not a drive to create a new political reality but was motivated by a loyalty to the national values that Britain had enshrined in its constitution but failed to honor in its treatment of American colonists. The central value in this loyalty was dedication to liberty (Greenfield, *Nationalism: Five Roads to Modernity* [Cambridge, MA: Harvard University Press, 1992], 412ff.). This means that the revolutionaries were actually acting as good patriots. Their loyalty was not to a national sovereignty but to the ideals that the British nation was supposed to ensure its citizens. It was this loyalty to the abstract ideal of liberty that constituted American patriotism until the secession of the southern states, which considered the sovereignty of individual states' rights to trump national unity and federal power.

59. For a Durkheimian study of the flag in the context of American civil religion, see Carolyn Marvin and David W. Ingle, *Blood Sacrifice and the Nation: Totem Rituals and the American Flag* (New York: Cambridge University Press, 1999), esp. chap. 2. I have found Marvin and Ingle's stimulating book helpful in reflection on the flag and civil religion, but I do not follow the relentless logic of their argument, which seems to grant "society" a collective mind of its own in conducting expiatory rituals on behalf of the nation-god who demands blood-sacrifice in order to maintain order and harmony. Committed to historical analysis, I wish to ascribe responsibility for the fetishization of the flag to those groups whose ideological interests are served by the enforcement of a national cultus. Marvin and Ingle also fail to distinguish patriotism and nationalism, a distinction that my account considers essential for understanding the role of visual culture.

60. For discussion of this, see Dolan, *The American Catholic Experience,* 294–320.

61. I have benefited from a fine study by William M. Halsey, *The Survival of American Innocence: Catholicism in an Era of Disillusionment, 1920–1940* (Notre Dame, IN: University of Notre Dame Press, 1980).

62. See Robert Handy, "The American Religious Depression, 1925–1935," *Church History* 29, no. 1 (March 1960): 3–16.

63. See James W. Fraser, *Between Church and State: Religion and Public Education in a Multicultural America* (New York: St. Martin's Press, 1999), 127–40.

64. Quoted in Halsey, *The Survival of American Innocence,* 71.

65. Quoted ibid., 72. Halsey discusses several attempts by American Catholic scholars and writers in the first decades of the twentieth century to discern the historical influence of Catholic ideas on the formation of American constitutional ideals (70–78).

66. Ibid., 48.

67. Reproduced and discussed by Thomas A. Tweed, "America's Church: Roman Catholicism and Civic Space in the Nation's Capital," in *The Visual Culture of American Religions,* ed. Morgan and Promey, 77–78.

68. See David Morgan, "'Would Jesus Have Sat for a Portrait?' The Likeness of Christ in the Popular Reception of Sallman's Art," in *Icons of American Protestantism: The Art of Warner Sallman,* ed. David Morgan (New Haven: Yale University Press, 1996), 192–93. The campaign persists to this day in the work of a Florida man named Morris Richardson, who began in 1949 to hand out wallet-sized images of Sallman's picture after the manner of the Indiana businessman, Carl Duning, who had initiated the project during World War II. See Sharon Kirby Lamm, "His Nickname Is Just Picture Perfect," *St. Petersburg Times,* February 18, 1995, 10; and Jim Carney, "Faith Is in the Cards," *Akron Beacon Journal,* November 29, 1997.

69. For a photograph of O'Riley posing with the *Head of Christ* and district court judge Sam Sullivan, see the *Durant Daily Democrat,* Sunday, August 28, 1949, 1; see also *Covenant Weekly* 39, March 24, 1950, 1. Judge Sullivan appears in another photograph with an autographed picture by the artist, Warner Sallman, which Sullivan placed "on the wall above his bench in the district courtroom here" (*Durant Daily Democrat,* December 6, 1950, 1). The police chief, the mayor of Durant, the postmaster, and the president and the manager of the Durant Chamber of Commerce were also presented by O'Riley with Sallman's image (*Durant Daily Democrat,* December 22, 1949, 2; April 30, 1950, 1; May 4, 1952, 4).

70. Will Herberg, *Protestant, Catholic, Jew: An Essay in American Religious Sociology,* rev. ed. (Garden City, NY: Anchor Books, 1960), 39.

71. Ibid., 258.

72. Ibid., 75, 80, 263.

73. By the 1990s, a wing of American evangelicalism had emerged as a prominent conservative force committed to the political Right. Led by such media-savvy figures as Rev. Jerry Falwell and Pat Robertson, the evangelical Right abandoned the apolitical position espoused by earlier generations of fundamentalists, Pentecostals, and evangelicals for an explicit advocacy first tapped into by Ronald Reagan during the 1980s.

74. Vera Stafford, "Christians need to speak up about Christ's picture," Letters to the Editor, *South Haven Tribune,* December 4, 1992.

75. Hon. Benjamin F. Gibson, *Washegesic vs. Bloomingdale Public Schools,* February 3, 1993, United States District Court, Western District of Michigan, Southern Division, File No. 4:92-CV-146, pp. 9–10. It is worth comparing the judge's rejection of the argument that the image was acceptable as a historical portrayal or an artistic work with previous case law. In the 1869–70 Cincinnati case, lawyers for the defendants, the board of education, argued that *McGuffey's Readers,* six of which the plaintiffs had entered as exhibits (as evidence that removing religious instruction from the public schools would require the elimination of all the *Readers* at great expense to the school system, even leaving students without books [8]), were not in fact religious books and therefore did not contradict the board's decision to eliminate Bible reading and religious instruction from the classroom (*The Bible in the Public Schools,* 123, 211). As one attorney claimed, when the Bible is read in

opening exercises, accompanied by singing, it becomes an act of worship; but when "the class takes up the Fifth Reader and reads the fifth chapter of Matthew . . . it is done, . . . if your Honors please, not as the words that fell from the second person of the Godhead, when incarnate on earth, but as a beautiful specimen of English composition—fit to be the subject of the reading of a class—and stands, so far as that exercise is concerned, on the same footing precisely as a soliloquy from Hamlet, or the address of Macbeth to the air drawn dagger" (211). In a much later instance, a similar appeal to historicity prevailed: when requested by Muslim groups to remove a sculptural portrayal of Muhammad from a frieze in the U.S. Supreme Court building, Chief Justice William H. Rehnquist defended the presence of the image as "intended only to recognize [Muhammad], among other lawgivers, as an important figure in the history of law" (as discussed by Sally M. Promey, "The Public Display of Religion," in *The Visual Culture of American Religions*, ed. Morgan and Promey, 40–41). The difference would appear to consist entirely in the pedagogical setting of the first instance and the visual context of the Sallman and Court building images in the other two examples. Were Christ's image hanging beside honorific portraits of Washington and Lincoln in Bloomingdale High School, and therefore displayed as portraits and as historical persons, one wonders if the judicial judgment might have been otherwise.

76. "Supreme Court Roundup," *New York Times,* May 2, 1995, A12.

77. The ongoing event stimulated robust press coverage and a flood of editorials from Michigan residents. See Cathy Sisson, "Citizens: Christ's Picture Belongs," *South Haven (MI) Daily Tribune,* November 5, 1992, 1, 3; Cris Robins, "Cover Hung over Jesus after Vigil," *Herald-Palladium,* March 1, 1993, 1, 4; Charlotte Channing, "Jesus Portrait Ruled Illegal," *Kalamazoo Gazette,* September 7, 1994, 1, 2; Rod Smith, "Jesus Portrait Down, Not Necessarily Out," *Kalamazoo Gazette,* February 2, 1995, 1, 2; and "Bloomingdale Must Remove Jesus Portrait," *Kalamazoo Gazette,* February 9, 1995, 1. It is noteworthy that no editorial writers that I am aware of identified themselves as Roman Catholic. The only view taken publicly by a Catholic person in the community was from a local priest, who dismissed the importance of the entire affair, stating, "I think the Lord is much more concerned about [starving children today] than . . . whether his picture is on the wall in a school in Bloomingdale" (Dave Person, "Priest, Nun Bidding Farewell to St. Thomas More," *Kalamazoo Gazette,* June 18, 1995, D1, D3).

78. Elisabeth Kauffman, "Commanding Decision," *Time* 102, no. 10, September 8, 2003, 14.

Conclusion

1. Catherine L. Albanese, *America: Religions and Religion,* 3rd ed. (Belmont, CA: Wadsworth Publishing, 1990), 11.

Select Bibliography

Albanese, Catherine C. *America: Religions and Religion*. 3rd ed. Belmont, CA: Wadsworth, 1999.

Anderson, Benedict. *Imagined Communities: Reflections on the Origin and Spread of Nationalism*. 2nd ed. London: Verso, 1991.

Askew, Kelly, and Richard R. Wilk, eds. *The Anthropology of Media: A Reader*. Oxford: Blackwell, 2002.

Avrin, Leila. *Micrography as Art*. Paris and Jerusalem: Centre national de la recherche scientifique and Israel Museum, 1981.

Bailey, Gauvin A. *Art on the Jesuit Missions in Asia and Latin America, 1542–1773*. Toronto: University of Toronto Press, 1999.

Barnard, Malcolm. *Approaches to Understanding Visual Culture*. Houndmills, England: Palgrave, 2001.

Baxandall, Michael. *The Limewood Sculptors of Renaissance Germany*. New Haven: Yale University Press, 1980.

Belting, Hans. *Likeness and Presence: A History of the Image before the Era of Art*. Trans. Edmund Jephcott. Chicago: University of Chicago Press, 1994.

Besançon, Alain. *The Forbidden Image: An Intellectual History of Iconoclasm*. Trans. Jane Marie Todd. Chicago: University of Chicago Press, 2000.

Boime, Albert. *The Unveiling of the National Icons: A Plea for Patriotic Iconoclasm in a Nationalistic Era*. Cambridge: Cambridge University Press, 1998.

Boorstin, Daniel J. *The Image: A Guide to Pseudo-Events in America*. New York: Vintage Books, 1992.

Burke, Peter. *Eyewitnessing: The Uses of Images as Historical Evidence*. Ithaca: Cornell University Press, 2001.

Butler, John F. *Christian Art in India*. Madras, India: Christian Literature Society, 1986.

Cassidy, Brendan, ed. *Iconography at the Crossroads*. Princeton: Index of Christian Art, Department of Art and Archaeology, Princeton University, 1993.

Christian, William A., Jr. *Apparitions in Late Medieval and Renaissance Spain*. Princeton: Princeton University Press, 1981.

———. *Local Religion in Sixteenth-Century Spain*. Princeton: Princeton University Press, 1981.

Cosentino, Donald J. *Defiant Maids and Stubborn Farmers: Tradition and Invention in Mende Story Performance*. Cambridge: Cambridge University Press, 1982.

———, ed. *Sacred Arts of Haitian Vodou*. Los Angeles: UCLA Fowler Museum of Cultural History, 1995.

Costantini, Celso. *L'Art chrétien dans les missions: Manuel d'art pour les missionaires*. Trans. Edmond Leclef. Paris: Desclée de Brouwer, 1949.

Davis, Richard H. *Lives of Indian Images*. Princeton: Princeton University Press, 1997.

Dean, Carolyn. *Inka Bodies and the Body of Christ: Corpus Christi in Colonial Cuzco, Peru*. Durham, NC: Duke University Press, 1999.

Doss, Erika. *Elvis Culture: Fans, Faith, and Image*. Lawrence: University Press of Kansas, 1999.

Eck, Diana L., ed. *Darsan: Seeing the Divine Image in India*. Chambersburg, PA: Anima Books, 1981.

Edwards, Elizabeth, ed. *Anthropology and Photography, 1820–1920*. New Haven: Yale University Press, in association with the Royal Anthropological Institute, London, 1992.

Elkins, James. *The Domain of Images*. Ithaca: Cornell University Press, 1999.

———. *The Strange Place of Religion in Contemporary Art*. New York: Routledge, 2004.

———. *On Pictures and the Words That Fail Them*. Cambridge: Cambridge University Press, 1998.

———. *Visual Studies: A Skeptical Introduction*. New York: Routledge, 2003.

Evans, Jessica, and Stuart Hall, eds. *Visual Culture: The Reader*. London: SAGE, 1999.

Freedberg, David. *The Power of Images: Studies in the History and Theory of Response*. Chicago: University of Chicago Press, 1989.

Gamboni, Dario. *The Destruction of Art: Iconoclasm and Vandalism since the French Revolution*. New Haven: Yale University Press, 1997.

Greenfield, Liah. *Nationalism: Five Roads to Modernity*. Cambridge, MA: Harvard University Press, 1992.

Grossman, Grace Cohen, with Richard Eighme Ahlborn. *Judaica at the Smithsonian: Cultural Politics as Cultural Model*. Washington, DC: Smithsonian Institution Press, 1997.

Gruzinski, Serge. *Images at War: Mexico from Columbus to Blade Runner (1492–2019)*. Trans. Heather MacLean. Durham, NC: Duke University Press, 2001.

Hackett, Rosalind I. J. *Art and Religion in Africa*. London: Cassell, 1996.

Hawting, Gerald R. *The Idea of Idolatry and the Emergence of Islam: From Polemic to History*. Cambridge: Cambridge University Press, 1999.

Hobsbawm, E. J. *Nations and Nationalism since 1780: Programme, Myth, Reality*. Rev. ed. Cambridge: Cambridge University Press, 1990.

Huyler, Stephen P. *Meeting God: Elements of Hindu Devotion*. New Haven: Yale University Press, 1999.

Irwin, Robert. *Islamic Art in Context: Art, Architecture, and the Literary World*. New York: Abrams, 1997.

Jenks, Chris, ed. *Visual Culture*. London: Routledge, 1995.

Kibbey, Ann. *The Interpretation of Material Shapes in Puritanism*. Cambridge: Cambridge University Press, 1986.

Koerner, Joseph Leo. "The Icon as Iconoclash." In *Iconoclash: Beyond the Image Wars in Science, Religion, and Art*, ed. Bruno Latour and Peter Weibel, 164–213. Karlsruhe and Cambridge, MA: ZKM Center for Art and Media and MIT Press, 2002.

Lambek, Michael, ed. *A Reader in the Anthropology of Religion*. Oxford: Blackwell, 2002.

Latour, Bruno, and Peter Weibel, eds. *Iconoclash: Beyond the Image Wars in Science, Religion, and Art*. Karlsruhe and Cambridge, MA: ZKM, Center for Art and Media, and MIT Press, 2002.

Lehmann, Arno. *Christian Art in Africa and Asia*. Trans. Erich Hopka, Jalo E. Nopola, and Otto E. Sohn. Saint Louis: Concordia Publishing House, 1969.

———. *Die Kunst der Jungen Kirchen*. Berlin: Evangelische Verlagsanstalt, 1955; 2nd ed., 1957.

Leidy, Denise Patry, and Robert A. F. Thurman. *Mandala: The Architecture of Enlightenment*. New York and Boston: Asia Society Galleries, Tibet House, and Shambhala, 1997.

Long, Kathryn T. " 'Cameras Never Lie': The Role of Photography in Telling the Story of American Evangelical Missions." *Church History* 72, no. 4 (December 2003): 820–51.

Lopez, Donald S., Jr., ed. *Buddhism in Practice*. Princeton: Princeton University Press, 1995.

Magritte, René. *Écrits complets*. Ed. André Blavier. Paris: Flammarion, 1979.

Marty, Martin E. *Modern American Religion*. Vol. 3: *Under God, Indivisible, 1941–1960*. Chicago: University of Chicago Press, 1996.

McArthur, Meher. *Reading Buddhist Art: An Illustrated Guide to Buddhist Signs and Symbols*. London: Thames and Hudson, 2002.

Metcalf, Barbara Daly, ed. *Making Muslim Space in North America and Europe*. Berkeley: University of California Press, 1996.

Miller, David C., ed. *American Iconology: New Approaches to Nineteenth-Century Art and Literature*. New Haven: Yale University Press, 1993.

Mills, Kenneth. *Idolatry and Its Enemies: Colonial Andean Religion and Extirpation, 1640–1750*. Princeton: Princeton University Press, 1997.

Mirzoeff, Nicholas. *An Introduction to Visual Culture*. London: Routledge, 1999.

————, ed. *The Visual Culture Reader.* 2nd ed. London: Routledge, 2002.

Mitchell, Jolyon, and Sophia Marriage, eds. *Mediating Religion: Conversations in Media, Religion, and Culture.* London: T. and T. Clark, 2003.

Mitchell, W. J. T. "Interdisciplinarity and Visual Culture." *Art Bulletin* 77, no. 4 (December 1995): 540–44.

————. *Picture Theory.* Chicago: University of Chicago Press, 1994.

————. "What Is Visual Culture?" In *Meaning in the Visual Arts: Views from the Outside. A Centennial Commemoration of Erwin Panofsky (1892–1968),* ed. Irving Lavin, 207–17. Princeton: Institute for Advanced Study, 1995.

Morgan, David, ed. *Icons of American Protestantism: The Art of Warner Sallman.* New Haven: Yale University Press, 1996.

————. *Protestants and Pictures: Religion, Visual Culture, and the Age of American Mass Production.* New York: Oxford University Press, 1999.

————. "Toward a Modern Historiography of Art and Religion." In *Reluctant Partners: Art and Religion in Dialogue,* ed. Ena Giurescu Heller, 16–47. New York: Gallery at the American Bible Society, 2004.

————. *Visual Piety: A History and Theory of Popular Religious Images.* Berkeley: University of California Press, 1998.

————. "Visual Religion." *Religion* 30 (2000): 41–53.

Morgan, David, and Sally M. Promey, eds. *The Visual Culture of American Religions.* Berkeley: University of California Press, 2001.

Moxey, Keith. *Peasants, Warriors, and Wives: Popular Imagery in the Reformation.* Chicago: University of Chicago Press, 1989.

Nelson, Robert S., ed. *Visuality before and beyond the Renaissance: Seeing as Others Saw.* Cambridge: Cambridge University Press, 2000.

Obrist, Hans-Ulrich, ed. *Gerhard Richter: The Daily Practice of Painting, Writings and Interviews 1962–1993.* Trans. David Britt. Cambridge, MA, and London: MIT Press and Anthony d'Offay Gallery, 1995.

O'Leary, Cecilia Elizabeth. *To Die For: The Paradox of American Patriotism.* Princeton: Princeton University Press, 1999.

Orsi, Robert A. *Thank You, St. Jude: Women's Devotion to the Patron Saint of Hopeless Causes.* New Haven: Yale University Press, 1996.

Panofsky, Erwin. *Meaning in the Visual Arts.* Garden City, NY: Doubleday Anchor, 1955.

Phillips, Ruth B. *Representing Women: Sande Masquerades of the Mende of Sierra Leone.* Los Angeles: UCLA Fowler Museum of Cultural History, 1995.

Plate, S. Brent, ed. *Religion, Art, and Visual Culture: A Cross-Cultural Reader.* New York: Palgrave, 2002.

Prebish, Charles S., and Martin Baumann. *Westward Dharma: Buddhism beyond Asia.* Berkeley: University of California Press, 2002.

Promey, Sally M. "The 'Return' of Religion in the Scholarship of American Art." *Art Bulletin* 85, no. 3 (September 2003): 581–603.

Reeves, Gene, ed. *A Buddhist Kaleidoscope: Essays on the Lotus Sutra.* Tokyo: Kosei, 2002.

Rinpoche, Sogyal. *The Tibetan Book of Living and Dying*. Ed. by Patrick Gaffney and Andrew Harvey. Rev. ed. London: Rider, 2002.

Roberts, Allen F., and Polly Nooter Roberts. "Displaying Secrets: Visual Piety in Senegal." In *Visuality Before and Beyond the Renaissance: Seeing as Others Saw*, ed. Robert S. Nelson, 224–51. Cambridge: Cambridge University Press, 2000.

———. *A Saint in the City: Sufi Arts of Urban Senegal*. Los Angeles: UCLA Fowler Museum of Cultural History, 2003.

Roberts, Mary Nooter. "Proofs and Promises: Setting Meaning before the Eyes." In *Insight and Artistry in African Divination*, ed. John Pemberton III, 63–82. Washington, DC: Smithsonian Institution Press, 2000.

Ruel, Malcolm. *Belief, Ritual, and the Securing of Life: Reflexive Essays on a Bantu Religion*. Leiden: E. J. Brill, 1997.

Sassower, Raphael, and Louis Cicotello. *The Golden Avant-Garde: Idolatry, Commercialism, and Art*. Charlottesville: University Press of Virginia, 2000.

Scheer, Monique. "From Majesty to Mystery: Change in the Meanings of Black Madonnas from the Sixteenth to Nineteenth Centuries." *American Historical Review* 107, no. 5 (December 2002): 1412–40.

Shachar, Isaiah. *Jewish Tradition in Art: The Feuchtwanger Collection of Judaica*. Trans. R. Grafman. Jerusalem: Israel Museum, 1981.

Smith, Jeffrey Chipps. *Sensuous Worship: Jesuits and the Art of the Early Catholic Reformation in Germany*. Princeton: Princeton University Press, 2002.

Steiner, George. *Real Presences*. Chicago: University of Chicago Press, 1989.

Storr, Robert. *Gerhard Richter: Forty Years of Painting*, exhibition catalogue. New York: Museum of Modern Art, 2002.

Sturken, Marita, and Lisa Cartwright. *Practices of Looking: An Introduction to Visual Culture*. Oxford: Oxford University Press, 2001.

Swearer, Donald K. *Becoming the Buddha: The Ritual Image Consecration in Thailand*. Princeton: Princeton University Press, 2004.

Takenaka, Masao. *Christian Art in Asia*. Kyoto: Kyo Bun Kwan with Christian Conference of Asia, 1975.

Tambiah, Stanley Jeyaraja. *The Buddhist Saints of the Forest and the Cult of Amulets: A Study in Charisma, Hagiography, Sectarianism, and Millennial Buddhism*. Cambridge: Cambridge University Press, 1984.

Tanabe, Willa Jane. *Paintings of the Lotus Sutra*. New York: Weatherhill, 1988.

———. "Visual Piety and the Lotus Sutra in Japan." In *A Buddhist Kaleidoscope: Essays on the Lotus Sutra*, ed. Gene Reeves, 81–92. Tokyo: Kosei, 2002.

Taylor, Mark C. *Disfiguring: Art, Architecture, Religion*. Chicago: University of Chicago Press, 1992.

Tweed, Thomas A. *Our Lady of the Exile: Diasporic Religion at a Cuban Catholic Shrine in Miami*. New York: Oxford University Press, 1997.

"Visual Culture Questionnaire." *October* 77 (Summer 1996): 25–70.

Walker, John A., and Sarah Chaplin. *Visual Culture: An Introduction*. Manchester: Manchester University Press, 1997.

Index

Compositors:	TechBooks and
	BookMatters, Berkeley
Text:	10/13 Galliard
Display:	Galliard
Printer and Binder:	Thomson-Shore